AMERICAN CARNIVAL

American Carnival

Journalism under Siege in an Age of New Media

NEIL HENRY

UNIVERSITY OF CALIFORNIA PRESS Berkeley Los Angeles London

University of California Press, one of the most distin-
guished university presses in the United States, enriches
lives around the world by advancing scholarship in the
humanities, social sciences, and natural sciences. Its ac-
tivities are supported by the UC Press Foundation and
by philanthropic contributions from individuals and in-
stitutions. For more information, visit
www.ucpress.edu.

University of California Press

Berkeley and Los Angeles, California

University of California Press, Ltd.
London, England

Library of Congress Cataloging-in-Publication Data

Henry, Neil, 1954–.
 American carnival : journalism under siege in an age
of new media / Neil Henry.
 p. cm.
 Includes bibliographical references and index.
 ISBN 978-0-520-24342-2 (cloth : alk. paper).
 1. Journalistic ethics—United States. 2. Journal-
ism—Economic aspects. I. Title.
PN4888.I 81146 2007
174'.0704—dc22 CatalogNumber

Manufactured in the United States of America

16 15 14 13 12 11 10 09 08 07
10 9 8 7 6 5 4 3 2 1

This book is printed on New Leaf EcoBook 60, con-
taining 60% post-consumer waste, processed chlorine
free; 30% de-inked recycled fiber, elemental chlorine
free; and 10% FSC-certified virgin fiber, totally chlo-
rine free. EcoBook 60 is acid-free and meets the mini-
mum requirements of ANSI/ASTM D5634–01 (Perma-
nence of Paper).

For Letitia and Zoë, as always—
and Hazel for all those walks

Contents

Acknowledgments

One of the great things about a publisher like the University of California Press is that any manuscript presented for publication must successfully pass through a process of review by anonymous peers. I thank those peers, whoever they are, for their frank criticism and suggestions. Their comments were very helpful. I thank Mary Severance and Reed Malcolm at the Press for believing in my work and am especially grateful to Mary Renaud for her valuable insights and tireless line editing.

I am indebted to Tom Goldstein, Thomas C. Leonard, Paul Grabowicz, and Robert B. Gunnison for looking at an early draft of this book and helping me attempt to maintain my bearings. My students, current and past, helped immeasurably; there are far too many of them to allow me to express my appreciation individually. In particular, however, the following folks, through their research and other assistance, were directly instrumental in helping this book finally see the light of day: Tomio Geron, Ryan Lillis, Edwin Okong'o, Jeremy Rue, and Shelly Meron.

I'm grateful to Tami Silicio and Calvert McCann for allowing me to reproduce the compelling photographs they so bravely took as citizen reporters on the cutting edge of their respective times.

Significant events in journalism history form a recurring backdrop to the modern story lines I explore in the following chapters. Until I began

researching and writing this book, I was not terribly familiar with the work of journalism historians, nor did I fully appreciate the richness of their field of inquiry. As a professional journalist and educator, I thank them. Their journal articles and books provided constant inspiration. Needless to say, any mistakes or misinterpretations of that history and literature are entirely my own, and certainly not intended.

Finally, I thank Letitia Lawson, my wife and muse, and the brightest human being I will ever have the blessed fortune to know.

Introduction

Some years ago, when I was a correspondent based in Africa for the *Washington Post,* a mysterious fellow representing the antigovernment peasant rebellion then raging in Ethiopia got in touch with me to offer a rare proposition: how would I like to visit Tigray, the provincial heartland of the insurgency, to report on life and the war behind the Ethiopian government's military lines?

At the time, I was visiting Khartoum, the teeming, dusty capital of Sudan, Ethiopia's neighbor, reporting on the social and economic policies of the Sudanese military government. But I promptly postponed the Sudan story in order to seize this unexpected opportunity. For years, Tigray had been a forbidden region. Located in Ethiopia's mountainous northern highlands bordering Eritrea in the Horn of Africa, it had been largely cut off from the outside world by the repressive government of the Marxist dictator Mengistu Haile Mariam. Only irregular truck convoys bearing international humanitarian food aid had been able to traverse the roughly five hundred miles across the Sudanese border to the heart of the rugged, rebel-held Ethiopian frontier—and they usually traveled only under cover of darkness, to evade the government's attack aircraft. Few Western reporters had visited Tigray since the worst of the fighting had erupted there, and in Eritrea,

some four years earlier, so I knew that this chance was too timely and newsworthy to ignore.

Still, my decision to take it was far more spontaneous and journalistically instinctive than rational—and, when I think back on it years later, recalling my comical lack of readiness, not terribly bright. But for the purposes of this book, it provides a useful starting point for examining both the powerful forces shaping and endangering professional journalism today and the role of education in this struggle, an examination that is the chief aim of the chapters ahead.

The shadowy rebel official told me that the trip would last from ten days to three weeks and that I had only a day to get ready. So I hurriedly went out and did the best I could. I bought a couple of wool blankets inside a tent at the main market in central Khartoum and a pouch of water purification tablets in what passed for a pharmacy in another tent. For food, I purchased a big bag of dried dates and assorted nuts from an outdoor vendor. The last thing I did the night before the trip was to type out a short message to my editors in Washington, using an ancient Teletype machine behind the front desk of my Khartoum hotel. In several succinct sentences, I briefly confirmed my plans and let them know that I would be "out of pocket" and unreachable for at least a week, and possibly as long as three.

The next afternoon, with my supplies, including notebooks, Bic pens, rolls of black-and-white Kodak film, and my trusty single-lens reflex 35mm Pentax camera in my shoulder bag, I joined a small group of hardy Scandinavian aid workers, and we immediately set out in a four-wheel-drive truck along a bumpy, hellish road leading southeast out of Khartoum. We crossed checkpoints at Sudan's barren border with Tigray a couple of days later, where we met up with a convoy of about fifteen grinding, groaning, canvas-covered trucks. Each carried wheat, corn meal, cooking oil, and other supplies donated from Western countries and destined for the hungry population of the province then controlled by the ragtag but determined Tigrayan People's Liberation Front.

The trip was extraordinary, revealing a beguiling land utterly frozen in time. In the main square of a town called Inda Selassie, we were startled to find a bronze statue of Italian fascist dictator Benito Mussolini, dating from Italy's 1935 invasion of the country. In a stark, otherworldly landscape strewn with rocks and offering little arable land, peasants ˙ ~ in ancient dwellings wrought from hand-carved heaps of ·ly isolated from the rest of the world. Most of the people piritual faith rooted in one of the world's oldest organized

branches of Christianity, the Ethiopian Orthodox Church, centered in the magnificent Tigrayan town of Axum and dating back to the second century AD.

But perhaps most startling were the rhythms of life in that besieged, impoverished, but deeply prideful place, where nearly every human activity—schooling, shopping in the marketplaces, attending religious services—took place after dark because of the Ethiopian government's air war against the rebellion. In daylight hours, the aid workers and I slept outdoors along riverbeds, our vehicles concealed from fighter aircraft by tree branches. By night, as workers distributed food to the peasants, I talked to the people and their leaders about their lives and dreams, hoping to paint a fuller picture of the situation when I returned. Until that trip, I had been compelled to rely on tight-lipped Ethiopian government officials, occasional foreign aid workers, and diplomatic sources in the American embassy in Ethiopia's capital, Addis Ababa, for news about the conflict in Tigray. But the hard truth was that the officials and diplomats knew little about what was really going on. So I worked like crazy during those nights inside the rebellion, asking critical questions and collecting every piece of information I could, as I had been trained to do in the fourteen years since starting my career as a night police reporter in Washington, D.C. As always, accuracy and detail mattered most:

What is your political philosophy?

How is your Marxism any different from the government's?

How many civilians were killed in the battle last week?

Can you direct me to the survivors?

What are your specific plans to improve the lives of the people if you manage to win?

Who will lead?

My notebooks soon filled with word sketches of the scenes I saw, notes of the interviews I conducted, and, just as important, a twisting, hand-drawn map of the roughly thousand-mile roundtrip route we traveled from Khartoum, to Adwa, to Adigrat and Mekele.

A couple of weeks later, I flew from Khartoum back to my base as the *Post*'s bureau chief in Nairobi, Kenya, where I worked nonstop on a series of narrative articles about the trip. After composing and rewriting the stories on a rudimentary, early-generation Compaq desktop computer, I clicked a button to dial a telephone number on my external

modem. When prompted, I sent the stories electronically via landline circuit-switching technology to a communications office of Reuters, the British newswire agency in London. Reuters then forwarded my stories on a similarly dedicated data transmission line to my newsroom in Washington.

About a week later, my articles about the rebellion began appearing on the front page of the *Post,* along with the black-and-white photographs that I had developed and sent by international air courier. The series was headlined "Tigray Province: Land of the Night." For thousands of Washington-area readers, the stories and photos represented one of the first inside accounts of a secretive peasant rebellion on the far side of the planet, a rebellion that within a year would indeed succeed in marching on the capital and overthrowing the Mengistu regime, sending the Ethiopian dictator fleeing to Zimbabwe.[1]

For better or worse, the Tigray reporting experience was pretty typical of the way I practiced journalism professionally and technically barely fifteen years ago as a correspondent responsible for covering nearly an entire continent for one of the world's leading newspapers. I was far from the most intrepid, technically skilled, or accomplished reporter in the history of foreign correspondence. But I did perform the job to the best of my ability in accordance with the years of hard training in reporting, writing, and professional ethics that I had absorbed at the *Post.* In Africa, perhaps more so than elsewhere, covering the news took enterprise, instinct, ingenuity on the fly, and not a little bit of sustained belief in one's ethical choices in the face of obstacles. As far as I was concerned, the mission of getting the truth in a very complicated place and trying to understand it, firsthand and independently, was a far more essential part of my purpose as a professional journalist than obsessing over the latest means of technology required to transmit what I had learned or trying to gauge the economic marketplace and political culture back home in which my news would be received.

For many reasons, my memories of that 1990 trip to Ethiopia came flooding back not long ago when I greeted my newest class of twelve entering students at Berkeley's Graduate School of Journalism, a two-year professional master's degree program, where I have taught news and feature reporting full time since 1993. I usually begin my annual class, an intensive introduction to journalism, with an hour-long lecture about the readings and assignments to come. But this time I decided to do something different. I led my students outside on a ten-minute walk to the Campanile, the soaring granite bell tower at the heart of the Berkeley

campus, where we took the elevator to the top. The late-summer afternoon sky was spectacularly clear, and we could see all the way to the Golden Gate, shimmering in the distance. As my students gazed at the San Francisco Bay Area landscape spread before them, I began to pepper them with questions: Which way is north? Which way is east? Which city is Oakland, and where is San Francisco? Which of those streets way off in the distance down there is Telegraph Avenue? Which is San Pablo, and which is University? The students, who seemed confused at first, soon erupted with a chorus of conflicting answers before breaking into gales of laughter.

"That's your first lesson in journalism," I told them. "Always know exactly where you are. In many ways, you guys are explorers. Your responsibility is to bear witness to the truth as you see and hear it, and to tell it accurately, especially for people who aren't there with you to see it for themselves."

Newly committed to journalism, the young students—most in their mid-twenties—were enthusiastic and very bright, filled with curiosity about the world and an eagerness to pursue the truth, the facts, the *news*—a job critical to the functioning of a healthy democracy. But as I observed them taking in the view from the Campanile that day, I couldn't help also reflecting on the enormous changes that have come to the professional news media since my career as a daily journalist not so long ago, the mounting pressure on journalism educators to stay current with these times, and the growing ethical and moral challenges the young people would likely face as a result of the media's transformation.

Certainly it is rare today for any journalist to be "out of pocket" practically anywhere on the planet, as I was from my *Washington Post* newsroom during those weeks in Ethiopia; the very idea is laughable. Communications technology has advanced so radically and swiftly over the past decade that virtually all corners of the globe, including the most distant parts of East Africa, are now reachable by wireless communications, cell phone, and satellite linkups. The Internet age allows not only direct and immediate digital transfers of text, sound, high-resolution still images, and video but also instant Web publication accessible by computer worldwide. When I demonstrate to my students how I struggled to file my stories from Africa as recently as 1992—yelling in my classroom, "That's Robert Mugabe, spell it M as in Michael, You, G as in George, A as in Apple, B as in Boy, E as in Eagle," to replicate how I often dictated stories to a telephone operator in the *Post* newsroom, spelling out each problematic word in a precise, military manner—they howl with

glee, likening my years of correspondence to something of a journalistic Stone Age, compared to the world they know.

A map of your journey sketched by hand in a ragged notebook? How retro! Everyone knows that by simply hitting a key or two on your laptop today you can instantly call up extraordinarily precise visual details of practically any address or patch of terrain on the planet, using Google's online satellite imaging database. Black-and-white photographs in hard copy? How old school! Today you only need to switch on your cell phone or BlackBerry or laptop computer and Web cam and let the images flow directly and in living color to viewers via your wireless linkup. Imagine having to develop film *by hand* in a darkroom, for goodness' sake, and sending the strips of film and contact sheets to your home office by airplane! Imagine, too, the frustration of having to wait more than *a whole week* just to reveal the fruits of your hard labor, your *news*, to the public! Certainly the technical capabilities of journalists, especially print journalists, have advanced further and in far more fundamental ways over the past decade than in the entire century or so that came before.

But if such wondrous powers are being harnessed today to improve the craft of reporting the truth accurately and fairly according to the time-honored ethics of the journalism profession, so too are these powers being exploited to disseminate rumor, lies, artifice, propaganda, and distortion. As revolutionary technology has shaped the work of journalists, so too have extraordinary assaults by government and advertisers on the professionalism that has made journalism so purposeful and valuable to democratic society. This professionalism—the belief that journalists exercise expertise acquired through training and experience, in performance of a vital public service—has long been an important deterrent to abuse of the public trust. But as journalism finds itself under growing siege from pressures both inside and outside the industry, we witness the emergence of a startling variety of unprofessional practices, intentional frauds, and other forms of corruption in the culture of the nation's media. While this wrongdoing has demonstrably deep roots in the nation's colorful journalistic history, as the following pages show, its vigor and slickness in an age of high-speed technology and high-pressure marketing presents, I believe, far more serious implications today—implications for young people who idealistically choose journalism as a calling, for citizens who must rely on professional and independent journalism to clearly understand the world around them, and for democracy itself.

To the average citizen, perhaps the most obvious examples of jour-

nalistic misdeeds are the plagiarists and fabulists in America's news-rooms who have famously made up sensational stories in order to advance their careers, for publications as distinguished and customarily trusted as the *New York Times,* the *New Republic,* and *USA Today.* But the forms of corruption I explore in this book are far more complex and extensive and far less publicized than the scandals represented by wayward individuals.

Today, for example, the nation's print and electronic media are increasingly filling news airtime and advertising space with video news releases, "advertorials," and other fake news generated by sophisticated public relations and marketing firms that serve not the public interest but the political and commercial aims of government, business, and advertisers. These firms are part of a highly profitable and rapidly expanding industry that utilizes the most advanced digital and satellite data transmission technology. Political and commercial advertising of all forms is often cleverly disguised as news and public affairs journalism, precisely in order to enhance its credibility, whether the product in question is a controversial new Medicare law pushed by the administration or an anticancer "wonder herb" hawked on AM radio by a smooth talker who fraudulently describes himself as a "health journalist." Government public relations contractors have been caught secretly bribing presumably professional print, broadcast, and online columnists to promote particular social and economic policies.

These misdeeds are at times nurtured and facilitated by powerful gatekeepers in the news industry itself. It is the gatekeepers, after all, who allow con artists and public relations specialists to hijack the image and name of independent journalism to sell specious products and political causes in print media and on the public airwaves. Pressured by corporate shareholders of publicly traded media organizations, and critically endangered by the economic competition of New Media such as the Internet, the mainstream news industry fights for survival by cutting costs and slashing the jobs of experienced journalists. The result is an even greater loss of professionalism and credibility, for as the traditional guardians of the news eliminate those who have been trained to provide it for citizens, they lower the standards of practice and expertise represented by those journalists. They also eviscerate the institutional knowledge and culture of professional mentoring so vital to a new generation of reporters, weaken their own gatekeeping ability, and allow ethical transgressions to thrive in the vacuum.

Public relations specialists and advertisers with expertise in video

news are especially exuberant today about cuts in local television news jobs around the country. On sites all across the Web and in their advertising brochures, these PR firms promise potential advertisers ever greater and more effective opportunities to "place" their products and political causes dressed up as credible "news." Indeed, some firms brazenly cite specific examples of "success" in these efforts to deceive. Television and radio station owners in the United States are all licensed by "the people," of course, and are entrusted with protecting the public interest. The stations, like America's newspapers and other print news media, vow to serve the people with independent news and information gathered under strict codes of ethics. These codes were crafted and refined over many decades of struggle in the twentieth century by dedicated professional journalists deeply committed to preventing the recurrence of the corruption, dishonesty, partisanship, racism, and sensationalism that had too often been exhibited by the press in the past. But today both the public interest and these ethical codes appear to play an ever-diminishing role in the face of urgent economic imperatives.

This corruption of professional values afflicts many other corners of the mass media, including book publishing, which similarly shows a growing insensitivity to the difference between truth and lies—and why the difference matters. Popular genres such as biography and "nonfiction memoir" have witnessed a spike in published works suffused with knowing falsehoods and fabrications. Like professional journalists, book editors and many trade publishers have long operated under established codes of professional ethics. Yet when popular works are exposed as lies, and their authors as con artists, publishing industry leaders, strangely, often defend the books, excuse the fabrications, and even dismiss the value of the truth itself if the fraudulent works—propelled to startling success by intense online and broadcast promotion—prove profitable enough.[2]

In an age of revolutionary technology, the weakening of editorial practices and the devaluing of truth make it easier not only for unsubstantiated news stories to speedily gain widespread circulation but also for technically deft, media-savvy hucksters to sell their fabrications as truth to reporters, and by extension to the public. Such fabrications are sometimes pranks, motivated by a simple desire to hoodwink a press that is endlessly hungry for sensation and attention. But fabrications also have played more serious and well-documented roles in recent times in efforts to undermine a candidate's drive for his party's presidential nomination with a digitally tricked-up photograph, to damage a president's

reelection campaign with digitally invented military service records, and even to provide false evidence of a clear and present danger justifying the decision to launch a war against another nation. For a democratic society whose vitality and sustainability derive directly from an informed citizenry—ideally, a citizenry informed by the truth—what does it mean when the idea of objective truth ceases to be a central cultural value in its major institutions?[3] What do these challenges mean especially to average citizens and to students of this rapidly changing craft?

This book explores the culture of wrongdoing and the forces undermining professionalism in journalism and the news industry today as interconnected parts of a single whole, a distinct pathology. It seeks to provide a comprehensive assessment of patterns of failure by individuals and media institutions alike, and the challenges these failures present to journalism education, and indeed to democratic society, at a time of dazzling technological innovation. Few eras in the history of American democracy would seem to cry out more strongly for a professional, enterprising, and trustworthy news industry, as citizens are inundated with a maelstrom of information of all kinds, from all directions, and as new tools allow us to communicate in more direct, compelling, and immediate ways than ever before. The times demand vigorously independent journalism and a news industry professionally dedicated to separating truth from myth and providing an informed context to world events.

Yet, as this book demonstrates, we see institutional fraud, failure, and betrayal as our news media struggle to adapt to the economic challenges of the new age. Just as disturbing is the growth of a political culture in which truth itself either doesn't matter as much as it once did or cannot be mutually accepted and agreed upon. According to nearly all public opinion polls, the citizenry is becoming increasingly jaded and disaffected, mistrusting many of our most important civic institutions, including, perhaps most of all, the news media.

And there is another development, perhaps more troubling and profound. At a time when practically anyone with a computer can self-publish and claim to be a "journalist," the meaning of the title itself is being eroded in popular culture, amid confusion about the function of professional journalism in society. Many of those who write on their own Web logs and on other free-ranging frontiers of the Web today convincingly argue that the new economic reality, in which information of

all kinds is available free online, can lead to a blossoming of democracy in American society. Many of those who are most enthusiastic about the New Media exult in the apparently diminishing role that the traditional news industry and professional journalists play in the lives of Americans and take pride in pointing out the ethical lapses, apparent bias, and economic struggles of the "MSM"—the mainstream media and the old ways they represent. Professional journalists, some argue, are no longer as necessary or relevant as we once were, since today every citizen can become a journalist, finding, reporting, and publishing the news themselves. So what if this New Media world is governed by few standards of professional journalistic practice, none of which are truly shared and widely accepted? Make way for the far freer age of the citizen journalist, with computer-generated online news aggregators taking the place of human editors and open-source news Web sites like Wiki News produced and maintained by citizen volunteers.

These vast new powers of individual expression are indeed invigorating citizen involvement, connection, and awareness in our representative democracy, which itself depends so profoundly on free speech. The most priceless gift bestowed by the Internet and digital technology is the enhanced freedom to communicate with our fellow citizens.[4] But the persuasive arguments in favor of citizen journalism, in which anyone with digital skills is presumed able and equipped to report the news, also presume that effective and meaningful journalism in service of the public interest is not a particularly difficult endeavor—that anyone can do it. That professional reporting, writing, broadcasting, and publishing require little skill or training beyond an ability to use a laptop computer, a digital recorder to collect video or sound, or a willingness to do Web searches. That one can practice journalism almost as if it were an extracurricular hobby or pastime, conducted in idle moments from one's living room or basement, not unlike the way amateurs regarded ham radios in decades past.

This concept is misguided. Professional journalism is anything but simple, and technology itself is no substitute for the human rigor required to seek out and report the news fully, independently, and accurately. Simply recognizing what constitutes meaningful news and informational context for a wide audience in an increasingly complex world, and understanding how the news starkly differs from opinion and commentary, can be an intellectual challenge that takes years of experience to master. Journalists must work hard to hone many critical skills: conducting unbiased and productive interviews; researching issues, whether

that involves digging into public records or knowing where to look for vital information that may be concealed in the shadowy corners of government, industry, and culture; comprehending fairly all sides of public issues; appreciating language and using it well to express news and information as clearly as possible.

Yet such skills are becoming devalued in the public's eye and even within the established industry itself. And as the media industry's investment in such professionalism lessens, so too does its vital influence in democratic society, leaving the citizenry more susceptible to distortion, bias, and blatant falsehoods. As I take stock of the marvels of the age, I can't help but worry about the direction of a society in which there are ever fewer arbiters who are trusted and recognized by a consensus of citizens—the professionals of information gathering, working according to highly evolved standards, skilled, fairly compensated, and charged with collecting hard news, contributing original content to the public record, and not merely reacting to events or pandering to political prejudice.

It may sound naïve to say so, but it wasn't very long ago that a degree of trust existed in the basic relationship between credible source and professional reporter, reporter and editor, journalist and publisher or station owner, news organization and community. But on nearly every level, and for a multitude of interrelated causes, this factor of trust in journalism has eroded significantly in recent years—in an era marked, paradoxically, by exceptional new powers to inform. As U.S. news organizations cut costs and eliminate reporting positions from Seattle to Philadelphia to Nairobi, weakening their ability to present the news, it seems eminently reasonable to predict that far fewer responsible and trained journalists will be on hand in the future when important news sources reach out for reporters in places like Khartoum, reporters who will willingly, accurately, and independently tell the world what it doesn't yet know. Media futurists and industry leaders may indeed be asking themselves: What business sense does it make to invest in trained journalists and maintain expensive news bureaus in far-flung locations in a world so closely connected by communications technologies? What purpose do professional journalists really serve in such a world? Can't public relations specialists (already well paid by others), eager advertisers, or citizen bloggers serve a similar and much less costly function? In such a world, the very idea of professionalism in reporting the news may be headed in the same direction as the Telex machine, the single-lens reflex camera, or the shortwave radio.

These are among the most pressing challenges and questions I face as

a teacher at a professional school of journalism, ones that seem to grow in complexity and urgency with each passing year. This book in one sense represents a personal, firsthand report from the front lines of a vigorous struggle for the survival of professional journalistic values, a struggle that is playing out with particular intensity inside the walls of schools like mine around the country. It is in such places that this changing field is most closely examined, monitored, and interrogated and professional standards most consistently defended and hammered out. As an institution, we are in a constant state of flux, fighting to stay current with evolving industry demands and technological innovation, while also seeking to protect the primacy of traditional standards in a world where such values are either devalued or threatened. Although few citizens know very much about this struggle, it carries, I believe, important repercussions for society. As a teacher, I worry most that young journalists finishing graduate programs like Cal's, if they are lucky enough to land jobs in truly professional realms of the craft, will enter an increasingly endangered vocation, one ostensibly devoted to truth seeking, but one in which they will face growing pressure to do otherwise, to sell a direction as south when the facts tell them it is north, or perhaps to remain silent altogether, compelled to turn a blind eye to the truths they witness.

MUSIC FOR AN AGE

In recent years, numerous media critics, scholars, and popular writers have addressed the problems of modern journalism from a host of different directions. Two of the most widely cited scholarly works about the effects of economics on modern news media practices, including market and political pressures that determine news content, are Ben H. Bagdikian's 1983 classic *The Media Monopoly* (updated in 2004 as *The New Media Monopoly*) and Edward S. Herman and Noam Chomsky's *Manufacturing Consent: The Political Economy of the Mass Media*.[5] These two books remain widely read in courses on mass media and society on campuses around the country. Bagdikian expresses compelling, and prescient, warnings about the dangers posed by the growing consolidation of America's major media corporations, arguing that participatory democracy, the well-being of the world community, and certainly the practice of journalism are ill served by the economic and political dominance of what *The Nation* magazine calls America's "National Entertainment State."[6] Herman and Chomsky argue that the mainstream news media have long pandered to and supported the in-

terests of economic and political elites, helping to manufacture consent on vital public issues on their behalf and at the expense of a large majority of Americans.

John Stauber and Sheldon Rampton's *Toxic Sludge Is Good for You: Lies, Damn Lies, and the Public Relations Industry* portrays the increasingly effective ways in which public relations specialists, working on behalf of political and commercial clients and using advanced video and other technologies, distort news and information about issues vital to the public, abetted by the willingness of America's depleted newsrooms to use unfiltered video news and print releases prepared by PR firms.[7] The book represents in some ways a chilling update—chilling, certainly, to professional journalists—of *Propaganda,* the 1928 book by Edward L. Bernays, the father of modern public relations and the chief public affairs steward of America's entry into World War I under Woodrow Wilson. It was Bernays who early on recognized that the sophisticated manipulation of public opinion by the "unseen mechanisms" of public relations would constitute "an invisible government which is the true ruling power of our country."[8]

Such liberal criticism of political, economic, and public relations pressures on the news media has been accompanied by conservative charges that the mainstream media are deeply afflicted with liberal bias. (While such political terms are often as highly charged as they are simplistic, they nonetheless are frequently employed as a kind of coded shorthand in our cultural lexicon for a wide host of complex attitudes and beliefs.) Bernard Goldberg's *Bias: A CBS Insider Exposes How the Media Distort the News,* for example, charges that the network's newsroom culture and top journalists slant the news to suit a liberal political bias, ignoring the professional ethic of objectivity.[9] Goldberg argues that social issues such as homelessness and poverty receive much greater network attention under Republican administrations because newsroom editors and reporters are personally and ideologically inclined to be critical of conservative policies. He also provides a wealth of insider, anecdotal accounts showing how liberal research and public interest groups influence CBS news reporting.

William McGowan's *Coloring the News: How Political Correctness Has Corrupted American Journalism* attacks affirmative action hiring policies in America's newsrooms, which have put more minorities in editorial positions, as well as the underlying premises behind such policies, which equate racial and ethnic diversity with sounder and better professional journalism.[10] McGowan also claims that "politically correct" val-

ues corrupt the coverage of news to the detriment of citizens and democratic society, arguing that the public's perception of such political bias in the mainstream media helped to fuel the enormous rise in popularity of conservative talk radio and Fox News.

Such charges of "liberal" media bias have elicited sharp counterarguments. Eric Alterman's *What Liberal Media? The Truth about Bias and the News,* for instance, maintains that conservative pundits such as Rush Limbaugh, George Will, and Ann Coulter relentlessly promulgate the idea of a "liberal" press in order to cow the news media into presenting conservative views as part of news coverage. They claim that they are countering a liberal bias—a bias that Alterman insists never existed.[11] Alterman's study of television and print coverage during the administrations of Bill Clinton and George W. Bush finds that the mainstream news media are in fact partial to conservatism, fearful of arousing protests from the right, and far more dedicated to conservatively oriented business imperatives than to presenting liberal views of pressing public issues.

Nevertheless, a rash of scandals involving plagiarism and fabrication over the past decade at numerous prestigious organizations, including CBS News and the *New York Times,* helped to lend heft to McGowan's and Goldberg's arguments that political bias by journalists was undermining ethical practices in the newsroom. The 2003 scandal involving the young black journalist Jayson Blair, who resigned from the *New York Times* after admitting to numerous acts of fabrication and plagiarism over his three-year career, was arguably the most emotionally charged and provocative. To McGowan in particular, who followed up *Coloring the News* with a new, Blair-inspired attack on liberalism in the press, *Gray Lady Down: Jayson Blair and How the* New York Times *Lost Touch with America,* the scandal represented proof positive of an institution whose professional ethics were systemically undermined by wrongheaded cultural values such as diversity, which in his view lowered standards of newsroom practices and endangered the public's right to know the truth.[12] Perhaps the most authoritative book on the Blair scandal adopts a much deeper institutional and intensely human angle, however. In *Hard News: The Scandals at the* New York Times *and Their Meaning for American Media,* Seth Mnookin movingly depicts the frenetic journalistic culture at the nation's leading newspaper of record as one influenced far more by individual careerism, vanity, and petty internal politics than by ideology.[13]

In broader strokes, James Fallows, in *Breaking the News: How the Media Undermine American Democracy,* depicts a modern media cul-

ture motivated by greed, in which journalists are less dedicated to the public service of news reporting and more to advancing their careers through television fame and bombast and padding their incomes by receiving outlandish fees to speak to trade and business groups.[14] Fallows argues that the zest for higher circulation and audience share places a premium on titillation and superficiality in news coverage, leading to an ill-informed and ill-served electorate and a democracy increasingly undermined, one in which the people have less and less reason to believe in an estate so critical to a healthy society.

The Elements of Journalism: What Newspeople Should Know and the Public Should Expect, by Bill Kovach and Tom Rosenstiel, presents the findings of a twenty-five-member national panel of journalists, formed in 1997 by the Committee for Concerned Journalists to examine many of the problems of journalism outlined here.[15] It amounts to a clarion call to journalists and news organizations to rededicate the profession to time-honored values including the search for truth, the need for independence, and the willingness to speak truth to power while being mindful of the need for fairness and moral conscience.

In the meantime, a number of recent works have attempted to grapple with the rise of the Web, the advent of citizen journalism, and their implications for professional practices. Dan Gillmor's *We the Media: Grassroots Journalism by the People, for the People* remains arguably the most influential work to both herald and celebrate citizen journalism.[16] Indeed, the book has helped to inspire numerous ventures by newspapers and other mainstream media to make themselves more accessible to the public and to host Web logs (blogs) and other forums for citizen-produced news and commentary. In Gillmor's view, citizen journalism represents a powerful antidote for the public's growing alienation from big media. In addition to being a how-to text for citizens who want to learn reporting and writing skills and master the technical tools intrinsic to the New Media age in order to become self-publishing journalists, Gillmor's work is a philosophical reflection on the changing relationship of journalists to citizens. Whereas this relationship was once almost entirely one-way, like a lecture, Gillmor observes, it is now characterized as a "conversation" of equals in a rapidly changing technological society.[17]

Additional illuminating work about the intersection of the Web and journalism has appeared in periodic reports on national conferences attended by bloggers, Internet experts, and professional journalists themselves. In late January 2005, for example, a conference titled Blogging,

Journalism, and Credibility: Battleground and Common Ground (sponsored by Harvard University Law School's Berkman Center for Internet and Society; the Shorenstein Center on the Press, Politics, and Public Policy; and the Office of Information Technology Policy of the American Library Association) featured fifty top experts from around the country. Panels and speakers discussed everything from the digital divide—between Americans who are experienced and technically skilled in using the tools of New Media and poorer, less educated citizens who remain unskilled—to ethics and credibility issues presented by a changing news order filled with grassroots ventures that share no widely accepted standards of practice.[18]

Finally, for the last several years the Project for Excellence in Journalism, a media research project based in Washington, D.C., and funded by the Pew Charitable Trusts, has produced a valuable and comprehensive annual study addressing many of the changes and ethical challenges associated with the emergence of New Media and the Internet and the impact on professional journalism and democratic society. In the project's 2006 Annual Report on the State of the News Media, the researchers concluded:

> What is occurring . . . is not the end of journalism that some have predicted. But we do see a seismic transformation in what and how people learn about the world around them. Power is moving away from journalists as gatekeepers over what the public knows. Citizens are assuming a more active role as assemblers, editors and even creators of their own news. Audiences are moving from old media such as television or newsprint to new media online. Journalists need to redefine their role and identify which of their core values they want to fight to preserve—something they have only begun to consider. . . .
>
> We believe some fears are overheated. . . . On the other hand, the most sanguine reaction to those changes—that they simply reflect an older medium's giving way to a newer one, and that citizens will have more choices than ever—strikes us as glib, even naïve.[19]

In sum, criticism, surveys, and analyses of the news media in recent years have taken up widely divergent, and often distinct and disconnected, themes. But if we listen carefully, we will discover that these dissonant and jarringly different notes derive from a single score or sheet of composition, the background music for the troubles and challenges of modern journalism. The music is persistent and at times eerily alluring and buoyant, not unlike the sweeping notes robustly pouring forth from the keys of a steam-powered calliope in an old-fashioned

amusement park. The music beckons us to step right up, to recognize and take stock of a show. The refrains are strangely intoxicating, lively, and fun. But the frantic, bellowing notes also caution us to be on the lookout, for much of what we may see or hear inside may not be as billed.

The calliope music is played in a realm that frequently represents itself as trustworthy and fair to the best interests of both citizen and society—indeed, professionally dedicated to the truth. But this realm is also characterized by acts of deceit and dishonesty, with the result that what is presented as professional journalism is in fact often not journalism at all. As chapter 1 describes, it's an amazing show featuring a glittery marquee outside the front gates, promising citizens more varied and far better sources of news and information than ever before. But once inside, we may discover the actual amount of original, professional, and independently gathered journalism shrinking before our very eyes.

Chapter 2 presents the first attraction: the freak show, a sideshow offering hair-curling exhibits of infamous journalistic liars who have brazenly betrayed the public's trust in the digital age and before. We hear the news industry's gatekeepers shout out like sideshow barkers to deplore them and their evil ways. But this chapter also examines the chilling and less publicized ways in which press institutions themselves have acted just as freakishly and unethically toward the truth, with American racial prejudice and the Blair scandal in particular as revealing backdrops.

The fun house is next, a rowdy attraction chock-full of mazes and distorted reflections of reality. Chapter 3 examines the colorful traditions of hoaxers and mischief-makers of the past and also illustrates how incredibly easy it is to hoodwink the news media in a modern culture hungry for instant sensation. Amid the lowering of ethical standards in the news industry and the rise of the Web, hoaxes sometimes result in comic effect but at other times terrific devastation.

Then, in chapter 4, comes the world of illusions, where political and commercial entities of all kinds are busily crafting increasingly sophisticated works of fake news, often with the complicity of presumably professional news organizations and aided by the cutting-edge technological skills of the advertising and public relations industries.

Finally, chapter 5 presents a study in contrast by examining what professional journalism really is; how its traditions, values, and achievements have benefited American society; and why its endangered status in an age of revolutionary technology poses serious ramifications for our

world. This chapter also explores ways in which we might better safeguard professionalism in this age of turbulence and uncertainty.

Here, then, is the American carnival, a singular realm inside our modern media in all their forms, where the craft of seeking and reporting the truth is under siege.

1

American Carnival

The event that convinced me of the need to reassess both the transformation of professional journalism and my changing role as a teacher did not take place in 2004, when I first heard official confirmation that the U.S. invasion of Iraq had been based almost entirely on cooked-up evidence largely unchallenged by the nation's news media. Neither did it stem from revelations that same year that the government increasingly was in the business of broadcasting propaganda disguised as journalism through the airwaves of willing local television news stations. Nor was it related to any of the notorious reporter scandals involving plagiarism and fabrication that have bedeviled America's top news publications over the past few years. While all these events certainly served as important signposts along the way, I realize now that my journey actually started on a rainy morning back in April 1998. That was the day one of my former graduate students told me an eye-opening story about her life on the job as a local television news reporter.

She was in her late twenties then, a young woman with a passion for news reporting and writing who dreamed of working as an on-camera national network correspondent. Like many television news aspirants, she was paying her career dues by starting out in a smallish city in the

West, with hopes of advancing to a big-city market such as Los Angeles, Chicago, or New York.

I admired the young woman's skills: she had been a terrific student during her two years at the University of California at Berkeley, with a talent for interviewing sources and researching court records and a commitment to professional values such as accuracy, fairness, and the importance of maintaining a moral conscience about right and wrong. When I heard she was visiting the Bay Area, I invited her to speak to a large undergraduate lecture class I was teaching that semester. Since the class focused on the role of the news media in democratic society, I thought it would be great for my 120 students to hear how she went about collecting and reporting the news each day in the "real world."

During her visit to my class, the young woman showed video clips of a few of her news stories, including a serious one about a murder investigation and a feature about the spring weather. As she answered the students' questions, she was as informative and captivating as I had expected. Her talk was a real hit.

But afterward, as we talked in the hallway of North Gate Hall, she told me another story about her job, one that was quite different from the inspiring anecdotes she had shared with the students just a few minutes before.

Several months earlier that year, in January, the Monica Lewinsky scandal had broken, bringing with it a national frenzy for news related to the presidency and the brewing constitutional crisis between Congress, the judiciary, and the White House over President Bill Clinton's sexual affair. In my lecture course that semester, I had been referencing the Clinton scandal and the front-page headlines it was generating, using it as an educational wedge to inform students about a wide variety of issues, from the impeachment process, the history of special counsels, and the grand jury system to the perils of anonymous sourcing and the growing influence of new, Web-based, non-mainstream information sources.

But my former student had been doing something far different in connection with this story, she told me, something that in many ways said more about the values and pressures of news reporting today than all my lectures put together. She said that her boss, the station's news producer, was eager to capitalize on the scandal's ratings draw by finding a sexy local angle that paralleled Bill Clinton's political travails. Her reportorial mission? To go out into the town she was covering and try to hunt down a married man who, like the president, was carrying on a sexual

dalliance; to interview him about his double life and its effect on his marriage and family; and to try to get a reaction from the mistress as well.

The assignment was not the sort of thing my former student had bargained for when she chose professional journalism as a calling. At a cost of more than $70,000, she had attended grad school at Cal, full of high ideals about the role of the press in a democracy and dreams of doing stories that really mattered for the public. Now she was being ordered to use those hard-earned and valuable skills to do something that veered sharply from the mission and purpose of journalism as she understood it.

But what could she do? Refuse to do the story? Quit in protest? Who would hire her in television news again? Who would pay the student loans she took out to finance her professional schooling? So she carried out the assignment, she told me, no questions asked. Using her investigative skills and the station's precious labor time, she eventually did track down such a subject, who was persuaded to do an on-camera interview with his face blurred out and his voice scrambled to protect his identity. She had succeeded. But she didn't feel much satisfaction. Neither did she tell this startling story to my undergraduate audience, she explained, because she didn't feel professionally comfortable discussing the assignment or secure enough in her job to speak publicly about it.[1]

That anecdote was among the first and perhaps the most memorable of a growing number of disquieting dispatches I have received from young people working in the field of professional journalism that have caused me to radically reexamine how I view the news industry and how I prepare my students to enter it. Although there has always been something of a gap between classroom theories about the function of journalism in a free society and the gritty day-to-day reality of the American newsroom, I've witnessed this gap widen considerably in the comparatively few years I have worked as an educator. My student's story was just one example of questionable, disturbing, and at times outrageous acts by news media organizations that each year hire young people leaving colleges and professional school programs like mine, brimming with enthusiasm and high regard for the calling, only to see their ideals twisted or crushed by the weight of conflicting institutional demands and special interests.

I don't think I was ever naïve enough to believe that the American news media were as clean and saintly as the professional standards adopted by governing organizations such as the Society of Professional Journalists, the American Society of Newspaper Editors, and the Radio-Television News Directors Association might have implied. These cher-

ished codes of conduct, which stress principles such as editorial independence, accuracy, and truth seeking, were developed over many decades in response to systemic bias, inaccuracy, and sensationalist excesses. But neither was I fully prepared to accept, as I listened to some of my former students relate their disappointing experiences, the reality of how the news industry's values and practices were being weakened by the relentless assault of outside political interests, profit pressures, and the manipulation of advertising and public relations.

One former undergraduate student, for example, who was working at a weekly newspaper in Northern California, told me how her managing editor had blatantly pressured her to write favorably about a controversial commercial development project whose chief backer was a close associate of the publisher. What about the idea we taught in college that a paper's business interests should never be allowed to conflict with the independent mission of reporting?

Another alum, working for a large, publicly traded family of newspapers in California, messaged me in despair when he heard that his newspaper's news and editorial staff would soon face another round of layoffs and budget cuts because the annual 25 percent profit promised to shareholders by the corporation's CEO had fallen 5 percent short of the target. In an age of stagnant or declining circulation and advertising revenues, executives at this newspaper were looking to cut costs to improve the company's bottom line. And journalists and editors, costly to keep, were likely target number one. My student wondered: What was so unsatisfactory about a 20 percent annual profit for newspapers? What about the notion that good and effective *journalism*, not shareholder pressure, should be the strongest and most important engine driving a news organization's success or failure?

Another young reporter with several years' experience covering major professional sports teams and an excellent record at culling sources was flabbergasted when a network television sports reporter suddenly appeared on the scene of an important news story on his beat in nearby Oakland and miraculously managed to get an exclusive on-camera interview with a source at the center of the story. The young local reporter and his colleagues were certain that the rich network had paid a considerable sum of money to the source, who refused to talk to anyone else in the media afterward. It wasn't the first time that this network had been suspected of paying for interviews, the beat reporters claimed. What about the caution against checkbook journalism that teachers always preached in graduate school? What about our warnings that if we treat

the news as if it is for sale, lies will flourish, and only the rich will be able to own and control it?

Assigned to her first reporting beat to cover the public relations industry for a national magazine in Los Angeles, another alum wrote harrowing messages to me about her intense on-the-job education in how deeply PR specialists and advertisers working for corporate and political clients had inserted themselves into the news-gathering process—and how complicit news media organizations have been in the corruption of their civic responsibilities. Over the past decade, for example, PR firms have become increasingly effective at churning out print and broadcast advertising that looks and sounds just like the mainstream journalism the public is used to reading, hearing, and viewing. Their aim, however, is not to present news and information gathered under professional rules of ethics; instead, they intend to sell a product or a political message. This deceptive marriage of two separate and conflicting missions in the form of "advertorials," "video news releases," and other techniques employing the latest in high-tech digital tools has grown into an industry worth hundreds of millions of dollars annually over the past twenty years. Increasingly, it is difficult for the average citizen to tell the difference between what's real news and what's fake.

Not coincidentally, this phenomenal growth in propaganda cleverly disguised as news has occurred while many news organizations are cutting back on staffing. America's television news networks, for example, employ fully a third fewer correspondents today than they did in 1985. The nation's radio newsroom staff shrank by 44 percent between 1994 and 2001. Cuts have also occurred in local television news and newspapers across the country.[2] Headline after headline on business pages in 2005 alone reported staff cuts at news services, magazines, and newspapers across America:

> September 22: A 15 percent staff cut in the newsroom of the *San Jose Mercury News,* with a loss of fifty-two full-time professional journalism jobs.
>
> September 24: A 15 percent cut in the newsrooms of the *Philadelphia Inquirer* and the *Philadelphia Daily News,* and a loss of forty-five professional journalism jobs at the *New York Times* and thirty-five at the *Boston Globe.*
>
> December 26: A cut of nine hundred editorial jobs at the Tribune Company's prestigious family of newspapers, which includes the *Los Angeles Times, Newsday,* the *Baltimore Sun,* and the

Chicago Tribune. That news sparked a Christmas week demon-
stration outside the corporation's headquarters in Chicago,
where protestors charged that the company's cost-cutting endan-
gered the public's right to be informed.[3]

The Project for Excellence in Journalism reported in early 2006 that, all
told, America's newspaper and magazine industries had lost more than
thirty-five hundred newsroom professionals over the previous five years
alone, a drop of 7 percent.[4]

These corporate trends signal only the latest chapters in a compelling
and longstanding story of major shifts in news consumption by Ameri-
cans over the past half century, shifts that have intensified as the New
Media challenge the dominance of newspapers and other traditional
media in American life. But even before the advent of the New Media,
the landscape had begun to change. From 1960 to 1995, the American
population grew from 180 million to nearly 260 million—but total daily
newspaper circulation in the United States remained roughly steady, at
59 million, according to Claude Moisy. As Moisy points out, this ex-
traordinary one-third drop in per capita readership will only accelerate,
since the rate of readership among the young is even weaker.[5] A 2004
survey of Americans between the ages of eighteen and thirty-four found
that 44 percent relied chiefly on Web-based portals such as Yahoo! and
Google for their news and information, with just 19 percent ranking
newspapers as their primary source. The survey also found increasing
numbers of young people abandoning traditional broadcast news
media.[6]

Television news long ago replaced newspapers as the chief source of
news and information for most Americans. But here, too, the job losses
among professional journalists locally, nationally, and overseas have
been acute. Longtime CBS News foreign correspondent Tom Fenton, in
a scathing analysis of the decline of foreign news reporting since the Cold
War, cites data showing that foreign coverage by broadcast and cable
networks has shrunk 70 to 80 percent since the early 1980s, largely re-
placed by celebrity news, "tabloidism," and "junk news."[7] Since 1995,
ABC and Fox have closed what were once full-time bureaus in Moscow;
CBS has closed bureaus in Paris, Johannesburg, Beijing, and Bonn; and
CNN has closed operations in Manila, Belgrade, Brussels, and Rio de
Janeiro. Latin American correspondents are rare; and the entire conti-
nent of Africa, apart from a skeletal operation run by CNN in Nairobi,

is completely bereft of a full-time, professional American news reporting presence.[8]

Closer to home, one troubling event that proved emblematic was recorded in a little-noticed story about the closing of Chicago's legendary, 105-year-old City News Service. CNS was a place where generations of young journalists and other writers, from Seymour Hersh and Ellen Warren to Mike Royko and Kurt Vonnegut, learned their craft by reporting on crime and other city beats for a consortium of Chicago newspapers. The news service functioned as a tip sheet for print and broadcast outlets. But a new owner, the Tribune Company, decided to close CNS shortly before Christmas in 2005, partly to save costs. A more important factor, however, was that the company's news competitors, instead of using the service as a tip sheet, were simply posting City News articles on their own Web sites and thus undermining the service's value to the Tribune. The closure stood as a stark cautionary tale about the wider ramifications of the power of the Internet and its effects on traditional professional journalism. Nineteen jobs, most of them filled by young people just starting their careers in Chicago, were lost.[9]

One consequence of this shrinkage in professional content in the nation's traditional news systems is that many news organizations now find it commercially advantageous not only to deliver easy, inexpensive fluff about celebrities, health, and decorating but also to disseminate fake reporting in order to fill the breach of actual news-gathering. The product may not be real journalism, but it *looks* like real journalism to the unassuming American citizen. Most important, fake journalism is practically free and helps to fill airtime in the relentless twenty-four-hour news cycle, in contrast to the high cost of actually paying professionals to report the news. In effect, public relations specialists and crafty advertising hucksters masquerading as professional journalists have become significant competitors for the journalism jobs my students are seeking after graduation.

In an e-mail message, another former student, who now covers the public relations industry for a Los Angeles–based magazine, described the pervasiveness of PR, advertising, and propaganda in all their forms in contemporary journalism. "Being in the 'real world' has shown beyond a doubt how much of journalism is colored by bias, by organizational limitations. . . . It has shown me that a large portion of our news is crafted by public relations companies." She recalled that the only time she'd heard PR discussed in journalism school was in a generalized con-

struct, with journalists as gatekeepers of truth and PR as simply an entity to avoid. "But that isn't reality," she continued. "The truth is that sophisticated public relations professionals guard almost every beat—from politics to business to entertainment—and rarely can you truly circumvent them. These are people you have to deal with day in and day out on any beat, and I think it is a disservice to young journalists to ignore that fact."

In addition, some young journalists express deep disenchantment over what they view as growing indifference by the news industry to the long-term goal of hiring newsroom staff who reflect the full range of intellectual, political, gender, and racial diversity in American society. A leading African American producer at a national network television news show wrote:

> [This is] the most important grossly under-reported issue in journalism today. I can only speak for the field I am in right now, network news, but the lack of minorities in key editorial decision-making positions is appalling. If one were to do a census survey of the editorial staff of the network morning shows, network evening news shows, and network news magazines it would be shocking to say the least. Yet little or nothing is written or said about the reality of this situation because no media organization is innocent and thus none of them feel comfortable raising this issue. This is a major, major concern, and this is why people of color continue to leave this profession. There is no one to mentor young broadcast journalists of color and there are so few role models. It's very depressing. This has been a problem for a long time but there is still little progress and the argument could be made that the problem has gotten worse.[10]

Another graduate, who reports on business and finance news for a top national newspaper, added this observation about the challenges and ironies of working in an era when astonishing new technological tools allow journalists to produce more and more, to work longer and harder, and to become proficient in many different media, even as they continue to receive incommensurate compensation:

> There was a point [in recent times] when I could honestly say I knew no young journalists . . . who were happy in their profession. Perhaps this says more about the commonalities of journalists' personalities than anything else. After all, we are a complaining bunch. But I found the state of affairs particularly telling. Reporters and editors I knew contemplated careers in music, modeling, real estate, education, public relations—almost *anything* but the grind of daily journalism. What is scariest about that is the people of whom I write were good, solid journalists on the fast track at their respective news organizations. They were beaten down by the unrelenting stress and pressures of the profession and discouraged by newsroom poli-

tics. Didn't we get into journalism to avoid corporate culture? How naïve we all were.

Journalism has always been a demanding, stressful, and far from lucrative way of life. We who chose this career path accepted these realities as part of the civic bargain. Most people who practice journalism full time do so mainly for the love of the craft and the sense of purpose and professional fulfillment that discovering, reporting, and writing about the world can bring. But it's that very quality of professional purpose that seems threatened. The distress I hear from young people struggling to maintain their faith in journalism has as a backdrop a litany of widely publicized ethical scandals that have plagued the news industry over the past fifteen years. The moral failures we know about have ranged from the subtle and devious to the downright perverse. In hindsight, some of the earlier incidents now seem almost misdemeanor-like compared to the larger scandals that dwarfed them shortly after the turn of the millennium. In 1992, for example, when producers at NBC News rigged incendiary devices to two GM trucks to make sure they caught fire during collisions that were being staged to dramatize an investigative story about the trucks' vulnerability to explosion, the incident illustrated the degree to which fakery as a communication tool had infiltrated an enterprise purportedly dedicated to truth.[11] More recently, however, the Bush administration has paid millions of dollars in taxpayer money, through contracts with giant PR firms such as the Ketchum Corporation and the Lincoln Group, to syndicated columnists and other media commentators to editorially promote White House policies and other Republican initiatives. These revelations suggest that forces outside professional journalism recognize that journalists and economically besieged news media organizations appear more and more willing to facilitate their own degradation.[12]

In 1996, when the *Los Angeles Times* published a gala Sunday magazine issue devoted to the opening of a sparkling new multimillion-dollar sports arena, it allowed a major corporate advertiser and the arena's sponsor to play an active role in designing and producing the magazine's editorial content in a $600,000 profit-sharing deal—but without informing either the paper's news staff or the public about the deception. This incident marked a distressing new chapter in the relationship between business and journalism, two interests often diametrically opposed to each other and traditionally intended, at least theoretically, to be kept separate. The *Times* case was a clear and troubling signal of how syner-

gistic this relationship was becoming even at some of the nation's most respected news organizations, with advertisers and shareholders clamoring for the upper hand.[13]

And when trained professional journalists such as Stephen Glass of the *New Republic,* Jayson Blair of the *New York Times,* and Jack Kelley of *USA Today* were unmasked as serial liars and fabricators, the scandals revealed systemic failures in editorial oversight.[14] These cases also ignited wide debate about a range of emotionally charged issues, from contemporary race relations in America's newsrooms to the moral character of the modern journalist to the brutal demands of the twenty-four-hour news cycle and the increasing pressures on reporters to entertain, enthrall, and sensationalize.

Plagiarism, fabrication, and similar ethical crimes have appeared almost as regular features of contemporary journalism. Even the biggest lies told by anonymous sources, government insiders, and morally wayward reporters have been accepted uncritically and disseminated as gospel by the press for many reasons: poor verification procedures, the nonstop pressure to be first with the news, even an institutional bent to believe authority at the expense of healthy intellectual skepticism. On the most benign level, such dishonesty has led to an explosion of often-mirthful hoaxes and other comparatively harmless New Media mischief in which both press and citizens have been snookered. On a more serious level, a fabrication during the 2004 presidential campaign helped to end the careers of longtime CBS News anchor Dan Rather and several high-ranking producers.[15] And, worse, this systemic dishonesty played a considerable role in manufacturing support for the march to war in Iraq in 2003 and the loss of tens of thousands of innocent lives.[16]

THE SHOW

As I monitored these disparate occurrences in my role as a teacher of professional news reporting and writing, working in a realm far removed from the world of daily journalism and the revolutionary technology sweeping it, and as I tried to piece it all together as part of a larger common fabric, I kept coming back to a single descriptive term—*fraud*—for the complex body of transgressions I was witnessing. I began to see more work in the news media that masqueraded as professional journalism but that in fact was quite the opposite. It was this idea of fraud, coupled with

a desire to figure out a way to talk to my students about the forces seeking to undermine professionalism, which led me in time to believe that these problems were not distinct or separate entities but rather were interconnected parts of a wider and singular phenomenon.

Our civics books tell us that journalism occupies a central role in a society predicated on the power of the people. Its purpose is to exercise its constitutional obligation to inform us truthfully about our communities and the world around us, to hold our elected leaders accountable, and to do so as independently as possible without fear or favor. We have long taken as an article of our national faith that an electorate thus empowered with truth is the surest defense against tyranny, corruption, and oppression.

First Amendment rights to freedom of speech and freedom of the press are certainly no guarantee that democracy will be fair, that the people will be truthfully informed, or that the press itself will be competent, objective, or effective. Journalists, after all, are intended simply to be messengers in a democracy, not instruments of change. Their function is to provide information and context so that citizens and leaders can make decisions to improve society. There is no certainty that an electorate thus empowered with the truth as the news media finds and reports it will translate it into correct decisions and a more just and peaceful society. Nonetheless, this ideal is recognized and shared by journalists and citizens—a standard of excellence, professional mission, and social responsibility in which journalism plays a central and beneficial role in democratic society. It's an ideal worth striving for, one that is today codified with refined rules of practice that were written after centuries of trial, error, failure, and professional evolution.

But such traditional ideals seem almost quaint and somewhat naïve today—anachronisms, or at least afterthoughts, at a time when other motives appear to hold sway in the news media. In fact, the rules are increasingly ignored. Journalism is a profession filled with paradoxes. We seem to hear more about fabricators and plagiarists today than ever before because the news media and the public help to uncover them, often with the aid of technology such as digital databases (to which, ironically, the wrongdoers may have turned to commit their wrongs in the first place). According to a now-familiar pattern of scandal, the wrongdoers are discovered, their crimes are investigated by editors, and then the miscreants are fired. The dismissals, whether at the *Sacramento Bee,* the *New York Times, USA Today,* the *Baltimore Sun,* or the Associated Press, are announced with much self-righteousness by officials who apologize to the public for the individuals' lapses. Credibility, the gate-

keepers vow, is our most sacred stock in trade! Yet we hear little about the similarly sinister frauds committed on institutional levels, the booming business in advertorials pretending to serve as real "news" or the well-paid fakers who sell all manner of products and political causes in the guise of journalism—often with the complicity of the news industry—precisely because a presumed credibility is the journalist's most valuable asset.

I began to picture significant parts of the news industry, in its myriad forms, as a kind of old-style traveling carnival show packed with entertaining illusions, misdirections, and masquerades, where more and more the show itself is the most important end, a theater of thrills and spills and wonders driven by sensation, myth, propaganda, and stereotype, and not necessarily by the truth. In my mind, this show features updated versions of everything from the dog-faced boys, sword-swallowing midgets, and bearded ladies of old to three-card-monte penny arcades, freak shows, and distorting fun house mirrors. Practically every corner of the lot provides plenty to marvel at, with more acts joining the show each year.

And amid it all are the members of a deeply fragmented American public—perhaps leery of trickery, deception, and lies—bent on simply disbelieving or disregarding large parts of the show, preferring instead to take stock in whatever they *want* to believe in, or be entertained or comforted by, whether it's Fox News, Comedy Central, or Moveon.org.[17]

Today there is "Republican" news, "Democratic" news, third-party news, alternative news, and, with the rise of the Web and the "blogosphere," new forces in the realm that only accelerate this societal fragmentation. Multitudes of self-publishers on the Web, representing an infinite range of political viewpoints, present rambling blogs, some pretending to be journalistic, that generally attract only like-minded souls who similarly are paddling their own virtual rowboats in the middle of Lake Me.[18] As a society, we seem to be losing the sense that most citizens of the commonweal share knowledge and basic facts generated by trustworthy and independent journalism. This fractured, self-segregating quality of our news and information environment often seems to best serve only the interests of ideologues, as they pander and push to divide us according to "left" or "right," "conservative" or "liberal," "dissenter" or "patriot," not unlike the partisanship that characterized eighteenth-century journalism in American democracy's unruly infancy.

Many, however, believe that blogging and citizen-based amateur journalism sites on the Web hold great civic promise. The general idea is that the more options we have for news and information of all kinds, and the less control the traditional news media exert over defining what is valuable and true, the better for society, since so many of us are so dissatisfied with what the traditional news media deliver to us. We as citizens can do a better job of reporting and determining what is credible and what is not.[19] This sentiment is a central tenet of what futurists like to describe as our modern New Media news "ecosystem." At the 2005 conference on blogging, journalism, and credibility described in the introduction, participants optimistically affirmed that "the new emerging media ecosystem has room for citizens' media like blogs as well as professional news organizations. There will be tensions, but they'll complement and feed off each other, often working together."[20]

All this may be true. But this view also presumes that professionalism in journalism doesn't matter as much in the New Media age as it did in prior decades, that high standards are not as central to the process of informing the people, and that there is not much qualitative difference between the mission of a free press in the twenty-first century's news ecosystem and that of the press in the nation's early years when news came by way of broadsides nailed to tavern doors in the town square by rabid party faithful. In such a new and still-evolving order, governed less and less by professionalism—or at least incognizant of the need for standards—it becomes far easier for objective truth and basic facts about important issues to become debatable notions in civil society and political discourse. The diminishment of standards also means that journalistic crimes like libel and slander, which spurred the development of careful standards of practice in the news media in the past, have become less serious transgressions when committed on the Web, where egregious cases abound.[21]

In such an age of transformation and disintegration, I believe that it becomes, in the end, far more difficult for people to reach agreement or even civilly discuss topics vital to society and even easier for leaders of every political stripe to ignore objective reality altogether for the sake of pursuing initiatives based on expedience and falsehoods.[22] A modern democracy exercising so much power in the world should be able to command a stronger, better, and more informed consensus about what is truthful and what is not. In fact, it deserves better.

If there is a serious disconnect between the practices of the media

today and their role in sustaining the healthy functioning of democracy, it is perhaps reflected best by the attitude of the people. Almost routinely, public opinion polls inform us that Americans distrust the news media and the integrity of journalists. In 2002, the Pew Research Center for the People and the Press reported that 56 percent of the 1,201 Americans surveyed said that news organizations "often report inaccurately." In the same survey, 62 percent thought that the media "[tried] to cover up mistakes," and 53 percent considered the media "politically biased."[23] A similar poll conducted by Pew in 2003, assessing public attitudes toward media consolidation, found that 71 percent believed that the media were "often influenced by powerful people and organizations," a rise of 18 percent from 1985, when the organization first asked this question.[24]

Journalists themselves are concerned that the news media are failing the people. In 2004, Pew researchers reported that more than half of 547 journalists interviewed around the country believed that "journalism is going in the wrong direction," with significant majorities believing "that increased bottom line pressure is seriously hurting the quality of news coverage."[25] Such pressures have also produced damaging episodes of business chicanery by top-level executives at news media corporations, eroding the trust of both the public and Wall Street. Recent years have seen a spate of scandals in which executives at respected newspapers around America have been accused of inflating circulation figures and engaging in other unethical practices in an effort to boost advertising income in tough economic times, leading in some cases to lawsuits being filed against media conglomerates by advertisers and shareholders who allege fraud.[26]

That deceptive and unethical practices by the news media are fueling the public's cynicism perhaps should not be surprising, given the general tenor of American society today. In many ways, we live in an age vividly defined by fraud, which has touched nearly every trusted institution in American life. Millions believe that our presidential elections have been tainted by electoral fraud. Widespread, long-term scandals have swept through our religious life, as trusted moral leaders have been led off to jail for crimes including rape and child sexual abuse. We have been shaken to discover that those we entrust with our life savings have been practicing fraud at the highest levels of the banking and accounting industries, cooking books, fabricating data on profits, thieving from pension and mutual funds. In athletics, fans have hardly been able to tell who is genuinely skilled as a baseball slugger or a track and field sprinter or a Tour de France cyclist and who is instead merely dependent on

performance-enhancing chemicals. Enigmatic, deceptive expressions like "plausibly live" and "virtual reality" have become integral to our cultural lexicon, all aimed at convincing us that fiction is just another version of truth.

In our academies, even leading scholars such as Stephen F. Ambrose and Doris Kearns Goodwin have been compelled to admit plagiarizing portions of their work from other scholars. The problem of intellectual dishonesty and fraud in academia and scientific research has become so troubling that a new peer-reviewed academic journal devoted to this subject, *Plagiary: Cross-Disciplinary Studies in Plagiarism, Fabrication, and Falsification,* was founded in 2006. One of its first articles examined scholarly misconduct in public health research in the wake of the scientific fraud perpetrated by South Korean researcher Hwang Woo Suk, who lied about advances he had made in human cloning.[27] On the Web today, one of the fastest-growing educational enterprises is dedicated to investigating whether high school and college student term papers have been plagiarized—particularly in light of other popular online enterprises dedicated to facilitating fraud by selling term papers to students. Investigators, some of whom charge up to twenty dollars per page, claim that at least 30 percent of all student papers submitted for verification of originality prove to have been plagiarized either in whole or in part. Educators are also concerned over students' use of smuggled graphing calculators, two-way pagers, personal digital assistants, and other technological tools to aid them in cheating during classroom exams.[28]

Indeed, the emblem of our age of advanced technology, the personal computer, every day attracts a relentless stream of e-mail solicitations from con artists the world over, all of them "phishing" for our bank account and social security numbers. And a contemporary high-tech crime in which a citizen's very existence can be stolen and exploited by criminals—identity fraud—has become one of the most telltale felonies of our time, claiming nearly ten million new victims in America in 2004 alone.[29]

That we have become a people accustomed to encountering fraud in nearly every corner of society was illustrated not long ago by a comparatively mundane but revealing episode involving *Newsweek* magazine and Martha Stewart, the homemaking tycoon who has made millions of dollars in a multimedia empire spanning television, books, and magazines. Convicted of insider trading and other fraud charges in connection with her stock dealings, the media diva was hauled off to spend nine months at a federal reformatory in West Virginia in 2004. In anticipa-

tion of Stewart's scheduled release in March 2005, *Newsweek* editors, surely eyeing big newsstand sales based on a Stewart cover, concocted a photo of the sixty-three-year-old celebrity, smiling broadly, entering a stage from behind bright yellow drapes, wearing a pink sweater and shiny jewelry, looking fit, trim, unwrinkled, and beautiful. The headline just below the *Newsweek* nameplate in the March 7, 2005, issue read boldly, "Martha's Last Laugh: After Prison She's Thinner, Wealthier and Ready for Prime Time."

Of course, there are no clean yellow drapes in federal prisons, no pink sweaters and jewelry, and the photo wasn't shot anywhere near Stewart's clink in the Appalachians. The magazine's editors instead had used high-tech digital tools to fabricate a very convincing cover shot, using a head-shot of a smiling Stewart from happier times long ago and blending it atop the slender body of an anonymous model, while resorting to other photo retouching fakery to craft the rest of the homey scene. Inside the magazine, in a credit line in tiny type on page 3, the editors pointed out that the cover image was something called a "photo illustration."

Here we had a public figure convicted of perjury and acts of fraud in one institutional corner of American life, high finance, being heralded shortly before her release from jail by an act of fraud in another institutional corner, the press. Leaving aside the fact that few professional journalists, much less millions of American citizens, know what the deceptive and enigmatic term "photo illustration" means, the fakery committed by *Newsweek* and the later defenses offered by the magazine's editor underscore how inured we have become to such media chicanery.

After *USA Today* first reported on the deception, National Public Radio's *All Things Considered* program caught up with Lynn Staley, assistant managing editor at *Newsweek,* to interview her about how and why the cover was concocted and whether the magazine had intended to dupe readers:

> *Robert Siegel:* Lynn Staley, if it's not a simple photograph of Martha Stewart, what is it?
>
> *Ms. Lynn Staley:* (Assistant Managing Editor, *Newsweek*): It's a photo illustration, which is how we designated it on our table of contents. And it's our practice to identify our photography, our photo illustrations, in that fashion . . .
>
> *Siegel:* Well, let's deconstruct this a little bit. Is this on the cover of *Newsweek*—is that the body of Martha Stewart?
>
> *Ms. Staley:* It is, as far as I know, not the body of Martha Stewart. She was unavailable to us.
>
> *Siegel:* Because she is in prison.

Ms. Staley: That is right.

Siegel: Is it the head of Martha Stewart?

Ms. Staley: It is, in fact, the head of Martha Stewart.

Siegel: In prison, or from some other time?

Ms. Staley: I'm not exactly sure when that picture was taken, but it was not within the last five months.

Siegel: So it's an old picture . . .

Ms. Staley: Yes.

Siegel: . . . of Martha Stewart's face stuck on somebody else's body. Fair game? I mean, don't we look at this and think that's a picture of Martha Stewart?

Ms. Staley: Well, it appears that there are enough people who have believed that we've somehow managed to orchestrate a photo shoot with Martha in the prison, which we did not. And we had no intention of trying to fool anybody or trick anybody into thinking that we had.

Siegel: Where are the boundaries here? I mean, you could have taken a picture of Martha Stewart with the body of a figure skater or the body of a professional women's basketball player. I mean, you could have done any number of things to make Martha Stewart appear to be doing something. Where do you transgress?

Ms. Staley: Well, I would have to say we did not feel that this was a transgression. The piece is about Martha's emergence, and we wanted to look ahead to what her future was likely to be. And so the illustration was meant to reflect *Newsweek*'s angle on the story and was crafted to reiterate that take.

Siegel: But isn't the point here also that—I mean, this cover— this is Martha Stewart I'm looking at. It's not an artist's rendering of Martha Stewart; it's a picture of Martha Stewart, which is somehow more—it conveys a sense of greater objectivity than a painting.

Ms. Staley: Yes, and—I mean, I'm not going to try and say that there's no gray area here because, of course, the joke is richer. But in fact, without the intention to deceive, which we clearly—I mean, we could not have been more explicit about how we labeled this . . .

Siegel: . . . do you have any regrets at all about it?

Ms. Staley: I think that, you know, we have to be a little careful. I mean, maybe the worst thing I could say is that we were possibly just a little too successful here.

Siegel: A little too convincing, a little too realistic.

Ms. Staley: Yeah. A little too successful, yes.[30]

In replies amounting to truly acrobatic feats of convoluted logic, the *Newsweek* editor explained to the public that the magazine's journalists certainly had "no intention" of deceiving citizens by concocting and publishing the phony image as if it were the real thing and insisted that the only wrong to which she was willing to admit was not an ethical "transgression" per se, but more a minor error in judgment. The editors were simply "a little too successful" in deceiving the public. (Successful in more ways than one, by the way: that week's issue became one of the biggest sellers of the year for *Newsweek*.)

In the following week's issue, the magazine's editors apologized for the misleading effect of such "photo illustrations" on reader perceptions and promised to use clearer language on the cover to identify a composite when it resorted to such fakery again. And resort to it the magazine would, the editors implied, since such practices, by Staley's own admission, had become standard and accepted in their editorial processes. In short, the editors told readers that the next time the magazine purposefully committed such fraud, they would abide by a newer and tougher ethical standard for the sake of reader credibility: they would *announce* it.[31]

The Stewart controversy was reminiscent of a similar furor over *Time* magazine's doctoring of a photo of O. J. Simpson for a cover published the same week the football star was arrested and charged with the murder of his wife and another man in June 1994. *Time*'s photo editors had taken a copy of Simpson's mug shot, which had been snapped by Los Angeles police, and significantly altered it, darkening his skin color from tan to near-black and deepening the shadows around his eyes and forehead. The editors performed this doctoring for aesthetic effect, to make Simpson's image appear much more threatening and fierce and in the process enhancing the cover's potential for sensation and newsstand attention. But it disturbed journalism ethicists and especially outraged many African Americans, who had long been sensitive to white racism and the subliminal association of dark skin with crime, lawlessness, and evil intent. *Time*'s managing editor issued a full-page apology in the magazine's July 4, 1994, issue. "To a certain extent our critics are absolutely right," he wrote. "Altering news pictures is a risky practice, since only documentary authority makes photography of any value in the practice of journalism."[32]

But more than a decade later, such doctoring through the use of sophisticated digital tools continues apace as an accepted news industry practice, largely because the business of selling magazines often assumes much higher priority than protecting the honor of the journalism the magazines produce. Indeed, while the Martha Stewart controversy may

have represented a comparatively minor blip in the cavalcade of news media misdeeds in recent times, it nonetheless highlighted a significant economic fact about the contrasting values many news organizations place on truth and artifice today: a top photo retoucher and airbrush specialist who is expert at using digital skills to enhance, manipulate, or fabricate imagery can easily command more than $10,000 for creative work on a single magazine photograph, and more than $20,000 if that photograph appears on a magazine cover. This latter figure, earned for several hours of doctoring, is barely $7,000 less than the median *annual* starting salary of an American newspaper reporter with an undergraduate degree in journalism, $4,000 less than the median annual salary for a local television news reporter, and $3,000 less than the median annual salary for a radio news reporter.[33]

MADAMS AND CUSTOMERS

The *Newsweek* controversy also points to more serious problems with photojournalism in general and its role in a rapidly changing and complex world. Nowadays anyone with a computer and image editing software tools can easily manipulate, fabricate, and disseminate faked images and documents for whatever purpose, from practical jokes and hoaxes to political provocation. Examples abound, including efforts to undermine the bid of presidential candidate John Kerry by publishing a doctored photo dating from his days as an antiwar activist in the 1960s and an attempt to sway British opinion of the war in Iraq by having a leading London daily publish fabricated and staged photos of British soldiers torturing and urinating on Iraqi prisoners.[34]

But when respected publications and journalists themselves commit such deceptions and later defend them before the public as accepted operating procedure, citizens are left with very little to trust or believe in. Why should we trust them? If journalists observe no higher ethical standards than your run-of-the mill political provocateur, snake oil advertiser, or political propagandist, how can journalists claim to be our gatekeepers of truth?

Most journalists who are unmasked as fabricators and con artists these days are hounded out of the industry, especially if they are low-level practitioners with no friends in high places. But it can be astonishing to witness the double standard that protects the powerful. Consider the career of Rick Kaplan, who occupied the top post at MSNBC News until his resignation in June 2006. Back in 1994, as executive editor of

World News Tonight with Peter Jennings at ABC News, Kaplan or-
chestrated a sleight of hand straight out of a carnival barker's handbook
when he hurriedly ordered correspondent Cokie Roberts to don a win-
ter trench coat one cold January night on deadline and to stand shiver-
ing, microphone in hand, before an image of the U.S. Capitol projected
on a wall behind her in ABC's warm and cushy Washington studios. The
intent was to fool millions of viewers into believing that the reporter
was actually on the scene as she delivered a live news report on con-
gressional reaction to that night's State of the Union Address by Presi-
dent Clinton.[35] Today, Roberts has outlived the ethical embarrassment
and remains a high-salaried correspondent for ABC. Kaplan, too, ad-
vanced to a powerful news position as president at MSNBC after a sim-
ilar stint at CNN, where he survived the so-called Tailwind scandal in
1998. In that instance, the news network, under his charge, broadcast
a report that the United States had used nerve gas in Laos during the
Vietnam war. But the evidence turned out to be fraudulent, and that
scandal cost news correspondent Peter Arnett and two producers their
jobs.[36]

Historians with broad perspective on the storied and certainly color-
ful past of journalism on this continent tell us that in fact little of today's
bounty of mischief is particularly new. Doctoring of photographs and
other forms of image fakery go back as far as the invention of photog-
raphy in the early nineteenth century. During the heyday of the sensa-
tionalist tabloid newspaper era in New York City, in the 1910s and
1920s, it was not uncommon for photo editors at the *Daily News,* the
Mirror, and the *Evening Graphic* to stage or fabricate images in the hunt
for readers and circulation boosts. A typical example was the *Evening
Graphic's* cleverly crafted front-page photographic composite, made
from a psychic's description, of an angelically robed Enrico Caruso, the
singer, greeting romantic actor Rudolph Valentino in heaven shortly
after the latter's death in 1927.[37]

This tradition of tricked-up photography continues today, most often
in the grocery store tabloids like the *Mirror* and the *Star,* which regularly
present arresting images such as "monkey-boys" dwelling in caves on
Mars and Adolph Hitler's return to life as a hardware merchant in
Dublin, Ohio, serving as a secret mentor to Osama bin Laden. Yet
episodes of photo doctoring also regularly occur in the mainstream press,
despite prohibitions against it in nearly every journalistic code of ethics.
Much of this doctoring is cosmetic, such as the intensive digital work
performed to make runway models and movie stars appear radiant. But

at times the doctoring is extreme and touches on deadly serious issues. One of the more notable controversies during the Iraq war involved a *Los Angeles Times* photographer, Brian Walski, who was fired after admitting that he had digitally altered the dramatic quality of an image of a British soldier guarding Iraqi civilians by combining features of two different photos. The faked photo was published on the front page of the *Times* and featured prominently in the *Chicago Tribune* and the *Hartford Courant,* among other newspapers, testimony to the ease of deception in the digital age.[38]

It's also not a news flash that in the history of American journalism, publicists, PR hacks, advertisers, and other outside political and business interests have long played influential roles in determining the kinds of news we get and when, where, and how we get it. Although Thomas Jefferson once famously claimed that if he had to choose between having a government without newspapers or newspapers without a government, he "wouldn't hesitate to choose the latter" as a bulwark against tyranny, he is also well known for some of the more damning quotes about journalism ever penned: "Advertisements contain the only truths to be relied on in a newspaper," he wrote in 1778. "Journalists and ad men agree that this is a half truth, but are unable to agree which half is truthful." A famous image by cartoonist Art Young, published in 1912 in the socialist magazine *The Masses,* vividly depicted a newsroom as a whorehouse, with the bald-headed editor as a "madam" in a fetching nightgown, a fat-cat advertiser as the "customer" at the newsroom entryway, puffing on a cigar, and legions of reporters and other editorial employees as prostitutes in various poses of undress beckoning for the mogul's attention.[39]

Press critic A. J. Liebling believed that the news we receive daily is largely dictated by the whims of downtown "dry goods merchants." It was Jef I. Richards, an oft-quoted advertising professor at the University of Texas at Austin, who once said in defense of the honor of the public relations and advertising professions, "There is a huge difference between journalism and advertising. Journalism aspires to truth. Advertising is regulated for truth. I'll put the accuracy of the average ad in this country up against the average news story any time." And it was a contemporary journalist, Alexander Cockburn, who once derided his profession's tendencies to reinforce ignorance and bias and commit deceit when he observed that "the First Law of Journalism is to confirm existing prejudice, rather than contradict it."[40]

From the days of Upton Sinclair's *Brass Check,* an early twentieth-century critique of the U.S. media that depicted journalism as a slut servicing public relations, political, and advertising powers, there has been

no shortage of critics and cynics decrying the profession's failures, its systemic corruption, and the harm its unethical practices have inflicted on democratic society.[41] In fact, we are not so far removed from the days when it was common for tabloid reporters to masquerade as surgeons, nurses, cops, or private detectives or to use hidden cameras in order to get scoops and when political and advertising payola greased the news industry even more blatantly than it does now. Not long ago, in a lovely reminiscence about his father, the legendary *New York Times* sports columnist Red Smith, who died in 1982, journalist Terrence Smith described how his father got his first newspaper sportswriting job in 1920s-era St. Louis:

> My father told a story, which may even be true, of how he ended up in sports by happenstance. When he was a copy editor for *The St. Louis Star* (it's gone now; my father always claimed to have killed every paper he worked for but the *New York Times*), there was apparently a scandal after it was discovered that three reporters in the sports department were on the take. The three were fired and the editor called my father over. As my father told it, the following conversation ensued.
>
> > *Editor:* Smith, what do you know about sports?
> > *Smith:* Just what the average fan knows, sir.
> > *Editor:* Are you honest, Smith?
> > *Smith:* I hope so, sir.
> > *Editor:* What would you do if a fight promoter offered you $10 to write about his fighter?
> > *Smith:* (long pause) Ten dollars is a lot of money, sir.
> > *Editor:* That's an honest answer, Smith. Report to the sports department.[42]

As citizens and professional journalists, we presume that we are far removed from those days. Journalistic standards and codes of ethics are far more advanced now than they once were, industry leaders repeatedly assure us. But what of the abuses we witness? Journalism's evolution and standards of practice should not be cyclical like the highs and lows of the economy, subject to changing performance and expectation depending on market forces. Is it too much to expect that the advances in professional journalism should be as lasting as advances in engineering or science or medicine? Shouldn't we demand that the industry that gives us news and information be scrupulous about reporting the truth independently without reverting to the bad practices of the past, just as we expect that the airline industry will not revert to producing propeller-driven biplanes made of canvas, glue, and hand-carved sheets of spruce? Journalism has progressed too far for the profession to tolerate today's

abuses. In a world of vast media penetration, dazzling technology, and unrestrained capitalism, the wrongs of journalism do seem manifestly greater, more sinister, and potentially more damaging than ever. In an era we have come to know as the Information Age, the Nuclear Age, and the Age of Terror all at once, the stakes for truth, lies, inaccuracies, and compromised reporting are that much higher, often resulting in actions that have life-and-death consequences.[43]

In key ways, journalistic corruption inflicts more significant damage to the fabric of a free society today than systemic dishonesty in most other institutions in American life. Fraud in journalism goes far beyond the material or transitory, especially at a time in world history when the American electorate wields more power for good and ill on the planet than any society in human history. Journalism is the lifeblood through which democracy and a just society are sustained, its entire worth dependent on credibility. Its power for good is generated by a professional devotion, dedication, and ability to get things right—and by having the sustained courage to do so in the face of power. When wrongdoing infects this process, when journalism reverts to its worst tendencies, the long-term damage is far more extensive than the sight of CEOs and accountants hauled off to jail for cooking books.

When professional journalism is systemically weakened in an age when we should expect it to be better after centuries of refinement aimed at creating higher standards, our faith in what joins us as a people in a civil society is also damaged in a way that is difficult to repair. It's this very lack of faith that seems to characterize much of the public's attitude toward the news industry. Indeed, perhaps the most disturbing sign of journalism's general disconnection from citizens in this era of doubt is the alarming degree to which our society has become so fractured that we are unable to agree on even the most basic facts about our lives, our communities, and the world.

Shortly after the 2004 presidential election, the University of Maryland reported in a survey that more than 70 percent of those who voted for George W. Bush in the November 2004 elections believed wrongly that the administration had found proof that Iraq possessed weapons of mass destruction. These same voters believed wrongly that world opinion supported the American invasion of Iraq. These voters also were convinced that Saddam Hussein's regime had a direct link to al-Qaeda terrorists and the 9/11 attack on America, despite all official evidence and widespread news coverage to the contrary on each point. This poll showed that millions of these voters relied heavily on Fox News, owned

by Rupert Murdoch, as their chief source for news and information, a finding that underscored the power of political bombast and argumentative tone to fuel events around the globe more quickly and significantly than professional journalism. The researchers reported that viewers of Fox, today the nation's most highly rated news channel and the news source most closely aligned with Republican Party interests, were nearly four times as likely to hold demonstrably untrue views about the circumstances surrounding the war in Iraq as Americans who relied instead on National Public Radio (NPR) and the Public Broadcasting Service (PBS).[44]

Since its founding in 1996, the Fox News channel has built a strong and loyal following among millions of Americans who consistently hear the channel describe itself as dedicated to a "fair and balanced" presentation of the news. Ratings for Fox grew by 7 percent in 2005 alone. For the fifth consecutive year, the channel, with its wide assortment of conservative-oriented news discussion programs, remained the most widely watched twenty-four-hour cable news network in America.[45] But the channel's greatest influence on American society and our news culture has come not from the network's journalistic contributions to the nation's public record but instead from its formula for economic success, a formula that features as its centerpiece not news but news talk programs hosted by combative personalities. In many ways, Fox News occupies a center stage in the American carnival, a sideshow of its own making where fiery bombast, entertainment, sensation, idle comment, and punditry serve as cheaper and livelier substitutes for actual news reporting and investigation. Unfortunately, we have seen its network and cable competitors struggle hard to follow suit.[46]

Jim Rendon, a former graduate student of mine now working as a staff writer for *SmartMoney* magazine in New York City, expressed it this way in an e-mail message not long ago, reflecting on the powerful and profitable nexis of entertainment and political bias in the news and the effect on democratic society:

> There are so many outlets offering so many different versions of events that people are increasingly able to read only those stories that bolster their opinions. While I am no fan of the objective journalism model (I am in the point of view backed up by fair and accurate reporting camp), I think we are heading towards a crisis of fact. There is simply less public consensus about what has actually occurred. People should look at journalism with a skeptical eye. However, partisan attacks on the media have made people more skeptical of stories that do not mesh with their political beliefs, yet completely accepting of those that do.

AGES OF TRANSFORMATION

When I left daily journalism in 1992 after sixteen years at the *Washington Post* and a stint at *Newsweek* magazine, I had little idea that I was about to find myself straddling two contrasting eras in the modern history of the news media. At age fifty-two, like most journalists of my time, I consider myself part of a generation that was motivated to join the profession by a series of inspiring works and acts of reportorial courage that in many ways defined American journalism in the 1960s and 1970s.

I was six years old on Thanksgiving Day in 1960 when I watched the CBS Reports program *Harvest of Shame* with my family on our first black-and-white television set. This landmark documentary, in which the chain-smoking Edward R. Murrow brought the hardships of migrant farm-workers to millions of American living rooms, proved the power of television to inform and move the public. At fifteen, in high school in Seattle, my pals and I scanned an issue of *Life* magazine one afternoon in the library, all of us stunned into silence as we viewed page after page of names and faces of Americans killed in Vietnam in only one week. At sixteen, I was moved by the corporate bravery exhibited by the *New York Times* and the *Washington Post* in defying the Nixon administration and publishing the Pentagon Papers, which detailed the secret history of our nation's involvement in Indochina. And at twenty, while in college, I followed the resignation of President Nixon in the wake of the Watergate scandal, a story broken by two young newspaper reporters, barely ten years older than I was, who followed hunches and investigated public records for the sake of getting at the truth and informing Americans about wrongdoing by their elected leaders. The Fourth Estate did its job, and, amazingly, the system worked, just as the Constitution promised it would. As a young citizen seeking to immerse myself in the spirit of my times, I was thrilled by the experience of learning about the press and its role in society.

Many still see those years from the late 1950s through the 1970s as a kind of golden age of American journalism, a time when television in particular came into its own as a journalistic medium. In the early days of television, the three networks began to see tremendous value in (and bestowed generous budgets on) news and documentary divisions as a way not just to gain ratings and profits but also, and equally important, to earn prestige. Interestingly, the chief impetus for the rise of TV news was an odd mix of civic-mindedness and abject penitence. It came as a direct result of the quiz show scandals of the late 1950s, when congres-

sional hearings revealed the full extent of fraud polluting the new medium. The networks worked hard to repair and restore their credibility as institutions in American culture, and it was through news—professional journalism—that the networks found it. NBC's White Papers, the groundbreaking CBS Reports documentary series, and the nightly news programs on each of the three networks came about as a direct result of the networks' fears that the Federal Communications Commission would revoke their licenses unless they demonstrated sustained and serious commitment to public service in the aftermath of the scandals.[47]

The rise of professional television journalism and its stunning capacity to provide instant coverage of breaking events, from political assassinations to moon landings to inner-city riots, also sparked reforms and improvements in the print media, just as it led to the demise of many evening newspapers and the marginalization of radio as a journalistic force. Unable to compete with television's immediacy, newspapers and magazines worked harder to produce investigative and explanatory journalism that provided badly needed context to news events that television couldn't match. Such crosscurrents in the evolution of journalism during that age helped to shape a better, more informative, and more responsive press.

But like most so-called golden ages in our cultural history, that period in journalism looks better in hindsight than it actually was, the bright glow of its achievements relegating its many failures and problems to the shadows.[48] In fact, this notion of a "golden" period is more mythical than real. This was, after all, the same era in which the nation's newsrooms remained almost entirely white and male, so segregated and disconnected from the lives of millions of Americans that when the Watts race riot erupted in 1965, for example, editors of the *Los Angeles Times* were compelled to enlist a black clerk in the advertising department named Robert Richardson to hurry to the community to report on the violence. The newspaper had never employed a single black journalist on its staff, and few in the sea of white faces in the newsroom even knew where Watts was.[49]

During the early years of that golden age, corporate and advertising pressures were not uncommon, with product placements in network evening news programs even more blatant than they are today on the network morning news shows. The first nightly news program NBC aired at the dawn of the new medium in 1950 was named after a cigarette company, the *Camel News Caravan*. Former NBC News president Reuven Frank, recalling his rollicking early days in television news in his 1991 memoir, *Out of Thin Air,* wrote revealingly about the overt restrictions advertisers placed on news content. In an interview with Robert Siegel

on NPR's *All Things Considered,* Frank, who was the chief writer for the NBC news program, expanded on his memory of an anecdote about Camel cigarettes that said a great deal not only about the struggle to raise journalistic standards but also about the almost Orwellian, and at times hysterical, control that advertisers sought over journalism:

Mr. Frank: I was not allowed to use any picture that had a no smoking sign in it. I was not allowed to use a picture of a live camel, of the animal the camel.

Siegel: That wouldn't be a problem occurring very often but what was their objection to seeing a live camel on the news.

Mr. Frank: Well to them a camel was this sweet-smelling cigarette endorsed by doctors. And the real camel, as anybody who has been to a zoo knows, is a large and smelly beast that is likely to spit at you or kick you. The serious problem came in the proscription of any picture of a man smoking a cigar.

Siegel: That is someone smoking something other than a cigarette.

Mr. Frank: Other than a cigarette, a cigar. They were not in the cigar business. And this was very difficult because at that time the most famous face in all the world was that of the former prime minister, the leader to victory, Winston Churchill. And Churchill's face always had a cigar in it. And if you could not use anybody smoking a cigar, you were going to miss some important news.

Siegel: You couldn't show a picture of Churchill.

Mr. Frank: I guess occasionally you could get a shot. But to do a story about Churchill, you could not do it without a cigar. So I went to the people I work for and I said, you can't do this. I mean, something has got to be done about it. And they were terrified. They were terrified, first of all because they were second-raters . . . otherwise they wouldn't have been in television. And also NBC had won this in a competition with CBS, and Camel paid enough for that program to run the entire television news department. So they did not want [anything] to jeopardize that.

And I said, well then I'll go down. I was the lowest man in the pecking order. I was the writer. And I said, I will go down to the agency and ask them. And I trotted myself down to 42nd Street, to the offices of the William Esty Company, and I said, look, you've got to give me some kind of dispensation on the cigar rule, otherwise I can't use Churchill and I can't run a news program. And without any argument he said, fine, okay. And I felt, you know, why all this stress, all this angst? And I thanked him and I headed to the door, and as I got to the door of his office, I was about to leave and he said, but only Churchill. I said how about Groucho Marx? He said no.

Siegel: So there was one cigar smoker permitted on your program.

Mr. Frank: In the entire population of the earth at that time, I could show one of them smoking a cigar and no others.[50]

It is also true that some of the finest and most courageous journalism practiced between the early 1950s and the early 1970s came not from the established mainstream news media but rather from the alternative press on society's margins. Less constrained by traditional socioeconomic or political sensibilities, such publications went forward with stories that most outlets either missed or were afraid to publish. On September 15, 1955, for example, *Jet* magazine printed the horrific photos of fourteen-year-old lynching victim Emmett Till, who had been beaten, shot, and thrown into the Tallahatchie River by white vigilantes, images that helped to galvanize the civil rights struggle. In 1969, freelance investigative journalist Seymour Hersh broke the explosive story of the massacre of Vietnamese villagers at My Lai by American GIs, more than a year and a half after the mainstream press had initially and falsely reported the atrocity as a victory by American troops over Viet Cong insurgents. Hersh's Pulitzer-winning work—which led to U.S. military tribunals and the criminal conviction of an officer responsible for the killings—first appeared in a tiny alternative news agency called Dispatch News Service. The My Lai story was eventually picked up by more than thirty newspapers, though *Life* and *Look* magazines both rejected it.[51]

With all its flaws, however, that era did offer up journalistic heroes aplenty, reporters with conviction, talent, and heart who inspired thousands of young Americans to consider journalism not just a career option but a noble and worthy calling. And one that was beginning to open its doors to minorities and women, after the tumult of the 1960s. Reading the work of newspaper writers such as Charlayne Hunter-Gault at the *New York Times* or witnessing television reporters such as Max Robinson anchor the news at ABC, young black college students and women graduates considering career paths in the early 1970s found compelling evidence that mainstream journalism was willing to adjust to seismic societal shifts to improve itself, to accept the call for equal opportunity, and to admit people who had traditionally been kept outside that mainstream.

The litany of widely admired names from that era—Murrow, Woodward, Bernstein, Huntley, Brinkley, Cronkite—remains to modern professional journalism what names like Koufax, Mays, and Aaron from baseball's golden age in the 1950s and 1960s are to the sport today. But that age has become little more than a flickering memory in many ways. Perhaps the most fitting signal of its demise came in the form of a some-

what anticlimactic revelation in 2005 of one of the era's most closely held secrets: the name of "Deep Throat," a former FBI official named Mark Felt, whose role as an anonymous source during the Watergate scandal proved critical in American journalism's finest hour.

By contrast, the heroes and inspirations for the new generation of reporters entering the profession today from classrooms like mine seem to come not from the ranks of editors and reporters who publish and broadcast meaningful works of political and social significance, but from those who make courageous ethical and moral stands against corporate, economic, and political pressures that often derive from the very news organizations that employ them, pressures that conflict with the journalist's mission to seek truth and report it. Investigative reporter Lowell Bergman, for example, is perhaps most famous not for his considerable achievements in print and broadcast journalism but for his resignation under protest in 1997 when CBS News bowed to corporate and legal pressures and declined to broadcast a story of his that was critical of the tobacco industry. Consider, too, Jon Lieberman, a respected Washington, D.C., news bureau chief employed by broadcasting giant Sinclair Corporation. Lieberman was fired shortly before the 2004 presidential election when he publicly opposed the archconservative company's plan to broadcast a politically biased documentary attacking the military experience of Democratic candidate John Kerry under the guise of "news."[52]

And consider young Baghdad-based *Wall Street Journal* reporter Farnaz Fassihi, a thirty-one-year-old graduate of the Columbia University School of Journalism and an example of the finest and most committed journalists of her generation, who sent an emotionally moving e-mail letter to friends in America about her experiences as a journalist in Iraq in 2004. Fassihi told the truth as she saw it, explaining in raw, gutwrenching detail the suffering and painful reality of life for millions of Iraqi civilians pressed between the insurgency and the American occupation. After the letter was publicly disseminated via the Internet, however, she was vilified by right-wing activists in the United States who accused her of possessing a hidden agenda against the war. The political furor mounted against her grew so intense that *Journal* editors were moved to encourage Fassihi to take a vacation from her post.[53]

The furor can be economic as well as political. One of journalism's most respected top executives of recent times, Jay Harris, a veteran newsman, gained national acclaim for his decision in March 2001 to resign his post, under protest, as publisher at the *San Jose Mercury News.*

One of the few African Americans holding top newsroom posts in American journalism, Harris chose to quit after being ordered by the newspaper's parent, Knight Ridder Corporation, to trim newsroom costs at the *Mercury News,* including editorial positions and news production, in order to boost the corporation's profitability. With profit margins in newspapers already ranging from 22 to 29 percent, Harris charged in a memo to his staff that he simply could no longer accept the relentless corporate pressure that was compromising the practice of news reporting and the public's right to know. Knight Ridder's new revenue targets could not be achieved, he wrote, "without risking significant and lasting harm to the *Mercury News* as a journalistic enterprise."[54]

The 2004 winner of a prestigious Ancil Payne Award, given annually by the University of Oregon to a professional journalist who fosters "public trust in the media by courageously practicing [the] profession in the face of severe political or economic pressures," was Virginia Gerst, a features editor at the *Pioneer-Press* in Glenview, Illinois, a suburb of Chicago. Her achievement? She resigned after a twenty-seven-year career at the newspaper when the publisher, Larry Green, ordered her to produce a favorable review of a local restaurant. Green was eager to regain the eatery's lucrative advertising revenue, but Gerst objected on the grounds that the restaurant was simply no good and that such a review would serve neither the truth nor the public interest.[55]

But identifying such heroes and inspirations can be a complicated task in today's news environment. Longtime *New York Times* investigative reporter and former Mideast correspondent Judith Miller was jailed in June 2005 by a federal judge on contempt charges in connection with her refusal to divulge information about an incident in which the identity of a CIA operative, Valerie Plame, was publicly divulged. Under federal law, it is a crime to reveal the names of CIA agents. Miller had never published an article naming Plame, but prosecutors wanted to know what she had been told while she was working on a possible story. For nearly two years, Miller and the *Times* fought for the right to protect the confidentiality of her sources. When the Supreme Court refused to hear her last appeal, she went off to federal prison rather than capitulate.

In earlier times, Miller's action might have seemed brave, admirable, and deeply honorable, attracting support from citizens and peers. But Miller had already become widely known not for her courage in that case but for her disturbing failures as a reporter in the months leading to the American invasion of Iraq in 2003. Her overreliance on questionable

sources who peddled fraudulent information on Iraq's alleged possession of weapons of mass destruction, published in numerous *Times* stories, helped to frame official debates over the rationale for the invasion, deceptively so, at a critical time in the nation's history.[56] Indeed, Miller's work came to symbolize a troubling wider culture of failed skepticism, weakened investigative zeal, and unquestioning acceptance of authority that characterized much of the mainstream media's coverage of power centers in Washington on this issue. Not long after Miller made a deal with prosecutors and was released from jail in 2005, after eighty-five days behind bars, the *Times* and Miller agreed that she would resign from the newspaper.

But perhaps the most revealing irony in the saga came with the revelation of the name of the anonymous source Miller had so staunchly sought to protect from prosecutors and the American public. It turned out to be a figure who had played an important role in her national intelligence reporting before the invasion: I. Lewis (Scooter) Libby. Far from a brave, Norma Rae–like whistle-blower or an ethically minded Deep Throat insider seeking to correct injustice or criminal wrongs— which is the popularly accepted model of the credible anonymous source whose identity is worth going to jail to protect—Libby represented something else entirely: as Vice President Dick Cheney's chief of staff, Libby was one of the nation's most powerful political operatives. According to court documents, Libby figured prominently as an anonymous source in a concerted White House political campaign in 2003 in which his superiors gave him explicit orders to leak classified information to Miller and other reporters to counter and discredit the claims being made by authoritative dissenters that Iraq represented no military threat to the United States.[57]

One of those dissenters was Joseph C. Wilson, a former foreign service diplomat who in 2002 had been commissioned by the CIA to investigate claims regarding Iraq's quest for nuclear capabilities. In a column published in the *New York Times* after the invasion, Wilson concluded that the administration's intelligence had been "twisted to exaggerate the Iraqi threat."[58] Wilson was the husband of Valerie Plame, a CIA agent and an expert in the field of weapons development in the Third World, whose identity Libby is alleged to have unlawfully revealed to reporters as part of the political campaign to discredit opposition. Libby was eventually indicted on federal charges of perjury and obstruction of justice in connection with the leak.

In the end, the Miller episode dramatically revealed unsettling ambi-

guities, suspicion, and moral ambivalence surrounding contemporary journalism and its expected function in American society. In essence, here was the professional journalist, Miller, and by extension the nation's most prestigious and influential newspaper, the *New York Times*, steadfastly protecting not the whistle-blower who could provide crucial information on a deadly serious issue, but the powerful forces seeking to *undermine* the whistle-blower. Here was the professional journalist going to jail to protect not the brave "little guy" or the ethical, well-placed insider, but instead a figure who was working to shore up the highest ranks of entrenched political power in the land.[59]

The morally complex and troubling lessons of the Miller saga stand in sharp contrast to the tragic story of Daniel Pearl, the talented *Wall Street Journal* reporter who was taken hostage when he went out one night in 2002 in Karachi, Pakistan, to interview a suspected member of al-Qaeda. Here was a journalist not much older than the students in my classroom, performing his job according to the most honorable traditions of truth seeking. Yet even here his experience represents a most anguished and defining episode about the professional journalist's uncertain place in the modern age. If the idea of inspiration in journalism today often comes from the experiences of reporters who must defy their institutions to tell the news, the martyrdom of this young reporter, whose murder by Muslim terrorists was recorded on video and distributed on the Internet by his killers as a political statement, says something far more distressing. The journalist's job is to tell the news, and sometimes this means possessing exceptional courage to go out and find it. But is this important mission worth sacrificing one's life? What sort of profession is journalism today, and what sort of world are we creating, that allows for such a senseless horror to befall a human being in the course of practicing an honorable profession? What sort of weird and obscene commodity is news when killers use the same digital tools of communication that journalists do to report their evil for political purposes the world over? Are Pearl's life and death examples of heroism we should honor, a story to inspire us in our collective cultural and professional memory, as the memory of World War II martyr Ernie Pyle does? Or is Pearl's experience instead a chilling caution, a warning, a lesson about the increasingly fragile place professional journalism occupies in this age of rampant and meaningless violence, even when it is performed correctly and with the highest ethical purpose? These complex questions serve as resonant indicators of the enigmatic quality of the

profession's role in the modern world—questions that remain challenging for a teacher to answer.

The truth is that professional journalism continues to play a complicated but critical role in a rapidly changing technological society. As troubled as journalism is today, it remains a craft more vital to democracy than ever. Despite all its shortcomings, and somewhat paradoxically, I believe that it is in many ways being practiced more effectively and certainly in far more varied styles than ever. I believe that this is true for certain corners of alternative media as well as for the so-called corporate and New Media. The *New York Times,* the *Washington Post,* and the *Wall Street Journal* are, in my eyes, the world's finest daily publications, the gold standard in public service–oriented news reporting and writing, newspapers whose value to society becomes ever clearer in the face of the economic struggles and demise of so many other print media. Among magazines, the *New Yorker* remains at the top of its game today, producing perhaps its finest reporting and providing an example of piercing, literary journalism, despite the harsh economic realities that confront the rest of the industry.

In addition, the exciting rise of online publications such as Salon.com, devoted to solid and fair journalism, points to the value of the Web as a new source of reporting. The emergence of journalistic blogs similarly offers optimism about the future of online sites as watchdogs and whistleblowers keeping an eye on the media, government, and industry and as sounding boards for instant public feedback, civic participation, and comment. Reporters and writers at other alternative media, from the *East Bay Express* to the *Washington City Paper,* broadcast organizations like the PBS *Frontline* documentary series, and the terrific family of news and information programs produced and distributed by National Public Radio, continue to produce effective and meaningful professional journalism in the finest traditions of the craft.

Interestingly, just eight years after the *Los Angeles Times* scandal in which the paper's owners allowed advertisers to control editorial content in a Sunday magazine featuring the city's new sports arena, the newspaper stood up to a major advertiser, earning, to its credit, such extraordinary animus from General Motors over a series of critical articles about GM vehicles in 2005 that the auto giant pulled all its advertising from the *Times.* The contrast between the two incidents was remarkable and represented a rare exception to the synergistic trends that have melded news and business interests throughout the modern media. Here was the largest newspaper in a state with the nation's largest number of auto-

mobile buyers standing up to the nation's largest automaker, despite the repercussions for its bottom line. The action of the *Times* and GM's response (it rescinded its ban on *Times* advertising four months later) seemed to convey the welcome civic message that in journalism the public interest could trump business interest when it came to reporting the news.[60]

One young former student of mine, who is employed as a beat writer covering education for a national daily newspaper, not long ago expressed this feeling of social efficacy and professional fulfillment in an e-mail message about his own work and his view of the news media and its future:

> I'm actually more optimistic, believe it or not. I came to journalism from activism, having grown tired of ramming my head against the brick wall of the status quo. I expected to enjoy writing about social issues as a journalist, but not necessarily to change things. Little did I know what an impact writing and journalism would have. I have affected federal legislation quite a few times, on a number of issues. I have also had a very tangible impact on policy. Some of my articles have helped close loopholes that gave excessive subsidies to companies at the expense of students. Others have stopped the administration from effectively cutting student grants. In all, these changes have meant that literally hundreds of millions of dollars more have been spent on federal financial aid than otherwise would have been.

Yet his experience in journalism, one in which his skill, talent, classroom learning, and professional idealism have clearly translated into tremendous workplace satisfaction, represents something of an exception to what I have come to know about the lives of young journalists in the industry today. Their lives are often very difficult, often as fraught with moral challenges and disappointments as with inadequate compensation. Nowadays young journalists are compelled to work harder and harder, in more forms of media, from radio and television to blogging, in newsrooms where punishing twenty-four-hour cycles have replaced set deadlines—and yet the institutional support for their labor in terms of pay and expenses appears to be diminishing, even at the nation's finest and most respected publications.

I also sense a sharpening anxiety that the lessons I knew well from the field, lessons learned barely fifteen years ago, are becoming less pertinent, and possibly irrelevant. Beyond the flickering black-and-white images of a broadcast from a distant time, what could the heartfelt and unadorned honesty of *Harvest of Shame* really mean in the classroom anymore to young people coming of age at a time when viewer atten-

tion spans are hopelessly minute and "news" is sometimes presented by way of "re-creations" and dramatizations? Do the journalistic lessons of *All the President's Men* from thirty years ago still apply at a time when government has become extraordinarily sophisticated at delivering the "news" itself and when most Americans simply don't trust journalists to have the public's best interest at heart?

My years in daily journalism as a city, national, and foreign correspondent were not without their own ethical quandaries, and I certainly worked as imperfectly and humanly as any reporter, grappling from time to time with company publicists and politicians seeking to influence my work in their favor. But I simply never had to do some of the things many young journalists are being asked to do today, nor did I have to wrestle with such demons of conscience as they sometimes face. I never had to spend professional time, energy, and skill searching for a cheating husband in order to grab ratings—or contend with the demoralization of having done so. I never had to compete against other journalists representing news organizations that were willing to pay tens of thousands of corporate dollars to sources for interviews.

I never had to work for a local television news station so profit-hungry that it promised favorable news coverage for advertisers and newslike interviews with corporate clients if the advertisers paid the station $15,000 per story, nor did I work for a station that charged "guests" such as entrepreneurs and hucksters as much as $2,500 to appear on their "news" programs, as stations in Florida and Mississippi did. Neither did my editors ever assign me to take part in fake "news conferences" staged by the network, where I was told to ask questions of someone posing as a baseball team executive, for the sole purpose of taping lively footage that could be aired during slow news cycles, as presumably professional baseball reporters did recently for ESPN's news program *SportsCenter* during baseball's off-season.[61]

I never worked at a newspaper so desperate for ad revenue that it published in its news pages, for a price, verbatim press releases from local businesses that resembled news articles.[62] No publisher or editor ever assigned me to write favorable stories for businesses featured in advertorials and special advertising sections published by the newspaper company itself. I never worked for radio station owners so driven by money that they were willing to sell the naming rights to their newsrooms to the highest corporate bidders.[63]

To the best of my knowledge, I never worked with fellow journalists who eagerly took cash under the table to shill for sponsor products in

their "beat" subjects during interviews on local television news pro-
grams, as many reviewers and so-called journalistic product experts re-
portedly do today.[64] Unlike a young, bright, and ambitious local televi-
sion news anchor in Cleveland named Sharon Reed, who had graduated
with a master's degree from Northwestern's prestigious Medill School of
Journalism, I never had to contemplate the idea that an editor would ask
me to shed my clothes and appear naked on camera expressly to boost
ratings and profits during "sweeps week"; nor would I have felt com-
pelled by circumstances or been willing to do so, as she enthusiastically
did, guided by her understanding of the modern values of her profes-
sion.[65]

During my full-time work in daily journalism, I never had to contend
with an environment so politically polarizing that excellent, Pulitzer
Prize–winning reporting like that of Dana Priest of the *Washington Post,*
who revealed the existence of a system of secret prisons for terror sus-
pects operated by the CIA in Eastern Europe, would prompt cries from
government supporters for the reporter's jailing. And during my years as
a daily reporter, I never had to worry that by simply doing my job and
telling the truth—by bearing witness for the American public on issues
of vital importance—I would put my life in jeopardy from persons in my
own country who did not want to *see* that truth. Such was the case for
Kevin Sites, a young freelance photojournalist stationed in Iraq who doc-
umented for NBC News the killing of a wounded Iraqi prisoner in Fal-
lujah by a U.S. Marine corporal, only to himself become the target of
death threats—not from Iraqis, but from Americans deeply distrustful of
the news media and outraged by what they considered an act of disloy-
alty by a journalist who was simply doing his job, and doing it well.[66]

THE JOURNALIST'S CHANGING IMAGE

In recent years, I have seen the image and concept of what it means to be
a "journalist" in American popular culture change markedly from the
clearer definition we knew and generally shared as citizens in a demo-
cratic society a generation ago. The meaning of the term has become dis-
turbingly murky and confused, connoting a mishmash of guises, pur-
poses, and roles. This vagueness likely contributes to the public's distrust
of those who consider themselves serious and truly professional practi-
tioners of the craft, especially when we consider the full range of per-
formers who have been lumped together under the title of "Journalist"
(writ large) in the past decade.

To the average American citizen, a Journalist is the television talker who is paid a considerable retainer to regularly make noise on cable news programs, arguing any question of the day regardless of whether he or she knows anything about the topic or not. The figure who hosts the show is a Journalist, too, paid a high salary not to seek out and report the news but to entertain an audience with a certain glibness and an argumentative personality. Today's Journalist is the rabidly opinionated Court TV news anchor and CNN Headline News commentator who blusters about a televised murder trial, proclaiming the defendant's certain guilt and urging the maximum sentence long before all the evidence has been presented or the jury has reached a verdict. Or she is the network television star with the sensational Q-rating who commands an annual salary of at least $8 million and magically has us believe, with treacly sincerity, that she understands the problems of ordinary working-class Americans.[67]

The broadcasters who have no problem taking money to play themselves in soft drink commercials are Journalists, as is the ESPN anchor who pads his salary by taping commercials for television sports advertisers and earns six-figure fees for speaking engagements before sports-related trade groups.[68] Yet another version of a Journalist is the Fox broadcaster who encourages listeners at an advertising and trade group convention to come up with novel ideas for him to help market their products deceptively, discreetly, and live during his network telecasts. Indeed, he revels in the opportunity, reportedly stating, "Think it up. I'll try. I have absolutely no pride." Other Journalists are the real-life network or cable television news personalities who accept Screen Actors Guild salaries to playact as journalists in order to lend recognizability and credibility to Hollywood and television scripts.[69]

The public accepts as a Journalist the inveterate Washington beltway insider with easily shifting loyalties and ethics who works as a Pentagon spokesperson, political campaign adviser, or presidential speechwriter one year and the next as a network news correspondent or magazine reporter whose independence and balance we are expected to trust.[70] In an age of confused loyalties and skewed professional values, other Journalists weirdly feel that their prime duty as news reporters is to share important information not with the general public to whom they are entrusted to report it, but rather with those they cover in order to affect judgments within those centers of power.[71]

In the minds of a surprisingly large number of Americans surveyed by the Annenberg Public Policy Center at the University of Pennsylvania not long ago, the title "Journalist" has come to encompass figures as fanat-

ical as conservative radio talk show host Rush Limbaugh and as stridently self-righteous as television talker Bill O'Reilly.[72] Also labeled a Journalist is the fellow who has no training or experience in news reporting but nonetheless manages to receive top security clearance to cover the White House for an obscure Web publication because of his strong Republican beliefs and connections. Once credentialed, this Journalist asks soft, staged, and leading questions of the president at nationally televised "news" conferences in order to boost the leader's standing in public opinion. He receives daily passes to White House press briefings and continues to attend briefings until his lack of professional experience and his involvement as a male model for Internet-based gay pornography sites come to national attention.[73]

Journalists are also those who faithfully take part in annual gatherings that feature off-the-record sessions with the corporate rich and politically powerful in far-flung retreats, like the World Economic Summit in Davos, Switzerland. By tacitly agreeing to treat certain conversations with the powerful as privileged information, these Journalists reveal a lack of moral concern about the corrosive effect on their presumed credibility and integrity.[74]

In the age of high-definition TV, a Journalist is the broadcaster who must regularly go in for the eye tuck, the hair transplant, or the Botox injection in order to project an appearance of youth and thus extend his or her longevity in the business of reporting the truth. Another Journalist is the nationally recognized television celebrity tapped to anchor the *CBS Evening News* not on the basis of her limited experience as a news reporter but because of her popularity among American viewers. When a forty-year veteran CBS news commentator publicly points out that the network could hire *eighty-five* genuine news reporters and correspondents at an annual salary of $250,000 each for what CBS will be paying the TV personality to anchor the news, executives dismiss his criticism as invalid, irrelevant, and misplaced.[75]

Still another curious figure dubbed a Journalist is the best-selling writer of science fiction who crafts a suspense novel based on the notion that global warming is a myth dreamed up by a conspiratorial cabal of U.S. climate scientists to further their own ambitions. He soon finds himself lavished with the highest honor bestowed in science journalism by the American Association of Petroleum Geologists. "It is fiction," concedes the spokesperson for the organization, whose mission is tied closely to the science of oil exploration, "but it has the absolute ring of truth."[76]

At a time of pervasive distrust of both the news media and the government, people gravitate to the Web in growing numbers to see works of reportage like *Loose Change,* a provocative short-form "documentary" produced on a laptop computer by a twenty-two-year-old self-styled investigative reporter. Cobbling together bits of video imagery, fact, conjecture, documents, political history, and forbidding music, this Journalist presents a compelling case for the conspiracy-minded, arguing that the 9/11 attacks on the United States were not the work of al-Qaeda or Osama bin Laden at all but instead can be traced to a group of powerful domestic "tyrants ready and willing to do whatever it takes to keep their stranglehold on this country." Since it was first put online in 2005, the documentary has been ranked among the most-watched independent videos in the nation.[77]

The documentary filmmaker who hires hundreds of child and adult actors to perform in fictional reenactments of the 1963 civil rights protest by thousands of grade-school children in Birmingham, Alabama, is also a modern Journalist. Using advanced digital editing skills, the Journalist smoothly merges period news clips of heroic protests from the 1960s with his own fictitious representations in order to create the illusion of a seamless historical reality. The Journalist doesn't inform viewers about the fabrications. In fact, he works very hard to convince them that what they are seeing is historical truth. The upshot of his shameless deceptions, which occupy the narrative heart of his film, is that the unsuspecting Academy of Motion Picture Arts and Sciences awards the Journalist its highest honor in the category of Nonfiction and Documentary film.[78]

A Journalist is the fellow fired from his job as a *Boston Globe* columnist after his bosses discover that he has been fabricating sources and committing plagiarism over the course of his long career. He nonetheless immediately lands another gig on MSNBC News as a highly paid commentator chiefly because of his talent for garrulousness. Two years later, the owners of the *Boston Herald,* the competing newspaper that had exposed the Journalist's transgressions in a series of outraged investigative reports, hire him to write columns for *them* instead.[79] In the American media carnival's smoke-and-mirrors show, a Journalist is the fabulist who is fired by his magazine for making up stories, but then writes a novel about his humiliation and soon sees a successful Hollywood film made about his life and times.[80]

This confused, contorted, and contradictory attitude about how journalism, its ethics, and the Journalist are defined in civil society is playing

a central role in important legal issues surrounding the evolution of the New Media. Consider the court case working its way through an appeals process in California, in which Apple Corporation is suing a group of bloggers, including a Harvard undergraduate, for releasing inside information on the company's research and products. The bloggers, whose Web publications focus on news, rumor, and gossip about Apple, insist that they are Journalists and are therefore entitled to regulatory protection under the state's shield law that allows them to protect confidential sources. Many see the case as an important crossroads testing the limits of free speech in the Internet age, underscoring the changing definition of the reporter.[81]

In startling ways, today's image of the Journalist in American culture seems to be moving farther and farther away from what professional journalists have traditionally been or are supposed to be: *practitioners of the craft of journalism*. Skilled hunters and gatherers of news, facts, and information in an increasingly complex society. Trained reporters and communicators dedicated to truth, balance, and fairness, not to celebrity gossip, punditry, rumormongering, or craven political or commercial bias. Journalists inherently believe and take professional pride in the value of reporting original news and information and informing the public for its own sake, rather than valuing rhetoric, online opinionating, or exercises in vanity such as "public conversations" with other celebrity journalists about the issues of the day.[82]

Real journalists are experts at presenting these reports to the public—these products of dedicated intellectual process, of digging and hard work—in as timely, substantive, accurate, and independent a fashion as possible. Journalists regard serving the public trust as central to their purpose, and they believe in questioning and, if necessary, challenging power and vested interests to protect that trust. They question the powerful on the behalf of the ordinary citizen and regard corporate and political elites as subjects to be watched closely, not as figures to be fawned over. Journalists are professionals with ethical and moral standards who inform the people in a democracy about the community and the world so that we all may become knowledgeable enough to make decisions about the best ways to improve our lives.[83]

For a host of reasons, however, that comparatively clear-eyed view of what professional journalism represents in civil society no longer really applies, having been muddied by so many pretenders, nonprofessionals, and charlatans. And the effects of this dilution of meaning are being felt in important institutions in American life such as government and the ju-

diciary, which, like the public, are treating the Fourth Estate with increasing disdain and contempt. For example, the courts in past years have usually sided with reporters who argued that they merited special legal protection governing the use and confidentiality of anonymous sources. Without such protections, whistle-blowers would be far less inclined to reveal to reporters important information about wrongdoing in government and business, all to the detriment of democracy and the public's right to know. But with the news media under increasing fire these days over problems of accuracy, credibility, and political bias, the courts no longer seem to see it that way. Judges are telling reporters and the institutions that employ them that they don't deserve any special treatment or protections under the First Amendment. As a result, the threat of jail time for reporters protecting confidential sources has become more pronounced, producing a chilling effect on how the media report the news.[84] Even worse, some media corporations, with an eye on profit margins and shareholder concerns, seem willing to betray sources and the profession's traditional values when put to the test by the courts.

The contrast between the two most recent eras in journalism's evolution is truly stark. In 1971, the *New York Times* and the *Washington Post* both struck a momentous blow for the power and freedom of the press in democratic society when they defied federal orders and refused to divulge the names of officials who leaked the Pentagon Papers to them. The newspapers bravely published the government papers, despite threats and legal action. The U.S. Supreme Court eventually backed up their arguments that the public had a right to know. But thirty-four years later, in June 2005, Time Inc. agreed to turn over a reporter's notes and other information in the Valerie Plame case to federal prosecutors after the Supreme Court declined to hear appeals by *Time* journalist Matthew Cooper. First Amendment advocates around America were stunned by *Time*'s decision. The controversy raised once again the crucial questions of anonymous sourcing and the function and trustworthiness of the press in a free society: if *Time* and other powerful news media institutions decide that they are unwilling to fight to protect confidential sources in the face of governmental, judicial, or business pressures, who will want to tell the news media the stories inside government and business that the people need to hear?[85]

Indeed, *Time*'s move and the jailing of Judith Miller almost immediately produced a dampening effect on the work of at least one news organization and perhaps many others. Editors of the *Cleveland Plain*

Dealer soon revealed their decision not to publish a "profoundly important" series of investigative articles that relied on confidential sources and illegally leaked government documents, for fear that its reporters could face the prospect of jail if the articles were published. Amid the tough new prosecutorial environment surrounding the press, the *Plain Dealer*'s lawyers strongly advised the editors to stay within the law. But staying within the law also meant that the public was deprived of vital news.[86]

Such moral ambiguities surrounding professional journalism are as deeply complex as they are troubling. And within this uncertain climate, and its ever-accelerating change, I find the task of comprehensively educating a new generation of reporters increasingly vexing. There are two parts of this mission as I see it today, one fairly straightforward, engaging, and inspiring; the other complicated, gnarly, and often unnerving. The comparatively easy part is teaching students how to report, how to write, and how to *critically think* as journalists. It also means exposing them to the many great works of journalism that have shaped and bettered American society, told citizens what we needed to know, and honored the promise of the First Amendment, from *The Shame of the Cities,* "The Death of Captain Wachow," and *Hiroshima* to more recent reporting on the abuses of Abu Ghraib. The canon of professional journalism, along with the many examples of individual and institutional heroism in service of informing society with the truth, will always remain central to the education of young journalists, just as great achievements remain central to the education of engineers, physicians, and lawyers in their fields. To show and to inspire is to educate.[87]

But the difficult part of the teaching mission is filled with lessons that are not so clearly defined or self-evident. It involves conveying the many specific, complex, and unsettling ways that the profession of truth seeking is struggling to maintain a firm place in American society; how journalistic integrity is increasingly under siege; and what those struggles may mean not only for my students in their future careers but also for citizens at a time of unprecedented technological advances. Indeed, the hard part is simply trying to keep up with these struggles and epic transformations, to make sense of them all, while continuing to teach exactly how and why traditional standards of professionalism in this craft matter more than ever. This effort requires not only that we listen to the cal-

liope as it plays its dissonant musical notes in the American carnival but also that we turn and actually follow in the direction of the noise and hubbub, and enter the carnival to witness the marvels it has to offer. For here is where we find, up close, the various modern sideshows in action, with their lively roots in U.S. history, briskly peddling works to the public that look just like the genuine article—professional journalism—but which are in fact often anything but.

2

Freak Show

From the day he arrived at the *New York Times* as a twenty-three-year-old full-time metro reporter in June 1999, Jayson Blair seemed destined for the fast track to success. By all accounts, the new hire from the journalism program at the University of Maryland at College Park was witty, smart, an engaging and excellent player of newsroom politics, and a deft writer on deadline. His top editors soon saw him as an energetic and ambitious young journalist who was willing to work long hours and who could be called on to report the most pressing crime stories quickly and well. Swiftly advancing up the corporate newsroom ladder as few other reporters of his age had done, Blair went from covering workaday local news stories in New York City to prized national assignments, including the Washington, D.C., sniper case, over a period of just four years, earning more than seven hundred bylines along the way. There seemed to be no stopping him, despite expressed concerns from several fellow reporters and editors that the young man's work was occasionally slipshod and prone to error.[1]

But it all came crashing down on Blair in the spring of 2003, when *Times* editors finally began to come to grips with the shocking truth: the seemingly brilliant young African American reporter they had been grooming for great things was in fact a liar, a hustler, a fraud. In the

course of a long investigation into scores of Blair's stories that had been published in the *Times,* the editors, acting on tips from whistle-blowers and Blair's own colleagues, discovered that he was a very crafty plagiarist who had frequently stolen the work of journalists at other newspapers and wire services using online digital databases and news Web sites and then claimed the work as his own.

He was also a serial fabricator who invented the names of nonexistent sources he had quoted and made up entire scenes and interviews, in both news and feature stories, that had never occurred. Deeply troubled, emotionally frail, and suffering from manic depression, Blair abused alcohol and drugs. Yet he still managed to fool his editors into believing that he was reporting from places he had never visited. Using his cell phone and tapping into the Web, he put together twenty-nine "news" stories with datelines from as far away as Ohio, Maryland, West Virginia, and Texas, many crafted as he sat in his underwear at his laptop computer, high on cocaine, in his Brooklyn apartment.

When the *Times* announced the scandal in a 7,200-word, front-page investigative story spread over five full inside pages on Sunday, May 11, 2003, the name Jayson Blair instantly became synonymous with fraud and malpractice in American journalism. The story was outrageous and revolting. For more than two years, editors at America's most respected and widely trusted newspaper of record had unknowingly enabled the systematic publication of lies and inaccuracies to trusting readers. Somehow, the newspaper's management system had grown so lax that no one had even noticed that Blair had failed to file expense accounts for many of his reporting "trips."

"Mr. Blair repeatedly violated the cardinal tenet of journalism," the *Times* announced in its investigative story, "which is simply truth."[2]

Almost instantly, the hiring policies that had attempted to promote greater racial and ethnic diversity in the newsroom came under sharp attack, lending fire to critics' charges that political biases on the part of the *Times* were hurting the public's right to know and thus democracy itself. Blair, who, the *Times* later learned, had not graduated from the University of Maryland, had been hired under a college internship and training program that was partially intended to assist in the development of minority journalists at the newspaper. Critics of affirmative action around the country leaped on the Blair scandal like leopards after raw meat.

To these critics, Blair's sins signified a lowering of standards in all corners of American life that had been affected by special efforts to improve minority employment and representation—everything from government

and journalism to manufacturing and education. "The *New York Times'* experience with Jayson Blair is, no doubt, an extreme case," wrote Roger Clegg in the *National Review*, "but other companies that demand diversity will inevitably sacrifice excellence as well. . . . The best people won't get hired and promoted." Added Tim Chavez in the *Nashville Tennessean*, "I used to champion the word 'diversity.' Now I squirm when I hear it. The Jayson Blair fiasco at the *New York Times* was the result of a double standard employed to benefit an African-American reporter grossly unable to do his job. A white, young reporter would have been shown the door for just a fraction of his offenses. The *Times* ultimately viewed diversity in its newsroom as more important than accuracy to its readers."[3]

On the television news talk shows, discussion of the Blair scandal also focused extensively on affirmative action. MSNBC's *Buchanan and Press* program featured an enthusiastically conservative black radio commentator and newspaper columnist named Armstrong Williams, who railed against Blair and the deceitful practices of the press:

> *Bill Press:* Pat, thank you. Armstrong Williams, if I—thanks for coming in, and let's get back to the issue, which is our question, whether we should blame diversity and affirmative action for Jayson Blair getting hired and being kept on the job (*unintelligible*). Focus on that. Armstrong, if I told you tonight that we invited you only because you were black, you'd be angry at me and it wouldn't be true. Isn't it also not true to say that Jayson Blair was kept on the job only because he was black?
>
> *Armstrong Williams:* You know, it doesn't matter why you invited me,
> *(radio talk show host)* Bill. The issue is that I chose to come, and you cannot separate this Jayson Blair story given the fact [of] the youthfulness of this kid, the number of mistakes, his background, or the fact that most reporters—if someone like myself or Pat Buchanan had been given that opportunity, Pat because he's white and the fact that I'm a conservative, I mean, we would not have had two strikes. On the first strike we would have struck out.[4]

Just two years later, Williams himself would become embroiled in a scandal involving deceptive practices when the media reported that he had been secretly paid $250,000 by the Bush administration to shill for White House education policies in his broadcasting programs and syndicated newspaper columns.[5] Here indeed was the irony of a prototypi-

cal sideshow barker in a media carnival calling public attention to a freak or a deviant, while secretly exhibiting traits that are just as unethical and that arguably have more serious social effects.

But, for now, the frenzy was about Jayson Blair. Columnists and editorial writers across America addressed larger issues about the fate of democracy, the First Amendment, and the public's right to be informed, with some calling the failures of the *Times* in the Blair scandal the equivalent of a capital crime against free society. "A great democracy like ours deserves a first-rate newspaper of record," wrote William Kristol in the *Weekly Standard*. "And the *New York Times* isn't it."[6]

Numerous critics were aghast to learn that the young black journalist had been promoted to the national staff of the *Times* despite compiling a record that included a high number of known factual errors in his stories. Out of 725 bylined articles, the *Times* had to write fifty corrections during Blair's four-year tenure, a discovered error rate of 6.9 percent. Williams, Chavez, and other critics pointed to this record of mistakes as proof that a double standard had existed for Blair and, by extension, other minority reporters who were working under the liberal hiring regime at the *Times*. It took the *Weekly Standard* to point out that a number of white reporters, including national staff luminaries such as Adam Clymer (9 percent) and R. W. Apple (14.1 percent), possessed correction records even higher than Blair's over the same four-year period.[7]

A more thoughtful observation about the scandal came from Alaska. "Journalism will survive these and other incidents of untruth-telling," wrote Stephen Haycox, a history professor at the University of Alaska, in the *Anchorage Daily News*:

> But they remind us of the difficulties of the search for truth and the slender reed of trust upon which the search rests. The *Times* [scandal] would have no currency today if we did not believe it is possible to arrive at some approximation of the truth and that the search for it matters. In a democracy that search is critical to citizenship, for policy judgments supported by the electorate, and the credibility of political leaders who codify and implement those judgments, must rest on informed truth. Most of what we know of the world today comes to us from journalists who ask penetrating questions and then report their findings, and from editors and analysts who try to understand the implications of what has been done and reported.[8]

Soon a bevy of books examining the Blair scandal from nearly every angle appeared. Conservative media critic William McGowan, who had already blasted the news media, including the *New York Times,* for its diversity hiring and editorial policies in his 2001 book *Coloring the*

News, earned a sizable new contract for a book with an even more alarming title, *Gray Lady Down: Jayson Blair and How the* New York Times *Lost Touch with America. Newsweek* media writer Seth Mnookin penned an inside account about the scandal, titled *Hard News,* examining numerous Blair stories and interviewing scores of sources at the *Times* to craft a gripping narrative about how Blair had been given special leeway and treatment by his top editors and eventually unmasked by journalists concerned about the newspaper's direction. Blair himself typed out a tell-all memoir about his experiences, the provocatively titled *Burning Down My Masters' House.* In this rambling account, the fallen reporter admitted that he had been psychologically unprepared to cope with the high-pressure world of daily journalism at a top national newspaper like the *Times* and had "lied and lied and lied some more" in a bid to stay in his bosses' favor. He also excoriated the management of the *Times* for treating him like a "rag doll."[9]

The African American scam artist became, in short, popular culture's most preeminent freak show attraction, a figure not unlike the weight-lifting bearded lady, the dog-faced boy, and the legless dwarf from the Coney Island amusement park days of old—Exhibit A in contemporary journalism's festival of deceit. But he was far from alone in his notoriety. Blair's downfall came two decades after the similar ruin of Janet Cooke at the *Washington Post,* whose editors returned the Pulitzer Prize she had earned in 1981 after the young black reporter admitted that she had fabricated a story about an eight-year-old heroin addict. More recently, columnists Patricia Smith and Mike Barnicle of the *Boston Globe,* Christopher Newton of the Associated Press, Diana Griego Irwin of the *Sacramento Bee,* Eric Slater of the *Los Angeles Times,* and Michael Olesker of the *Baltimore Sun* were either fired or forced to resign after episodes of fabrication, plagiarism, or both. More than a dozen other newspapers around America reported similar scandals.[10]

Then there was the case of Jack Kelley, *USA Today*'s star foreign correspondent. Here was a forty-three-year-old, seasoned professional with more than twenty years of experience covering many of the era's most significant news stories, from conflict in the Mideast and democracy protests in China to rebel movements in Eastern Europe. But when *USA Today* editors convened a special panel for a two-month review of about 100 of his 720 stories, the panel found that Kelley's "journalistic sins were sweeping and substantial. The evidence strongly contradicted Kelley's published accounts that he spent a night with Egyptian terrorists in 1997; met a vigilante Jewish settler named Avi Shapiro in 2001; watched

a Pakistani student unfold a picture of the Sears Tower and say, 'This one is mine,' in 2001; visited a suspected terrorist crossing point on the Pakistan-Afghanistan border in 2002; interviewed the daughter of an Iraqi general in 2003; or went on a high-speed hunt for Osama bin Laden in 2003."[11] Kelley's extraordinary work had been influential in informing decision makers in Washington's foreign policy establishment. And, like Blair, Kelley had been protected and enabled by a culture of corporate favoritism at his newspaper.

There was also David Brock, a conservative journalist who helped to frame the contentious debates over the nomination of Clarence Thomas to the U.S. Supreme Court in 1992. In an article that year in the *American Spectator,* which he later expanded into a best-selling book, *The Real Anita Hill,* Brock depicted Anita Hill, the female law professor who had accused Thomas of sexual harassment, as a sexual predator and pathological liar who was romantically obsessed with the judge. The attacks on Hill's credibility helped to sway Senate votes in support of Thomas's nomination. It wasn't until ten years later, in his book *Blinded by the Right,* that Brock came clean and admitted that he had faked interviews, invented evidence, and fabricated comments and quotes that falsely undermined Hill's accusations against Thomas.[12]

And then there was Stephen Glass of the *New Republic,* a gifted young writer whose extraordinary two-year career as a fabulist and an ingratiating newsroom charmer was dramatized in the 2002 film *Shattered Glass.* This young perpetrator of frauds was so brazen that he made most others look like pikers by comparison, inventing more than two dozen articles during his time at the magazine, once going so far as to construct an elaborate Web site to support one of his more majestic fabrications, in order to throw investigating editors off his trail. The story of his rise and fall came to encapsulate the power of New Media tools not only to create deception but also to reveal truth, for it was an editor at a real Web site, at a company called Forbes Digital Tool, who first tipped the magazine's editors to Glass's fabrications when the Web editor was unable to find many of the sources Glass cited in a story about computer hacking.[13]

Still, it was Blair whose quick rise at the world's most powerful newspaper and sudden ignominy seemed to resonate most powerfully in American society. It was Blair whose story touched on the divisive issues of race, class, and entitlement. And it was Blair whose face appeared on the cover of *Newsweek* and who came to symbolize the lying, untrustworthy, immoral, unqualified, lazy, and *undeserving* black male—the

age-old and powerful stereotype festering still in the darkest heart of American racism.[14]

From every angle, the Blair scandal was an extraordinary cultural spectacle. The travesties were so numerous that it became difficult to judge which was the most egregious. Arguably, Blair's greatest offense was not that he had lied about interviewing the father of U.S. Army private Jessica Lynch at the family home in rural Palestine, West Virginia, while Lynch was held captive in Iraq. In that March 2003 article, Blair described how Lynch's father had "choked up as he stood on his porch here overlooking the tobacco fields and cattle pastures"—although Blair was never in West Virginia, had never spoken to any members of the family, and had invented a landscape that in fact did not exist. Neither was Blair's greatest sin his riveting, front-page story on April 19, 2003, about his bedside interviews with two soldiers wounded in Iraq and convalescing at the National Naval Medical Center in Bethesda, Maryland. One of the soldiers reportedly told him, "It's kind of hard to feel sorry for yourself when so many people were hurt worse or died." Blair never visited the hospital, and he spoke to one of the soldiers only by telephone after he had been discharged. "Most of that stuff I didn't say," the soldier told the *Times* later. Nor was Blair's greatest transgression that he had invented scenes and copied the work of other journalists in thirty-six of seventy-three articles he wrote while working for the newspaper's national staff.[15]

Rather, Blair's most damaging crime against journalism and American society was one that was almost completely lost in the fiery national debates about the *Times* scandal and what it signified about the credibility of the press, the public's trust in it, and the health of American democracy. That crime was that Jayson Blair dishonored the lives and legacy of the many courageous Americans who had struggled tirelessly and often unpopularly to clean up, correct, and reshape the nation's press and sharpen its commitment to professionalism over the past century, especially in its treatment of racial issues, even in the face of mob violence. That this past was so widely ignored amid the furor was perhaps the most distressing aspect of the scandal.

HISTORY WITH LIGHTNING

For nearly a week that blistering summer, Chicago was gripped by terror. Scores of white toughs roamed the city's streets hunting down black people and attacking them with bricks, bats, and knives, while a few

blacks fiercely sniped back with firearms. The city seemed intoxicated with racial hatred, stoked higher with each passing day by Chicago's sensationalist, race-baiting newspapers. Thousands of Chicagoans were burned out of their homes in the days and nights of madness, including hundreds of Polish American immigrants living near the city's stockyards.

The year was 1919. By the time the violence ended, at least thirty-eight persons had been killed, more than five hundred injured, and hundreds of millions of dollars worth of property and goods destroyed. The mayhem was part of a wider pattern that swept America like an apocalypse that bitter summer. From tiny Elaine, Arkansas, and Omaha, Nebraska, to Harlem and Washington, D.C., whites attacked blacks in racial violence that tore through twenty-six towns and cities in a season memorialized as the "Red Summer" by black intellectual James Weldon Johnson.

But just as the Chicago riot stood out as one of the worst explosions of hate, what grew directly from its ashes was in many ways even more remarkable. Shocked by the bloodshed, civic leaders, both black and white, joined together to study the problems of Chicago race relations and to recommend changes, including urgent reform of the local press, to help make sure that such conflict never happened again. Formed by the Illinois governor, the twelve-member panel, including six members of each race, called itself the Chicago Commission on Race Relations. The product of the panel's three-year labors was a compelling, seven-hundred-page work, *The Negro in Chicago: A Study of Race Relations and a Race Riot,* published by the University of Chicago Press in 1922. Long out of print, largely forgotten, and buried by time much like the catastrophe that spawned it, the book stands as testimony today to an expression of racial cooperation from a time in the nation's history when such cooperation was rare.

This was a period when black Americans were being lynched at unprecedented rates in the South, and white bigotry and assaults on the rights of black people and immigrants were being culturally legitimated by the eugenics movement and pseudoscientific studies like Madison Grant's 1916 work *The Passing of the Great Race.* Grant, an aristocratic founder of the Bronx Zoo and a prominent zoologist whose influence helped lead to the creation of Yellowstone National Park, extolled white genetic superiority and warned white Americans that interracial coexistence and procreation, as well as immigration from non-European countries, would derail human progress. The book became an instant bestseller and was ecstatically reviewed by numerous publications including

the *Saturday Evening Post* and the *New York Times*.[16] Reprinted in 1918, 1920, and 1921, the book was also translated into German, French, and Norwegian. As scholars later discovered, Grant's book proved influential to an admiring young German veteran of World War I, Adolph Hitler, who read it in translation, along with books by other American eugenicists, in 1924 while serving time in jail for mob action. In 1930, Hitler wrote a note of appreciation to Grant, calling the tome "my bible."[17]

The era's most common representations of black Americans in the mainstream press came almost exclusively by way of crime news and the comics pages. The latter regularly featured lazy, slovenly, and dim-witted black characters drawn from the nation's minstrel traditions. Cartoon characters like the stable boy called Asbestos in "Joe and Asbestos," and Joe Palooka's valet, Smokey, were little more than derogatory stereotypes straight from the fetid liturgy of white racism. But in many white homes during the days of racial segregation—including homes in Chicago in 1919—such popular newspaper depictions symbolized all that was known of the black experience.

The nation's racial attitudes were perhaps most tellingly represented by D. W. Griffith's 1915 film *The Birth of a Nation*, a stunning exemplar of cinematic innovation and the power of narrative imagery, which glorified the rise of the Ku Klux Klan. President Woodrow Wilson and his cabinet enjoyed a special screening of the film in the White House shortly after its release, which was timed to coincide with the fiftieth anniversary of the end of the Civil War. After taking in the incessantly degrading depictions of freed blacks as violent, treacherous, and sexually depraved, and the stirring scenes of valorous white southerners donning KKK robes to resurrect their supremacy by violence, the Virginia-born president was reportedly inspired to exclaim, "It is like writing history with lightning. And my only regret is that it is all so terribly true."[18]

Both the newspapers and newer forms of media emergent in that age promoted a generally demeaning and dismissive attitude toward the aspirations and potential of black people, and the painful, reverberating psychic effect on black Americans was acute. When novelist Richard Wright was a deeply impoverished eleven-year-old growing up in rigidly segregated Mississippi in 1919, he managed to get a low-paying summer job as a newspaper carrier. He was overjoyed with the job, he later wrote, not because of the wages, which were measly, but because he had become an avid reader of fiction by then, despite cultural attitudes that discouraged black education, and he knew that the newspaper regularly

featured a magazine insert of exciting stories like "Riders of the Purple Sage."

For many weeks, Wright sold and delivered the newspaper, which was published in Chicago, and reveled in the magazine stories. Then one day, a black man on his route asked the boy if he had ever read the newspaper he was delivering. Wright told him no, that he wasn't interested in the news, only the fictional adventures in the insert. Whereupon the man opened up the newspaper and showed young Wright the kinds of news it contained. He pointed to a racist editorial cartoon featuring "a huge black man with a greasy, sweaty face, thick lips, flat nose, golden teeth, sitting at a polished, wide-topped desk in a swivel chair."

> The man had on a pair of gleaming shoes and his feet were propped upon the desk. His thick lips nursed a big, black cigar that held white ashes an inch long. In the man's tie was a dazzling horseshoe stickpin, glaring conspicuously. The man wore red suspenders and his shirt was striped silk and there were huge diamond rings on his fat black fingers. A chain of gold girded his belly and from the fob of his watch a rabbit's foot dangled. On the floor at the side of the desk was a spittoon overflowing with mucus. Across the wall of the room in which the man sat was a bold sign, reading

> The White House

> Under the sign was a portrait of Abraham Lincoln, the features distorted to make the face look like that of a gangster. My eyes went to the top of the cartoon and I read:

>> The only dream of a nigger is to be president and to sleep with white women! Americans, do we want this in our fair land? Organize and save white womanhood![19]

In *Black Boy,* his searing coming-of-age memoir about the physical, emotional, and psychological effects of growing up under the heel of white oppression in Mississippi, Wright wrote that he was as deeply ashamed as he was baffled by the discovery of the rancid contents of the newspaper he carried. He was distressed too by his realization, as a boy, that the American press represented just another agent for oppressing his people. But what most unnerved Wright was the painful reality that the newspaper, a publication sponsored by the Ku Klux Klan, was written and printed in Chicago, the northern city that represented so much hope to so many poor blacks, the shining place to which so many millions were migrating in that era.

That the Chicago Commission on Race Relations even met in the wake of the devastating 1919 riot seems almost miraculous, given the

ugly racial tenor of the age. But the biracial panel saw it as a matter of life and death. Painstakingly, the civic leaders examined nearly every socioeconomic aspect of the city's racial problems and collected the testimony of hundreds of citizens. Their investigation uncovered long-smoldering problems in race relations and attitudes in a rapidly transforming Chicago that had provided flash points for the explosion, problems that reflected similar conditions in other American cities convulsed by racial violence that summer.

By the millions in the 1900s and 1910s, black Americans, most of them sharecroppers from the South, had been migrating to rapidly industrializing northern cities in search of jobs and better lives. In Chicago, where the black population had doubled in the 1910s, the influx produced a crisis of overcrowding in the city's so-called Black Belt, where most African Americans resided under de facto segregation, producing an overflow into working-class neighborhoods that had traditionally been white. Such new circumstances of daily life in a city ill prepared to cope with massive social and economic change only heightened tensions between the races. So too did the fierce competition for jobs in the stockyards and other industries between the impoverished new arrivals from the South and the already established communities of largely Italian, Irish, and Eastern European immigrants, the commissioners reported.

African Americans themselves had also changed, increasingly unwilling to be constrained by old-fashioned, bigoted attitudes about their race. Black Americans of a new generation were arriving in Chicago and other cities, ready to make their mark on American society, with a newfound pride of place and a sense of having earned respect. The generation's new attitude was perhaps best symbolized by the recent return of thousands of black U.S. Army veterans of World War I. Many had fought valiantly in the trenches of France and Belgium in units like the 369th U.S. Combat Regiment and now were set on demanding dignity and equality at home, much to the dismay of white Americans, who were more accustomed to black servility.

As the biracial Chicago commission reported, the flash point for the 1919 riot was rooted in all of these factors. On a sweltering July afternoon, violence erupted at a Lake Michigan beachfront that in recent weeks had seen confrontations between black beachgoers and whites at the customarily white beach. Seeing a quartet of black youths frolicking on a makeshift raft just offshore, an enraged white onlooker hurled a rock at them. One of the young people was struck on the head and drowned. Amid the chaos and fury that ensued, blacks demanded that

the police on the scene arrest the stone thrower. The police refused to do so, igniting even more indignation and protests from the black onlookers. A cop soon gunned down a black man, and all hell quickly broke loose.

The commissioners recommended numerous steps to improve race relations in Chicago, including the construction of more affordable housing and better support for civic groups assisting blacks in their transition to life in the city. They recommended that schools, churches, and other institutions work to make racial education and improved communication and understanding a priority. They also faulted the police and elected officials for failing to heed obvious warnings about the deadly powder keg in the city's heart and urged them to make practical reforms that would allow them to respond to conflict more quickly and effectively.

But the authors of *The Negro in Chicago* saved their most powerful assessments and damning criticism for the city's newspapers. The commissioners charged that the press, a critical entity in the life of the city that was explicitly responsible for providing truth to citizens when Chicagoans were in desperate need of it, instead disseminated lies, distortions, and incendiary rumors. The study assailed the newspapers for feverishly reinforcing ignorance and prejudices that only inflamed hatreds.[20]

"Cases of exaggeration could be adduced from every Chicago newspaper," the leaders wrote, arousing "vengeful animosity, fear, anger, and horror." There was the shocking July 29 story in the *Chicago Tribune* reporting that whites were dying at rates more than double that of blacks in the violence. The commissioners decried the story as a fabrication that only fueled the resolve of white gangs to even the score. The true tally at that point was the exact opposite. There was the *Chicago Daily News* story on July 30 about blacks arming themselves with homemade bombs and possessing enough ammunition to last for "Years of Guerrilla Warfare"—another irresponsible rumor accepted as truth, sparking more violence by the roaming gangs of thugs. Then there was the *Chicago Herald-Examiner* article on July 29 reporting that two white women and a baby had been slain by rioting blacks, an article headlined "[Blacks] ATTACK WHITE WOMEN AS RACE RIOTS GROW." The story was as criminally irresponsible as it was false, the leaders wrote.[21] But the mere mention of defenseless white women in the press, as articles simultaneously invoked the specter of rampaging black males, helped to stir the frenzy of the white rioters.

The commissioners also criticized the black press for fabricating information and pandering to prejudice and hate. They pointed in partic-

ular to the August 2 *Chicago Defender* story falsely reporting that a white mob had dragged a young black woman and her three-month-old baby from a streetcar. The paper reported that thugs had bashed the infant's head against a telephone pole, slashed the woman to death, and then cut off her breasts and held them "atop a pole triumphantly while the crowd hooted gleefully."[22]

Neither the white press nor the black press was interested in the truth, the commissioners wrote, only in perpetuating myths and lies. The races hardly knew each other, and the newspapers were clearly determined to keep it that way. The panel concluded that the newspapers had contributed to the intolerable conditions that led to the catastrophe. They urged the newspapers and major wire services, including the Associated Press, to take steps to increase human understanding and stop pandering to stereotypes and bigotry.

Black people in Chicago "live and think in a state of isolation which is almost complete, and no white group understands it, or can fully understand it," the city leaders explained. Whites, meantime, "are generally uninformed on matters affecting [blacks] and race relations. They are forced to rely on partial and frequently inaccurate information and upon traditional sentiments." Year after year, the city's white press had consistently fed citizens a litany of hateful, false, and distorted coverage of black Chicagoans, who were depicted almost exclusively as criminal, immoral, untrustworthy, and mentally inferior. Blacks in Chicago "almost without exception point to the Chicago press as the responsible agent for many of their present difficulties. The policies of newspapers on racial matters have made relations more difficult, at times fostering new antagonism and enmities and even precipitating riots by inflaming the public."[23] As William M. Tuttle Jr. put it in a 1970 book on the Chicago experience, "Men generally believe only what they want to believe, and Chicago's newspapers assisted them in this pursuit."[24]

HOMICIDE

The events of the Red Summer of 1919 illustrate two dynamic and opposing social undercurrents in the practice of journalism, then and now: the damaging results and lasting legacy of journalism practiced maliciously, wrongfully, and with little regard to the truth; and the courageous tradition of civic and professional reformism driven to improve journalism for the sake of democratic society.

Looking back on the Red Summer nearly a century later, one sees

both how far American journalism has progressed and how many of the same issues of inaccuracy, sensationalism, fabrication, and stereotyping persist. If fraud is to the practice of journalism what homicide is to civilized society—a crime encompassing varying degrees of intentionality, resulting in social harm and disregard for the good of democracy—practically all forms of this journalistic offense were on vivid display during this period and provide a fascinating template with which to consider similar wrongs committed by the news media in the years since.

In the early 1900s, for example, drawing on years of racial bigotry, Atlanta's four daily newspapers took part in a campaign against black Americans as vile as any in American history. Day after day, the *Atlanta Journal,* the *Constitution,* the *Evening News,* and the *News* feverishly competed to see which could demonize the city's black population more, depicting African Americans as opium and cocaine peddlers, sexually unrestrained and morally depraved criminals who represented direct threats to white society. Each alleged crime, each alleged act of insulting behavior of blacks toward whites—especially white women—and each act of violence by indignant whites toward blacks became instant fodder for front-page news accompanied by sensational headlines: "NEGRO GRABS GIRL AS SHE STEPS OUT ON PORCH," "BOLD NEGRO KISSES WHITE GIRL'S HAND," "INSULTING NEGRO BADLY BEATEN IN TERMINAL." As Mark Bauerlein observes, the black crime scare, which was largely fabricated and sensationalized by the white press over many months, helped to inflame a citywide hysteria that eventually resulted in a riot directed against blacks in which more than a dozen people were killed over a four-day period. According to Bauerlein, the press-aided catastrophe set back race relations to such an extent that the possibility of moving toward the creation of a "new" South was delayed by more than fifty years.[25]

In Washington, D.C., during the Red Summer of 1919, the city's newspapers—the *Washington Post,* the *Herald,* the *Tribune,* and the *Star*—riled racist passions to a fever pitch for more than a month with sensationalist, front-page coverage about a black sexual predator allegedly on the prowl for white women. The drumbeat of headlines—"13 SUSPECTS ARRESTED IN NEGRO HUNT; POSSES KEEP UP HUNT FOR NEGRO; HUNT COLORED ASSAILANT; NEGRO FIEND SOUGHT ANEW"—was incessant. On July 19, after rumors that a black suspect had been released by police, a mob of four hundred whites took the law into their own hands and began hunting down, beating, and killing black men. For four days, violence shook Washington, resulting in the murders of at least thirty

people and injuries to more than one hundred fifty others. The worst violence resulted directly from an erroneous story in the *Washington Post* on Sunday, July 20, headlined "MOBILIZATION FOR TONIGHT," which reported that all available members of the armed forces were being called to gather downtown at nine o'clock that night for a "clean up" operation. There had been no such order. But a white mob of thousands gathered and provoked outright warfare with blacks, many of whom had armed and barricaded themselves in their own neighborhoods.[26]

Few horrors of this period were as devastating and senseless as the 1921 Tulsa race riot. Like the Atlanta and Chicago newspapers, the race-baiting *Tulsa Tribune* had tirelessly depicted blacks as immoral, criminal, ignorant, and depraved, and its news pages had instilled fear and revulsion in white readers. When a black teenager was arrested for allegedly assaulting a white female elevator operator—"NAB NEGRO FOR ATTACKING GIRL IN ELEVATOR," a news article proclaimed—the *Tribune* published an editorial headlined "TO LYNCH A NEGRO TONIGHT." The inflammatory article prompted a crowd of seventy-five armed black citizens—many of them World War I veterans—to march on the town courthouse to try to protect the suspect. They soon encountered a crowd of whites. Amid a moment of tension, a gun accidentally went off. Terror and violence quickly swept the city, as white Tulsans exhorted each other to "get busy and try to get a nigger."[27] By the time the race riot ended a week later, as many as three hundred people had been killed, and more than ten thousand black residents were left homeless after frenzied white mobs, aided by local cops, stormed and burned down nearly every building in the thirty-five-square-block black neighborhood.

Even the nation's most respected newspapers, aspiring to newly emerging standards of professional journalistic practice, frequently expressed sentiments that demeaned African Americans and foreclosed hope for their future in America. Reflecting on the riots that swept the nation in 1919 and the militancy of the "new" postwar Negro seeking equal rights, an editorial in the *New York Times* read, "There had been no trouble with the Negro before the war when most admitted the superiority of the white race."[28] Reliving those times through the microfilm records is a sickening experience, a horrific show of newspaper sensationalism and unbridled racism. To read the mainstream press and its coverage of race in those days is to come face to face with a national past that in many ways can't help but continue to reverberate, so relentless and pervasive were the excesses.

This period saw an expansion of the black press as a direct result of

the insulting coverage of black people in white mainstream newspapers, which either degraded blacks or ignored them altogether. An example of the way the black press assessed the attitudes of mainstream newspapers toward black Americans came in a 1926 front-page article in the *Pittsburgh Courier*, which attacked the nation's wire services for ignoring the more than seven hundred deaths in a devastating Pennsylvania flood that year. It was typical, the *Courier* bitterly reported, of the "inhuman trait of the Caucasian press." Carter G. Woodson, the widely respected and accomplished editor of the *Journal of Negro History*, was so disillusioned by the treatment blacks received at the hands of most of the nation's newspapers that he gave up hoping for any change. In 1922, the same year the Chicago Race Commission published *The Negro in Chicago*, Woodson wrote that there was no use complaining about the distortions of black life in America: "We must learn to tell the story ourselves. It is our duty to develop a press."[29]

Yet the racial excesses were only a part of a much wider pattern of press transgressions. Throughout the first several decades of the twentieth century, critics despaired over newspaper sensationalism and the editorial obsession with crime, celebrity, catastrophes, and sex. Critics also protested the publication of manufactured news serving political and business interests, doctored photographs, made-up stories, and other manifestations of the "yellow journalism" that had helped to build the political climate propelling the United States into the Spanish-American War in 1898.

The Progressive Era, from the 1890s through the early 1920s, is remembered by many historians as the period when independent, investigative journalism began to flower and come into its own as a genre in America, roughly between 1902 and 1912. These new journalists and their periodicals—termed "muckraking" by Theodore Roosevelt, who blasted them for ceaselessly hunting for ills in society instead of concentrating on its blessings—generally believed in the power of the press to uncover wrongdoing by political and business leaders in order to inform the masses and improve democracy. This journalistic progressivism came in the form of a wide array of investigative stories, exposing abuses that ranged from political corruption and "bossism" to unsafe and unsanitary practices in industry, from the exploitation of labor to the abysmal conditions in inner-city slums and mental hospitals. The leading muckraking magazines of the age—among them *Collier's*, *Cosmopolitan*, *McClure's*, *Everybody's*, and *Arena*—aggressively investigated the most pressing social problems of their time. *McClure's*, in

particular, drove the muckraking age with the publication of investigations such as Ida M. Tarbell's *History of the Standard Oil Company*, an attack on monopolies; and Lincoln Steffens's explosive examination of political corruption in *The Shame of the Cities*.

But the muckraking journals largely failed to investigate one notable social crisis: the lynching of black people in the South, by far the era's greatest ongoing injustice against human rights and civil society. During a ten-year period, 883 lynchings took place in the United States, the vast majority—796—committed against blacks in the South. The muckraking magazines generally ignored the subject. But when they did address it, they frequently condemned the victims for the unspeakable acts of which they had been accused—often the rape of white women—rather than condemning the lynchers. Hostage to the racial bigotry pervasive among white Americans in their era, most muckraking journalists appeared to view the condition of black Americans as separate from and irrelevant to the wider social movement that aimed to inform the public and uplift democracy. As Maurine Beasley writes in an article examining the coverage of lynching by five leading muckraking magazines:

> Although a prime goal of the muckrakers was to fight lawlessness, and lynching represented lawlessness at its zenith, [*Collier's*] editors did not equate regional violence against an oppressed minority with the kind of injustice that subverted the democratic processes. In its waxing and waning on lynching, *Collier's* displayed a schizophrenic reaction. Sometimes it adamantly condemned the crime; other times it attempted to blame victims, not perpetrators. It appears the magazine switched positions from time to time to placate its white Southern readers. . . .
>
> Obviously, the leading muckraking publications failed to fight lynching with anything near the zeal they employed against economic and political wrongdoing. Two, *Cosmopolitan* and *Everybody's*, avoid the subject. The other three, *Collier's*, *Arena*, and *McClure's*, shifted positions, condemning lynching but still printing material that served to excuse it. Part of the muckrakers' refusal to expose lynching for what it was—intimidation of a minority by mob action—apparently stemmed from the philosophy of Progressivism, which revealed a blind spot regarding blacks.
>
> Progressivism constituted a broad movement aimed at solving the problems of modernization and urbanization by political action from an educated, enlightened citizenry. Its underlying concepts, based on Anglo-Saxon ideas of participatory democracy, contrasted sharply with the experience of government common to masses of immigrants accustomed to semi-feudal political structures dominated by political bosses. The Progressives saw immigrant voters tied to boss rule as threats to their vision of democracy. Even more did they view the black population of the South as unsuited for participation in the democratic process.[30]

Paradoxically, it was during this period that journalism as a profession began to adopt stronger ethical standards. The first professional codes of journalistic ethics were written at that time, founded on principles intended to separate opinion from fact; to aim for balance, fairness, and public service; and to divide the business and advertising functions of a newspaper from its news-gathering processes. As Michael Schudson points out, these early twentieth-century reforms promoting editorial objectivity were also shaped by economic considerations—the desire to gain wider readership through greater credibility. *Editor and Publisher* magazine, today the management bible of the newspaper trade, began publishing in 1901. The first school of journalism opened in Missouri in 1908. The Society of Professional Journalists was founded in 1909, and the American Society of Newspaper Editors was organized in 1922. Throughout these years, increasing numbers of newspapers, from the *Brooklyn Eagle* and the *Sacramento Bee* to the *Seattle Times,* seeking to prove their public service mettle to readers, also adopted their own codes of ethics founded chiefly on the ideal of seeking truth independent of business, advertising, and political favor in order to inform the people and improve democracy.[31] Yet despite these advances, the bigoted and demeaning coverage of black Americans in most mainstream local newspapers continued virtually unabated and set a distinct pattern for decades to come.[32]

In 1968, the National Advisory Commission on Civil Disorders, known as the Kerner Commission (named after its chairman, Illinois governor Otto Kerner), was charged with examining the causes of the devastating race riots that had shaken America in that era. The views that the Chicago Commission on Race Relations had expressed after the 1919 riots, warning of the dangers of persistent ignorance and prejudice spread by America's press, seemed starkly relevant nearly a half century later. The 1968 Kerner Commission heard the testimony of hundreds of witnesses and experts, including black scholar Kenneth L. Clark, whose reflections on the similarity of crisis between the eras was noted in the commission's report:

> One of the first witnesses to be invited to appear before this Commission was [Clark], a distinguished and perceptive scholar. Referring to the reports of earlier riot commissions, he said:
>
> > I read that report . . . of the 1919 riot in Chicago, and it is as if I were reading the report of the investigating committee on the Harlem riot of 1935, the report of the investigating committee on the Harlem riot of 1943, the report of the McCone Commission on the Watts riot of 1965.

> I must again in candor say to you members of this Commission—it is a
> kind of Alice in Wonderland—with the same moving picture re-shown over
> and over again, the same analysis, the same recommendations, and the same
> inaction.[33]

In its most remembered exhortation, the Kerner Commission warned that the United States was moving dangerously toward the creation of two irreconcilable societies, one black and one white, separate and unequal. After painstakingly studying the black experience in America and its history, the commission recommended significant changes to enhance opportunities for black Americans in jobs, housing, education, and most other spheres of American life. As the 1919 Chicago panel had done, the Kerner Commission charged the nation's media with contributing to a culture of ignorance and prejudice that imprisoned African Americans in stereotypes and helped to foster and perpetuate the poverty and discrimination that eventually led to turmoil.

> Our second and fundamental criticism is that the news media have failed
> to analyze and report adequately on racial problems in the United States
> and, as a related matter, to meet the Negro's legitimate expectations in
> journalism. . . .
> Along with the country as a whole, the press has too long basked in a
> white world, looking out of it, if at all, with white men's eyes and a white
> perspective. That is no longer good enough. The painful process of readjustment that is required of the American news media must begin now.
> They must make a reality of integration—in both their product and personnel. They must insist on the highest standards of accuracy—not only reporting single events with care and skepticism, but placing each event into
> meaningful perspective. They must report the travail of our cities with compassion and in depth.[34]

Specifically, the commission recommended that the nation's news media take steps to include black voices in an industry that was monolithically white (as well as male). America's print and broadcast news media urgently needed to train and hire more black journalists. The purpose was not cosmetic, nor was it simply aimed at appeasing minority protests in a time of national crisis. Rather, the purpose was to improve participatory democracy by reflecting in the nation's mainstream media the realities of life faced all of its citizens, including those who had been either systematically misportrayed or ignored.

Scholars of journalism history have documented the many longstanding grievances about bias and stereotyping in the nation's press. One study found that more than 50 percent of the local news stories

about black people in five southern newspapers during the 1950s were solely about crime. Two other studies examined photographs of black people in three national magazines between 1937 and 1957 and reported that the vast majority of images depicted them as servants in the background or as lazy simpletons. Less than 1 percent of *Life* magazine's content between 1937 and 1972 was devoted to black Americans, and even then coverage included only issues that directly affected white society, such as school integration. Black people appeared in fewer than 1 percent of the *New Yorker* magazine's cartoons from 1946 to 1987, and in all those cases they were shown in stereotypical roles as bellhops, cooks, and maids. Another study charged that most northern newspapers in the 1950s had "engaged in a conspiracy of silence about oppression and discrimination against African Americans, supposedly to suppress racial tensions." For more than 150 years, until the late 1950s, the *New York Times* society page had published a grand total of one wedding announcement featuring a black couple. And in southern newspapers, such as the *New Orleans Times-Picayune,* it was common practice until after the civil rights era for photo editors to airbrush out the faces of black people in crowd shots so as not to offend the sensibilities of white readers.[35]

Even now, scholarly assessments of the nineteenth and early twentieth centuries reveal new insights about press failures and racist outrages that have been ignored, long forgotten, or even covered up. In some cases, revisionist historians have remembered the journalistic offenders in a far more favorable professional light than they merit.

Consider the life of Josephus Daniels, the longtime publisher of the *Raleigh News and Observer* in North Carolina at the turn of the twentieth century. Daniels achieved prominence as a national Democratic Party committeeman and served as President Woodrow Wilson's secretary of the navy between 1913 and 1916. He later became the U.S. ambassador to Mexico during the presidency of Franklin D. Roosevelt. Daniels is remembered today with wide admiration as a prominent southern Democrat who was a progressive political thinker, a dedicated journalist, and a strong defender of the First Amendment, who fought against railroad, textile, and tobacco monopolies and advocated public spending to support education. But, as scholar W. Joseph Campbell reveals in a recent study, Daniels was far from "one of the fine figures of American journalism," as a leading historian described him in a history of the American press published in 1962.[36]

Like many southern newspaper publishers of his era, Daniels was a longtime proponent of white supremacy, and his strong editorial views helped to inform and shape debates over the issue of suffrage and other rights for black people. Even given the racist tenor of his era, however, Daniels was something of a man apart, filling his newspaper's column inches with hysterical and vitriolic entreaties for his fellow white citizens to resist the specter of "Negro rule" and "restore permanent White supremacy to North Carolina." During statewide election campaigns in 1898 and 1902, Daniels penned fiery, race-baiting editorials urging North Carolinians to vote Democratic in order to rid the state of "Negro domination" and to prevent conditions in which "life is insecure, womanhood is endangered, property is unprotected, and the law is almost a nullity." Campbell came across a particularly "chilling" editorial cartoon that was printed in the *News and Observer* in 1898. Entitled "The Vampire That Hovers over North Carolina," it depicted the black vote as a "huge, bat-winged figure trailing a lizardlike tail," clawing at the shapes of white men and women.[37]

Daniels's paper was without peer in leading "a campaign of prejudice, bitterness, vilification, misrepresentation, and exaggeration to influence the emotions of whites against blacks."[38] It also helped to spark a frenzy of mob violence. After a black newspaper in Wilmington published a provocative editorial in 1898 suggesting that some white women cried rape to hide "clandestine interracial sexual liaisons when they are detected," Daniels went into high gear. The *News and Observer* leaped on the black journalist's editorial as evidence of growing black insolence and arrogance. The newspaper reported a string of increasingly sensationalist examples of black lawlessness, sexual misconduct, and other outrages in Republican-controlled Wilmington, and the white supremacist political campaigns around the state exploited the controversy to further fuel racist resentments.[39]

The result was a devastating race riot in Wilmington that year, in which at least eleven black citizens were killed. White mobs forced black leaders to board trains heading north and banished them from town, and the black newspaper's offices, to Daniels's glee, were set ablaze and destroyed. The young black publisher, Alexander Manly, barely escaped the violence and moved north. "Manly, the Defamer of White Womanhood, Escapes," read a portion of the headline on an article in Daniels's newspaper about the Wilmington violence the next day. Two years later, when North Carolinians went to the polls to vote on black disenfranchisement, Daniels heralded the moment by republishing portions of

Manly's editorial of 1898, while urging white citizens "to remember the infamous language."[40]

Two years after this 1898 coup by whites in Wilmington, North Carolina joined the growing roster of southern states that deprived black Americans of the vote and began a steady process of turning back other Reconstruction-era reforms, establishing a system of legal racial segregation and inequality throughout the region. Many white newspapers in the South took part in these antiblack campaigns, but, as Campbell points out, Daniels's *News and Observer* was virtually unrivaled in its intensity and influence. Black political participation in North Carolina soon became nonexistent, state law mandated inequality and enforced black poverty, and all hints of reform or new political thought were suspended for more than a half century.[41]

Daniels's most noted biographer, Joseph L. Morrison, and others who have addressed Daniels's history and place in journalism are prone to excuse his excesses, given the harsh racial attitudes of his era, and often insist that he should not be judged by modern standards.[42] Campbell argues, however, that such views would also effectively deny a meaningful place in history to the courageous voices of dissent of that era, including a white Trinity College (now Duke University) history professor named Spencer Bassett. It was Bassett who published a controversial essay in 1903 in the journal *South Atlantic Quarterly*, urging better racial understanding and warning that the white frenzy against black rights in the state's press and political life was dangerous to North Carolina's development. In retaliation, Daniels quickly decried Bassett as a "freak." Under heavy fire from the white press, Bassett eventually offered to resign his position. The college rejected the offer. Several years later, the professor took a job at Smith College in Massachusetts.[43]

It's a hallmark of the freak show traditions in the American media carnival that the sideshow barkers themselves at times are more freakish than those they demean and decry. This certainly seems to be the case with Josephus Daniels. Even today, many decades after the bloodshed and injustice that his newspaper actively helped to foment, the editorial page of the *Raleigh News and Observer* reprints each morning the stirring call for journalistic integrity once issued by its founder, whose own practices stood in sharp contrast to the ideals he espoused:

> I advise and enjoin those who direct the paper in the tomorrows never to advocate any cause of personal profit or preferment. I would wish it always to be the "tocsin" and to devote itself to the policies of equality and justice

to the underprivileged. If the paper at any time be the voice of self-interest or become the spokesman of privilege or selfishness it would be untrue to its history.

Throughout U.S. history, the press has traditionally treated other minorities, including Native Americans, Asian Americans, and Hispanic Americans, no better than African Americans were treated. White newspapers actively campaigned for the exclusion of Chinese immigrant workers in the late 1800s and for the internment of Japanese Americans during World War II. Hysterical, race-baiting coverage by local newspapers helped to fan the "Zoot Suit" riots in Los Angeles in the 1940s, in which white U.S. servicemen attacked Latinos. "The patterns of news media shortcomings are all the more disturbing," write Beverly Ann Deepe Keever, Carolyn Martindale, and Mary Ann Weston, editors of *U.S. News Coverage of Racial Minorities,* "when weighed against the press's self-professed ideals of independence, accuracy, fairness, and fearlessness. Again and again, studies [of how the press has treated minorities] . . . have revealed violations of those ideals." They also observe:

> The powerful mythologies and stereotypes . . . also found their way into the framing of news stories. . . . Journalists covering twentieth century Native Americans sometimes fit them into the mold of the Hollywood Indians of Western movies. Similarly, stories involving African-American men too often cast them in the stereotype of sexual or athletic prowess or criminality. Another aspect of the power of stereotypes is that, according to minority journalists working in the white media, stories that conform to the stereotypes are more likely to be used than those that do not.[44]

The success and downfall of contemporary fabricators such as Janet Cooke of the *Washington Post,* the *New Republic*'s Stephen Glass, and *USA Today*'s Jack Kelley rest on a similar, if more subtle, trafficking in stereotypes. Cooke, Glass, and Kelley thrived on reporting stereotypes as reality, presenting editors and audiences with depictions of the world that were readily accepted and believed because they fit existing preconceptions. In her riveting 1980 story about an eight-year-old heroin addict, Cooke crafted expertly descriptive scenes of a fictional child's heroin use that seemed too vivid not to be true and fabricated quotes in inner-city dialect that seemed believable to most of the paper's largely white, middle-class, suburban readers—"They don't BE no jobs," Jimmy says. "You got to have some money to do anything, got to make some cash."[45]

Glass, too, was adept at evoking the fast times, jargon, and loose lives

of the young and ambitious in the Washington, D.C., of the Clinton era. Glass himself was young and ambitious, and he seemed to enjoy unusually good access to this select subculture, just as Cooke had seemingly enjoyed special access to ghetto Washington by virtue of her race. The writers' special attributes reinforced their purported credibility as reporters. Glass's fakeries included sensational exposés of drug use and sexual promiscuity among young conservatives in the capital and a particularly well-written article about a sexual novelty show that featured a new condom, modeled after Monica Lewinsky's adventures, called the "Monicondom."[46]

Many of the Glass articles either relied on anonymous sources or named sources that did not exist. The stories seemed credible chiefly because they provided details that were readily accepted as true by readers, editors, and other outsiders who were predisposed to believe stereotypes about Washington's political culture and the youthful aspirants who peopled it. As Charles Lane, the editor who eventually discovered the fabrications and fired Glass, put it in an interview with the *Pittsburgh Post-Gazette,* "His stories traded on stereotypes, on the world as some of us believe it is, or we'd like it to be. So there were stories on the pot-smoking young conservatives and on department-store Santas who were really child molesters. All of this kind of stuff fit into people's preconceptions. And it's the biggest reason we should all be ashamed."[47]

The investigation at *USA Today* found that Kelley had also deftly used stereotyping to force home the credibility of his fraudulent work. The religious and ethnic stereotypes he promoted conformed with the sensibilities and prejudices of American readers during his stint as a foreign correspondent between 1993 and 2003. To a society shaken by the attacks of September 11, 2001, Kelley, a devout Christian who was not hesitant to reveal the role of his moral beliefs in his news reporting and views of the world, offered up vivid vignettes from the war-wracked Middle East: the young Muslim boy declaring, "This one is mine," as he pointed to a picture of the Sears tower; the Jewish settler bitterly vowing, assault rifle in hand, to kill "the sons of Arab whores." To American readers, Kelley's stories seemed to accurately reflect life from an alien culture on the far side of the globe where hatred was of biblical proportion and violence and death were rampant.[48] As John Gorenfeld wrote in an insightful article for Salon.com: "Kelley's forgeries fit snugly into the pre-existing grooves of people all over the world looking for coverage of evil Jews, or cute Muslim boys who turn out to be devils."[49]

More important, Kelly's articles and stereotypes also helped to feed

important policy discussions in Washington and official reaction among government leaders and media insiders, including the ubiquitous conservative black columnist Armstrong Williams, who eagerly spread Kelley's works of fraud while secretly on the payroll of the Bush administration. According to Gorenfeld:

> What stands out in Kelley's phony oeuvre—remarkable by any standard, with imagined Cuban refugees drowning by moonlight and multiple fake decapitations at a suicide-bombing in Jerusalem—is the way he trafficked in particularly explosive stereotypes. And what makes him emerge as a more dangerously misguided figure than his tarnished peers—Jayson Blair and Stephen Glass among them—is how influential those tales became. On Sept. 30, 2001, for example, Tim Russert ran the Sears Tower kid anecdote past Defense Secretary Donald Rumsfeld on "Meet the Press." . . . The kid—whose classmate completes the picture of evil in the story by telling Americans, "I will get your children, I will get their playgrounds"—became a mascot of the dangerous new world post-9/11. The week he spoke to Rumsfeld, Russert also asked former Sens. Gary Hart and Warren Rudman to consider the report. Kelley's fiction inspired an Oct. 13, 2001, column by syndicated columnist Armstrong Williams, a conservative voice picked up in more than 75 newspapers. As readers passed [Kelley's] story around, the kid showed up in the letters section of *Stars and Stripes,* and in an Oct. 18 letter to the Syracuse, N.Y., *Post-Standard.* Shawn Harmon, a 35-year-old reservist, dared pacifists and "the whole UC Berkeley Crowd" to turn the other cheek, in the light of Jack Kelley's article—proof, he said, that we have to "rid the world of this virus."[50]

Gorenfeld concluded:

> Kelley told a lot of people what they expected to hear. Don't we all expect those colorful foreigners of the Mideast to talk like Indiana Jones characters, calling their enemies "sons of whores," like Avi Shapiro, or uttering lines like "I will make my body a bomb that will blast the flesh of Zionists, the sons of pigs and monkeys," like the 11-year-old Ahmed in the (thus far undisputed) Kelley piece, "The Secret World of Suicide Bombers"? Who, feeling guilty about the deaths of civilians, wouldn't be soothed to read that Ahmed's small frame and boyish smile are "deceiving," because his vulnerability "mask[s] a determination to kill at any cost"? Or that school kids bombed in Afghanistan might not be so innocent after all, perhaps dreaming of blowing up a Chicago landmark?[51]

Reporters who fabricate seem to do so for a host of reasons: to curry favor with bosses in high-pressured workplaces where the demand for sensational stories, feeding an ever-increasing range of synergized media, is constant;[52] to meet the fierce production needs of a twenty-four-hour news cycle; to earn awards, raises, and promotions; perhaps even to ex-

perience the singular thrill of spinning good yarns that the multitudes accept as the truth and that only the fabricator knows are lies. Journalists are excellent storytellers of facts. But the fabricators can't resist the impulse to embellish or improve on the facts when they believe that the facts are not as compelling, as sensational, or as convincing as the story warrants. Michael Finkel, a *New York Times Magazine* reporter who was fired in 2002 after admitting that his story about a man working in appalling conditions on a cocoa plantation in West Africa was a fabrication and a composite based on other interviews, alluded to this impulse in an article in the *San Francisco Chronicle*. He told the newspaper that his lie made for a better story and that he believed it would never be discovered in part because it took place on the far side of the world. "I deluded myself into thinking I was serving a higher truth," he told the *Chronicle* reporter, in words that seemed to echo Kelley's political-religious aims. "I knew it was a one-time idiotic act, but I felt like it was an error of creativity, rather than evilness. I didn't think I would get caught."[53]

In fact, journalistic fabrication boasts a long and colorful past involving not only ruined and scandalized reporters but also some of the most illustrious names in the history of the profession, whose reputations nonetheless remain legendary and esteemed. In an insightful 2003 article in the online journal *Slate*, Jack Shafer describes how H. L Mencken in the 1920s, A. J. Liebling in the 1940s, and Joseph Mitchell in the 1950s all confessed in their memoirs to various acts of prevarication. Mencken, in his memoir *Newspaper Days*, bragged about frequently concocting characters while he was a city hall reporter in Baltimore, including a "wild man" running down the streets of the city. Liebling invented characters for his *New Yorker* articles and, according to Shafer, "spooned into their mouths whatever dialogue he wanted to attribute to the man on the street, sometimes giving readers no sense that he might be invoking artistic license." Mitchell also "diluted fact with fib," riddling his prose with embellishments and composites. Yet we generally excuse excesses by such literary luminaries, partly because we wrongly presume that journalistic ethical standards were lower a half century ago than they are today, and partly because we attribute far more benign intent to these forebears that to the conniving of Blair or Glass.[54]

Successful fabricators in the high-pressured circumstances of daily reporting, then and now, often may find themselves in the difficult position of competing against their own stories to maintain the illusion of their reportorial and storytelling magnificence. Making things up be-

comes a habit. This seemed to be the case with Glass and Blair, and certainly with Kelley. Each fabulous, incredible scoop demanded to be topped by another, and then by another, with none of these wrongdoers able to maintain the illusion after all. But in a much larger sense, these deceptions also illustrate the exceptional powers of journalists to work magic when they tell us what we want to hear, in the ways we want to hear it, and to reinforce what we presume to already know of the world and the human race. And few deceptions in American culture continue to resonate more than racial, religious, and ethnic stereotypes. Stereotyping is anathema to professional journalism's commitment to seeking truth and reporting it fairly. That these wrongful perceptions continue to flourish in society and the press underscores how much journalism as a vocation and we as a people remain products of our past.

Cicero once said, "Not to know what happened before one was born is to remain a child." The words are particularly meaningful when it comes to the history of the press in the United States, a history whose powerful influences in shaping racial attitudes in contemporary society are rarely referenced in the modern news media or popular culture. It is an ugly, vicious past, shameful and largely covered up.

Not long ago, the editors of the *Los Angeles Times* penned a brief, eight-hundred-word acknowledgment of that history when the paper expressed regret for its racist news and editorial coverage of the fighter Jack Johnson, the first black heavyweight champion, who fought a century ago. The occasion was the national airing of *Unforgivable Blackness*, a PBS television documentary by filmmaker Ken Burns about the tortured life of Johnson. A cultural forebear of Muhammad Ali, Johnson had the temerity to express racial pride during the Jim Crow era; defeated a white man—the Great White Hope, James K. Jeffries—for the boxing title, to the shock and dismay of white Americans in 1910; and, worst of all, consorted with white women. For these sins, he suffered greatly at the hands of the nation's press and the federal government.

After Johnson's victory over Jeffries sparked riots by white mobs against blacks in numerous cities across America, leaving at least twenty-six persons dead, a *Times* editorial, "A Word to the Black Man," warned black Americans to remember their place in society: "The white man's mental superiority does not rest on any huge bulk of muscle, but on brain development that weighed words and charmed the most subtle secrets from the heart of nature." The editors warned blacks: "Do not point your nose too high. If you have ambition for yourself or your race, you must try for something better in your development than that of the

mule."[55] In 1913, Johnson was convicted of violating laws prohibiting the transport of a woman—his girlfriend—across state lines for "debauchery." What Johnson didn't lose in the ring, the government essentially took from him on trumped-up charges. Forced by the Burns documentary to look back at their embarrassing journalistic legacy, the *Times* editors vowed to support efforts under way in Congress to lobby for a presidential pardon for Johnson, a half century after his death. The editorial was titled simply, "Shame on Us."[56] The newspaper's recognition of this past stands as a rare exception to the wider rule of silence most other newspapers have adopted about their history of recklessly disregarding the truth.

It's something of an article of faith in the conservative movement today that we have moved far beyond the damaging days of racial prejudice and systemic inequality and discrimination in American society, and that social policies to redress centuries of wrongs, such as the three-decade experiment in affirmative action, have long outlived their usefulness. This matter remains highly contested both in the nation's court system and in public opinion.[57] But to even the most casual observer of the nation's news media and their history of covering race, it's clear how much work remains to be done to overcome the burdens of our past, to achieve even the most basic racial awareness and understanding. When Jayson Blair became the poster child for fraud and dishonesty in modern American journalism, his offense was not just that he had lied, as a number of his predecessors and contemporaries had done. His exceptional infamy stemmed from the simple fact that he had lied while black—an offense that resonates with exceptional vigor still in the American carnival of stereotypes.

WE REGRET THE OMISSION

In the absence of journalistic professionalism, our society can easily fall victim to two types of fraud. One consists of crimes of commission, including fabrications, stereotyping, and other transgressions in which misinformation is intentionally published or broadcast. This is, in essence, the profession's capital crime, fraud in the first degree, committed with intentionality and disregard for the truth. The second consists of crimes of omission: intentionally withholding information from the public, ignoring and suppressing news in order to serve some commercial or political interest judged by the news medium to be of greater value than the public's right to know. In one form of fraud, the citizenry is in-

formed by myth and falsehood. In the other, the citizenry is intentionally prevented from learning the truth. A distinct social harm results from each. In journalistic crimes of commission and omission, society suffers from an electorate motivated by myths in the former case and by ignorance in the latter.

The many slogans, mottoes, and nameplates that adorn newspapers' front pages colorfully represent the publishers' idealistic stances on such issues. Newspapers typically vow to report everything that's worth knowing, as reflected by the *New York Times'* promise to report "All the News That's Fit to Print" and the *Atlanta Journal-Constitution'*s vow that it "Covers Dixie Like the Dew." Some papers, such as the *Examiner* of Jackson County, Missouri, or the *Philadelphia Inquirer,* promise to look deeply into things. Others, like the *Wichita Eagle,* pledge to keep a broad lookout; while still others, like Mississippi's *Jackson Clarion-Ledger,* intend to sound the news loudly and boldly. Some, like the *Orlando Sentinel,* claim that they stand guard over the public's interest; others, like the *Cleveland Plain Dealer,* promise to simply give you the news straight. And quite a few newspapers are just plain quirky in their self-identification. How else to explain mottoes such as "Our Aim: To Fear God, Tell the Truth, and Make Money" (Kansas's *Columbus Daily Advocate*), "Liked by Some, Cussed by Many, Read by Them All" (Georgia's *Blackshear Times*), and "If You Don't Want It Printed, Don't Let It Happen" (Colorado's *Aspen Daily News*).[58]

But most mottoes and nameplates allude to the journalistic mission of providing information, news, and, most important, *light* to the people. So it is that the metaphor of light shows up in perhaps more mottoes and nameplates than any other in American news history. The word *sun* has graced the names of countless publications, from the *New York Sun* of the early nineteenth century to the *Baltimore Sun,* the *Las Vegas Sun,* Tennessee's *Jackson Sun,* Nevada's *Sierra Sun,* California's *San Bernardino Sun,* Arizona's *Yuma Sun,* and the *Lowell Sun* in Massachusetts. The *Beacon* and the *Star* are also common names. The *Savannah Morning News* proclaims itself "The Light of the Coastal Empire," while the *Baltimore Sun* declares that it bestows "Light for All." The Scripps-Howard newspapers share perhaps the most noble newspaper slogan ever coined: borrowing from Dante, their front pages declare, "Give Light and the People Will Find Their Way."

Of course, noble sentiments and deeds do not always go hand in hand. In the nineteenth century, the *New York Sun's* "It Shines for All" motto probably should have read "It Shines for Some," given the newspaper's

rabid crusade against rights for black Americans during its tempestuous and unseemly history. More significant, though, history shows that ideals have regularly been sacrificed in the interest of *preventing* light from reaching the people.

Such crimes of omission have clearly harmed the healthy functioning of democracy over time as much as crimes of commission.[59] On Sunday, July 4, 2004, for example, the people of Lexington, Kentucky, awoke to read a startling admission by the editors of the morning newspaper, the *Lexington Herald-Leader*. There, taking up nearly the entire front page, was an article boldly headlined "Front-Page News, Back-Page Coverage." Just below the newspaper's nameplate, this line appeared in bright red type: "CLARIFICATION: It has come to the editor's attention that the *Herald-Leader* neglected to cover the civil rights movement. We regret the omission."[60]

Thus began a remarkable package of stories, published on a day "the nation celebrates its liberties and marks the fortieth anniversary of the Civil Rights Act of 1964," of how the local press in the southern city suppressed news of sit-ins, boycotts, marches, and other protests by black citizens fighting racial segregation throughout the 1960s. Years before the newspapers merged as one in 1983, both the *Lexington Herald* and the *Lexington Leader* had been guilty of intentionally ignoring "one of the most important stories of the 20th century," the editors reported in 2004, chiefly because the established press didn't want to bring attention to a movement opposed by many of the community's white citizens and businesses. Accompanied by beautiful, vivid black-and-white photographs of events during the Lexington struggle, all snapped by Calvert McCann, a young African American photographer who had taken part in the demonstrations as a high schooler and whose compelling images had never before been published, the series of articles was spread over three full inside pages. The stories depicted a local press whose central purpose in those years had not been to inform people about the truth in their community but rather to protect with silence and omission a system of inequality increasingly under fire from rights activists in Lexington and other cities throughout the South.

The extraordinary confessions and apology by the *Herald-Leader* had been sparked by a speech on journalistic ethics given some months earlier at the University of Oregon by John Carroll, then editor of the *Los Angeles Times* and formerly the editor at the *Herald-Leader* between 1979 and 1991. Titled "The Wolf in Reporter's Clothing: The Rise of Pseudo-News in America," Carroll's remarks focused on the growing in-

fluence of cable talk and news programs such as those on the Fox network, where political bias and rumor are disguised as journalism. Carroll emphasized the importance of making corrections in professional journalism, whether the errors were large or small, noting that in 2003 alone the *Los Angeles Times* had printed 2,759 corrections to stories in which there were inaccuracies.

"Like a factory on a river," Carroll said, "daily journalism is an industry that produces pollution. Our pollution comes in the form of errors. America's river of public discourse . . . is polluted by our mistakes. A good newspaper cleans up after itself." Alluding to the political bias and other excesses of Fox News, whose viewers were far more likely to hold factually inaccurate views about the war in Iraq and about Saddam Hussein's alleged ties to al-Qaeda and the 9/11 attacks, Carroll noted that a similar journalistic cleanup at Fox would be a gargantuan environmental undertaking. "How could Fox have left its audience so deeply in the dark? I'm inspired to squeeze one last bit of mileage out of our river metaphor: If Fox News were a factory situated, say, in Minneapolis, it would be trailing a plume of rotting fish all the way to New Orleans."

It was in this context that Carroll pointed out that some mistakes of the American news media, such as the lack of fair news reporting about the civil rights movement in many newspapers in the 1960s, were simply too large and grievous to deal with in a short sentence or two, as most corrections could be handled. "We never published that one," Carroll said about his hypothetical correction to the *Herald-Leader*'s failures in the 1960s, "though we probably should have made amends in some fashion, for corrections large and small are essential to our credibility."[61]

Surprisingly, the special projects editor of the *Herald-Leader,* John Voskuhl, took up the challenge and assigned a state education reporter, Linda B. Blackford, and a news researcher, Linda Minch, to the story. The two women had timely and fitting news pegs: the upcoming fortieth anniversary of the Civil Rights Act and the fiftieth anniversary of the Supreme Court's *Brown* decision outlawing racial segregation in the nation's schools. For Voskuhl, the project represented an attempt by the newspaper not only to come to terms with its failures but also to set the record straight for history. As Voskuhl told an interviewer for *Editor and Publisher* magazine, Kentucky historians had repeatedly expressed to him how unreported events undermined historical research and limited the ability to draw lessons from history. The historians told him, he said, that "doing research on the civil rights movement in general is complicated by the fact that a primary resource, newspapers, is almost utterly

unhelpful. Papers always think of their obligations to their readers, but not always of their obligation to history."[62]

Two months later, Blackford and Minch returned with their story about the newspapers' journalistic sins. The package examined nearly every aspect of how the *Herald* and the *Leader* had treated news relating to race and civil rights in the 1960s—for example, customarily relegating "colored" news to back pages and intentionally withholding significant news stories about marches and other protests by civil rights leaders, including visits to Kentucky by Dr. Martin Luther King Jr. While the newspapers occasionally published news about the civil rights struggle from other parts of the South on their front pages, these articles usually reported arrests and violence, with little examination of the underlying causes of the movement. Although in later years, scholars and other researchers exploring Lexington's rich civil rights history wrote master's theses and other projects that relied extensively on oral histories provided by black and white Lexingtonians who had been involved in the struggle, those memories "never made it into the local newspaper." As Blackford and Minch wrote in their front-page story:

> The people in charge of recording the "first draft of history," as journalism is sometimes called, ignored sit-ins and marches, or relegated them to small notices in the back pages. The omissions by the city's two newspapers . . . weren't simply mistakes or oversights, according to local civil rights leaders and former employees of the newspapers. The papers' management actively sought to play down the movement. The rare march or protest that made front page news usually involved arrests of demonstrators and was described in the terse, clipped tones of a police report.[63]

Don Mills, an editor at the time, recalled the policies of the *Herald* and the *Leader*: "It was a standing order that [a desegregation] effort at a dining room or restaurant or march would not get Page One coverage. The management's view was that the less publicity it got, the quicker the problem would go away." As the *Herald-Leader* journalists reported in 2004, "That stance was not unusual among newspapers across the South. But from today's perspective many experts agree that the decisions made at the *Herald* and *Leader* hurt the civil rights movement at the time, irreparably damaged the historical record and caused the newspapers' readers to miss out on one of the most important stories of the 20th century."[64]

The newspapers had ignored Lexington's early, pioneering role in the struggle for racial integration and equal rights in public spaces. That history included a sit-in at a whites-only restaurant on a sweltering night in

July 1959 when five black and five white activists waited vainly for service while seated at the counter for two tense hours, amid the cursing of the manager and other diners. The event, which occurred a full year before nationally publicized sit-ins in Greensboro, North Carolina, and other southern cities, was never reported. In 1960, the Lexington struggle grew even more visible when twenty-five activists, black and white, asked for menus at the restaurant counter in the city's busiest department store on Main Street. For two hours they waited, attracting crowds of obscenity-spewing opponents and police squad cars. But the local press largely ignored this action, too:

> In many ways this was a momentous event for Lexington, a peaceful Central Kentucky town that prided itself on bourbon and bonhomie, provided you were white. If you were black you encountered injustice more reminiscent of the Deep South: separate schools, parks, washrooms, and theater seats. Good jobs were few; chances for advancement were even fewer. So as people began to challenge that way of life, how did the newspapers respond? With a short story on an inside page in the Sunday edition, a story so brief it didn't even merit a reporter's byline.[65]

Those who were leaders in Lexington's black community at the time recalled their frustration as they tried to get the city and its institutions, especially the local press, to give the struggle for equal rights the attention they felt it was due. Local leaders of the Congress of Racial Equality (CORE) requested meetings with city officials, trying to explain their motives. Audrey Grievous, who was then head of the local chapter of the National Association for the Advancement of Colored People (NAACP), met with *Herald* and *Leader* editors. "I don't remember specifics, but I do remember storming out of there," Grievous told Blackford and Minch in 2004. "So that's when we knew they weren't going to bother with us at all." Neither would the newspapers publish letters to the editor from local leaders. According to one editor from the period, Herman Phelps, "We refused to publish those letters because we felt they might have a tendency to intensify racial discord."[66]

Colleagues of Fred Wachs, the publisher of the *Herald* and the *Leader* during that era, believed that such policies of omission derived from Wachs's efforts to do what he felt was best for the community. In this sense, omissions about the civil rights struggle were on a par with the omission of anything else that might give the city a harmful reputation. For example, as Blackford and Minch pointed out, "a photo of horse racing always appeared on the sports page" in a community whose cultural identity was linked to the sport, just as "a ref-

erence to the harmful effects of cigarette smoking might be spiked from a story," since Kentucky's economy was greatly fueled by the tobacco industry.[67]

Interestingly, many of Lexington's civil rights leaders also felt that the press's reluctance to cover news of the political movement was driven not just by conservative racial attitudes, but by bottom-line financial considerations as well. A former NAACP leader, Thomas Peoples, commented that "when it came to excluding civil rights coverage, Wachs wasn't protecting the town so much as the papers' bottom lines. . . . They catered to the white citizenry, and the white community just prayed that rumors and reports would be swept under the rug and just go away."[68]

The *Herald-Leader* report concluded with views from several experts, including a University of Kentucky professor, Abby Marlatt, who charged that the lack of press coverage delayed progress and possibly exacerbated ill will in the city. State historian and Georgetown College professor James Klotter added: "Silence can be a pretty frightful thing. The effect is that the story hasn't been told, the acts of courage and the acts of resistance and all those things that made up the civil rights movement in Lexington at that time. Those stories will remain too hidden from the public view, and over time they will be lost."[69]

Reaction to the *Herald-Leader*'s series of stories was swift and widespread, with mentions in the press as far away as Great Britain, Japan, and New Zealand. So rare was this newspaper correction concerning its role in history that CNN, CBS, and the Associated Press featured stories on it. The *New York Times* covered the story on its own front page, while the *Herald-Leader*'s editor, Marilyn Thompson, was featured in a long interview about the project on NPR's *All Things Considered*.[70]

One week later, an editorial in the *Herald-Leader* reflected on the paper's unusual project, the reaction it had garnered around the world, and the power of press omissions to restrain progress:

> It's now almost unfathomable that the publisher in Lexington and many of his counterparts across the South thought that the movement against American apartheid would die if they deprived it of publicity.
>
> History has generously vindicated the protestors who risked arrest and worse to oppose racial segregation and keep the flame of justice alive. It's fair to say that this newspaper today would not ignore such a story. It's also fair to ask what we, as a newspaper, and Lexington, as a city, are ignoring.
>
> Are we overlooking struggles that 40 years from now will appear as momentous as the quiet yet courageous protests photographed by a young Calvert McCann half a lifetime ago?

What Lexington's newspapers did during the civil rights movement was wrong and should never have happened, though the decision to ignore black activism probably suited many in Lexington very well at the time.

Why our exposure of old omissions drew so much attention we're not sure; perhaps because an institution was criticizing its own past performance.

Perhaps because the old omissions are also an example of the human impulse to avert the gaze from conflict and unpleasantness.

The problem with the averted gaze is it also overlooks the injustices that produce conflict and unpleasantness. The problem with overlooking injustice is that it festers, eventually poisoning all that it touches.[71]

Three weeks later, *Editor and Publisher* magazine took an informal survey of other newspapers across the South to determine whether the *Herald-Leader* project had sparked editors' interest in investigating their own publications' past. That spot check failed to turn up any newspapers considering a similar review, despite evidence that hundreds of publications throughout the region were guilty of the same journalistic offenses in that era.[72]

In 2006, however, three notable examples of southern press confessionals did come to light, with editors expressing apologies for either suppressing news of the civil rights struggle in the 1960s or actively stoking racial hatred that led to violence against blacks in other eras. After a summer intern looking through the newspaper's equipment closet discovered a cache of never-published photographs from the 1950s and 1960s depicting the civil rights struggle in Alabama, editors at the *Birmingham News* admitted that the paper had conspired to censor and withhold information about the movement to avoid drawing attention to it. Similarly, the *Waco Tribune-Herald* apologized for the role its journalists played in directly inspiring white mob violence during the 1916 "Waco Horror," when a young, mentally disabled black man was brutally beaten, tortured, and lynched in the city. "We recognize that such violence is part of this city's legacy. We are sorry any time the rule of passion rises above the rule of law. We regret the role that journalists of that era may have played in either inciting passions or failing to deplore the mob violence," the newspaper's editors wrote in an editorial published on the ninetieth anniversary of the rioting. "We are descendants of a journalism community that failed to urge calm or call on citizens to respect the legitimate justice system." Additionally, the *Tallahassee Democrat* commemorated the fiftieth anniversary of an anti-segregation bus boycott in the Florida capital with a special twenty-page insert that included

an apology by the newspapers' editors for siding with white segregationists in that battle and impeding progress toward equal opportunity.[73]

But the Lexington *Herald-Leader* and the newspapers in Birmingham, Waco, and Tallahassee are far from the only publications or broadcast outlets to suppress or ignore the news or to admit to flagrant abuses of the public trust. They are just among the very few to display the willingness to admit it.

In *The Powers That Be,* David Halberstam's monumental 1979 work tracing the modern rise of the major print and broadcast news corporations, the writer reveals how the Kennedy administration heavily pressured the *New York Times* in 1961 to kill a story about the CIA training Cuban exiles and planning for an invasion of Cuba to overthrow Fidel Castro. President Kennedy told the *Times* editors that publishing the story would pose a threat to national security and that the blood of the exiles would be on the newspaper's hands. The *Times* caved under the pressure and published a greatly sanitized article, removing all mention of the invasion plans. Months later, after the disastrous Bay of Pigs invasion in April 1961, in which more than two hundred of the U.S.-trained fighters were killed and eleven hundred taken prisoner, Kennedy told *Times* writer Turner Catledge that he wished the newspaper *had* run the story, for it likely would have prevented the biggest foreign policy failure of his administration.[74]

More recently, in 2005, the *New York Times* reported that it had again suppressed a news story with major national security implications at the request of the political regime, this time for twelve months. The story concerned the U.S. National Security Agency (NSA), which had been conducting a widespread and illegal spying operation on American citizens in connection with the war on terror, using extensive telephone wiretapping and sophisticated Web tracking and other digital technology. The newspaper censored itself for months before finally reporting the story on its front page several weeks before the publication of a book on the subject by the *Times* reporter who first uncovered the operation, James Risen. The story included a small paragraph on an inside page noting that *Times* editors had withheld its publication at the request of the Bush administration "for a year."[75]

Interestingly, *Times* editors declined all further comment on their handling of the controversial story in the weeks after its publication when they were asked for further explanation by the newspaper's public editor, Byron Calame. "The *New York Times'* explanation of its decision

to report, after what it said was a one-year delay, that the National Security Agency is eavesdropping domestically without court-approved warrants was woefully inadequate," Calame wrote. "And I have had unusual difficulty getting a better explanation for readers, despite the paper's repeated pledges of greater transparency. For the first time since I became public editor, the executive editor and the publisher have declined to respond to my requests for information about news-related decision-making."[76]

The *Times* had created the post of public editor, or readers' representative, in late 2003 after the spate of reporter scandals that had roiled the newsroom. At the time, the paper pointed to the establishment of the post as a significant reform aimed at regaining reader trust and credibility by allowing greater transparency and light to shine on its internal operations. It wasn't until August 2006, however, that *Times* executive editor Bill Keller held an interview with Calame and elaborated on some of the reasons the newspaper had withheld the story. The chief reasons, he told Calame, included an editorial need to firm up the story's sourcing and credibility and a need for more reporting on the degree of serious debate within the administration on the legality of the NSA program. But perhaps Keller's most fascinating disclosure was his admission that the newspaper sat on the story not just "for a year," dating back to December 2004, but indeed for a longer period, dating back to several weeks before the hotly contested November 2004 presidential election. Keller told Calame that the decision to sit on the story was made on the eve of the election itself, a revelation that sparked wide speculation about whether the story's publication would have hurt or helped Bush's reelection. Keller maintained that the timing of the story, which won a 2006 Pulitzer Prize, was dictated in the end more by the paper's desire for journalistic fairness than by any other factor.[77]

The NSA episode underscored two significant and continuing themes in journalism: the variable nature and volatile possibilities of "light," and the power of language itself to those who seek to control it. What to the press and many Americans became widely known as a domestic eavesdropping, wiretapping, and computer tracking operation without legal warrants, intended to spy on unsuspecting citizens in a free society, was very quickly and officially described instead as an "anti-terrorist surveillance program" by the administration in the days and weeks after the *Times* exposed it.[78]

The electronic media have practiced similar self-censorship. In 2004, the Bush White House and national security officials prevailed on CBS

News to withhold airing a bombshell of a story alleging systematic abuses and torture of Iraqi prisoners at the notorious Abu Ghraib prison in Baghdad. The investigative report, which was set to air on the network's 6o *Minutes II* program in April 2004, featured horrific photos of Iraq prisoners, some naked, being abused in sickening fashion by their American captors, many of the shots taken by the U.S. soldiers themselves. For two full weeks, the network held off on the story at the behest of government officials who warned that airing it along with the provocative photographs could put American lives in jeopardy in Iraq. Like the Bay of Pigs and domestic spying stories, the Abu Ghraib episode of government-inspired self-censorship highlights a continuing problem in the news media's exercise of its role in democratic society: should the "light" of news be controlled by journalists, or are there occasions when that light is so controversial that it should be subject to control by the government in the interest of "national security" and the "national interest"? CBS gave in to these pressures, as did the *Times*. It was not until April 28 that CBS aired the full report, and even then only after it became clear that the *New Yorker* magazine was on the verge of reporting the same story despite similar pressures from the White House.[79]

More recently, the longstanding tension between the public service mission of professional journalists and government efforts to control information, especially in wartime, was again revealed when the *New York Times* on June 26, 2006, published an account of a secret initiative by the Bush White House to monitor the banking records of millions of Americans as part of its strategy in the anti-terror war. This time, the *Times* defied fierce entreaties from the government to desist from publication, choosing instead to inform the public about an issue that raised significant questions about individual rights to privacy and the exigencies of national security. While many in the news media hailed the *Times* exposé as a fine example of the press performing its vital function in a free society, the newspaper came under heavy fire from the administration and its supporters, with the president disparaging the disclosure as "disgraceful" and a Republican member of Congress labeling it "treasonous."[80]

THE ACCEPTED NORM IN AMERICA

The "light" of information presented by the photographic image, particularly in wartime, has been a source of tension between the press and the government since the U.S. Civil War, the first military conflict to be extensively photographed. After the battle of Antietam in September

1862, in which 3,650 men were killed, pioneering photographer Mathew Brady dispatched two young protégés, Alexander Gardner and James Gibson, to capture images of the fallen in the Maryland countryside. The young photographers returned to Brady's New York City studio with powerful images of the dead that were presented in a public exhibit that same year. For the first time, many Americans were able to witness the horrifying result of the conflict with their own eyes. "Mr. Brady has done something to bring home to us the terrible reality and earnestness of war," an anonymous *New York Times* reviewer wrote about the exhibit, which attracted thousands in October 1862. "If he has not brought bodies and laid them on our dooryard and along the streets, he has done something very like it. It seems somewhat singular that the same sun that looked down on the faces of the slain, blistering them, blotting out from the bodies all the semblance to humanity, and hastening corruption, should have thus caught their features upon canvas, and given them perpetuity for ever."[81]

In subsequent wars, the government has attempted either to block that "singular" light from reaching the public by enforcing policies censoring the press or to harness the power of the light for its own propagandistic purposes. During World I and most of World War II, the government expressly forbade the press to publish photos of dead bodies or scenes of slaughter, in an attempt to prevent the undermining of the war effort. And the press itself has customarily withheld graphic imagery of war's realities, out of deference to the fallen.

But corollary questions central to the idea of democracy consistently arise from these traditions: where should the government's power to control and censor information end, and where should the people's right to know the truth about conflict begin? In the Iraq war, in particular, this question has proven especially pertinent and compelling. The Bush administration has been exceptionally rigorous in pressing the news media to withhold publication of controversial photographs of war scenes, including images of caskets of the American dead. Officials insisted that the policy was intended to protect the privacy of loved ones, but critics charged that it was meant to prevent unsettling images from reaching the public and possibly damaging support for the war. In general, the news media went along with these policies. But in an age of high-tech digital tools where practically anyone can record images and send them around the world via the Internet, it has not been especially difficult to circumvent such policies.[82]

So it was that a young airplane cargo handler named Tami Silicio—

not a journalist—decided one day to take photos of coffins containing bodies of dead American soldiers in the hold of a cargo plane and to send the photos via e-mail to a friend in Arizona, asking her to forward them to her hometown newspaper, the *Seattle Times*. Her intent, Silicio later said, was to honor the dead by showing Americans back home what their sacrifice had been. To its credit, the *Times* published the compelling images on its front page—and, indeed, Seattle readers reportedly responded overwhelmingly favorably. But in yet another indication of the struggle for government control over war imagery, and the singular power of its light, Silicio was fired from her post.[83] The episode also raises a question as vital as ever about the values of the American experience: What sort of democracy is it whose government so distrusts the capacity of the people to wisely absorb, process, and understand the news?

But journalistic sins of omission go beyond those imposed by government pressure during wartime. They also flourish in times of peace under policies of self-censorship set by news organizations themselves. Several years ago, for example, the new conservative Catholic owners of the *Gazette* chain of community newspapers in San Luis Obispo County, California, instituted a new editorial policy explicitly forbidding editors and writers to publish any news that reflected positively on gay people or the issue of abortion rights. The order prompted resignations by twelve full-time journalists and editors at the chain's five newspapers, but not before the journalists queried the new management about the kinds of stories that could not be covered. An annual AIDS bicycle ride for charity through town that attracted ten thousand visitors? Management said no. How about a failed abortion, in which a young woman dies? Management said yes, because the story reinforced a negative view of abortion.[84]

Ron Bast, one of the editors who resigned in protest over the new policy of omission, charged that "this has to do with basic freedom-of-press issues. You don't have a newspaper whose motto is 'Hometown Journalism at Its Best,' and then exclude a large percentage of the population."[85] Shortly before he quit, Bast said he asked the new management if there were plans to publish an announcement for readers about the chain's new journalistic policies. He recalled his conversation with the chain's chief operating officer, Todd Hansen, in an interview on Salon.com:

> So I asked, "Will you publish your stand, saying 'We're a Christian newspaper dedicated to the values of heterosexual union and pro-life'?"
> And he said, "No."

I asked, "Why not?"
He said, "Because it's bad for business."
That's when I decided to bail.[86]

In response to the controversy, the new owners of the chain, Mary and David Weyrich, released a statement explaining their views of the controversy, journalism, and its place in modern society. "Call us old-fashioned," they wrote, "but it hasn't been too many years since our professed beliefs were the accepted norm in America. Society has changed to the detriment, we believe, of us as a people. Truth does not change. We have not changed."[87]

In a certain sense, the Weyrichs were right. As we have seen, the practice of excluding news that strays or detracts from the "accepted norm" in American society has long been a peculiar custom of the press, one with plenty of precedent and effects. Several years ago, researcher Herman Chiu examined the portrayal of Chinese immigrants in four western Oregon newspapers during the late nineteenth century and discovered that, although the Chinese were the majority population in several towns, the dominant press of the era almost completely ignored them. As a result, they were, as a people, erased by the press from Oregon history. As Chiu wrote, " 'Yellow vermin,' 'filthy rats,' 'moon-eyed nuisances'— these were just a few of the names newspapers in Oregon hurled at Chinese during the 19th century. But that was only when the papers bothered to acknowledge their existence at all."[88]

The "accepted norm" also did not offer much room for coverage of news that was bad for business in the pages of San Francisco's dailies in the early twentieth century. The *San Francisco Chronicle,* seeking to protect business and political interests and the city's reputation during a terrible plague epidemic, helped to lead a news blackout about the public health crisis, which only exacerbated the effects of the epidemic and badly delayed federal efforts to fight it. Hundreds of citizens died from plague in those years as the city's leading newspaper denied the crisis even existed.[89]

Neither did the "accepted norm" allow much space for any serious coverage of the women's movement for equal rights as it unfolded in the 1960s and early 1970s. Monica Morris, a researcher who summarized the lack of coverage by the mainstream press in a 1973 journal article, concluded that the absence of stories could not simply be "construed as a deliberate and calculated strategy of social control. Nonetheless, the re-

sult of lack of coverage would be much the same as if it were a deliberate strategy: the movement would remain unknown to the general public; it would be prevented from becoming news."[90]

Then, too, the "accepted norm" provided strong disincentive for the nation's sporting press to investigate the steroids scandal in professional sports as it spiraled out of control for more than a decade between 1990 and 2005, when Congress finally grew so infuriated by baseball's lack of accountability that it ordered public hearings into the crisis. So deeply accepted was this norm of silence about the fetid smell at the heart of the national pastime that most sportswriters performed more like cheerleaders than journalists. They continued to report on the unearthly feats of Sammy Sosa, Mark McGwire, Barry Bonds, and others, while ignoring the undiscussed but obvious scandal of artificial performance enhancers that were polluting the sport. Amid this media silence, the abuse of steroids by young people across America who were seeking similar athletic excellence reached new and distressing levels. As Gwen Knapp of the *San Francisco Chronicle,* one of America's finest sports columnists, candidly put it in 2005, looking back on the media's coverage of baseball in that period, "I have lied. A lot of sportswriters lie. We cover for athletes all the time." Alluding to lies of omission regarding the newspaper's coverage of Giants' player Barry Bonds, Knapp continued, "The media can't be trusted. This is true. We didn't catch the weapons of mass destruction hoax in time, and we've probably whiffed just as badly on steroids. Maybe it's tasteless to mention those failures in the same sentence, but if we had any perspective, Bonds would play ball for less than a schoolteacher's wage."[91]

But sometimes the omission of stories by the news media has been of an immense scale. For example, recent studies have revealed the remarkable patterns of omission by *New York Times* foreign correspondent Walter Duranty, whose coverage of the Soviet Union in the 1930s was so widely admired that he received a Pulitzer Prize in 1932. It wasn't until more than seventy years later that his newspaper reported that Duranty, who had written extensively and generally positively about the progress of collectivization in the Soviet Union under Josef Stalin, was undeserving of the prize, having actively denied the existence of a famine that killed more than seven million peasants in the Ukraine under Stalin's harsh policies in those years. In a belated report about Duranty published on October 23, 2003, the *Times* expressed "regret" for his "lapses" in failing to cover Stalin's brutal actions in crushing peasant re-

sistance, reiterating that his work constituted "some of the worst re-
porting to ever appear in this newspaper." Referring to Duranty's jour-
nalistic omissions about arguably one of history's worst acts of genocide,
executive editor Bill Keller expressed indignation over the reporter's
"credulous, uncritical parroting of propaganda"—in essence, Duranty's
surrendering to an "accepted norm" proffered by the Soviet regime in
those years. "As someone who spent time in the Soviet Union while it still
existed," Keller, a former foreign correspondent, said, "the notion of air-
brushing history kind of gives me the creeps."[92]

Yet such airbrushing and intentional omissions have not been un-
common in American journalism, even in the most extraordinary and
unlikely circumstances. Consider the peculiar work and dual life of
William L. Laurence, a *New York Times* correspondent covering the
Pentagon and science in the years immediately after World War II. Three
months after the atomic bomb was dropped on Hiroshima, in Septem-
ber 1945, Australian journalist Wilfred Burchett had evaded strict U.S.
military censors to write an astonishing story, which was published
worldwide, about the horrors of the human suffering at Hiroshima, es-
pecially the effects of radiation poisoning. Seeking to counter Burchett's
intrepid reporting, the Pentagon invited a small group of journalists, in-
cluding Laurence, to witness the effects of atomic testing in New Mex-
ico. Burchett's work had infuriated the military officials, and they were
determined to maintain a public posture of downplaying civilian suffer-
ing from the bombs and denying the existence of radiation sickness. Lau-
rence eagerly consented and did not disappoint. The reporter had already
written glowing articles about the atomic bomb program and supported
the claims of top generals about its effects.

But Laurence "knew better," as authors Amy Goodman and David
Goodman reveal in their book *The Exception to the Rulers,* and consis-
tently suppressed the truth in order to serve military and government
aims. "He had observed the first atomic bomb test on July 16, 1945, and
he withheld what he knew about radioactive fallout across the south-
western desert that poisoned local residents and livestock. He kept mum
about the spiking Geiger counters all around the test site."[93]

It was no secret that the army wanted to play down or deny the exis-
tence of radiation sickness, so as not to alarm the public and threaten re-
sources for further development of the weapon. In September, after
Burchett's article first ran in London's *Daily Express,* Laurence wrote
about his guided visit to New Mexico. In a front-page piece headlined

"U.S. ATOM BOMB SITE BELIES TOKYO TALES: TEST ON NEW MEXICO RANGE CONFIRM THAT BLAST, AND NOT RADIATION, TOOK TOLL," he waxed favorably about the military's tour and how it had put "a lie to these claims." "The Japanese," he wrote, "are still continuing their propaganda aimed at creating the impression that we won the war unfairly, and thus attempting to create sympathy for themselves and milder terms. . . . Thus, at the beginning, the Japanese described 'symptoms' that did not ring true."[94]

That Laurence's work, published in the *Times*, so consistently echoed and supported U.S. military policy and propaganda about the bomb was not coincidental. According to the Goodmans, Laurence was also on the payroll of the Pentagon at the same time that he was reporting on defense and science as a *Times* writer. In fact, Laurence, an enthusiastic and strong proponent of the atomic program, had written many of the government press releases that followed the attack on Hiroshima. The press releases were published verbatim in many newspapers across America because government restrictions and censorship prevented independent eyewitness accounts. Laurence also wrote statements for President Harry Truman and the War Department as part of a propaganda campaign extolling the new weapon.[95]

In their 1995 book *Hiroshima in America: Fifty Years of Denial*, Robert J. Lifton and Greg Mitchell concluded this about the *Times* correspondent: "Here was the nation's leading science reporter, severely compromised, not only unable but disinclined to reveal all he knew about the potential hazards of the most important scientific discovery of his time."[96] Like Duranty, William L. Laurence was a winner of the Pulitzer Prize. The honor was bestowed in 1945 for ten articles he wrote that year in the *Times* about the atomic bomb program.[97]

While the reasons journalists and news media organizations withhold news and information from the public may vary widely, the practice clearly is not a relic of history but a continuing dilemma with sometimes broad implications for society. In April 2003, as the initial U.S. invasion of Iraq was winding down, a top CNN news executive, Eason Jordan, revealed that for thirteen years the network had refrained from broadcasting information about brutalities committed by the Saddam Hussein regime in order to protect the lives of Iraqis who were working for the network's Baghdad bureau. During a 1995 meeting in Baghdad in which Eason Jordan participated, for example, Saddam's son Uday had vowed to murder two of his own brothers-in-law who had de-

fected to neighboring Jordan and also to kill the ruler of that country, King Hussein. In "The News We Kept to Ourselves," an op-ed he wrote for the *New York Times* about this and other episodes of self-censorship, Jordan explained, "If we had gone with the story, I was sure he would have responded by killing the Iraqi translator who was the only other participant in the meeting. After all, secret police thugs brutalized even senior officials of the Information Ministry, just to keep them in line."[98]

Feeling a "moral obligation," Jordan privately sent word to King Hussein of Uday's threats to have the monarch assassinated, threats which the king dismissed as the ravings of a lunatic. Several months later, however, Uday followed through on his plans for his relatives, luring his brothers-in-law back to Iraq, where they were quickly murdered.

Eason Jordan described other incidents that he felt could not have been reported earlier: a man whose teeth were pulled out with pliers wielded by Uday's henchmen as punishment for an act of disloyalty; an Iraqi-born CNN cameraman who had been tortured with electroshock in the basement of secret police headquarters to get him to confess that his boss, Jordan, was a CIA operative. There was also the story of a Kuwaiti woman who once committed the crime of talking to CNN on the telephone. She was beaten daily for two months, in front of her father. On the eve of the U.S. invasion, thugs smashed the woman's skull and tore her body apart, "limb by limb," before leaving the remains in a plastic bag on her family's doorstep. "I felt awful having these stories bottled up inside me, " Jordan concluded in the *Times* after the fall of the Saddam regime. "At last, these stories can be told freely."[99]

But many readers around the world, learning of Jordan's confessions, questioned the morality and high cost of keeping the "news to ourselves," along with the motives of a network that has long described itself as "The Most Trusted Name in News." It was in many ways a looking-glass experience illustrative of the deeper complexities stewing at the heart of the American media carnival: CNN by its own admission failed to report the news in order to protect the lives of those who told them the news. But by failing to report the news, the network also seemed to defeat the purpose of having a news bureau in Baghdad in the first place. What was the point of being one of few Western news outlets on the scene in Iraq if the network's journalists felt compelled to censor themselves about the truth as they witnessed it? One writer, Mark Steyn

in the *New York Sun,* seemed to sum up the reaction best in an essay published ten days after Jordan's confession:

> If news is the issue, CNN didn't need to be in Iraq. The truth of what was going on was easily ascertained from talking to Iraqis in Amman, Kuwait, and London. But that doesn't work for CNN. They sell themselves as a global brand and it's more important to them to be seen to have a Baghdad bureau than to have any real news emerging from that bureau. What mattered to CNN was not the two-minute report of rewritten Saddamite press releases but the sign off: "Jane Arraf, CNN, Baghdad." . . . As Jordan acknowledged this squalid tradeoff cost real lives. Once the terms of doing business with Saddam were clear, they should have gotten out. But CNN willingly conceded the right to report any news for what it saw as the far more valuable right to be allowed to continue to *appear* as if it were reporting the news.[100]

One problem with attempting to examine intentional omissions of news by journalists and media organizations is the obvious fact that we are often not made aware of the information that they do not want us to learn. For whatever reason, the news medium keeps us in the dark. Occasionally, though, a media organization may be more than willing to shed light on its decisions to editorially omit, if for no other reason than to express a kind of patriotic adherence to what it perceives as an "accepted norm" of American sensibility and government policy. Such was the case in a remarkable controversy in May 2004, a year after Eason Jordan's CNN confession, when Ted Koppel of the ABC News *Nightline* program devoted a full hour of his broadcast to reciting the names and depicting the faces of all Americans killed in action in Iraq in all their youth and vitality. Koppel announced in advance that the program, titled "The Fallen," was intended to provide a way for American viewers to connect with, remember, and honor the dead. This mirrored the precedent of *Life* magazine, which in 1969 published photos of dozens of American dead from one week in the Vietnam war.[101]

Indeed, the *Nightline* project was in some ways history repeating itself, but with modern overlays of media corporate synergy. What soon transpired was an effort by a major media corporation itself—not the government—to prevent American viewers from witnessing the broadcast. The Sinclair Broadcasting group, a heavy contributor to Republican causes and a strong proponent of the Iraq war, objected so strenuously to the ABC project that it prohibited the six ABC affiliates it owned from broadcasting the show. Sinclair officials charged that the *Nightline* program was "motivated by a political agenda designed to undermine the efforts of the United States in Iraq."[102]

Millions of citizens were thus intentionally denied exposure to a kind of "light" provided by the news, simply because a media giant decided for us that darkness better served the public interest.

Jayson Blair and Sinclair Broadcasting could not possibly represent more contrasting entities in our cultural perceptions. Yet, as the foregoing cases demonstrate, they do share in a sense a similar place in the media's American carnival, a realm where a *show* of professionalism and steadfast commitment to independence, high standards of practice, and public service often substitutes for the real deal. There is, in the end, no qualitative difference between crimes of commission and omission in the practice of journalism, or between sins committed by individuals and institutions. The damage stemming from all these categories of sins is tacit: we become a people intentionally informed not by truth and clarity but by inaccuracy, lies, misinformation, stereotypes, myth, and noninformation. As a result, wise decision making by leaders and the public on issues of great importance and the goals of justice and fairness in society are at times profoundly compromised.

Journalism standards in the traditional news media are higher and more closely observed today than those of wilder and more ungoverned eras. The bloody days and nights of America's Red Summer of 1919 are a distant memory, as is the "yellow journalism" that dominated news coverage in the early twentieth century, when professional reforms helped to turn the craft in a newer and more responsible direction. Yet failures do recur, despite advances in craft and ethics, as the media's problems in covering the Iraq war reveal.

The key challenge for the news media still is to heed the established codified standards even as the industry undergoes enormous transition. Courageous citizens and professional forebears, after all, issued those entreaties to seek truth and report it according to values of fairness, balance, diversity, and verification for a reason, and their legacy deserves to be honored. But can those standards possibly be honored as well as they should be in the face of intense business pressures, shrinking editorial staffs, and the growth of New Media, the Web, and citizen journalism? How do these struggles of professional journalism affect the quality of information in an age when the sheer *quantity* of information becomes ever more vast, confusing, and unwieldy each day? The next chapter begins to probe these questions in a realm on the other side of the Amer-

ican carnival lot, an often comedic place demonstrating that there is something intrinsic to the basic nature of journalism and the creative people who practice it that will likely always remain difficult to fix, no matter how hard ethicists may try. Sometimes journalists just can't keep themselves from straying; sometimes they just *have* to report stories that are simply too sensational not to be believed. It's been thus since the earliest days of the republic. And now, in the age of e-mail, text messaging, the Web, and other frontiers of New Media, this remarkable attraction is doing a land office business. The fun house of the American carnival is next. Step right up. The show's about to begin.

3

Fun House

The distinguished-looking, gray-haired anchor on BBC World television news had a great scoop to report during his morning newscast from the international channel's London studios. Even better, he had an articulate and perfectly authoritative source ready to confirm the scoop during a live on-air interview. The date was Friday, December 3, 2004. The occasion was the twentieth anniversary of one of history's worst industrial disasters. Just past midnight on that date in 1984, forty tons of poisonous gas burst from a ruptured storage tank at a Union Carbide pesticide plant in Bhopal, India. More than 3,500 sleeping residents were killed nearly instantly, and 15,000 more succumbed to fatal respiratory and other internal ailments in the ensuing years. The disaster had also left 120,000 survivors waiting vainly for just compensation from the corporate giant for their misery in the years that followed and for a cleanup of the despoiled environment, including poisoned groundwater and other remnants of toxic waste.

Now, for the first time, a representative of Dow Chemical—which had bought Union Carbide three years earlier—appeared ready to announce on the BBC newscast that the corporation had accepted full responsibility for the disaster and had agreed to a multibillion-dollar settlement with the survivors. It was extraordinary news.

"A day of commemoration in Bhopal," the anchor told his audience of millions around the world, as he turned at his desk to face a live on-screen projection of the BBC's Paris studios, where the Dow representative, identified as Jude Finisterra, sat before an image of the Eiffel Tower to issue the historic announcement. The dark-haired Finisterra, his eyes wide with earnestness, his tone of voice impassioned and sincere, said, "Today is a great day for all of us at Dow, and I think millions of people around the world. It is twenty years since the disaster, and today I'm very, very happy to announce that for the first time Dow is accepting full responsibility for the Bhopal catastrophe. We have a $12 billion plan to finally, at long last, fully compensate the victims, including the 120,000 who may need medical care for their entire lives, and to fully and swiftly remediate the Bhopal plant site."

As words proclaiming the BBC scoop suddenly appeared in bold white letters on the screen beneath his image—"BREAKING NEWS: Dow Accepts Full Responsibility"—Finisterra went on to report more remarkable steps. Dow would soon liquidate Union Carbide, "this nightmare, this headache for Dow," and use the $12 billion in assets for Bhopal relief in order to provide greater and fairer compensation for victims, who until now had been limited to a maximum compensation of $500 each. Finisterra pledged that the corporation would also publicly reveal for the first time the full chemical composition of the toxic gases accidentally released at Bhopal, which would help doctors to develop medical relief for the survivors. Furthermore, Finisterra announced that the corporation would push for the extradition of former Union Carbide chief Warren Anderson, who had fled India for Long Island, New York, in the wake of the 1984 disaster to escape multiple homicide charges filed against him by the Indian government. "This is the first time in history," Finisterra said proudly, "that a publicly owned company of anything near the size of Dow has performed an action which is significantly against its bottom line, simply because it's the right thing to do."[1]

News of Dow's announcement spread around the world within minutes via the Reuters newswire and other financial news services, including London's AFX News. Early-rising American viewers of CNN heard the news on the *Daybreak* show, where business reporter Carrie Lee said, "Dow Chemical has some things going on. Basically, the company is accepting full responsibility for a disaster in India. They put together a $12 billion compensation plan, so that's something worth watching." The World Wide Web, including popular news aggregators such as Yahoo! and Google News, also soon featured the announcement promi-

nently. The story, in the form of a "Quote of the Week" featuring Finisterra, showed up in an early edition of at least one American newspaper, the *Atlanta Journal-Constitution*. Reaction was also swift in world stock exchanges, including Frankfurt, where Dow's share price reportedly fell 4.24 percent in the twenty-three minutes after the interview aired, causing a loss of nearly $2 billion.[2] And in India, where the Internet and satellite television widely reported Dow's change of heart, thousands of residents of Bhopal who had gathered to commemorate the disaster, some carrying photographs of their dead relatives, reportedly wept with joy over the news.[3]

The Finisterra interview aired twice around the world during the BBC's news cycle over the next two hours before Dow officials angrily denied the story, charging that no one named Finisterra worked for the corporation. Only then did officials of the BBC, arguably the world's finest and most respected international news organization, realize that they had suffered an embarrassment that in many ways has become symbolic of larger problems of credibility in journalism's New Media age of instantaneous news delivery: the journalists had been snookered, hoodwinked, hoaxed.

But this wasn't just any hoax. Like many such tricks played on the news media in modern times, this was an act of extraordinarily believable theater, one committed by two savvy media watchers who knew how to manipulate and exploit the global system of news and information and the Internet for what they considered an important cause. Unlike most hoaxers, these con artists *wanted* to be discovered as liars, wanted their lie itself reported by the media in order to bring public attention to significant and ugly truths about the otherwise largely forgotten Bhopal tragedy. It was a hoax with a deadly serious political purpose.

The unwitting accomplice to the crime, the BBC, quickly retracted the Dow story, apologizing to the corporation and telling the world that it had been duped by an "elaborate deception."[4] In fact, as the world would soon discover, one of the most surprising aspects of the deception was not how elaborate it was, but how incredibly simple. The perpetrators revealed themselves as two Paris-based American political activists and performance artists named Andy Bichlbaum and Mike Bonanno. The pair, part of a squad of like-minded souls dubbed the Yes Men, described themselves as dedicated to exposing and reminding the world of what they considered crimes by the world's major multinational corporations. In earlier years, for example, the Yes Men had staged stunts at various trade shows and corporate shareholder meetings to attract media

attention to the wrongs of capitalism. At one point, they successfully pretended to be shady officials of the World Trade Organization to mock and publicize what they viewed as sinister WTO policies that were causing environmental and labor abuses around the planet.

As part of that campaign two years earlier, the Yes Men had crafted a mock Web site, www.dowethics.com, which mimicked the appearance and style of the official Dow Chemical site, replete with the motto "Living, Improved Daily." The site listed a contact e-mail address and several vaguely satirical items testifying to Dow's integrity and commitment to a clean environment. An eager young BBC news producer, engaged in what was turning out to be a frustrating journalistic quest to find Dow and Union Carbide officials willing to discuss the twentieth anniversary of the Bhopal disaster, eventually stumbled on this site. Bichlbaum and Bonanno had forgotten about the bogus Web site, which had been dormant since 2002, until they received an e-mail from the BBC requesting comment. After numerous exchanges of phone calls and e-mail messages between the phony Dow officials and the BBC, the Dow corporation "spokesperson" agreed to come on the air live to tell the world that Dow indeed was ready to make a major announcement regarding Bhopal. His only request to the BBC, a mild one, was that the interview and announcement had to be conducted from Paris. (What the Yes Men didn't tell the BBC was their reason for this minor request: they were so strapped for cash that they couldn't afford to buy train tickets or airfare to London.)[5]

So it was that the forty-one-year-old Bichlbaum, adorned in a white shirt and tie and his "thrift shop" suit, appeared in the BBC World news studios that December morning in Paris as Jude Finisterra. He had invented his unusual pseudonym on the spur of the moment to reflect the underlying themes of their deception: Jude, the patron saint of impossible causes; and Finisterra, which is translated from Latin as "end of the world."[6] (Bichlbaum, too, is a fake name. Andy Bichlbaum reportedly was born Jacques Servin in Tucson, Arizona.)[7]

Why the BBC was so eager to report this story could be at least partially explained by the basic definitions of news. Every good professional reporter instinctively knows what news is. News is that which is unusual, many textbooks for journalism students explain, an event or happenstance occurring outside the normal routine. News is current, is happening now, and has a certain proximity or connection to the audience receiving it. News often involves conflict, usually of a political or physical nature. Perhaps most important, news has consequences for and rel-

evance to the lives of many people—it means something.[8] The Bhopal story and Dow's extraordinary announcement certainly fit this description. Here was a huge multinational corporation, long reviled by many Indians for its lack of accountability and concern for the Bhopal victims, suddenly embracing responsibility after years of explicitly denying that Dow was accountable for Union Carbide's mistakes before Dow had purchased it. It was surprising news that could affect the lives of many people in India. It was news that was also relevant to Dow shareholders, many of them Americans, and others around the world. And it was happening now, live and in color, with the BBC as the exclusive agent for reporting it.

But the BBC journalists weren't the only ones who understood the nature of news in modern society. Like so many modern hoaxers, the Yes Men knew exactly which journalistic buttons to push to engage the attention of a news producer and anchor, how to play the part of the corporate public relations flack. They also had counted on the story's urgency, timeliness, and news value to help override normal verification procedures at the BBC. They understood the pressures of journalism in an age of instant news and had the digital skills to bypass or trick the verification procedures. Then there was the obvious question that the Yes Men were sure the frenzied BBC would never think to ask: Who the devil would want to impersonate a flack for a corporation? And, just as significant, the Yes Men knew that Dow officials would eventually have to respond to the hoax, thus drawing attention to the anniversary of an exceptional tragedy, which was being ignored by most of the world's major news media.

Until the hoax, Dow had repeatedly insisted that it had nothing to do with the disaster and that all legal liabilities, including a $470 million settlement reached between Union Carbide and the Indian government in 1989 in exchange for dropping lawsuits against the company, had long been resolved. In a statement to the Associated Press one day before the hoax, a Union Carbide official said that the company had spent $2 million attempting to clean up the plant between 1985 and 1994 and that environmental studies in 1998 indicated that poisoning in the Bhopal groundwater was likely caused by poor drainage and other pollutants, not by Union Carbide chemicals. Since Union Carbide had sold its stake in the plant in 1994 to an Indian firm, officials said, Dow had no remaining connections to the town.[9] Everyone's hands, in short, were now clean. But twenty years later, the uncomfortable reality was that hundreds of thousands of poor Indians in Bhopal were still reportedly suf-

fering environment-related diseases, growth retardation in boys, irregular menstrual cycles in young girls. And no one was answering for the sicknesses and the poisons in the wells.[10]

Perhaps the most telling irony of the Yes Men's stunt was that the BBC became the victim of the hoax precisely because it was one of the few cable or broadcast media organizations with global and American reach that possessed the professional journalistic chops to do any sort of reporting at all on the continuing conditions in Bhopal. Neither Fox, NBC, ABC, CBS, CNN, nor any other network or cable news station devoted significant time or attention to the anniversary. The American electronic media were essentially hoax-proof, since not a single one of the outlets apparently had attempted to find Dow or Union Carbide officials for comment. As Bonanno later told an interviewer for the *Guardian* of London, "The BBC was not our target. It just so happens that the BBC is one of the only news outlets that has consistently given a ton of coverage to the Bhopal disaster and so they were desperate to find someone from Dow who would speak."[11]

The one American television network that did repeat the bogus BBC story about Dow's settlement with Bhopal survivors as it had originally aired, CNN, was apparently so uninformed about Bhopal and the history of the disaster that one of its anchors couldn't even get the details of the retraction of the hoax correct. As Mary Costello put it on CNN's *Daybreak* program, "Just moments ago, Carrie Lee said that Dow Chemical had reached a settlement. We understand now that that story is a hoax. We wanted to pass that along to you. Again, that story that you heard just moments ago on CNN about Dow Chemical settling with that company in India, it's a hoax."[12]

The story of the hoax itself soon became a top news story on wires around the world and on news Web sites, as did the Dow denials. In Charleston, West Virginia, where Union Carbide employed nearly two thousand workers, Dow officials felt compelled to issue a public statement calming fears that the corporation intended to sell off the subsidiary to pay compensation to the Indian victims:

> The BBC was the subject of a hoax by an activist who falsely identified himself as a Dow employee. BBC has retracted the erroneous story. Dow confirms that there was no basis whatsoever for this report. The BBC has been informed of this error, and has pulled the erroneous story. According to a statement issued by the BBC, "This information was inaccurate, part of an elaborate deception." The person did not represent the company. We want to make it clear the information he gave was entirely inaccurate. This is an unfortunate situation for everyone involved.[13]

In the end, the BBC hoax was a remarkably revealing episode from a realm of the media carnival where the unexpected meets the gullible, with sometimes explosive results, and where both news consumers and journalists are prime targets for bamboozling. But it also pointed to a fascinating irony about the modern news media: in a sense, the hoaxer's lie in the BBC episode helped lead the way to reporting a lingering truth about Bhopal—while the truth itself was widely ignored or forgotten by institutions presumably in the business of reporting it. Columnist Dennis Roddy, reflecting on the BBC incident in the *Pittsburgh Post-Gazette* one week later, wrote, "It remained for a duo of pranksters to test the credibility of each side's argument [in the Bhopal controversy] by rushing to the edge of plausibility, shouting down the canyon and waiting for a credible echo. In the Information Age, the Yes Men had to lie their way into the truth."[14]

Welcome to the carnival fun house, a lively place full of trickery where hoaxes, spoofs, and extraordinary feats of myth-making rule the day. It has always been thus. With each new advance in communications technology—from newspapers to radio to television to today's New Media—hoaxes crafted by both news organizations and sources have been recurrent attractions. Schemes are played by and against the media for a host of reasons, from simple amusement to serious political agitation to a perceived need to protect cherished national myths. But the degree to which they succeed is often directly related to the hunger of journalistic organizations for sensation, scoops, and profit and to the occasional failures and indifference of understaffed and unprofessional news systems. In the New Media age especially, with the Web's instantaneous news and reaction, its easy accessibility, and its use by millions—from dedicated professional journalists to the multitudes of self-publishers—the Internet is where deceivers and hoaxers first hatch their tricks and where the tricks are picked up and disseminated more widely. Ironically, it is also where more and more work is done to debunk the mischief. The rambunctious and wholly ungovernable quality of the news and information landscape is both its greatest attraction and perhaps its most troubling feature.

The hunt for profits, the search for celebrity, the desire to push a cause or a product or a political belief—all these factors may contribute to the successful dissemination of lies and hoaxes, as we'll see. But the underlying reality is that professional journalists and their presumed ethical standards play a less central role today as arbiters, gatekeepers, or guardians of credibility. The weakening of journalistic professionalism

and centrality in this rapidly transforming system not only makes lies and hoaxes more possible but also poses compelling new questions about the quality of the news informing democratic society.

Make no mistake, the media fun house features a few distinct elements that also serve the interests of journalism. Modern journalism is being challenged not only to inform democratic society with news about critical issues but also to do so in compelling, vibrant, and ever more entertaining ways. Jon Stewart's fake news *Daily Show* and the fictional reporter Stephen Colbert's "truthiness" comedy bits on the *Colbert Report* satirize the news each night on the Comedy Central cable television network, to the delight of the show's savvy, mostly young viewers. In a sense, the popularity of these shows testifies to the enduring power of hoaxing and satire to reveal and inform as well as to the sheer value of entertainment itself as a force for illumination. In an intensely competitive New Media age, the ability of journalists to report according to professional standards while also capturing citizens' attention will surely be tested more and more—even as journalists attempt to keep the public trust by respecting the difference between fact and invention.

GREAT ASTRONOMICAL DISCOVERIES

For the longest time in American history, it was the press itself that typically performed the occasional magic acts of invention, chiefly to amuse and titillate onlookers and to generate attention, higher circulation, and profit. In the nineteenth century, a pioneering penny paper, the *New York Herald,* saw its circulation rise after it terrified thousands of readers with a bogus report about wild animals escaping from the Central Park Zoo. Lions, tigers, leopards, baboons, snakes, giraffes, rhinos, and monkeys—all were loose in the streets of New York, bloodthirsty and fierce, fighting each other and devouring human beings, the *Herald* reported. The newspaper even declared that the governor had called out the National Guard to capture or kill the beasts. The story took up the entire front page on Monday, November 9, 1874, and featured a series of sensational headlines:

AWFUL CALAMITY

The Wild Animals Broken Loose from Central Park

Terrible Scenes of Mutilation

A Shocking Sabbath Carnival of Death

SAVAGE BRUTES AT LARGE

Awful Combats between the Beasts and Citizens[15]

The story provoked pandemonium that morning all across the city, with New Yorkers taking up knives and all manner of firearms, and mothers forbidding their children to leave home for school. The perpetrator of the hoax, *Herald* editor Thomas B. Connery, later said that he hadn't intended to cause harm. In fact, he claimed that he hoped the story would be good for the city and would help bring attention to security problems at the zoo. His competitors at the *Times,* the *Sun,* the *Tribune,* and other newspapers were irate, however, and denounced the *Herald* for causing such chaos. The *Herald* nevertheless remained unapologetic, declaring in an article that the editor of the *Times* might have been indignant because he too was tricked by the hoax, since it had reported that he left home that morning "with a brace of pistols, prepared to shoot the first animals that would cross his path."[16]

Among the many hoaxes that suckered American newspaper readers in the early twentieth century was a vivid 1924 story by Sanford Jarrell, a young journalist for the *New York Herald-Tribune,* who described how the rich were different during the early era of Prohibition: for one thing, the rich could enjoy the luxuries of a "sin" boat anchored on the coast just outside the fifteen-mile legal limit, where, according to Jarrell's firsthand account, legions of well-to-do revelers anchored their yachts, guzzled fine whiskey, and engaged in bawdy excess every night until dawn. It was a fabulous work of imagination replete with riveting detail, including millionaires adorned in top hats and spats, flappers in sparkling sequined gowns dancing jigs on waxed floors, and a "Negro jazz orchestra" that turned the sin boat into a swinging cabaret. Part of the headline to the piece, which took up four columns on the front page, read: "Wine, Women, Jazz and Revelry Turn Night to Day on Mystery Ship Flying the British Flag." For weeks there had been rumors about such a "sin" boat, and Jarrell's editors had sent him to check it out. Unable to verify the story or locate the vessel, he did the next best thing: he made it up, complete with a shady rum runner who agreed to take him out to the vessel if he could prove he was a reporter and not a government agent. Jarrell even claimed to have spent the night on the "sin" boat, going to sleep at 4 A.M. in a five-dollar stateroom.[17]

Not to be outdone, competing newspapers such as the *Evening Post* and the *World* followed up Jarrell's report with versions of their own, corroborating the story. The *Post* went a bit further, citing customs officials who confirmed that "wealthy New Yorkers were holding sky-

larking parties aboard ships in Rum Row." As the citizens, cops, and federal officials alike went about trying to locate the ship, Jarrell published two more stories in the next five days sustaining his hoax, with one piece speculating that the ship had weighed anchor and pressed north toward Canada. It wasn't until the sixth day that Jarrell finally confessed to his editors that his stories contained "embellishment" and that he had made up the whole thing. He was, the paper reported, "dishonorably dismissed."[18]

Jarrell was in many ways the journalistic forebear of more contemporary deceivers such as Jayson Blair, Stephen Glass, and Jack Kelley. But so too were some of the most illustrious figures in the nation's political and journalistic history. From the earliest days of the republic, clever journalists and other scribes have recognized the value of a good hoax or work of satire when told well. Benjamin Franklin, for one, was a serial hoaxer while he ran the *Pennsylvania Gazette* in the 1730s. To ridicule citizens who believed in witchcraft, he concocted a hilarious tale about a group of people who had been accused of "making their neighbors' sheep dance in an uncommon manner." Their fellow villagers conducted a trial—consisting of several tests—to prove that satanic influences were at work. The accused accepted these tests but insisted that two of their most strident accusers, a man and a woman, be subject to the same experiments. The villagers first tried to prove that the accused were witches by placing each one on a scale to check to see whether the individual could outweigh a huge Bible. All four of the subjects easily outweighed the good book, though. Failing to find proof with that test, the villagers next decided to dunk the suspects, bound hand and foot, in a pond to see whether they could float; apparently, floating would have been proof that the accused were witches. One of the accused, a skinny fellow, did indeed begin to sink, but the others managed to float well enough, Franklin wrote, including the female accuser. In a panic, the accusing villager demanded another water test, in which she floated again. Stumped by this impasse, the villagers eventually decided that the women, who unlike the men had been tested fully clothed, should be tested again in the nude, when the weather grew warmer, whereupon the tests were suspended.[19]

Franklin published his most famous hoax in 1747 in London's most popular daily, the *General Advertiser*, to which he was a regular contributor of news and opinion from America. This tale was yet another effective social commentary on the foibles and occasional moral hypocrisy of colonial American life. Franklin reported on an impas-

sioned speech purportedly made in a Connecticut courtroom by a woman named Polly Baker, who was being prosecuted by the Crown for the crime of bearing a child out of wedlock. It was the poor young woman's fifth such offense, and she pleaded for mercy from the court. Unable to afford a lawyer, she told her judges that she had already been forced to pay two fines for earlier births and had suffered two public whippings as well. Warming to his subject, Franklin, as Polly, continued:

> I have brought five fine children into the world at the risque of my life; I have maintained them well by my own industry, without burthening the township; and would have done it better if it had not been for the heavy charges and fines I have paid. Can it be a crime (in the nature of things I mean) to add to the number of the King's subjects, in a new Country that really wants People?[20]

Polly pleaded that if her crime was religious, the judges should let the "eternal fire" of hell be her final punishment, not "your additional fines and whipping." She claimed that she had never refused a proposal of marriage from any man and in fact had consented to one proposal when she was still a virgin. However, she was "too easily confiding in the person's sincerity that made it," and "I unhappily lost my own Honour, by trusting to his; for he got me with child, and then forsook me." Polly next stunned the judges by informing them that the father of her firstborn had become a magistrate, a judge like them, and she protested the moral double standards of a society that would allow a dishonest man every opportunity to rise in station while consigning her to lifelong suffering and abject poverty. Polly concluded:

> What must poor young women do, whom custom have forbid to solicit men, and who cannot force themselves upon husbands, when the laws take no care to provide them any; and yet severely punish them if they do their duty without them; the duty of the first great command of nature, and of nature's god, encrease and multiply. A duty from the steady performance of which, nothing has been able to deter me; but for its Sake, I have hazarded the loss of the publick esteem, and have frequently endured publick disgrace and punishment; and therefore ought, in my humble opinion, instead of a whipping, to have a statue erected to my memory.[21]

The article containing Polly's speech finished with a remarkable note to readers: not only did the court dispense with the charges against her, but so stirred was one judge by the young woman's words that he married her the following day.

"The Speech of Miss Polly Baker" appeared in the *General Advertiser* on April 15, 1747, and was an immediate sensation in England. It was

reprinted in at least five other newspapers in London, with copies made in numerous other British cities, in the ensuing days. When it arrived in America in periodicals brought by sailing vessels in July of that year, it was republished in newspapers in many American cities, Boston, New York, and Annapolis among them. Franklin's biting commentary skewering the hypocrisy of the colonial justice system, which would oppress innocent poor women like Polly while protecting the men who mistreated her, was so convincing that she was widely accepted as a real character, and her story was considered true. It was even quoted by a few historians and scholars of early America, who saw the speech as a serious public document.

For many years, few realized that Franklin had fabricated the Polly story, though he admitted it some years later while living in France. The success and longevity of the hoax lay in Franklin's brilliance as a writer and the impact of the social issues he addressed. In an age full of literary satire in the press, he was something of an American answer to Jonathan Swift. As journalist Max Hall described it in his book *Benjamin Franklin and Polly Baker,* which examines in fascinating detail how Franklin created the hoax and why it resonated so deeply, "Even in the twenty-first century, someone will surely reincarnate Polly Baker."[22]

Journalism has long served as a kind of staging ground for talented writers whose career trajectory and ambitions eventually led them to the realm of fiction. Journalism traditionally prizes those who are skilled as storytellers almost as much as it prizes those who are able to collect news and information. In journalism, however, it's expected that the stories told by these raconteurs are the truth. Nonetheless, many future novelists who started their careers in journalism couldn't resist getting a head start on exercising their literary imaginations. A few thrived on it, in fact: Mark Twain and Edgar Allan Poe proved especially gifted at using their brilliance as storytellers and writers to foist hoaxes on American readers. If the news itself wasn't interesting enough, those guys simply made it up.

Long before the days of *Innocents Abroad* and *The Adventures of Tom Sawyer,* Twain started out as a journalist for a newspaper called the *Enterprise* in Virginia City, Nevada, the rough-and-tumble western mining town where he ended up in 1861 after deserting from a Confederate army unit in Missouri. There Twain found a ready outlet for his creativity, inspired by the wildness of the region, the backward rowdiness of the people, and the fakery and swindling by mining companies, stock traders, and con artists of all stripes that typified the times. Tall tales

were very much a part of the western mind-set. As Fred Fedler observed in *Media Hoaxes,* a comprehensive compilation of press hoaxes, Twain's editor "encouraged his reporters to write human-interest stories (including hoaxes) and they helped make the *Enterprise* famous. The reporters might summarize a murder in a paragraph or two, then devote an entire column to a humorous sketch. The more absurd, the more fantastic, the more ridiculous their stories became, the more their readers seemed to like them."[23]

Twain made up everything from ax murders and bank holdups to silver discoveries, deadly saloon brawls, and rampages by Indians. But he was particularly adept at devising hoaxes when he was motivated by revenge, as, apparently, he often was. He got back at petty politicians, barkeeps, banks, a San Francisco water company, rival journalists—no matter the offense, big or small, Twain would let fly in the newspaper with complicated and colorful tales and practical jokes that mercilessly ridiculed the targets of his ire. After a falling-out with a local coroner and justice of the peace, for example, Twain wrote an elaborate hoax about the discovery of an ancient petrified man in the mountains nearby. He described the absurd lengths to which the supercilious official went to determine a cause of death, ordering an inquest on the spot and struggling for hours to figure out a way to dislodge the corpse from the bedrock to which it had become eternally attached by limestone sediment. The hoax, which portrayed the hapless official as an utter and complete ignoramus, was reprinted in numerous papers around the West. Revenge was Twain's.[24]

More than a century earlier, Edgar Allan Poe had also gotten his literary start as a freelance writer of feature stories that were published in newspapers and magazines. Like Twain, he was a dedicated hoaxer at times, displaying particular skill at storytelling that involved science and scientific discovery. Unlike Twain, however, Poe was a somewhat lugubrious sort, his work for the press often reflecting the gloomy and the gruesome, the same themes that typified his most famous novels.

One of Poe's earliest hoaxes was a long, detailed account of the adventures of Hans Phaall, a repairer of fireplace bellows in Rotterdam. After losing his job, Phaall is under siege by creditors of all sorts. In desperation, he concocts an elaborate plan to escape his troubles by building the world's most powerful gas balloon. He kills three of his most insistent creditors before flying away one April night in 1835. In a first-

person account, Phaall tells of dodging bolts of lightning in the earth's upper atmosphere and meteorites in outer space, of using a contraption to trap air inside his basket so that he can breathe. Low air pressure causes blood to seep from his ears and eyes as he soars into the velvety blackness of space lit by millions of stars. Phaall travels 237,000 miles before crash landing on the moon eighteen days later, where he finds a wondrous city made up of earless, speechless "idiots." He lives with them for five years, learning about the moon's climate, life forms, and atmosphere, as well as other precious secrets about the stars and planets. He eventually returns by balloon to Rotterdam, where he delivers an account of his adventure in the form of a letter to the mayor and the local university's chief astronomer. Then he vanishes as quickly as he had arrived. At the end of his story, he requests that in return for his secret knowledge of the deepest wonders of space, the officials must pay him and pardon his murder of the creditors.[25]

"The Unparalleled Adventures of One Hans Phaall" was published in a Richmond, Virginia, magazine of news, opinion, and literature called the *Southern Literary Messenger* in June 1835. It began by reporting that the city of Rotterdam was thrilled by the electrifying return of the mysterious Phaall. The story was seen as journalism, in a fashion, for its day, and assumed to be true by those few who read it in the magazine. Whether Poe's tale had a direct effect on subsequent events involving the *New York Sun* no one can say for certain. But what is true is that the penny paper later that same year published a hoax not unlike Poe's, which not only startled and amazed thousands of readers at a time of great popular interest in the powers of science but also led to significant hikes in circulation and profit for the paper's owners.

In many ways, the hoax that appeared in the *Sun* remains the gold standard for fakery in the history of the print press in America. Ironically, the author of this monumental fiction—a rambunctious journalist named Richard Adams Locke—was a descendant of John Locke, the philosopher whose impassioned seventeenth-century writing on liberty and the importance of an informed and empowered citizenry helped to inspire the founders of America to enshrine press freedom as a cornerstone of democracy a half century later.[26]

In a series of front-page accounts beginning on August 25, 1835, Richard Adams Locke, who had distinguished himself as a crime and court reporter for the *Sun,* told of astonishing news published in a peri-

odical called the *Edinburgh Journal of Science,* just received by packet ship. The series of headlines read:

GREAT ASTRONOMICAL DISCOVERIES

LATELY MADE

BY SIR JOHN HERSCHEL, LL.D., F.R.S., & C.

At the Cape of Good Hope

John Herschel was widely known as an accomplished planetary astronomer and was the son of William Herschel, an astronomer who had discovered the planet Uranus. But that was about the only thing real about the amazing stories that followed in the next two weeks in the *Sun.* Locke, in his guise as a writer for the Edinburgh journal, announced right at the top that "we have the happiness of making known to the British public, and thence to the whole civilized world, recent discoveries in astronomy which will build an imperishable monument to the age in which we live, and confer upon the present generation of the human race proud distinction through all future time."[27]

On and on Locke went in breathless description of how Herschel had made significant new discoveries by using a new telescope in an observatory perched in a mountain clearing near Cape Town, South Africa. The instrument was unique, combining elements of telescope and microscope, powered by gas burners, and equipped with "hydro-oxygen reflectors" that made it possible, Locke wrote, both to see exceptionally far and to focus on objects as small as eighteen inches in diameter many thousands of miles away.

All this scientific jargon and esoteric folderol lent an air of credibility and set the stage for Locke to inform *Sun* readers about what Herschel had discovered. In this, he did not disappoint, stretching out the series over five successive days in the newspaper. Focusing the telescope on the moon, Herschel had spied mountains, lakes, and strange vegetation, Locke reported, "a lunar forest with trees unlike anything I have seen, except the largest of yews in the English backyards." Herschel and his assistants next saw animal life—flocks of flying red and white birds, pelicans, cranes, huge herds of small bison, a unicorn that bounded around like "a kitten," goats with beards, and a weird sort of species resembling a cross between a beaver and a man that walked on two legs, carried its young in its arms "like a human being," and dwelt in "huts that are constructed better and higher than those of many tribes of human savages." These life-forms must have been acquainted with fire, the astronomer re-

ported, since he could see smoke emanating from the tops of all the huts. Locke was on a roll.

According to Frank M. O'Brien, author of a history of the *Sun,* by August 28, 1835, just three days after the moon series began appearing in the penny paper,

> the newspaper had the satisfaction of announcing that it had achieved the highest circulation of any daily in the world. It had, it said, 15,440 regular subscribers in New York and 700 in Brooklyn, and it sold 2,000 in the streets and 1,220 out of town—a grand total of 19,360 copies, as against the 17,000 circulation of the *London Times.* [The *Sun's* press] had to run ten hours a day to satisfy public demand. People waited with more or less patience until three o'clock in the afternoon to read about the moon.[28]

Fittingly, on the most profitable day in the newspaper's two-year history, the *Sun* announced Herschel's most sensational discovery. While focusing his gaze on a temperate plain of the moon, he had noticed four flocks of "large, winged creatures" descending from the lunar sky. Alighting on the plain, the creatures stood on two feet and folded their wings into their backs. "Certainly they were human beings," the astronomer reported, "for their wings had now disappeared, and their attitude in walking was both erect and dignified." These beings were "evidently engaged in conversation; their gesticulation, more particularly the varied action of their hands and arms, appeared impassioned and emphatic. We hence inferred that they were rational beings." The famed scientist continued, "We scientifically denominated them the vespertilio-homo, or man-bat; and they are doubtless innocent and happy creatures, notwithstanding some of their amusements would but ill comport with our terrestrial notions of decorum."[29] The *Sun* even enlisted the skills of its staff artists and engravers to produce etchings of the man-bats and other lunar life-forms at work and play in the distant world, which were sold as supplements to the newspaper.

Interestingly, Locke also endeavored to hammer home the credibility of his hoax by appealing to earthly notions about race commonly accepted by white Americans in the nineteenth century, likening human conditions on the moon to those at home. Locke noted that Herschel had also discovered on a higher lunar latitude a different tribe of the man-bats, who possessed less "wooly" hair and "a larger stature than the former specimens, less dark in color, and in *every respect* an improved variety of the race."[30]

The impact of Locke's hoax cannot be overstated. As O'Brien wrote, "New York now stopped its discussion of human slavery, the high cost of living . . . and other familiar topics, and devoted its talk-

ing hours to the man-bats of the moon. The *Sun* was stormed by people who wanted back numbers of the stories, and flooded with demands by mail."[31] The rival New York City and state newspapers were agog and mostly credulous, with many writers speculating on what the discovery meant for humanity. Locke's hoax was so convincing that a delegation of Yale professors excitedly traveled to the *Sun*'s offices in New York to get a copy of the *Journal of Science* from which the newspaper had so liberally excerpted. Locke managed to evade them. It wasn't until weeks later, when a rival newspaper, the *Journal of Commerce,* asked the *Sun* for the rights to reprint the series, that Locke felt compelled to admit that he had made up the whole thing.

The Moon Hoax was an extraordinary piece of work that stunned even Edgar Allan Poe, who had been hard at work on a new installment of his own hoax when Locke's story first hit the streets. His project paled in comparison, and he soon abandoned it. At first, Poe was outraged that someone had stolen his idea.[32] But later, he reportedly wrote that Locke's hoax "was, upon the whole, the greatest hit in the way of sensation—of merely popular sensation—ever made by any similar fiction in America or Europe."[33] This remarkable episode from the history of American journalism points out the ironic conclusion that, had contemporary fabricators such as Stephen Glass and Janet Cooke, who like Locke possessed a genius for making up entire stories out of whole cloth, lived in an earlier epoch, they might have been viewed not as pariahs but as among the most clever and illustrious literary figures of their time.

It was, of course, the guise of journalism that helped to sell Locke's fiction as truth. In the years since then, the press-created hoax has continued to live on in a fashion, through every changing fad and era. In 1958, it was Ralph Gleason, a jazz columnist for the *San Francisco Chronicle,* who decided to turn the world on its ear one day by reporting a surprising new trend among hipsters and musicians of the Beat Generation, who supposedly were starting to turn their backs on hipness to embrace something called "the Up-Beat." The mischievous Gleason reported conducting an interview with one such trendsetter, a sax player named Shorty Pederstein, who had deserted his former life of beards and sandals to find new peace at a swank Nob Hill address. Now clean-shaven, he lounged around in tennis togs.

"We eschew the verbal shorthand popularly supposed to be the language of this in-group," observed the fictional Pederstein to the *Chronicle,* speaking in a style reminiscent of Maynard G. Krebs, "and we re-

ject the death-wish symbolism of the dark shirt and black stockings. The square has come full circle, so to speak. The hipster today is exactly what the tourist doesn't see. What he sees are the other-directed camp followers making themselves over in the image of an in-group they never knew."[34] Beats going square? Upon reading the *Chronicle* hoax, the local bureau of United Press International hopped all over the news and sent it around the world on the wire as its own story, without crediting Gleason. "San Francisco's famed 'beatsters' are shaving off their beards, Jazz Musician Shorty Pederstein explains," the UPI story declared. "The beard has lost its effect and is now respectable. To wear a beard is no distinction. Not to wear a beard is the strongest pattern of nonconformity." The story appeared in hundreds of newspapers around the country. Gleason reportedly was so gleeful over the impact of his fictional interview that he spread copies of the UPI story all over the *Chronicle* newsroom.

Hoaxes committed by the press are customarily timed, fittingly so, for April Fool's Day. One of the most memorable in recent years was written by author George Plimpton and published in *Sports Illustrated* magazine on April 1, 1985. It was a profile of a young baseball pitching sensation the New York Mets were trying to sign. According to Plimpton, Hayden "Sidd" Finch was a gangly six-foot-four Harvard dropout who had wandered around for several years in India and Tibet, become a Buddhist, slept on yak fur, practiced yoga, played the French horn, rarely wore shoes, and possessed the amazing ability to throw a baseball 168 miles per hour with exacting control. The Mets wanted Finch desperately and didn't want the rest of baseball to find out about him, so they were being very secretive about their efforts to attract him, Plimpton explained. The problem was that Sidd Finch couldn't decide whether he wanted a career as a French horn player or as a major league pitcher. The story prompted an avalanche of letters to the magazine from both admiring Mets faithful and skeptical disbelievers. *Sports Illustrated* kept the hoax going for two more weeks before announcing that Plimpton had invented the entire story.[35]

UNUSUAL HAPPENINGS

On October 30, 1938, just over a century after Locke's groundbreaking hoax in the *Sun,* a twenty-three-year-old actor and wunderkind producer named Orson Welles harnessed the credibility and dramatic realism of

journalism to tell a terrifying tale that highlighted the exceptional powers of the broadcasting media to instantly captivate and fool listeners. Welles's Mercury Theater radio enactment of H. G. Wells's science fiction thriller *War of the Worlds,* concerning an invasion of murderous aliens from Mars in rural New Jersey, started innocently enough with the music of "Ramon Raquello and His Orchestra" playing "La Comparsita" from the Meridien Room of the Hotel Park Plaza in New York City. After a few moments, the voice of a network newsman suddenly broke into the program to announce, "Ladies and gentlemen, we interrupt our program of dance music to bring you a special bulletin from Intercontinental Radio News."

The announcer reported "unusual happenings" on the distant planet Mars, including explosions and other violent disturbances witnessed by astronomers at observatories in Illinois and New Jersey. The radio show returned to the music program, which was interrupted repeatedly by the announcer's urgent and realistic-sounding news bulletins. Soon the announcer introduced a news reporter, Carl Phillips, who was on the scene in New Jersey, where he conducted a live interview with an astronomer at Princeton about the unusual outer-space happenings. A jet of blue flame was seen streaming toward earth. Phillips's voice was next heard from the scene of a New Jersey farm near the town of Grovers Mill, where he had rushed after hearing reports that a strange craft had crashed there.

Coincidentally, little more than a year earlier, on May 6, 1937, radio news had broken new ground in cultural impact with on-the-scene news reporting by Herb Morrison of Chicago's WLS, who had witnessed and narrated the crash of the dirigible *Hindenburg* as it happened in Lakehurst, New Jersey. His unforgettable screams as he watched the dirigible slam into electrical wires, catch fire, and plunge to earth, killing thirty-two passengers and crew—"It's burst into flames! . . . Oh, the humanity!"—were etched forever in the minds of those who heard him.[36]

Now the fictional reporter Phillips of "Intercontinental Radio News" was narrating the happenings live in *War of the Worlds,* just as it unfolded before his eyes, for six million listeners on a hundred stations across the country on the CBS radio network. As the reality of the alien landing suddenly hit home for him on the farm in Grovers Mill, the journalist's voice, like that of Morrison at the *Hindenburg* crash, grew more and more compelling and quavered with emotion as he watched the top of the spacecraft begin to stir:

Carl Phillips: Just a minute! Something's happening! Ladies and gentle-
men, this is terrific! This end of the thing is beginning to
flake off! The top is beginning to rotate like a screw and the
thing must be hollow!

Voices: She's movin'! Look, the darn thing's unscrewing! Stand back,
there! Keep those men back, I tell you! Maybe there's men in
it trying to escape! It's red hot, they'll burn to a cinder! Keep
back there. Keep those idiots back!

(suddenly the clanking sound of a huge piece of falling metal)

Voices: She's off! The top's loose! Look out there! Stand back!

Carl Phillips: Ladies and gentlemen, this is the most terrifying thing I have
ever witnessed. . . . Wait a minute! Someone's crawling out
of the hollow top. Someone or . . . something. I can see peer-
ing out of that black hole two luminous disks. . . . Are they
eyes? It might be a face. It might be . . .

(shout of awe from the crowd)

Carl Phillips: Good heavens, something's wriggling out of the shadow like
a gray snake. Now it's another one, and another one, and an-
other one! They look like tentacles to me. I can see the
thing's body now. It's large, large as a bear and it glistens like
wet leather. But that face, it . . . Ladies and gentlemen, it's
indescribable. I can hardly force myself to keep looking at it,
so awful.

　　The eyes are black and gleam like a serpent. The mouth is
V-shaped with saliva dripping from its rimless lips that seem
to quiver and pulsate. The monster or whatever it is can
hardly move. It seems weighed down by . . . possibly gravity
or something. The thing's . . . rising up now, and the crowd
falls back now. They've seen plenty. This is the most ex-
traordinary experience, ladies and gentlemen. I can't find
words. . . . I'll pull this microphone with me as I talk. I'll
have to stop the description until I can take a new position.
Hold on, will you please, I'll be right back in a minute. . . . [37]

The sound effects in *War of the Worlds* were brilliantly rendered—
shrieks of terror as the alien, a huge metallic creature on legs, attacked
the humans; explosions of guns and bombs; the whine of twisting met-
als; bullets whistling through the air; the wails of ambulance, police, and
fire truck sirens; the gruff orders yelled by militia officers; the pleas for
calm from the "secretary of the interior"; the stamping feet and panicked
cries of crowds; the crackling sounds of trees and houses set ablaze by
the fire-breathing beasts from Mars. But more than this, it was the voices
of the journalist and the radio announcer that proved the most effective

at making the terrifying scenes seem real and vivid. In the end, the announcer summed up the night's horrors for the listening audience after the intrepid journalist Phillips was slain by the monster, his charred remains identified in the local morgue:

> *Announcer:* Ladies and gentlemen, I have a grave announcement to make. Incredible as it may seem, both the observations of science and the evidence of our eyes lead to the inescapable assumption that those strange beings who landed in the Jersey farmlands tonight are the vanguard of an invading army from the planet Mars.
>
> The battle which took place tonight at Grovers Mill has ended in one of the most startling defeats ever suffered by an army in modern times; seven thousand men armed with rifles and machine guns pitted against a single fighting machine of the invaders from Mars. One hundred and twenty known survivors. The rest strewn over the battle area from Grovers Mill to Plainsboro, crushed and trampled to death under the metal feet of the monster, or burned to cinders by its heat ray.[38]

History shows that some radio listeners on that Halloween eve were deeply moved, terrified, and panicked. Telephone lines to police and newspapers' city desks were jammed. A few farming families who lived near Grovers Mill fled in terror. So sensational was the effect across the country, as far away as San Francisco, St. Louis, New Orleans, Providence, and Birmingham, that a chagrined Welles felt compelled to issue an apology for scaring his listeners, explaining that it had all been just a radio play. If Richard Adams Locke's Moon Hoax was the most sensational trick in newspaper history, Orson Wells's radio hoax was surely the most distinctive and influential in the new age of broadcasting. And both had conveyed exceptional realism by incorporating aspects of the singular believability of journalism.[39]

Over the past half century or so, however, a fascinating new trend in media hoaxes has emerged in American society: increasingly, the news media themselves are targets of realistic deceptions by crafty and devious citizens who understand the ingredients of "news" in a fast-paced era of heavy media saturation, new technologies, and endless news cycles. These individuals perpetrate hoaxes for a wide array of reasons, including personal amusement, profit, celebrity, and political agitation. But all share a remarkable ability to exploit the industry's relentless hunger for attention and higher audience share, not to mention the basic human instincts that

make journalists so eager to be the first to tell the news, even at the risk of failing to verify the facts before they report them. So many of these hoaxes and practical jokes have proliferated in recent years that they have spawned a burgeoning cottage industry of Web sites devoted to reporting and debunking hoaxes that have been erroneously reported as gospel by various gullible members of the world's media.[40]

Of course, some of the deceptions committed against the media today slip by for a surprising length of time. In the summer of 2003, for example, a local television news reporter in Las Vegas named LuAnne Sorrell was tipped off to an extraordinary story about the development of a new game for male sports enthusiasts called Hunting for Bambi. Her source was Michael Burdick, the inventor of the game and an erstwhile local entrepreneur, who enthusiastically telephoned Sorrell one day to tell her about the growing success of the phenomenon.

According to Burdick, the hunting game featured men who dressed like deer hunters in camouflage outfits and carried nonlethal paintball guns as weapons. Burdick claimed that the hunters paid him between $5,000 and $10,000 each for a chance to roam a patch of desert acreage outside Las Vegas, where they were free to chase down and shoot fleeing naked women, who were paid to act the role of prey. The women could "win" the game if they were able to collect four flags dispersed throughout the acreage. Burdick told the reporter that he paid the women $2,500 if they collected the flags and escaped the game without getting shot during each session and $1,000 if they failed and were hit. This monetary incentive added to the excitement and realism of the hunt, he enthused. For their money, the male hunters not only enjoyed the unusual attractions of the "sport" but also received a video of their adventures to take back home, including shots of the men posing proudly with their naked spoils. Burdick told Sorrell that some of the hunters came from as far away as Germany.

As any reporter would have been, especially a reporter covering America's "Sin City," Sorrell was deeply intrigued by this tale and went out to interview Burdick, who arranged for her to talk to a few of the women and the hunters about the sport and to witness a demonstration. During the interview, Burdick showed Sorrell what appeared to be very realistic video scenes from recent games in the desert brush, with panting, well-endowed women, some of them showgirls from the Las Vegas casinos, fleeing from men who were stalking them with paint guns in hand. It all seemed perfectly credible to Sorrell, who next did the sort of thing any good reporter would do: she sought to provide context for the

story by interviewing a noted local psychologist. After Sorrell described the hunt to him, the expert weighed in on the sport's possible effects on the general level of violence directed against women in society. Sorrell did not, however, find any other sources to confirm whether real "Bambi hunts" had ever taken place.

Sorrell's report, which aired on July 10, 2003, on CBS affiliate KLAS *Eyewitness News,* was a corker. An anchor introduced it with breathless urgency: "It's a new form of adult entertainment," the anchor proclaimed, "and men are paying thousands of dollars to shoot naked women with paint ball guns. They're coming to Las Vegas to do it. This bizarre new sport has captured the attention of people around the world, but Channel 8 *Eyewitness News* reporter LuAnne Sorrell is the only person who has interviewed the game's founder."[41]

As Sorrell told the story in her narrated voice-over, video scenes rolled from a recent "hunt" outside Las Vegas, with a woman's genital region and breasts discreetly blurred out. The report featured on-camera interviews with Burdick and his players:

> George Evanthes has never been hunting. "Originally I'm from New York. What am I going to hunt? Squirrels? Someone's cats? Someone's dogs? I don't think so," said Evanthes. Now that he's living in Las Vegas, he's finally getting his chance to put on his camouflage, grab a rifle and pull the trigger. But what's in his scope may surprise you. He's not hunting ducks or deer, he's hunting naked women.

There were even arcane details about the rules of the hunts that only added credibility to the astonishing report:

> Burdick says safety is a concern, but the women are not allowed to wear protective gear—only tennis shoes.
>
> Burdick says hunters are told not to shoot any woman above the chest, but he admits not all hunters follow the rules. "The main goal is to be as true to nature as possible. I don't go deer hunting and see a deer with a football helmet on so I don't want to see one on my girl either," said Burdick.
>
> The paint balls that come out of the guns travel at about 200 miles-per-hour. Getting hit with one stings with clothes on, and when they hit bare flesh, they are powerful enough to draw blood.
>
> Evanthes shoots one woman and says, "I got the one with the biggest rack."
>
> Gidget is the one who took the paint ball shot to the rear. She says, "It hurt. It really hurt. I didn't think it was going to be that bad." When asked if she cried she says, "yeah, a little bit."
>
> So why does a woman agree to strip down and run around the desert dodging paint balls? Nicole says it's good money.

Next came the words of wisdom and insight from the serious psychologist, who by virtue of merely commenting on the "sport" added even more realism to the tale:

> Marv Glovinsky is a clinical psychologist. He says Hunting for Bambi is every man's fantasy come true. "You might think of all men as little boys who have never grown up, so they entertain their adolescent fantasies and they go through life being adolescents on the hunt."
> But Glovinsky says this so-called game that mixes violence with sexuality can be dangerous for men who cannot distinguish fantasy from reality, and acting out the violence in this game could lead to them acting out real violence.

News of Sorrell's story from the gaming and vice capital of the world—a story that seemed eerily plausible—soon traveled worldwide. Reuters spread word of the KLAS piece around the globe on its newswire, and MSNBC, Fox, and CNN quickly reported it, too. Religious leaders and politicians reacted strongly. "Las Vegas is a place where anything goes," said the city's outraged mayor, Oscar Goodman, "but this crosses the line." He vowed to shut the business down. Women's rights groups, including the Nevada Coalition Against Sexual Violence and the National Organization for Women, condemned the game as dangerous exploitation. "It's appalling, and it's really frightening," Rita Haley, president of NOW's New York City chapter, told the *New York Post*. "It says something about the men who want to play this game and something about the financial climate that drives women to participate. The big fear is that somebody who plays will eventually want to use real bullets."[42]

Paintball enthusiasts decried the wrongful and sexually degrading uses to which the weapons were being put to use, saying that the game cast their own sport in a bad light. Gun advocates, including the senior editor of *Gun Week,* a publication sponsored by the right-wing Second Amendment Foundation, reportedly weighed in with the opinion that the men in the "Bambi" hunts were not true sportsmen but were "depraved" and "sickos."[43] From there, Sorrell's story took on a life of its own. The U.S. Bureau of Land Management announced that it would conduct its own investigation based on officials' speculation that the hunts were taking place without permits on public property (with the federal government owning nearly 90 percent of the land in Nevada).[44] Even officials at the Walt Disney Company reacted to the news and began to consider legal action over the unseemly and wrongful use of the name "Bambi."[45]

Not unexpectedly, the curious new sport triggered an avalanche of reaction by newspaper columnists, who wrote about everything from its

sociological and sexual implications to the evidence it offered of American moral and cultural decline. The headlines blared:

MAKING WOMEN TARGETS IS PERVERSE

PIG'S IDEA TO HUNT WOMEN IN DESERT HURTS US GUYS

BAMBI HUNT PAINTS AN UGLY PICTURE OF WOMEN

In tabloid fashion, the *New York Post* proved the most creative: "LOADED FOR BARE—PAINTBALL HUNTERS 'STALK' NAKED VEGAS BABES."[46] There was even editorial rumination about the original animated character "Bambi" in the classic 1942 Disney film. One observer pointed out that Bambi was in fact a "buck," not a "doe," in the film and concluded that he could hear Freud "laughing in his grave" over the psychological implications of the misguided presumptions about the animal's name and gender.[47]

Fox News talker Bill O'Reilly, on his program *The O'Reilly Factor,* a big-tent feature attraction of its own in the American media carnival and a show where talk, bombast, and sensation serve as substitutes for professional journalism, seemingly took LuAnne Sorrell's story the farthest. O'Reilly invited the entrepreneur Burdick and one of the hunted "prey," a shapely woman named "Julia," to discuss the sport during a live on-air interview. For a view from the "other" side, presumably in acknowledgment of the need for journalistic fairness and balance, the show also invited a former prosecutor, Wendy Murphy, who teaches at the New England School of Law, to appear.

O'Reilly milked the sensationalism factor for all it was worth right at the start of the segment:

> *O'Reilly:* In the "Back of the Book" Segment tonight—again, this next story is not for children—in Las Vegas, you can pay thousands of dollars to stalk naked women with paint guns. It's sad but true. . . .
>
> All this is repulsive to many people, but is it illegal?
>
> Joining us now from Las Vegas is Michael Burdick, the founder of this game, and one of the women who works for him, goes by the name of "Julia." "Julia," do you think this might be a little demeaning to you and other women, to allow yourself to be stalked by guys with paint?
>
> *"Julia":* I don't think so. I had a lot of fun doing it, and I didn't see anything wrong with it.
>
> *O'Reilly:* No, I don't know if anything's wrong with it. I mean everybody decides that on their own, but it's—it . . .
>
> *"Julia":* Right.

> *O'Reilly:* It puts you in a position as a woman, as an American woman, where you're basically pandering to some kind of bizarre instinct, does it not?
>
> *"Julia":* I don't believe that at all. I figured it out as a game, and I had fun doing it, and that's all that mattered to me.[48]

O'Reilly next turned to Burdick, arguing that the hunting game might "take advantage of ladies like 'Julia,' who, you know, want to have some quick money, and—you know. Don't you feel bad about this?" To which Burdick replied, "No," adding that the game had started from a desire to have fun with an old joke line by comedian Steven Wright—"Women: Can't live with them, can't shoot them." From there, he said, the whole thing "just blew up." Burdick told millions of American viewers, "I mean it was a great process that just took off, and we started getting bombarded [with] e-mails from women and men alike that wanted to be hunted and hunt."

Finally, the expert weighed in with her view:

> *Wendy Murphy:* You know, Bill, you asked Mr. Burdick if there was
> *(former prosecutor)* anything that he found uncomfortable about this? I mean—of course—and you put your finger right on it. Of course he's not uncomfortable. He's making a fortune exploiting women, taking advantage of the fact that this is a society where violence against women is celebrated, and we should be ashamed of that, not encouraging it, and . . .
>
> *O'Reilly:* All right, but wait. Wait. "Julia" wants to be exploited. She's sitting there making some money that she probably couldn't make anywhere else. She wants to be exploited. And if it's paint, you know, I mean I don't know if you can tie that into violence against women, can you?
>
> *Murphy:* Look, of course, this is violence against women, and it's all too real. This isn't a video game which are objectionable enough. This is real.[49]

But as it turned out, none of it was real. The only indisputable element in the story was Burdick's flair as an entrepreneur. He had succeeded in drawing attention to his video sales business by feeding the media carnival's insatiable appetite for sensationalism. There was no real Bambi Hunt. Burdick had staged all the video scenes, with his friends as actors, in the hope of selling the videotapes on his Web site for $20 each to pornography enthusiasts. To promote his videos, Burdick had claimed that the hunts were genuine in order to gain news exposure and publicity. He

was also savvy enough to recognize two key factors that would make the story credible: having it told by a journalist, of course, but also making sure that the story tapped into a part of American culture where one could easily imagine such hunts and abasement of women to be normative and true. Two weeks after Sorrell's first report, when the Las Vegas mayor's investigators got to the bottom of the story and found out that it was all a scam, Burdick was hit with misdemeanor charges of operating a business without a license. News outlets around the world were forced to retract the story, but by then Burdick was chortling all the way to the bank. The hoax worked. His Web site, www.huntingforbambi.com, where the name of his business is now trademarked, today features testimonials to the publicity the hoax attracted, including blurbs from ABC, CNN, Fox, MSNBC, CBS, NBC, Howard Stern, Jay Leno, and *USA Today.*

Burdick's hoax was one in a long line of similarly oddball but successful pitches crafted by con artists who were able to profit as a direct result of their ability to sucker the press. The most remarkable of modern times was the work of a war memorabilia dealer from Stuttgart, Germany, named Konrad Kujau. In the early 1980s, Kujau grew obsessed with learning how to mimic Adolf Hitler's handwriting. After two years of practice, Kujau became so good at forging der Führer's script that he decided to write a daily diary in Hitler's hand covering the years of his rise and fall between 1932 and 1945. The result was a monumental work of some sixty-two volumes that combined elements of madness and pure inventive genius, which Kujau then set about trying to sell to the press.

Telling a German reporter that he had acquired the bound journals from a former Nazi general in East Germany who had rescued them from a crashed airplane near the end of World War II, Kujau sparked a frenetic bidding war for what became known around the world as the "Hitler Diaries." A top German historian and handwriting expert, called in to examine the journals, vouched for their authenticity, escalating the intense media interest. Alas, chemical analysis soon revealed that the paper on which Hitler had supposedly penned his daily thoughts had not been manufactured until years after the war's end. This and other evidence proved that the journals were little more than crude forgeries, and Kujau was soon sent off to jail to serve five years for fraud.

But all this occurred only after much of the world's news media had accepted the hoax, including *Stern* magazine, which paid $4 million for the rights to publish the diaries. *Newsweek*, which had been granted rights to read portions of the diaries, trumpeted the story on its May 2, 1983, cover: "SPECIAL REPORT: Hitler's Secret Diaries." Inside, the magazine ran more

than twelve pages of stories, with headlines such as "Hitler's Secret Diaries," "Hitler and the Holocaust," and "The Hitler Diaries: A Scholar's Appraisal." *Newsweek* also printed numerous excerpts from the phony journals—"The English are driving me crazy," "I'm beginning to think [Himmler] is out of his mind," "How on earth does Stalin manage it?"— and reported that the journals "provide glimpses of Hitler's innermost thoughts and even of his sex life and his relationship with Eva Braun." While expressing caution that the diaries could yet prove fake, the magazine nonetheless thundered on: "Ultimately," one article proclaimed, "the diaries may lead to revisions in the history of the Nazi era."[50]

SWINGIN' ON THE FLIPPITY-FLOP

While Burdick, Kujau, and their ilk clearly had profit in mind, other hoaxers seem to revel more in the simple celebrity they gain by causing mischief and mayhem in the news media. Consider the peculiar career of one Joey Skaggs, a self-described "multimedia artist" who has spent the better part of forty years scamming the news media with hoaxes. He is something of a patron saint and pioneer of what he calls a form of performance, or conceptual, art, in which he considers the news media his "art medium" or canvas.[51]

In 1976, for example, Skaggs invented a mythical business, a "Cathouse for Dogs," which he advertised in the *Village Voice*. The ad invited dog owners to bring their sexually deprived pets to his New York City shop, where for $50 they could treat Fido to sexual intercourse with another dog. The mythical dog bordello business attracted phone calls not only from potential customers but also from the New York City news media, including WABC-TV News and the *SoHo News,* which issued an outraged editorial against the business.[52] In 1986, Skaggs appeared on ABC's *Good Morning America* program as "Joe Bones," the owner of a New York–based business called the "Fat Squad," which employed beefy, full-time workers as live-in enforcers to physically restrain overweight clients from eating and otherwise breaking diets in their own homes.[53] He has masqueraded as "Kim Yung Soo," a businessman soliciting New York City pet shelters for dogs to use as meat in his soup business in South Korea; as a self-styled leader of a new civil rights organization called Gypsies Against Stereotypical Propaganda; and as an activist Roman Catholic priest roving the city's teeming sidewalks offering "religion on the go" for spiritually minded pedestrians. Each prank was reported as news by the New York City press.

As recently as 2000, Skaggs devised a hoax that fooled the *Los Angeles Times, Mother Jones* magazine, and numerous radio stations. He concocted a business called the "Final Curtain," complete with a Web site, to satirize the funeral industry. It was a kind of funeral theme park, art gallery, and cemetery where artists and other Americans with a creative sense could live their final days in time-shares, eat in restaurants with death-related themes like "Dante's Grill," design their own tombstones, and even pick a site for their passage to eternity. "Death Got You Down?" the advertisement for Skaggs's mythical business read in the *LA Weekly* and the *Village Voice*. "At Last, An Alternative!" As the Web site for the Final Curtain observed, "Death faces us all, but there's a lack of imagination which accompanies our passage. Until now the handling of death has been regimented and boring, limited by those who control it, whether the state, church, morticians or our survivors. At the Final Curtain, we are throwing away all the rules."[54]

Why do such harebrained notions of news still find credence in modern journalism? The reasons are many. As Skaggs told an interviewer for *U.S. News and World Report* several years ago, "The media's job is to question a premise, but information overload and the strain to get a story first [get] in the way of getting it right."[55]

But sometimes it's even simpler than that. A young Seattle woman named Megan Jasper perhaps best exemplified how remarkably easy it can be for practically any ordinary citizen in modern America to hoodwink even the most respected news organizations hungry to tell a story. In 1992, Jasper, then an independent record producer with expertise in Seattle's grunge music scene, grew exasperated after fielding call after call from journalists around the world inquiring about this strange but compelling new phenomenon and its growing impact on fashion and music. As Jasper later explained it, she was surprised by the credulity of the journalists who knew so little about the grunge subculture yet were determined to ferret out details about its nature. The journalists, she said, had a "weird idea that Seattle was this incredibly isolated thing." She said she realized that she could tell them anything. "I could tell [them] people walked on their hands to shows," and the journalists would believe it.[56]

One day, on the spur of the moment, Jasper did just that, in an interview with a reporter for a British music magazine. She simply made up whatever weird stuff came into her head. She explained that Seattle grungers regularly used a new kind of vocabulary, or code, that only they understood. She told him, for instance, that grungers called torn jeans

"wack slacks." An "uncool" person was a "lamestain." "Bound and gagged" meant that the grunger was staying home on a Friday or Saturday night, while "swingin' on the flippity-flop" meant that he or she was hanging out.

Assigned to report on the grunge movement in Seattle, a *New York Times* reporter eventually ran across the British magazine story in the course of his research, and naturally he too turned to Megan Jasper, grunge record producer, for expert knowledge. The result was a long, well-written, and colorfully descriptive article featuring the grunge movement and its counterculture habitués, published on November 15, 1992, in the new Styles of the Times section of the nation's newspaper of record.[57] It included a short sidebar article headlined "LEXICON OF GRUNGE: BREAKING THE CODE." Sure enough, there was the long list of grunge slang terms as Jasper had defined them for the reporter, including "harsh realm" (a bummer), "kickers" (heavy boots), "cob nobbler" (a loser), and "tom-tom club" (uncool outsiders).[58]

The *New Republic* was the first to widely report the hoax two months later, after Jasper herself admitted it in an interview with the *Baffler,* a Chicago-based cultural magazine. The *Baffler* article, referring to the publisher of the *Times,* was titled "Harsh Realm, Mr. Sulzberger!" By then, the story of Jasper's masterwork had become well known throughout the iconoclastic grunge movement in Seattle, where one local record company was reportedly selling t-shirts for $10 each stenciled with the words "Lamestain" and "Harsh Realm" on the front and a reprint of the entire *Times* sidebar on the back.[59]

In 1982, a researcher named J. Barton Bowyer wrote a revealing book investigating the nature of fraud, deception, and cheating in many fields of endeavor in culture and society. The book, which possessed the dazzlingly hyperextended title *Cheating: Deception in War & Magic, Games & Sports, Sex & Religion, Business & Con Games, Politics & Espionage, Art & Science,* provided an interesting theoretical framework for examining how people have practiced fraud throughout history and how and why it succeeds. The study aspired to be comprehensive, involving players as disparate as Uri Geller, Adolf Hitler, Josef Stalin, David and Goliath, virgin prostitutes, the Trojan Horse, convicted pyramid schemers, Al Capone, and General George Tecumseh Sherman, among multitudes of others, in its somewhat eccentric pages.[60]

Bowyer divides cheating and deception into two categories, "Hiding the Real" and "Showing the False." Under "Hiding the Real," he describes techniques such as "Masking," "Repackaging," and "Dazzling";

while "Showing the False" features methods such as "Mimicking," "Inventing," and "Decoying." The book argues that cheating and deception have long played a central role in human experience and points out some of the historical ironies that have resulted, including the story about how one of history's most diabolical deceivers, Stalin, became one of its biggest dupes after making a pact with Hitler. Its analysis of gambling and gaming offers timely context that helps explain, for example, the enormous popularity of televised poker tournaments in recent years on cable channels, in which such skills of deception are on riveting display. But the book offers surprisingly little analysis of journalism or the mass media, though many of the same factors seem relevant.

"Hiding the Real" and "Showing the False," and all the accompanying techniques Bowyer describes, are often front and center in U.S. popular culture and media, where hoaxes remain very much alive and at times exceptionally effective. Our culture seems saturated with them; as a society, we are in some ways more enchanted by the lie than by the truth because lying can be so much more entertaining. How else to explain the national publicity, cultural resonance, and millions of dollars in revenue lost by the Wendy's fast-food chain in 2005 after the devious hoax in which a woman claimed to have found a human finger in her bowl of chili? How else to explain the frenzy of media attention that same year devoted to the "Runaway Bride," a Georgia woman who disappeared for a week and then crafted an elaborate tale about being kidnapped and bundled off to New Mexico, when she was only trying to escape her impending wedding?

In movies, television, and radio, the hoax continues to enjoy a vigorous life. It has been a recurrent theme of Hollywood entertainment, from the days of *Meet John Doe* (1941), the classic Gary Cooper and Barbara Stanwyck film based on a reporter's hoax about a populist hobo decrying social inequity during the Great Depression; and *Ace in the Hole* (1952), starring Kirk Douglas as an unethical New Mexico newspaper reporter whose outsized ambitions lead him to concoct a news hoax that proves deadly. From Allen Funt's hoax-related *Candid Camera* programs of the 1960s to the modern age of MTV's *Punk'd* and other programs of its ilk, television producers have capitalized on the entertainment value of the lie and the hoax. Not long ago, the cable network Spike TV aired as one of its first original offerings a reality-show hoax featuring actor William Shatner as part of a Hollywood crew purportedly making a movie on location in the small rural town of Riverside, Iowa. The movie was a fiction; instead, the reality show, titled *Invasion Iowa,* aimed to

ridicule the citizens of Riverside as it recorded the reactions of the "hay-seeds" to the film crew and stars who suddenly had appeared in their midst and were ostensibly about to make their town famous.[61]

In addition, there is the amazingly long-lived hoax that provides the premise of the splendidly singular *Da Ali G Show* on the Home Box Office channel. In this odd reality-based show, the incomparable British comedian Sacha Baron Cohen stars in three different roles, the main one that of a flamboyant "hip-hop" journalist from London named Ali G. (He also starred in *Borat*, a 2006 feature film, as a boorish journalist from Kazakhstan exploring the U.S.) Often wearing oversized and yellow-tinted shades, a goatee, a peculiar-looking skull cap, and other attire that seems to blend baggy hip-hop with the working-class East End of London, Ali G travels around the United States promoting his fictional British news program and somehow manages to get on-air interviews with an array of leading American public figures in politics, business, entertainment, and news media. The show's "hook" is that these otherwise circumspect and intelligent figures unfailingly take Cohen seriously in his guise as a foreign "reporter," no matter how wacky or incomprehensible his behavior is.

Television reporter Sam Donaldson, Andy Rooney of CBS's *60 Minutes*, former secretary of state James Baker, former United Nations secretary general Boutros-Boutros Ghali, former member of Congress Newt Gingrich, and a squad of southern evangelical church leaders—all took part in presumably serious sit-down interviews with the freaky Ali G in the 2004 season. During an interview about the war in Iraq with fiery archconservative television gabber and occasional presidential candidate Patrick Buchanan, Ali G kept referring to the Bush administration's failure to find "BLTs" on the ground in Iraq. Listening intently to the fake journalist as they conversed, Buchanan inexplicably used the same acronym (which stands for a bacon, lettuce, and tomato sandwich), referring to Saddam Hussein's use of "BLTs on the Kurds in the north" instead of using the correct acronym for weapons of mass destruction—WMDs.

The *Phil Hendrie Show* is similarly premised on a continuing hoax. Broadcast nationally on more than 150 stations each night, this radio talk show is hosted by the Los Angeles–based Hendrie, who is known as the "man of a thousand voices." Hendrie's voice characterizations include a wide range of fictional characters such as "Ted Bell," a rich restaurateur with contempt for the problems of the less fortunate; "Steve Bosell," a litigious crybaby who frequently files lawsuits against neighbors, co-workers, and even his own family for perceived picayune hurts;

and "Doug Danger," a self-described "gay man and gay journalist" who finds homophobia in nearly everyone he meets.

Hendrie's "talk show"—which he describes as a send-up of the talk show genre that defines much of today's radio landscape—consists mainly of Hendrie as a supposedly objective public affairs interviewer questioning his imaginary "guest" of the night. He uses an in-studio microphone for his own host voice and a telephone microphone for the voice of his "guest," who thus seems to be on the phone with him. This acrobatic act works because Hendrie is adept at performing both ends of the question-and-answer talk show format, smoothly switching roles. As the objective moderator, Hendrie takes seriously the news topics his "guests" bring to the nightly discussion.

One night, the first hour of Hendrie's three-hour show featured "Chris Norton," an entrepreneur with a business called "Dream Date," which catered to "unattractive" college women who hadn't been invited to their proms. For a fee, Norton, a self-described "male model," could be hired to chaperone them. The second hour featured "Tony Neale," who offered a service called "White Eye for the Black Guy," which offered to teach black men how to navigate day-to-day society in a manner that was "less intimidating" to whites. Neale wanted to school black men about how to act on busy downtown sidewalks, in department stores, and at the bank, where he would teach them "how to write a check." Although the topics are decidedly provocative and outrageous, the show's real gag is provided by the ordinary listeners who call in from around the country with their opinions, which are often angry, emotional, and confrontational.[62]

At times, Hendrie's show is original and inventive and provides a sharp satire of the general inanity of many radio and television call-in talk shows. But it is also a disturbing program. Hendrie is shameless in his frequent use of racial and ethnic stereotyping in his voice characterizations. Among the show's regular "visitors" are the bloodthirsty Arab American "Raj Faneen," the lazy Hispanic welfare recipient "Dave Oliva," and the ignorant and crude African American woman "Clara Bingham." Hendrie stereotypes Jewish lawyers, Korean shop owners, Catholic priests, and others, exploiting, pandering to, and relentlessly reinforcing the most bigoted attitudes about race, religion, and ethnicity. Even for the listener who is in on the "joke," Hendrie's nightly hoax can be a depressing experience that is in some ways no less demeaning to minorities than racist comedy programs like the *Amos 'n' Andy* radio show of the 1940s—an old-style minstrel show, replete with slurs like "rag-

head," "wop," and "jungle bunny," updated and made to order for America's airwaves in the new millennium.[63]

PRINTING THE LEGEND: JOURNALISM AND MYTH

With the prevalence of fraud and deception in popular Western culture, society has traditionally relied on professional journalism to sift the real from the fake, especially when the issues are vital and the truth matters most. But, as we've seen, the news media often seem just as gullible as the rest of us, and at times their failure has serious repercussions.

In April 2004, a time of intense national debate about Britain's role in the war in Iraq, anonymous sources contacted editors at one of the nation's largest newspapers, the *Daily Mirror* in London, and presented them with shocking photographs that depicted British soldiers abusing and torturing Iraqi detainees. The most disturbing image showed a soldier urinating on a prisoner, who sat cowering in the corner of a flatbed army truck with his head encased in a hood, his wrists bound behind him, his shirt torn open. The photographs surfaced during the same week that images of American soldiers abusing Iraqis at Abu Ghraib prison in Baghdad were being widely published, and the *Mirror*'s editors were convinced that the British photos were genuine. On May 1, 2004, just three days after CBS's *48 Hours* broke the news of the Abu Ghraib scandal in the United States, the tabloid *Mirror* published its front-page account of British torture and abuse of prisoners. Labeled a "World Exclusive," the story's headline read "VILE . . . But This Time It's a BRITISH Soldier Degrading an Iraqi," and was accompanied by a full-page photo of the soldier relieving himself over his captive, whose hood and chest were soaked with urine.

The story and the photos created an enormous furor in Britain. Prime Minister Tony Blair was under constant and withering assault by opponents and the press, including the *Mirror,* for his decision to join the U.S. invasion of Iraq; and the *Mirror*'s story only fueled the opposition's claims that the conflict was morally wrong and unnecessary. The story and photos, which were also reprinted in numerous newspapers in the United States, forced the British government to launch an intensive investigation. For days, the *Mirror* stood by its story, insisting that the scandal vindicated its editorial position opposing the war. Then, on May 13, after army investigators located the truck depicted in the pictures, the government announced that the photos couldn't possibly have been taken in Iraq and that they had probably been faked. The vehicle was sta-

tioned at a barracks near the town of Preston and had never left England. Someone had apparently staged the photos to agitate against the war, but the effect was in some ways the opposite after the hoax was revealed: Blair's government was vindicated, not damaged, and the press itself was widely criticized. On May 14, the editor who had approved the story was fired, and the *Daily Mirror* apologized for the error in a headline that took up the entire front page: "SORRY . . . WE WERE HOAXED."[64]

But equally if not more disturbing is the government's use of similar elements of fraud and hoaxes in its dealings with the news media, particularly during times of war, and the media's frequent acquiescence to such deception. On March 16, 1968, during the Vietnam war, for example, U.S. Army public relations officials told a group of American reporters gathered for a daily press conference in Saigon about the successful start of a campaign known as "Operation Resolved to Win." The army officials claimed that hundreds of Communists had been killed over the previous six days in an elaborately planned series of attacks employing U.S. and South Vietnamese ground troops, tanks, and helicopter gunships on the northern coast and in the suburbs of Saigon. There had been no loss of American lives, the officials reported. That same day, United Press International (UPI) sent its press conference story via wire to America's newspapers. This is how the first three paragraphs of the story about the campaign ran in one of those newspapers, the *Albuquerque Journal*, the next day:

DRIVE KILLS 216 REDS IN SAIGON

SAIGON (UPI)—American and Allied troops killed 344 Communists Saturday, 216 of them in Saigon suburbs with U.S. tanks spearheading the Vietnam war's biggest campaign.

American spokesmen said that battles 35 and 16 miles from Saigon pushed to about 500 the number of Communists killed since some 40,000 Allied troops launched "Operation Resolved to Win" six days ago.

On the northern coast, 330 miles from Saigon, U.S. soldiers rode helicopters in an assault that trapped and killed at least 128 Communists.[65]

To the army, the operation represented yet another mission accomplished in a war the government assured Americans was winnable. It wasn't until more than a year later that the truth about the third paragraph of the UPI story—a story also carried by the Associated Press and run in many newspapers across the country[66]—was fully revealed, in an investigative story by freelance journalist Seymour Hersh, who was then working for Dispatch News Service, an alternative press agency. The hel-

icopter assault had in fact occurred at a village called My Lai, where American soldiers had committed one of the war's worst atrocities against civilians, rounding up primarily elderly men, women, and children and gunning them down in a ditch. Some were bayoneted; some of the women were raped. The report that "128 Communists" had been killed was something of a hoax of war—in fact, between 350 and 500 unarmed civilians had been murdered in cold blood. The truth came out largely as a result of a persistent letter-writing campaign to Congress, the White House, the Pentagon, and finally the press by an outraged soldier named Ron Ridenhour who had heard about the atrocity from former fellow soldiers who had witnessed it. Ridenhour wanted the world to know the truth, and his efforts finally led to an army investigation. The officer in charge of the operation, Lt. William L. Calley Jr., was eventually convicted of murder. Without Ridenhour, it's entirely possible that the army's hoax would still be considered truth.[67]

A more recent example of government deception is also telling about the persistent power of official myth to bury truth. Shortly after the 9/11 attacks on America, Pat Tillman, a popular and highly paid National Football League player, suddenly decided to give up his multimillion-dollar football contract in order to join the U.S. Army Rangers with his brother and take up the fight against terrorism. Tillman was hailed as a role model, a patriot, and a hero for his sacrifice. When word came on April 22, 2004, that Tillman had been killed in action while on a Special Forces patrol in the mountains of southeastern Afghanistan, the nation immediately mourned his loss. The army reported to the news media that Tillman, whose unit had been assigned to seek out and kill Taliban and al-Qaeda fighters, had died in a medical treatment facility in Afghanistan after his vehicle had come under indirect and direct assault from "enemy forces." An April 30 press release declared that shortly before he was killed, Tillman had "ordered his team to dismount and then maneuvered the Rangers up a hill near the enemy's location. As they crested the hill, Tillman directed his team into firing positions and personally provided suppressive fire. . . . Tillman's voice was heard issuing commands to take the fight to the enemy forces."[68]

Tillman was posthumously awarded the Silver Star for valor. His brother, Kevin, also a U.S. Army Ranger in Afghanistan, was with Tillman's unit at the time of his death but did not witness the assault. Kevin flew back to the United States with his brother's body. On May 3, several thousand mourners attended an emotional memorial service for Pat Tillman in his hometown of San Jose, California, where they and a na-

tional television audience heard Arizona senator John McCain say that Tillman had given "a lesson in the true meaning of courage and honor." They also heard a fellow soldier remark in an address that Tillman had "died trying to save fellow [soldiers] caught in a rush of enemy fire." Television features that night and newspaper headlines the next day, May 4, echoed the *San Francisco Chronicle,* which hailed Tillman as "A True Hero Athlete." He "Answered the Call of Battle," the *Atlanta Journal-Constitution* asserted, as the *San Mateo Times* reported, "War Hero's Death Touches Even Those Who Never Met Him."

Yet even as all this drama was playing itself out, army officials knew that the details of Pat Tillman's death were very different from the statement they had given to the world. They knew the truth on the day Tillman had been killed. But they chose to withhold the details not only from the press but even from Tillman's family, in an effort to sustain a myth. Pat Tillman had certainly been a hero in answering a call to duty. But the truth was that he had been killed not in an ambush by enemy troops but by his own fellow soldiers, after a tragic series of events and miscommunications that had led them to fire on each other. The army's narrative about Tillman's death was a deception, a hoax, intended to protect both his remarkable legend and his fellow soldiers. The army attempted to correct the record on May 30, revealing that Tillman "probably died of friendly fire while his unit was in combat with enemy forces."[69]

The full truth about the circumstances of Pat Tillman's death did not reach the public until more than seven months later. It was a story riddled with egregious and indefensible errors of judgment by panicked officers in the field; destruction of evidence pointing to criminal negligence by fellow Rangers, including the burning of Tillman's uniform and other effects; and cover-ups by army officials determined to prevent the truth from coming out. The *Washington Post* reported the story in a two-part investigation that condemned the military for deceiving the public and Tillman's family. Reporter Steve Coll, who had investigated army records and interviewed participants in the tragedy, wrote:

> The records show Tillman fought bravely and honorably until his last breath. They also show that his superiors exaggerated his actions and invented details as they burnished his legend in public, at the same time suppressing details that might tarnish Tillman's commanders. . . .
> Friends and family describe Pat Tillman as an American original, a maverick who burned with intensity. He was wild, exuberant, loyal, compassionate and driven, they say. He bucked convention, devoured books and

debated conspiracy theories. He demanded straight talk about uncomfortable truths.

After his death, the Army that Tillman served did not do the same.[70]

That the truth can be a frequent casualty of war was certainly borne out by the Tillman story and the contrast between the facts and the hoax-like narrative army officials initially released. In a sense, the episode was evocative of the lessons expressed at the climax of a 1962 Western starring John Wayne and James Stewart, *The Man Who Shot Liberty Valance*, a film that highlights the journalistic dilemma of whether to tell the truth or sustain a myth. The plot of the John Ford classic revolves around the killing of a brutal outlaw, Liberty Valance, who long had terrorized the territorial town of Shinbone. James Stewart plays Ranse Stoddard, a young lawyer, new in town, who is robbed and beaten by the outlaw. John Wayne is Tom Doniphon, the fastest gun in the territory, a poor rancher in love with the same pretty girl, Hallie, as Stoddard.

Stoddard is determined to practice law in Shinbone and to help the territory achieve statehood. But when Valance brutally beats Stoddard's friend, the local newspaper editor, and burns down the office, the lawyer decides to take the law into his own hands and kill Valance, even though he doesn't know how to use a gun. Hallie, played by Vera Miles, is frightened and begs Doniphon to help him. Soon Doniphon realizes that Hallie is in love with the lawyer, not with him. Stoddard meets Valance on the main street for a nighttime showdown, and he miraculously manages to shoot him dead. The town is amazed and overjoyed. The people at last are free of the bully. The legend is born. Stoddard, "the man who shot Liberty Valance," goes on to lead the territory to statehood, marries the pretty Hallie, and rides his fame to become the state's first senator.

The climax of the film is Stoddard's return to Shinbone from Washington, D.C., for the funeral of his old friend Doniphon, who has died alone, a pauper. A reporter for the local newspaper wants to know why the famous and successful senator should want to pay his last respects to such an anonymous man. As he sits beside the coffin, Stoddard for the first time tells the full truth about what happened the night of the shooting, a truth he has kept secret all those years at Doniphon's order. The lawyer hadn't killed Valance at all. Doniphon, realizing that Valance would surely kill Stoddard, fired at the outlaw in the darkness at the

same time Stoddard managed to get off a wayward shot. It was Doniphon's bullet that had killed the villain, not his. The rancher performed the deed only because of his love for Hallie, and he told Stoddard to keep it secret for Hallie's sake, too, so that the lawyer could win the nomination as a territorial leader. Stoddard had always hated his reputation as "the man who shot Liberty Valance," knowing that it was built on a lie.

Upon hearing this story, the news reporter at first doesn't seem to know what to do, since the truth conflicts with the legend he and the rest of society have all come to believe. But then the journalist starts tearing up his notes.

"You're not going to print the story?" the senator asks.

The reporter replies, "No sir. As our late great editor used to say, 'It ain't news. This is the West. When the legend becomes fact, print the legend.'"

The words conveyed a certain poignancy in the film. The journalist concluded that the lie about the elected leader and the myth about the state's birth had to be protected and sustained because it was deemed better for all concerned, including democratic society, than the truth. But in real life, such crimes must have no place or application in professional journalism, perhaps especially in an age of relentless information saturation, when people badly need clarity and fact. Indeed, the acceptance of lies by unchallenging journalists arguably remains perhaps the greatest threat to true justice and democratic society, as recent times reveal. That many dogged journalists do not accept such lies—even in the face of intense pressure—says a great deal about a troubled craft whose mission today is arguably more vital to democracy's health than ever, especially when so many forces seek to undermine it.

Indeed, as we will next see in the American carnival's world of illusions, these influences are at times so tricky, deceptive, and effective that citizens should be excused if they find it increasingly difficult to separate out exactly who is a professional journalist from the many pretenders elbowing for space on the scene. And citizens should also be excused if they find it harder and harder to tell which news is really *news* these days and which works are something else entirely.

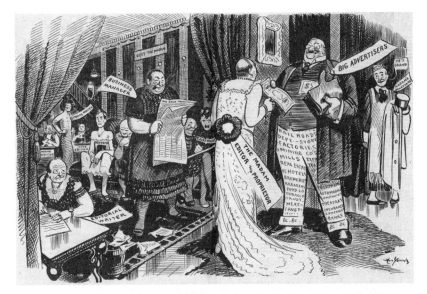

Art Young's cartoon "Freedom of the Press" appeared in the radical magazine *The Masses* in December 1912. This theme, which depicts the newsroom as a brothel, with the press vying for the favors of advertisers and the politically powerful, has been revisited by generations of media critics. (Courtesy of the Bancroft Library.)

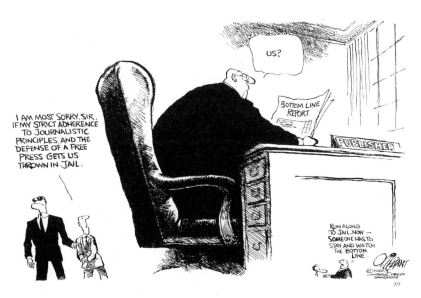

Pat Oliphant's 2005 cartoon about the failure of media corporations to protect journalists illustrates the often tense relationship between the mission of a free press and its for-profit ownership. (Oliphant © 2005 Universal Press Syndicate. Reprinted with permission. All rights reserved.)

Jayson Blair and Jack Kelley are among the most notorious plagiarists and fabricators in contemporary journalism. (Photo of Jayson Blair by Mayita Mendez, © 2003, *Newsday;* photo of Jack Kelley courtesy of Associated Press/*USA Today*.)

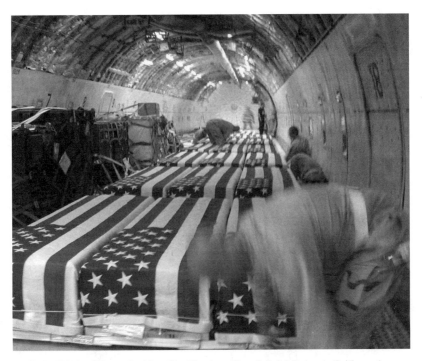

Tami Silicio's 2004 digital photographs of the coffins of American soldiers who had died in Iraq signified the growing power of citizen journalism. After receiving them via e-mail, the *Seattle Times* published the photographs in defiance of government restrictions; the newspaper's decision to publish the photos of the coffins being shipped back to the United States met with widespread public approval. (Photo by Tami Silicio/ZUMA Press.)

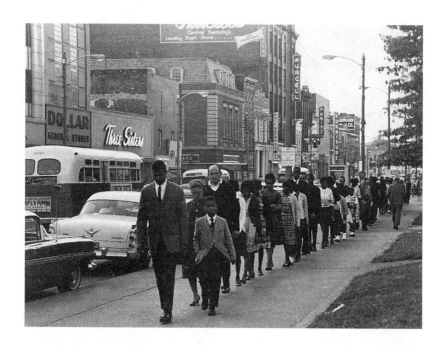

A collection of photographs by Calvert McCann depicting the black civil rights struggle in Lexington, Kentucky, in the 1960s—including marches, sit-ins, and boycotts—was published by the *Lexington Herald-Leader* on July 4, 2004. The paper's editors ran the photographs alongside a series of stories in which they acknowledged that the *Herald-Leader* had intentionally neglected to cover the movement at the time. (Photos courtesy of Calvert McCann.)

Protesters gathered outside the headquarters of Sinclair Broadcasting in 2004 after the corporate media giant refused to air on its local stations an ABC News/*Nightline* report that memorialized American soldiers who had died in Iraq. This was one incident in a long history of self-censorship in the American media. (Associated Press photo/Hans Ericsson.)

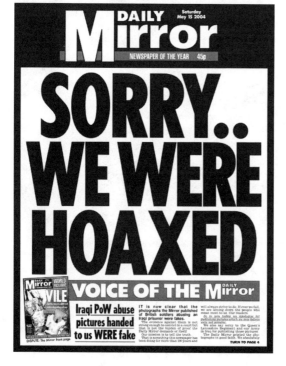

Hoaxes—such as Orson Welles's powerful radio production of *The War of the Worlds* in 1939 and the faked photographs of British soldiers abusing Iraqi prisoners sent to London's *Daily Mirror* in 2004—have accompanied the rise of nearly every form of communications technology, from newspapers to radio to television to new media. (Associated Press photos.)

4

World of Illusions

To the average American viewer, the story must have looked and sounded for all the world like a typical television news segment. The subject: new Medicare legislation only recently passed by Congress and signed by President George W. Bush, and the supposed benefits it would bring to millions of elderly Medicare recipients and prescription drug buyers around the country. Officials of the Bush administration, including Health and Human Services secretary Tommy Thompson, seated at a desk before an American flag, were interviewed on camera, all strongly touting the new law. Additional background visuals—known as "B-roll" in broadcast industry jargon—featured shots of the president signing the bill into law at a White House gathering of cheering supporters; pharmacists counting out pills from behind a drugstore counter; and a few smiling and vibrant elderly Americans engaged in a variety of activities: getting their blood pressure checked by a physician, accepting prescriptions, and playing cribbage.

At one point, the story featured a pleasant exchange between a pharmacist and an elderly customer:

> *Pharmacist:* "[This new benefit] helps you better afford your medications."
> *Customer:* "It sounds like a good idea."
> *Pharmacist:* "A very good idea."

All the while, a confident and poised female narrator could be heard explaining the details of the new law. She ended her voice-over with a credible and authoritative journalistic sign-off: "In Washington, this is Karen Ryan reporting."[1]

The story was smoothly produced, professionally edited, and fast-paced. It was specifically designed to fit easily into the common rhythms of typical local newscasts, and it succeeded splendidly. During a two-week period in January 2004, local television news producers aired it at least sixty-four times on more than forty small- to mid-market stations in various parts of the country, and millions of Americans viewed it. Indeed, if the *New York Times* had not disclosed the true origins of the story two months later, during that contentious presidential campaign, it might well have gone largely unexamined and unremarked—just another ninety-second piece among hundreds of such news stories saturating local airwaves daily and filtering into our subconscious in a media age when news and information cycles are relentless.

But when the *Times* reported on its front page on March 15 that the segment had actually been produced not by an independent news operation but by a Washington, D.C.–based public relations firm under contract with the Department of Health and Human Services (HHS) to disseminate pro-administration reports in the guise of "news," a national firestorm erupted.[2] Democratic Party leaders and news commentators assailed the White House for spending millions of taxpayer dollars to distribute propaganda through the news media and for misleading unsuspecting citizens about the nature of what they were seeing. In fact, local stations had aired the video news releases without identifying them at any point as government productions.

"Clearly, it's improper," railed Senator Edward M. Kennedy, "and clearly it's outrageous to use Medicare beneficiaries' money for campaign slogging, and that's what this is all about."[3] *Newsday* columnist Linda Winer reflected the outrage and disgust expressed by an overwhelming number of the nation's editorial writers and other professional journalists when she wrote: "So now we have it: the tax-supported government infomercial, intended to fool people into thinking that their very own newscasters had investigated the plan for prescription-drug coverage and found it wonderful indeed. . . . There are laws against impersonating a police officer and against practicing medicine without a license. At the risk of appearing ridiculously idealistic about my battered profession, I believe that fake journalism can be equally destructive."[4]

Today, when the credibility and economic sustainability of modern journalism are frequently analyzed and debated, few threats to the news

industry's public standing pose as lethal a challenge as scandals involving editorial fraud. For a profession expressly dedicated to truth and accuracy, what could be more damaging than the public exposure of systemic deceptive practices? Such crimes arguably are to professional journalism what intentional malpractice resulting in wrongful death is to the profession of medicine, what cooking the books of a publicly traded company is to accounting, or what judicial bribery that fixes a verdict is to law and justice. And few press controversies in recent times seemed to encapsulate as many of the moral challenges facing journalism as did the incident that became known around the nation as the "Karen Ryan story."

Here was a remarkable tale involving nearly every volatile theme stewing at the center of the profession's troubled, confused, and changing identity. Here was a self-styled reporter with apparently questionable ethics who seemed willing to sell her integrity in order to make a buck. Here was the government spending millions of dollars in public money to spread propaganda through seemingly unquestioning news media that failed to protect citizens' right to the truth about a highly controversial issue—in this case, Medicare reform, which critics were decrying as a billion-dollar gift to American drug companies. Here was a highly sophisticated public relations firm earning immense profits by disguising political advertising as journalism in order to lend it credibility. And here were the economic hard times of a corporate television news industry that has slashed reporting budgets so sharply over the past two decades that news operations increasingly rely on fake news generated by PR outsourcers to fill airtime and to maintain high profit margins for shareholders.

But perhaps most revealing was what happened in reaction to the Karen Ryan episode—and what *didn't* happen—in the weeks and months that followed. While government, the advertising and PR industries, and other sectors took significant steps to publicly address the ethical issues involved in the use of video news releases and to openly explain and hold their offices accountable, the news media themselves—especially the scores of local television stations that had broadcast the Ryan stories—did and said very little. Instead of examining their practices and how their systems had failed, most insisted that it was the government and the PR firms, not the stations, who had violated the public's trust. The transparency and accountability that journalistic organizations typically demand of government were stunningly lacking in the news media's reaction, in the analysis of the media's central role in the scandal, and in the broadcasters' failure as gatekeepers of information disseminated to the public. Here was the

civic entity presumably most dedicated to light and truth apparently unable to fashion a comprehensible response to the scandal apart from hollow, self-righteous outrage or a peculiar silence that seemed vaguely protective of a dirty secret about industry practices.

Within a few days of the *Times* article, more information about the Karen Ryan story trickled into the press. The segment turned out to be part of a $124 million public relations campaign funded by the Bush administration to spin government policies favorably in the news media—an allocation bigger than the annual budgets of most local television news operations. A similar PR-produced story about the Medicare law, also narrated by a self-described reporter, Alberto Garcia, had aired on Spanish-language news stations at about the same time.[5] The stories had been sent to local stations with an accompanying script for news anchors to read as an introduction. For the Ryan story, the introduction began this way: "In December, President Bush signed into law the first-ever prescription drug benefit for people with Medicare. Since then, there have been a lot of questions about how the law will help older Americans and people with disabilities. Reporter Karen Ryan helps sort through the details." Several stations aired this introduction verbatim before showing the Ryan story.

An angry spokesperson for HHS, William Pierce, quickly defended the department's motives by telling reporters that such PR practices were nothing new and that video "news releases" and video "handouts" had been common practice at HHS and other government offices for years. He pointed out that under the Clinton administration in the 1990s, HHS had produced such advertising for Medicare policies, disguised as news stories. "Yes, we are trying to influence the news," Pierce told *Television Week,* an industry trade journal. "That's what a news release is." He added that it was up to each station to decide what to do with the material. "There is no way this can be deceptive," he asserted. "If they run the whole package, that's their choice."[6]

Pierce's explanations did little to dampen the growing tumult, though, and at least eighteen professional journalism organizations soon took steps to demand that the government reform its practices. One group, the American Society of Newspaper Editors (ASNE), dashed off a letter to HHS secretary Thompson imploring the administration to "stop using deceptive practices." "Certainly, material distributed to television stations that doesn't identify the government as the source and ends with a voice-over such as 'In Washington, I'm Karen Ryan reporting' is outside

the bounds of ethical behavior for HHS or any other government agency," wrote ASNE's president, Peter Bhatia.[7]

Meanwhile, the figure at the center of the maelstrom, Karen Ryan, was verbally batted around like a piñata by moralizing commentators and journalists on the evening cable news talk programs. The debates centered almost exclusively on the allegedly unethical and deceptive practices of the Bush administration and PR firms and on Ryan as the new public face of journalistic mendacity. The frenzy reflected a typical media pattern in which an individual is demonized instead of the system in which such deceptions are allowed to flourish. Although Ryan was arguably the least blameworthy figure in the dispute, she was assailed as a sellout and professional fraud. One program, Chris Matthews's *Hardball* on MSNBC, likened her to a whore:

> *Matthews:* Let me go to Howard. Is this going to be a little bit of a bump in the road for the administration when it's trying to counter the charge of deception, lying, and all that stuff, that's putting out an ad that's clearly deceptive?
>
> *Fineman:* Well, I don't know if this one itself will catch on, but I think it was a pretty outrageous thing to do. But I'm sure it reflects the White House's view of the role of journalists.
>
> *Matthews:* Yes. Hire one. Hire one. Turn them into a hooker and then say they're the real thing, you know . . .[8]

In the wake of the controversy, a number of government and professional institutions did take immediate steps to examine the ethical issues it raised for their work and to hold their offices publicly accountable. Leading the way, pressed by congressional Democrats, was the federal Government Accounting Office (GAO), the investigative arm of Congress, which convened a special panel to study the video news releases produced by HHS and its Centers for Medicare and Medicaid Services (CMS). The GAO's final report, issued on May 19, was a seven-thousand-word document that presented exceptional background and valuable history about the rise of video news releases (VNRs) as sophisticated new tools of the PR industry throughout the 1990s and their increasing use by local television news operations.[9]

The report noted that the market for video news releases has burgeoned in recent years in part because they can be easily and quickly distributed by independent transmitters such as CNN's Newsource. This distribution branch of CNN uses digital tools to send numerous PR story packages, or "bundles," directly to local stations each day via satellite. Fox, the Associated Press, and NBC also operate electronic news trans-

mission services, which collect substantial annual fees both from VNR producers and from the broadcast stations that subscribe to the services. The transmissions include everything from real news gathered by journalists to advertising disguised as news, with no industry standard or strict ethical codes in place to clearly distinguish the VNRs from works of journalism. This distribution and marketing system allows VNR producers to be associated with a prestigious corporate news name like CNN and also saves them the trouble of contacting local stations directly.

The GAO report pointed out that even though the distribution services label most video news releases differently than actual news reports, many local television producers who ran the Karen Ryan VNR mistook it for a CNN work of journalism, since it had been transmitted by CNN Newsource. Although most stations use only B-rolls or parts of VNRs to help fill out their own independent reporting on the same topics, many stations do indeed regularly use VNRs to fill airtime. The growing use of such "fake" news has created ethical problems throughout the television news industry, the GAO study concluded, especially since so many VNRs, like the Karen Ryan story, are apparently broadcast by local stations without clearly identifying the producers of the pieces as special-interest groups.

According to the GAO panel, the key issue for HHS was whether it had practiced deception in its use of video news releases and whether it had broken rules against using federal funds for propaganda in its effort to sway the public about the Medicare reforms. Anthony H. Gamboa, the GAO general counsel, wrote:

> The story packages and lead-in scripts . . . were clearly designed to be seen and heard directly by the television viewing audience and not solely by the media receiving the package. CMS and HHS officials told us that the story packages were designed so that television stations could include them in their news broadcasts exactly as CMS had produced them, without any production effort by the stations. . . . Evidence shows, and CMS acknowledges, that the story package could be broadcast without edit or alteration, and actually was broadcasted unedited in some markets. Television audiences viewing the story packages were not in a position to determine the source from the other materials in the VNR packages.[10]

The panel concluded that HHS had failed to clearly identify itself as the source of the VNR and had deceptively created the appearance of an independent news story, using individuals who portrayed reporters but in fact had been hired by an HHS subcontractor. It further concluded that HHS had violated federal prohibitions against using taxpayer funds

for covert publicity and propaganda. In many ways, the GAO panel and its final report represented a model of transparency and accountability, a government agency publicly facing a controversial issue involving ethical practices in the executive branch. It took its oversight function seriously, targeted ethical faults, and recommended sanctions.

The federal government was not alone in this spirited and very public self-examination. Public relations professionals and advertisers nationwide also debated ethics in the weeks after the Ryan controversy, explaining the use of video news releases as valuable and influential tools of public information. The discussions in respected trade publications and magazines covering the PR industry were insightful, engaging, and at times bitingly witty about the failure of the U.S. news media to understand or even recognize PR trends that had been under way for decades. "The *New York Times* has been in a blissful Rip Van Winkle–like slumber for the past ten years, but the paper of record finally awoke this month and was startled to find out that the government is paying for video news releases to win support of its policies," read an editorial about the Ryan affair in *O'Dwyer's PR Services Report.* "We wonder how many stories in the *Times* are based on press releases. We are perplexed how journalists feel that print releases are okay, while video releases are the handmaidens of the Devil."[11]

In that same issue of *O'Dwyer's*, VNR producers strongly defended their use of journalistic techniques to disseminate advertising through news stations: "Are video news releases, by their nature, deceptive?" wrote Greg Hazley. "Is the video PR industry capitalizing on understaffed newsrooms racked by cutbacks?" "By the news reports, we in the industry look like we're trying to pull a fast one with the viewers," said Kevin Foley, president of KEF Media Associates in Atlanta and a former newspaper reporter and PR executive. "The media are the filter here and they have to pass judgment on what airs. They are certainly not unwitting victims. If we can provide quality news content, why wouldn't they consider airing it?"[12]

Anita Chabria, writing in *PR Week,* addressed the challenges ahead for VNR producers in the aftermath of the Ryan controversy and the question of how public relations firms could continue to make sound advertising in the form of "news" stories for local stations while also protecting the image of their clients from the ethical flak:

> The underlying issues remain daily concerns for PR pros who have relied on video news releases for more than 30 years. Some in public relations have even expressed hesitancy to use them in the future, or at least until memo-

ries of the Ryan controversy fade a little further. But scrapping video news releases altogether isn't the answer. Instead, experts say, the trick is to maintain high ethical standards and quality production values to craft video news releases that are both usable for news stations and that generate exposure for paying clients. "The first step in creating a good video news release and avoiding any confusion is to be up-front," says Doug Simon, president and CEO of the production and event company DS Simon Productions. "What we do by definition is advocacy. It's not journalism," he says. "If you communicate that to the station, then they know that. It's about accuracy, and it's identifying the funding source. From my point of view, that is the entire ball game in terms of protecting your client from a negative response."[13]

Chabria offered suggestions, culled from a wide range of experts in the PR field, that VNR producers could use to make sure their works remained effective:

Do clearly identify the footage as a video news release.

Do provide a "package" that will allow stations to build their own story from the provided footage.

Do make sure all facts are accurate.

Don't use the word "reporting" in your VNR if anyone other than an independent journalist is speaking.

Don't try to hide the client—broadcasters are fine with VNRs as long as they are identified.

Don't distort the facts. All that will do is harm your client's credibility.[14]

The Public Relations Society of America (PRSA), the industry's largest professional trade organization, with more than twenty-eight thousand active members, echoed and codified this advice for its members in the group's official publication, *Public Relations Tactics*. While reaffirming that the video news release remained "a basic PR tool used by corporations, organizations, and other entities to provide news content to television stations, and thus communicate with the public," the organization acknowledged that the Ryan controversy showed the need for "a better understanding of the role and usage of video news releases." PRSA noted that "three principles are at work here: A VNR is the television equivalent of a press release and, as such, should always be truthful and represent the highest in ethical standards. Producers and distributors of video news releases and the organizations they represent should clearly and plainly identify themselves. Television stations airing video news releases should identify sources of the material."[15]

Public relations expert Paul Griffo, who wrote the PRSA article, ana-

lyzed the Ryan controversy and then offered three recommendations to the trade group members:

> 1. Organizations that produce video news releases should clearly identify the VNR as such and fully disclose who produced and paid for it at the time the VNR is provided to TV stations.
>
> 2. PRSA recommends that organizations that prepare video news releases should not use the word "reporting" if the narrator is not a reporter.
>
> 3. Use of video news releases or footage provided by sources other than the station or network should be identified by the media outlet when it is aired. . . .
>
> PRSA supports the use of video news releases as useful PR tools. They will continue to be effective when practitioners adhere to the highest standards of practice as described above.[16]

The debates over ethics that took place among government regulators and public relations professionals alike were comparatively open, healthy, and informative. As for the person at the center of the debate, Karen Ryan herself was equally forthright and strongly defended her work, while expressing outrage that she had been made a scapegoat for the news industry's failings. Stung by the attacks on her integrity by the press and ridiculed in monologues by Jay Leno on the *Tonight Show* and Jon Stewart on the *Daily Show,* Ryan answered back with a blistering essay in the trade journal *Television Week*.[17] Describing herself as the owner of a small public relations business, Ryan insisted that she had been hired only to perform a voice-over for the HHS spot. A former news reporter and producer for ABC and PBS, with a "professional career of more than 20 years in television news," Ryan resented the media's cheap shots concerning her ethics as a PR professional and suggested that journalists take a look at their own set of ethics:

> I've been called a hooker on national TV, a phony by a large Ohio newspaper and an actress by the newspaper that prides itself in having "All the News That's Fit to Print." Yet if the truth had been accurately reported, these are boldfaced lies promulgated by journalists who violated one of the basic rules of their trade: Check your facts.

She identified herself as "a proud public relations professional" and stated that she had done "nothing wrong" by accepting the contract to provide the voice-over. She also noted that she was merely the subcontracted bottom rung of a long public relations ladder that originated with the multimillion-dollar contract the Bush administration had bestowed on the PR corporate giant Ketchum, Inc. Ketchum had been engaged to advertise White House initiatives in the guise of journalism. Video news

releases were central to that publicity effort, Ryan explained, adding that public relations experts were simply doing their jobs in disseminating such works. She pointed out that video news releases had become far more accepted in local television news than television journalists seemed willing to admit publicly. She charged, however, that American journalism was not doing its job of effectively filtering that information for the public:

> Today's news organizations are bombarded with information, 24–7. How it is reported or disseminated is where the journalistic debate begins. The role of the reporter or journalist is supposed to be as gatekeeper of that information, with the innate responsibility to verify its truth or dig deeper. . . .
> There is something wrong when a clearly marked video or print news release is used by a news organization without questioning its source or factual basis.

"WELL, THIS IS SILLY. WHOEVER DID THAT?"

So what did the forty local television news operations who aired the HHS video news release have to say publicly about their role in the scandal? Amazingly little. Many local news station producers defended their standards by pointing to the generally accepted ethical code adopted by the Radio-Television News Directors Association (RTNDA). Among several provisions under the heading "Truth," the code states that professional electronic journalists should "clearly disclose the origin of information and label all material provided by outsiders."[18] (Video news releases are not specifically mentioned in the RTNDA code, which was most recently amended in 2000, and the RTNDA has no powers of enforcement.)

The Society of Professional Journalists issued a one-page press release, written by Gary Hill, head of the society's ethics committee, which decried the Bush administration's use of video news releases and the "professional laziness" of the television stations that aired the HHS segment.[19] But apart from that note of criticism, and a minor reform soon announced by CNN Newsource in which the network vowed to better identify and distinguish VNRs from actual news feeds, there was little public discussion, self-examination, or self-criticism in the industry. In the immediate aftermath of the Ryan episode, the news media announced few if any changes in practices.[20]

One station director in Nashville, however, was remarkably candid about his station's use of the HHS segment, after Jon Stewart's *Daily Show* on the Comedy Central network "outed" the station nationally.

Stewart had acquired both the HHS video news release and a list of all the local stations that had broadcast it, including Nashville's WTVF. The *Daily Show* then aired the story with the Nashville station's call letters, chosen at random from the list, superimposed on the screen, in a segment lampooning the news media's complicity in the VNR imbroglio. The *Daily Show*'s coverage of the story represented a weird, through-the-looking-glass experience in which a program consisting of fake news was telling the truth about a legitimate news operation's use of fake news.

Revealingly, it was only when he heard about the *Daily Show*'s segment focusing on his station that the Nashville news director, Mike Cutler, discovered that WTVF had aired the VNR. An embarrassed Cutler told the *Nashville Tennessean*:

> I read the *New York Times* article and said, "Well, this is silly. Whoever did that?" And I didn't say, "Gosh, maybe I should look," after I read the article. I didn't even think that it could be us. . . . We do three hours of news in the morning. I suspect that the producer of the 7 A.M. hour probably said, "Well let me see if there's something fresh on the feeds that we haven't already run in the last two hours" and, in searching, said, "Well, here's a Medicare story. Let me plug that in." . . . It's our fault for taking it and believing it to be 100% unbiased. But I don't fault a dairy farmer for saying we should drink more milk. And if the Republican administration wants to put out something that says we've done a good thing for Medicare, they have a right to free speech just like anyone else. But as watchdogs, we should be questioning those things.[21]

Deborah Potter, the executive director of the Radio-Television News Directors Foundation, seconded that view and provided some interesting background on the growth of the video news release industry. In an article in the *American Journalism Review*, she wrote, "Using video news releases to push products and policies has been common practice for two decades or more. Thousands of these videos are produced every year. Groups from county governments to multinational corporations rely on video news releases to get their message out. It's often cheaper than buying advertising and more credible to the audience." Some VNRs, she argued, were in fact very helpful, providing stations with "newsworthy video they couldn't get any other way—like crash tests from the Insurance Institute for Highway Safety, or b-roll of a new medical procedure. But viewers deserve to know if what they're seeing is a handout from a commercial or government source."[22]

Potter linked the ethical problems surrounding the use of VNRs di-

rectly to bottom-line economics in the television news industry: the reason more than forty stations aired the government's Medicare video, she explained, "is that many television newsrooms are so thinly staffed they can't possibly produce enough news stories of their own to fill all the hours of programming on their schedules. No one should be surprised to learn that video news releases can and do get on the air as 'news helper.'"[23]

No one?

No one, perhaps, except millions of unassuming American consumers of news and information who have *not* been informed by news broadcasters about the extent to which such fake news from third-party sources has seeped into the nation's newscasts over the past ten years. Instead of investing in better journalism, many news operations have instead focused on cutting costs and editorial staff, with the paradoxical result that while they have more and more airtime to fill with news, they have fewer practitioners of professional journalism to fill it. The situation is tough for local operations as well as the news networks, where the number of full-time salaried news correspondents today is one-third fewer than in 1985.[24] It is in this vacuum that "fake" news appears to be flourishing, a problem that was first reported by David Lieberman in a 1992 *TV Guide* cover story titled "Fake News: A Special Report; What We See Isn't Always News—It's Public Relations":

> Most VNR material looks so realistic it's hard for viewers to tell the difference. But don't blame the PR pros for doing their jobs. If you are confused about what news is real, and what's fake, the fault lies with the newscasters. The vast majority ignore the pleas of their own trade group—the Radio-Television News Directors Association—to include a label on the screen that identifies the material supplied by non-news outfits. "When that isn't done, even if it's without malicious intent, then there's a problem," says RTNDA president David Bartlett.
>
> If it's so easy to justify with a simple label, why don't stations do it more often? The answer is: *Newscasters have their own images to protect.* Eugene Secunda, a professor of marketing at Baruch College in New York City, points to the essential irony of the problem: "If you are a news director, why would you do anything that might in any way compromise the believability of your program?"[25]

More than a decade later, this moral ambiguity in the nation's news industry has become a full-fledged concern. How many American viewers would believe what they saw—and, more important, how many would continue to watch—if stations were compelled to label every news segment that depended on or was entirely produced by

third-party political, business, or PR sources? If recent studies are any guide, the number of such segments has been growing exponentially, and in ways more alarming than even the most fervent critics of television news could have foreseen. Researchers at the Project for Excellence in Journalism (PEJ), for example, a Washington think tank that conducts annual studies on the state of the news media, media business practices, and the public's attitude toward journalism, reported in an examination of local television news in 2001 that the influence of sponsors and third-party feeds to news broadcasts was soaring. A survey of 118 news directors reported growing direct influence of advertisers and other commercial interests on news content and ever-rising use of VNRs in news broadcasts as a substitute for independent reporting.[26]

Specifically, a series of studies by PEJ examined 33,911 television news reports from 1998 to 2002 and found that the percentage of material from third-party political, advertising, and other sources rose from 14 percent to 23 percent of all reports. (More than 75 percent of all stations used video news releases in some form, according to the studies.) The percentage of stories that included reporting by a local correspondent fell from 62 percent to 43 percent. These trends mirrored similar economic realities on network and cable news levels.[27] Perhaps most disturbing, as the authors of the PEJ series of studies, Tom Rosentiel and Marion Just, later reported in an op-ed in the *New York Times,* few stations were informing viewers that third-party feeds produced by PR firms aired in their broadcasts were not the result of independent reporting:

> In 2001 and 2002, we asked local TV news directors whether they used video news releases from government or other third parties, and if so, whether they identified the source.
>
> In both years, only slight majorities of news directors surveyed said they never ran video news releases (56 percent one year, closer to 60 percent the next). An additional 10 percent said although they used them, they always clearly labeled the source.
>
> But that meant that a quarter to a third of news directors in our surveys showed video news releases and disclosed the source "occasionally," "rarely" or "never." Why would they do that when "press release journalism" has always been considered an insult?
>
> Other evidence provides the answer. For several years, the audience for local news at the traditional times of 6 P.M. and 11 P.M. has been declining. Yet, the news directors reported, the companies that own these stations have generally continued to expect high earnings, usually profit margins in excess of 40 percent.

To meet those demands, most stations have added programming, usually without adding resources. In 2001, when asked "what was new at your station," 29 percent of news directors said that they added programming. The percentage was highest for the stations in the smallest markets with the fewest resources; in those cities, nearly 40 percent of stations had added hours. And fully 71 percent of all stations reported budget cuts.

One news director wrote: "Adding a 5 P.M. newscast. Don't have staff to make it a local show. Tough!"[28]

The wider story of the news media's obliviousness and cavalier attitude toward airing video news releases eventually came to light in March 2005, when the *New York Times* published an investigation of the Bush administration's widespread use of VNRs as tools to spread political messages.[29] The *Times* reported that news directors at many of the forty television outlets that had aired the HHS story didn't even know they had done so—even as they insisted that they objected on ethical grounds to the use of VNRs without proper identification. It was as if the nation's local television news operations were a kind of new-millennium Potemkin village, where producers, journalists, and news directors readily preached ethical standards but where actual practices were something entirely different. A news director at WDRB, for example, the Fox-owned station in Louisville, Kentucky, told the *Times* that she would not allow her station to be co-opted by special interests and insisted that she would never have allowed the HHS story and others like it to air, calling them "inherently one sided." But a check of records kept by Video Monitoring Services of America showed that WDRB had indeed aired at least seven "news" segments produced by Karen Ryan's PR consulting business on behalf of commercial and government clients without disclosing the origin of the reports.

A station director at KGTV, the ABC affiliate in San Diego, was even more forthright about his station's ethics and the use of government and commercial "news" segments, saying, "It amounts to propaganda, doesn't it?" Yet when the *Times* reporters again checked records from the video monitoring agency, they discovered that, from 2001 to 2004, KGTV had aired, at a minimum, more than two dozen reports produced by third-party PR firms for business and government clients without telling viewers where they had originated.

As the *Times* article revealed, inside at least one local news station, and perhaps inside others, treatment of the HHS story had involved a clear intention to deceive the public. When News 10 Now, a cable news station in Syracuse, New York, received the HHS VNR and

script via satellite, news producers decided to try to enhance the credibility of the report by deleting Karen Ryan's voice and instead using one of their own reporters to narrate Ryan's intro and script in nearly the exact language. The episode amounted to a fraud *within* a fraud, with presumed journalists shamelessly plagiarizing the work not of other journalists but of PR advertisers, and with the public none the wiser.

After the scandal broke, many local television news directors seemed to feel that the *less* the public knew about the processes by which news made it onto the air, the better. When the *Times* reporters confronted them with evidence that their stations had indeed aired government- and business-funded news segments produced by PR firms, "most news directors were at a loss to explain how the segments made it on the air. Some said they were unable to find archive tapes that would help answer the question. Others promised to look into it, then stopped returning telephone messages. A few removed the segments from their Web sites, promised greater vigilance in the future or pleaded ignorance."[30]

Despite the revelations, the Bush administration continued full steam ahead with its multimillion-dollar PR campaign. In February 2005, White House officials ordered agencies to ignore the GAO's 2004 decision on the illegality of government-produced "covert propaganda" and to continue freely producing VNRs without being obligated to identify their origin. The U.S. Justice Department and the Office of Management and Budget later distributed a memo arguing that such informational segments were indeed legal, whether or not the true origin of the reports was revealed.[31] Once again, the Bush White House had batted the ethical ball back into the court of the television news industry, practically daring journalists to deal with the central issue of their own abdication of responsibility. "This is not our problem," said HHS spokesperson Pierce. "We can't be held responsible for their actions."[32]

But as the broadcast news media remained conspicuously quiet, it was left to yet another government regulatory office, the Federal Communications Commission (FCC), to take further steps on the video news release controversy. In April 2005, after weeks of protests from citizens and advocacy groups, including a petition written by the Center for Media and Democracy and signed by more than forty thousand Americans demanding that the government crack down on news broadcasters, the FCC issued what it called a "reminder" to stations who had been broadcasting VNRs derived from government sources. The agency declared that the licensed broadcast and cable stations must clearly disclose

"the nature, source and sponsorship" of the material and that "viewers are entitled to know who seeks to persuade them."[33]

The FCC notice sparked a range of reactions in the PR industry. If stations were forced to disclose the origin of third-party material, what form should such disclosure take? A logo in the corner of the screen? A bottom-line crawl? What repercussions would such identification have for the business and credibility of the news organizations that frequently run VNRs and for the lucrative PR industry itself? The appeal of such releases, after all, is that they seem to be independent news reports—wouldn't disclosing the deception undercut their effectiveness? *Advertising Age,* which estimated the VNR business in America at more than $150 million annually, reported that the FCC action could deal a "blow" to the industry. Many PR firms and VNR producers, however, said that while the ruling might have an effect on VNRs originating from political sources, segments produced on behalf of corporate sponsors would be exempt:

> Larry Moskowitz, president, CEO and chairman of Medialink, the biggest producer of VNRs, interpreted the rules as meaning that their origins need only be disclosed if the broadcaster is being paid to run them—which rarely happens. "What we see pretty clearly is that as long as video news releases are delivered from non-government agencies without payment, no disclosure is required. Government material and controversial matters must be disclosed." He called the FCC action "nothing new" and said stations still need to air movie trailers in entertainment segments and car clips in pieces about new cars. "I don't know what stations can do without the material. We don't see any impact. There will certainly be some dust, and yes, people will be questioning, but at the end of the day the industry will evolve."[34]

Not until April 2005 did the RTNDA finally rouse itself to issue new ethical guidelines for news directors that touched on the use of VNRs and the controversies that had roiled the industry. The occasion was the organization's annual convention, which was, fittingly enough, held in the city whose motto is "What Happens in Vegas Stays in Vegas." The new standard declared: "Television and radio stations should strive to protect the editorial integrity of the video and audio they air. This integrity might, at times, come into question when stations air video and audio provided to newsrooms by companies, organizations or governmental agencies with political or financial interests in publicizing the material."[35]

Whether local stations will feel compelled to heed these new guidelines anymore than they heed the ethical rules already on the books to "clearly disclose the origin of information and label all material provided

by outsiders" remains to be seen. According to *Advertising Age,* most experts predicted that some stations "may ask for more information on who sponsors the video news releases, but otherwise do not anticipate that much will change."[36] For many VNR producers, neither the GAO finding, the FCC ruling, the RTNDA's new guidelines, nor an effort by the U.S. Senate to require federal agencies to disclose the origin of their video releases seemed to have much effect.[37]

As Larry Thomas, the CEO of Multivu, a leading PR firm specializing in fake news specifically intended to air on local news programs, put it in a comment to *PR Week:* "Business is fantastic. [It's] better than ever." As recently as April 2006, more than two years after the HHS controversy, and a full year after the RTNDA's new guidelines, the Wisconsin-based Center for Media and Democracy reported that over the previous year at least sixty-nine local television news stations had broadcast fake news segments without informing viewers that the segments had been wholly funded and produced by corporations ranging from General Motors to Pfizer to Capital One. The center also reported that eight out of the ten largest media markets in the country routinely offered these PR segments as real news, and that some stations edited out disclosure of origin provided by the PR firms. One local station, KRON in San Francisco, even admitted that it had turned over nearly three full hours of its five-hour morning news broadcasts during one week in March 2006 to fake news segments funded and produced by the government of Australia, which aimed to showcase tourism in that country in the guise of independent feature reporting. "We're appalled," one demoralized KRON news reporter said. "We essentially let the government of Australia become our news directors."[38]

THE REAL THING

The signal reason the Karen Ryan controversy and the gnarled web of deceptions surrounding the use of VNRs are so significant is that, by a wide margin, most Americans continue to turn to local television as their chief daily source of news and information about the world. Television is by far our most dominant medium, the news tonic of choice for the masses, one that carries remarkable power to shape public opinion. As recently as December 2004, the Gallup organization reported that 51 percent of respondents in a yearly national poll said that they viewed local television as their chief source of daily news, with local newspapers second at 44 percent.[39]

The Ryan episode also crystalized a number of elementary cause-and-effect hypotheses touching on the role of journalism and the news media in a free society. If, for example, local television stations, pressured to increase profit margins and cut costs, employ fewer trained journalists to gather and produce news, the stations must then turn elsewhere to fill airtime and compete in the ratings. If the stations increasingly turn to third-party sources to fill this airtime—including PR firms contracted to produce "news" stories for political and commercial clients—viewers are seeing fewer works of independent, professional news-gathering and more stories chiefly intended not to inform but to influence their political opinions and spending habits. Since most Americans get their news and information from local television, they make decisions at the ballot box and elsewhere based increasingly not on works of independent journalism but on advertising deceptively produced to look like journalism.

In that case, the ideal of a democracy empowered by an informed electorate acting on facts becomes little more than a contorted mockery of itself. We become a society motivated more by illusions and myths than reality, a distortion facilitated by the negligence and complicity of news organizations that are presumed to hold the public's trust sacred but whose practices undermine that trust.

The plain truth is that a truly *journalistic* accounting of the Medicare reform story would have incorporated the already widely reported news that the Bush reforms were extraordinarily controversial, with two distinct and opposing sides deserving of recognition. That is precisely what modern journalism is for, and that is what professional journalists do. Whereas many Republicans touted the new legislation's supposed advantages for consumers, most Democrats decried it as little more than a bonanza for private insurance companies and drug manufacturers capitalizing on the ills of the elderly. The journalistic story—a public service treatment based on independent reporting and possessing a fealty to fairness and accuracy—would have pointed out this conflict of opinions as a matter of course. Only an advertiser, a propagandist, or a similarly biased source with an agenda other than informing the public fairly—or a television news operation too lazy, understaffed, or uncommitted to professional standards to know the difference—would have been motivated to disseminate as blatantly one-sided a report as the HHS/Karen Ryan story.[40]

The comparative lack of accountability, ethical gatekeeping, and journalistic integrity shown by America's local news stations both during and after the Ryan episode hinted at how vulnerable society had be-

come to such manipulative and deceptive practices. But in a larger sense, these episodes of fake news in recent years also point out the extraordinary emergence of journalism itself—or, to put it more accurately, the techniques, the illusion, the *guise* of journalism and journalists—as an increasingly influential and effective vehicle for selling products and political messages in contemporary American culture.

Advertisers have long employed the imagery of popular cultural figures, both real and imagined, to encourage consumers to buy their products. Credibility has always been key to this process: consumers must *believe* if they are to buy. The notion that a product's authenticity can inspire consumer trust is a staple of advertising campaigns, perhaps most famously symbolized by Coca-Cola's "It's the Real Thing" slogan, now nearly sixty years old and still going strong.[41] As part of this relationship between commerce and consumer, it helps to have a trustworthy and believable figure such as a widely admired celebrity—or, even better, a trustworthy and believable vehicle like professional journalism—to hammer the point home. Lydia E. Pinkham, for example, became an unlikely millionaire in nineteenth-century America by producing a vegetable compound laced with booze that was fraudulently billed to cure all manner of "female complaints" and increase fertility. Her company became enormously successful after heavy advertising in newspapers that prominently featured her photograph, depicting her as a smiling, trustworthy, middle-aged housewife and mother, along with the words "The Savior of Her Sex" and "Only a Woman Can Understand a Woman's Ills." If the average American housewife couldn't trust a wholesome figure like Lydia Pinkham, the ads suggested, whom could she trust?[42]

Babe Ruth appeared on boxes of Wheaties cereal as early as 1933 and pitched everything from cigarettes to cars, becoming the first athlete to find success as a major marketing power. He traded on his competitive prowess, baseball heroics, and, perhaps most of all, his smiling, good-guy image as a professional sports figure. Ruth cleared the way for the advertising superstardom of successors such as Michael Jordan. Advertisers have also sought to harness the popularity of Hollywood film actors, such as the beloved "girl next door" Mary Pickford in the 1920s, Robert Young as the neighborly Dr. Marcus Welby in the 1970s, the earnest John Houseman of Smith Barney's "They Earn It" campaigns in the 1980s, and the fedora-wearing, truth-seeking gumshoe Karl Malden for American Express, also in the 1980s. Trusted professions have been pressed into service for advertisers. "Nine out of Ten Dentists Recommend Crest Toothpaste" is perhaps history's most famous dental health

slogan, while medical doctors have been trotted out for both good and ill, all the way back to the peripatetic quacks and hucksters who called themselves "Doc" and tried to sell magic elixirs out of the back of a covered wagon in the prototypical Old West traveling medicine show. "For 100 Percent of What Doctors Recommend Most for Your Pain—Take Bayer Aspirin" was a common slogan in the 1970s, while another ad in the 1950s insisted that "More Doctors Smoke Camels Than Any Other Cigarette."

But when it comes to the relentless enterprise of hawking goods in the American marketplace, in an age when capitalism reigns virtually unopposed throughout the world, few advertising vehicles or characters seem as ubiquitous, as effective, or as largely unrecognized as the "Journalist" and journalism. Whose role in democratic society rests more fundamentally on the sheer virtue of credibility than a journalist's, after all? Whose civic function is tied more squarely to a presumption of believability, knowledge, and trust? To the average American, what purpose does a journalist serve other than to know things and report the truth? It is precisely because of these presumptions of credibility and trust that advertisers seek to use the illusion of professional journalism as a tool of commercial persuasion. The Frito Bandito, Mr. Clean, Charlie the Tuna, the Energizer Bunny, Tony the Tiger, Mr. Whipple, Smokey the Bear, the AFLAC duck, Elsie the Cow, the Dutch Boy, the Marlboro Man, Morris the Cat, Mobil's Pegasus, Snap, Crackle, and Pop—time to make room for the Journalist in the long cavalcade of effective and persuasive American ad figures.

It's no accident that everyone from Bush administration propagandists to Madison Avenue advertising executives are working to harness this masquerade of journalism to reach American consumers. The fact is that the trick seems to work. This ascendancy of the *illusion* of journalism as a vehicle for political and commercial advertising has been a long time coming—press releases written in news style for print media on behalf of political and commercial clients date back at least a century, for example—but it has gained speed and overtness over the last two decades. It's not just that PR professionals like Karen Ryan and many others are pretending to be journalists and public affairs interviewers on the nation's airwaves—and doing the job convincingly. It's also that advertisers have become astonishingly sophisticated at churning out ads that resemble journalism in all areas, from photos, print, and video to radio and the Internet. And revenue-hungry newspapers and magazines, along with federally licensed broadcasters, seem eager to disseminate these works.

In truth, the public relations techniques of fusing advertising with the illusion of "news" and credible, third-party endorsements for commercial and political products boast a long tradition, starting with American newspapers. Historians point to examples from the early twentieth century, in which advertisements were disguised and embedded in news articles, even in reputable dailies such as Joseph Pulitzer's *New York World*.[43] A modern Internet successor to this old-fashioned sleight-of-hand is the use of embedded hyperlinked ads in news articles published on the Web, in which an unassuming reader rolling the mouse on certain underlined words and phrases will suddenly find commercials popping up on the screen.[44]

Today, the once ham-handed and tawdry techniques of illusion from long ago have morphed into a modern PR mega-industry employing thousands of workers, a billion-dollar enterprise encompassing everything from VNRs and infomercials to advertorials and "infotainment." Aspects of faux journalism in service to product marketing and political persuasion are found nearly everywhere in the print and broadcast media. You can't flip through a newspaper or magazine without seeing display ads dressed up to look like news and feature articles. Although newspaper and magazine codes of ethics require that such ads be accompanied by disclaimers, the disclaimers are often so tiny and inconspicuous as to be virtually undetectable—intentionally so, to avoid drawing the reader's attention to the deception. On television and radio, talk show "moderators" join self-professed "experts" to hype products on half-hour commercials disguised as "public affairs" programs or journalistic interviews, where viewers or listeners are encouraged to phone in for mail-order products.

We are awash in Orwellian terminology pointing to this extraordinary fusion of reality and fakery, a lexicon manufactured by the machinery of PR and a willing press. Information, the commodity central to the work of journalism, has been merged with commercials, a form of broadcast advertising, to create the term *infomercial*. Documentary and commercial have led to *documercial*. Information and entertainment have fused to become *infotainment,* while advertising and editorial have united in the expression *advertorial*. Strategic product placement on reality TV programs such as *Survivor, The Simple Life,* and *American Idol* has given birth to the term *entermercial*. We even have *informercialtainment,* a hideous construction crafted recently by Madison Avenue television advertisers to describe in a more fetching manner the commercial spots that Tivo users prefer to skip while replaying television progams.[45] The

thrust of much of this language, of course, is to validate the highly sub-jective aims of advertising by melding them with the values of authentic information and independent journalism, even though the aims and val-ues directly oppose each other.

Barely more than a quarter of a century ago, in 1976, E. B. White, the scholar, essayist, English-language stylist, and steadfast defender of civil and press liberties, took on the Xerox Corporation, *Esquire* magazine, and the accomplished journalist Harrison E. Salisbury over the moral problems underlying this issue of journalism and its relationship to forces opposing its mission. Salisbury, recently retired from the *New York Times,* had accepted $55,000 in salary and expenses from Xerox to write "Travels in America" for *Esquire,* a series of pieces to com-memorate the nation's bicentennial. His commission was part of a larger business contract between the magazine and Xerox, in which Xerox also purchased $115,000 in advertising to accompany the articles, the first of which was published in February 1976.

The arrangement provoked criticism on editorial pages across the country. When White, a longtime *New Yorker* essayist and Pulitzer Prize winner, read the Salisbury article and heard about the deal, he immedi-ately embarked on a crusade against it. He wrote a letter to the editor of his local newspaper, the *Ellsworth American,* near his farm in Brooklin, Maine, calling the arrangement a "disaster" for freedom of the press. A long exchange of letters between White and Xerox officials ensued and was later published in the *Authors Guild Bulletin,* a quarterly publica-tion of an organization dedicated to protecting authors' rights. White was seventy-six, retired, and no longer writing much, but the Xerox deal with Salisbury infuriated him. As he told the *New York Times,* "It made me jump. And when I jump, I jump in the direction of a typewriter."[46]

Although Xerox had guaranteed Salisbury absolute editorial control over his work, White insisted that the journalist's independence couldn't help but be compromised. More important, White was distressed that the arrangement would establish an alarming precedent for the practice of modern professional journalism. More companies, he feared, perhaps even government, would be tempted to use similar tactics to covertly or overtly influence journalism and public opinion. "Whenever money changes hands, something goes along with it, an intangible something that changes with the circumstances," White wrote to Xerox. "It would be hard to resist the suspicion that *Esquire* feels indebted to Xerox, that Mr. Salisbury feels indebted to both, and that the ownership, or sovereignty, of *Esquire* has been nibbled all round the edges." White continued:

A funded article is a tempting morsel for any publication—particularly for one that is having a hard time making ends meet. A funded assignment is a tempting dish for a writer, who may pocket a much larger fee than he is accustomed to getting. Sponsorship is attractive to the sponsor himself, who, for one reason or another, feels an urge to penetrate the editorial columns after being so long pent up in the advertising pages. These temptations are real, and if the barriers were to be let down I believe corruption and abuse would soon follow. Buying and selling space in news columns could become a serious disease of the press. If it reached epidemic proportions, it could destroy the press. I don't want I.B.M. or the National Rifle Association providing me with a funded spectacular when I open my paper. I want to read what the editor and publisher have managed to dig up on their own—and paid for out of the till.[47]

White then recalled his on-the-job training in journalism in the 1920s under a legendary magazine editor, linking his fiery opposition to the Xerox deal to deeper traditions in the profession and the evolution of its standards:

About a hundred and fifty years ago, Tocqueville wrote: "The journalists of the United States are generally in a very humble position, with a scanty education and a vulgar turn of mind." Today, we chuckle at this antique characterization. But about fifty years ago, when I was a young journalist, I had the good fortune to encounter an editor who fitted the description quite closely. Harold Ross, who founded the *New Yorker,* was deficient in education and had—at least to all outward appearances—a vulgar turn of mind. What he did possess, though, was the ferocity of independence. He was having a tough time finding money to keep his floundering little sheet alive, yet he was determined that neither money nor influence would ever corrupt his dream or deflower his text. His boiling point was so low as to be comical. The faintest suggestion of the shadow of advertising in his news and editorial columns would cause him to erupt. He would explode in anger, the building would reverberate with his wrath, and his terrible swift sword would go flashing up and down the corridors. For a young man, it was an impressive sight and a memorable one. Fifty years have not dimmed for me either the spectacle of Ross' ferocity, or my own convictions—which were identical to his.[48]

So widely respected was the elderly White, and so persuasive was his call to protect journalistic integrity and independence, that Xerox dropped the experiment, conceding that it had been a big mistake.[49]

It's a measure of how radically ethical standards and sensibilities have changed in professional journalism that thirty years later we accommodate in our everyday language words such as *advertorial, infomercial, documercial,* and the like—clumsy, deceptive, oxymoronic constructions that White, the co-author of the classic guide to clear writing, *The Ele-*

ments of Style, would detest. Worse, we see business-journalism arrangements similar to the one that Xerox abandoned in 1976 now in full flower. The fears that White expressed so eloquently about the disappearing barrier between professional journalism and political and commercial advertising have in significant measure been realized. And it's not only that business and advertisers play more powerful roles in editorial content today than they once did; it's the fact that advertisers and government alike are themselves producing deceptive works that millions of Americans consider news and information.

Revenues from the television infomercial industry alone are estimated today at $256 billion annually, and growing. In 2004, an average of 250,000 infomercials aired each month on broadcast and cable television stations in the United States and Canada, a rise of 3 percent over 2003.[50] Why is so much human energy and so much money continuing to flow into this kind of advertising? The simplest answer is that messages that look and sound like advertising are no longer especially compelling to citizens who are literally bombarded with ads in nearly every corner of their waking lives.[51] Many consumers have learned to tune out overt, slick, or blatant advertising, or at least to recognize that its purpose is to manipulate, deceive, or, at best, entertain. Ads that look like journalism, however, are different. They tend to be more convincing because the sales motivation is better hidden, embedded, perhaps disguised in an interview format borrowed from public affairs or other journalistic broadcasts, and presumably driven by values of accuracy, truth, and fairness.

Although the print and broadcast news media are not especially forthcoming or transparent about the newsroom processes that allow such effective advertising to be disseminated during local news programs—as was plainly evident in their response to the Karen Ryan episode—America's PR companies are more than eager to spread the word in order to drum up more of this lucrative business, making it clear to potential corporate clients just how much such advertising can boost sales and profits. But for the concerned citizen and certainly for the dedicated American journalist, it is horrifying to see how significantly business and political advertising has compromised the mission of the news industry, at times with the industry's full participation. In the past, young journalists fresh out of universities and graduate schools considered other young journalists to be their main competition for jobs in the field of broadcast news. But nowadays their chief competitors instead are well-paid PR professionals who are hungry to provide the illusion of journalism, free of charge to broadcasters, in a fashion that also serves their paying corporate and political clients.

Writing in *Public Relations Tactics,* the professional journal of the Public Relations Society of America, Amy Goldwert Eskridge—like Karen Ryan, a former network television journalist who used her journalistic expertise to open a PR business specializing in video news—advises PR firms to serve their corporate clients' interests better by making sure they don't "offend the sensibilities of news stations."

> It's a delicate challenge: pleasing your client while trying to capture the interest of broadcast news. Sure, the video news release can be an invaluable tool, but a video filled with key messages resulting in few [actual broadcasts] is a disappointment to everyone involved.
>
> The enthusiasm for video news releases is one upside to personnel cutbacks and budget constraints broadcast news organizations have endured recently. Stations lack resources to scope out their own stories, and are more open to news from outside sources.[52]

The trick, the New York–based Eskridge writes, is to create in intricate detail the illusion of a news story that serves the client's interest. Eskridge, owner of AGE Productions, whose clients have included Microsoft, IBM, Eli Lilly, and Donald Trump's companies, lists concrete suggestions to serve that faux journalistic end, demonstrating a sophisticated familiarity with broadcast news and the values that determine newsworthiness:

Start with a good, newsy script.

Just for a moment, forget about everything your client has told you he or she wants to accomplish and pretend you are at home watching the news. Be honest with yourself about whether your script is something you might hear on a news program or if it sounds more like a commercial. If the product name is mentioned more than once in a sound bite and in the narration, you've more than likely overbranded it.

Don't overburden your expert.

It's vital that your spokesperson sounds sincere. They may have flawless credentials, but if you force him or her to repeat a scripted sound bite, chances are they won't sound believable. Unless your spokesperson is a trained actor, let him or her study the messaging prior to the taping and then use his or her own words to make the points.

Think visually.

Television is a visual medium. Try to incorporate the product into the video so you don't have to continually repeat the name. Manufacturing shots of a new drug or a doctor explaining to a patient how to apply a medication are video shots that news people use and audiences often remember. . . .

Who will care?

Ask yourself if the story contains new information that is useful or interesting to a wide audience. If it doesn't, it won't get much airtime, if any at all.[53]

Similarly, Paul Griffo, a Washington, D.C.–based PR professional and longtime VNR and advertising producer, seeks to debunk what he calls "five myths" about video news releases. Declaring that they are far easier to place and far more widely used than the news industry will ever admit publicly, he issues valuable practical advice for creating and placing advertisements disguised as news segments that in many ways echoes the advice that journalism professors give their students about the most effective ways to attract the interest of professional editors at print and broadcast outlets:

Myth #1: Networks never use video news releases. . . .

Regardless of what network producers or correspondents say in public, if you can deliver the goods—a current news hook, solid interviews and good supporting video—they'll use your material. And don't forget, there are more news hours to fill these days with news segments on the morning shows, expanded news coverage, and the overlap of network, cable and Internet news coverage.

Myth #2: A VNR that is longer than a minute and a half will not get aired.

Contrary to popular belief, it is not the length of the VNR that determines whether or not your story airs, but the quality of the content. While it is true that news stories are typically one to two minutes in length, I have had smashing success with video news releases that are three minutes or longer.

Myth #3: Your VNR must have a third-party expert to add credibility.

This is some of the worst advice VNR producers provide their clients. When it comes down to the final broadcast, you will often only have a minute or two to get in your licks. What a waste to pay thousands of dollars to produce and distribute a video news release, and have someone other than your company principal or spokesperson featured on the evening news.

Myth #4: Your interviewees will come across better if they don't try to prepare for the interview.

VNR producers who say this have obviously never been interviewed on network news. Having been a media spokesperson for almost 15 years, I still prepare intensely for on-camera interviews. First, I write out the sound bites I am planning to say, and then rehearse them over and over again, until I can deliver them smoothly and naturally. I recommend that you or your company representatives do the same before an interview for a VNR. . . .

Myth #5: Your VNR must be read by a former television news reporter, or it will be rejected.

A VNR can be read by anyone with a reasonably professional broadcast voice. Remember that the reporter who picks up your story will most likely do his

or her own voice-over narration. The important thing is that your VNR script be written in broadcast news style, with a compelling human-interest angle.[54]

Sounding just like a terrifically informed career adviser to a young news reporter seeking a toehold in the field, Griffo goes on to counsel public relations pros: "Don't let more than a day lapse between the time you pitch your story and the actual feed. Pay attention to what you see on the evening news and cable news broadcasts, and pattern your video news releases after what you observe there. If you can tell a good story using good video, you can be reasonably certain that your video news release will get good pickup."[55]

Scores of immensely profitable PR firms echo these success stories, with convincing testimonials reaching out to potential corporate and political clients. Consider TVA, a multimillion-dollar, Los Angeles–based firm boasting a staff of more than a hundred producers, former journalists, publicists, and other media experts and a client list reaching into the hundreds, "from global, multi-billion dollar corporations to local charities." The Web site lists clients by category, from Automotive to Entertainment to Medical Real Estate. TVA's site guarantees that its video news features find "massive placements on national and local television and radio stations . . . in newspapers, and in prominent trade publications targeted to your intended audience—for less than $1/10^{th}$ the costs of traditional advertising *(and with four times more credibility!)*."[56]

TVA showcases its pool of experts who are paid to "report," produce, and narrate news and feature stories for agency clients. The list includes a dozen or more former journalists and producers for television stations and networks including CNN, ABC, and NBC. At least one figure, Mark Kristi, is also simultaneously employed full time as a working journalist and anchor for KTLA News in Los Angeles, according to TVA's site.[57]

But it's in the Web site's long list of "frequently asked questions" and answers that TVA's publicists reveal how and why the firm's specialty has become so effective:

> Since 1987, thousands of TV, airline, radio and print media outlets have come to rely on our media booking services and ready-made News Features to meet their own growing need for editorial content due to staff cutbacks. We have a team of over 140 publicists, writers, media strategists, producers, etc. including a large Media Relations Department to maintain our carefully cultivated contacts in our database—and to keep track of their editorial calendars, preferred formats and [the] running-lengths broadcasters and

editors need. Our veteran producers, directors, writers and editors *(including former CNN and top daily newspaper and wire service editors)* will develop the plan to your approval, implement it, and measure the results. You will receive a monthly usage map plus actual clippings from newspapers, detailed TV, airline and radio broadcast affidavits, bar charts, pie charts and circulation data—verifying the guaranteed number of interviews, Feature Story placements and audience impressions promised you. . . .

We create feature stories that programming directors and editors throughout the country pick up because they find something new or helpful to their audience—and because they're always eager to fill their shows and publications with quality content. TVA has a long-standing relationship with editors and broadcasters. . . . Our Media Relations Department is keeping track of who the contacts are at each publication or station and what format each needs to receive.

Your distribution is not to a media list from a directory but to carefully *cultivated* contacts who rely heavily on these releases and who take the time to send us usage cards and clippings. Editors and broadcasters receive releases specifically tailored to their needs. . . .

Over 90% of TV news programs rely on independently produced news feeds (particularly when it comes to covering positive news stories). 67% of all dailies and 90% of all newspapers have under 30,000 in circulation. The editors of these papers are low on staff, low on time and need something that is ready to run. They are hungry for good feature releases in camera-ready or computer-ready copy form.[58]

MIRACLE CURES AND FIREWALLS

While television certainly offers a bounty of examples of advertising masquerading as journalism and news, radio is perhaps even more rife with problems, especially with the gigantic expansion of commercial time after the radio industry was deregulated in 1996. Today, in a highly consolidated industry controlled by a mere handful of media conglomerates, commercials take up more than twenty minutes of every hour of broadcast time on American radio stations.[59]

Among the most effective commercial spots aiming to hawk everything from remedies for baldness and arthritis to new age herbal "antidotes" to aging are those ads that copy the techniques and presentation of news and public affairs interview programs—in other words, more fake journalism. Many of these spots air at 3 A.M. and other wee hours of the morning, primarily targeting the insomniac elderly. Listen to the AM radio airwaves on an early Sunday morning, for example, at 5:30 A.M. on station KHTK in Sacramento, when a well-disguised half-hour advertisement in the form of a news and information interview program

called *Ask the Experts* is broadcast. The show features a fellow identi-
fying himself as "Jay Donnell," a studio moderator who conducts a
phone interview with Bill Sardi, an "expert" in "human rejuvenation,"
whom Donnell repeatedly describes as a "well-known" and "widely re-
spected author" and "health journalist."

On a typical show, the topic is better health, the aging process, and
hyaluronic acids. Sardi, the "health journalist," enthusiastically describes
these substances as naturally occurring chemical compounds in the human
anatomy that possess "miraculous powers" to smooth wrinkles, loosen
joints, strengthen nails, moisturize eyes, and otherwise rejuvenate the body
and extend life. Sardi then tells the moderator that he has studied and writ-
ten extensively about hyaluronic acids and says that he "can't rest" until
he shares the curative secrets of the "youth molecule" with the listening au-
dience. He reports on the dietary products developed in pill form to restore
the acids to older Americans. Donnell backs up the "health journalist's"
credibility, pointing out that Sardi is the author of five books and many ar-
ticles on the subject. On first impression, the show resembles a typical AM
radio call-in and interview program. It's even interrupted at times for Don-
nell to say, "Let's take a station break," during which listeners are urged
to call an 800 number where they can purchase herbal and dietary sup-
plements and longevity products containing these miracle acids.

Leaving aside the fact that Western physicians question the efficacy
of such acids in pill form,[60] and leaving aside too the issue of Sardi's
claims to authority on medical issues, advertisements like this, in which
journalistic credibility is used to attract and persuade unassuming con-
sumers, raise the question of who, exactly, is a journalist in modern
America. The term *health journalist* implies that the individual is a re-
porter, writer, or broadcaster whose expertise and beat are focused on
health issues and who is committed to accuracy, truth, and serving the
public interest. A check of "health journalist" Bill Sardi's background,
however, reveals something else: a tireless huckster devoted to self-
promotion, marketing, and the relentless peddling of medical remedies
based on pseudoscience. "Meet Bill Sardi, Your Health Journalist,"
Sardi's Web site, askbillsardi.com, proclaimed in 2005. An author? Of
sorts. His five books, with titles such as *How to Live 100 Years with-
out Growing Old* and *The New Truth about Vitamins and Minerals,* are
essentially self-published by Here and Now Books, the media wing of
Sardi's business enterprise. The Web site listed a mailing address in San
Dimas, California, through which consumers could buy his publica-
tions.

A journalist? That depends on how you define it. Sardi's Web site claimed that he had a degree in journalism and public relations from California Polytechnical Institute at Pomona, along with a combined twenty-six years of experience in "ophthalmology," "nutrition," and "natural health."[61] But apart from his own publications, which are chiefly devoted to self-promotion and the touting of wonder health remedies, there is little in the LexisNexis.com database of news media articles to support the contention. The name Bill Sardi is mentioned twenty times in the comprehensive database that goes back to the late 1970s. His name is attached to a handful of short published letters to editors of newspapers such as the *Washington Post,* the *Los Angeles Times,* the *London Times,* and the *Inland Valley Daily Bulletin* of Ontario, California, on a range of arcane science and medicine-related topics, from the healing powers of mineral waters and novel vitamins to views about genes and amino acids. But mainly Sardi's name appears regularly in *PR Newswire,* a public relations wire service through which more than forty thousand corporations and individuals are able to disseminate information about their companies in the form of self-serving press releases.

On the *PR Newswire,* Bill Sardi is the author and contact name for news releases about alternative medicine remedies and supplements said to be effective in reversing the effects of old age. These press releases urge news media organizations to contact Bill Sardi at his organization in San Dimas for more information and to visit his Web site at askbillsardi.com and his publishing venture at hereandnowbooks.com. A further check reveals that the San Dimas mailing address for Sardi's publications is identical to the address listed for lifespannutrition.com, a company peddling 165 different dietary supplements and other health aids on the Web, ranging in price from $6 to more than $50 per bottle. In addition, Bill Sardi is identified on the Web and in the news media as the president of Longevinex, which offers "the molecule mankind has been waiting for," a supplement extracted from red wine, purported to prevent cardiovascular disease, and sold for $35 a packet at longevinex.com.[62] In other words, the prolific news reporting and writing practiced by Bill Sardi, "health journalist," apparently has come chiefly in the form of vanity press publications, radio infomercials, and press releases by Bill Sardi beseeching news media and consumers to direct their attention to Bill Sardi, mainly aimed at gaining exposure and sales for Bill Sardi's alternative health products.

Radio especially seems full of such examples of fake journalism as a direct-response marketing vehicle. For every Bill Sardi, there is a "Dr.

Janet" Maccaro, who similarly pitches miracle cures in half-hour, interview-style radio programs in the dead of night, aimed at the elderly. In recent years, at 4:15 A.M. on Christian-oriented KFAX radio in San Francisco, for example, Maccaro, a self-styled "PhD in holistic medicine and nutrition," could be heard gushing with sincerity and earnestness as she pushed a "specially formulated" product called "Glucosamine Cream," which contains what she calls "the body's natural hormones" and works to provide "quick, safe pain relief" from "inflamed joints and sore muscles caused by overwork and arthritis." Maccaro, like Sardi, appears on the airwaves via telephone in conversation with a studio anchor playing the role as the objective journalist-interviewer who enthusiastically approves her expert claims. The pseudo–public affairs program also features station breaks, during which the journalist-interviewer invites listeners to purchase "Dr. Janet's cream" by calling an 800 number.

Then there is the case of Kevin Trudeau, arguably the most successful and shameless huckster in the history of television and radio infomercials and print advertorials. In an industry whose chief aim is to erase the lines between news, information, and shilling, Trudeau has proven a master at peddling nutritional supplements like "Coral Calcium Supreme" and other alternative health products purportedly capable of improving memory; relieving pain from arthritis, migraines, and sciatica; and curing heart disease, lupus, cancer, and multiple sclerosis. With an engaging personality and wholesome Midwestern looks, Trudeau, who once served two years in jail for credit card fraud, reigned for more than a decade in the 1990s in infomercials across the electronic media landscape, often starring as a mild-mannered, journalistic interviewer of presumed "experts" in the field of alternative health. On occasion, he played the role of a seasoned investigative reporter, feigning skepticism about a product's promise until the "expert" could persuade him; at other times, he was wholly and enthusiastically convinced of a product's magical powers. Along the way, Trudeau amassed a fortune in direct-response sales.

According to the Federal Trade Commission (FTC), Trudeau's May 2003 infomercial for Coral Calcium tablets, in which he interviewed Dr. Robert Barefoot, a self-described "scientist" who claimed to have discovered the cause of cancer, was the most successful infomercial of the year, racking up direct sales of the product in the tens of millions of dollars. The FTC filed charges in federal district court in June 2003, charging that Trudeau's and Barefoot's claims were false and unsubstantiated. When the case was finally settled in September 2004, the FTC, noting that Trudeau's deceptive practices were not only "prolific but recidivist,"

took the unprecedented step of banning him from producing or appearing in infomercials on the nation's television and radio airwaves, fined him $2 million, and took his house and $180,000 Mercedes. Nevertheless, the indefatigable and adaptable Trudeau appears to be on the comeback trail. He has sued the FTC, charging that the government is infringing on his right to practice his trade. He has also become an author: on his Web site, naturalcures.com, Trudeau is marketing a self-published tome titled *Natural Cures "They" Don't Want You to Know About.*[63]

In an interesting bit of backlash, helped along by the wonders of the Internet age, the misdeeds of Trudeau and other con artists have inspired the growth of a veritable cottage industry of Web-based and other sources aiming to expose such false advertising. Quackwatch.org, for example, is dedicated to combating what it calls "health-related frauds, myths, fads, and fallacies" as disseminated by direct-response advertisers, including hucksters masquerading as journalists. Similarly, the Center for Media and Democracy's PR Watch investigates deceptive practices and other abuses by public relations firms and their effect on journalism and society.[64]

Unfortunately, these ethical minefields are not limited to the terrain of commercial advertisers. It's disturbing that government has also displayed contempt for independent journalism, attempting to use journalistic cover to cynically pursue political agendas. At a time when the U.S. government is mired in the arduous process of building a new democracy in Iraq, for example, it chooses to spend millions of taxpayer dollars as part of a secret public relations campaign, planting fake pro-American news stories, written by Pentagon officials, in that nation's fledgling press.[65] It's also disturbing that deceptive practices like these evidently have sifted down to state and local levels. In 2005, the administration of California governor Arnold Schwarzenegger came under fire for producing a video news release much like the Karen Ryan story—including narration by a PR professional playing the role of a journalist—that touted controversial proposals to amend meal break rules for workers. The intent was to air the VNR directly on local television news stations around the state, without indicating its source. Although only one local station in California aired the release, the deceptive PR practices nonetheless caused a storm of debate about the respective functions of government and the press in democratic society.[66]

And it's illustrative, too, of journalism's endangered place that new corners of industry and commerce are adopting these practices in order to control their messages to the public and to bypass the filter of critical professional journalism altogether. For many decades, American pro-

fessional sports and news organizations have enjoyed a very close and mutually beneficial relationship. Professional football, for example, an exceptionally popular and profitable enterprise, has a long public relations tradition dating back to its birth in the 1920s. Historically, teams and league officials have allowed print and broadcast journalists close access to locker rooms, players, and coaches in order to report the inside human stories behind the games on the field. Sports news is very popular with American readers, listeners, and viewers; and comprehensive coverage has translated into solid audience shares and healthy circulation figures for the news media. Sometimes this journalistic coverage, by its nature, has been critical of owners, coaches, or players. But teams and league officials accepted this fact, this journalistic professionalism, as part of the bargain for publicity.

But in the age of New Media, and the relentless market forces that drive it, at least one National Football League team, the Washington Redskins, the richest franchise in professional sports,[67] and the team's owner, Daniel Snyder, are taking significant steps to marginalize all independent press coverage by restricting, and at times forbidding, reporter access to team players and coaches. Snyder sees journalists not as agents that provide helpful publicity for his lucrative entertainment enterprise, but increasingly as a drain on its profitability. Snyder reportedly believes that the team itself can better control its vital PR messages by directly producing newslike video, sound, and text content—its own "news" interviews, its own background feature stories on players and their families—for WashingtonRedskins.com, the team's Web site. If reporters need information, Redskins PR officials often direct them to the Web site. In fact, the Redskins now strictly forbid professional journalists from WashingtonPost.com to cover team news conferences and other events because the team views the newspaper's Web site as a business competitor. For the Redskins, the situation seems win-win: not only do they increasingly control the "news," but not a single word of that news is potentially harmful to the team's popularity and profitability, unlike the content of the occasionally critical professional press.[68]

Such disdain for the role of independent news media by government and industry clearly undercuts the process of creating a truly informed citizenry, so essential to democratic society. But what also makes these complex and increasingly pervasive trends so unsettling in the United States is the degree to which legitimate news organizations, engaged in the competitive hunt for audience and revenue facilitate, encourage and at times even mimic some of these shady practices.

The ideal construct of a newspaper, magazine, or television news operation—the model taught in journalism schools for many decades—holds that the news and editorial department of a media company must remain separate from its business and advertising department, because the interests of the two are often in conflict. The former's mission is to gather news and information of vital public interest without fear or favor; the latter's mission is to maximize profit. This so-called firewall dividing the two must remain unbreachable. If business and advertising interests are allowed to play a role in determining news and editorial judgments, the value of the company's most sacred stock in trade—its journalistic independence, credibility, and commitment to the public's interest—can be compromised and damaged. And when that happens, the whole enterprise can collapse.

Unfortunately, this construct as a teaching model seems as outmoded today for schools of journalism as teaching the Dewey decimal system might be for schools of library science in the computer age. Useful and inspiring, yes. But outdated, to say the least, for evidence shows that business and advertising concerns play increasingly significant roles in determining the kinds of news Americans get and do so in more varied and complex ways today than even two decades ago.

In 1919, Upton Sinclair's *Brass Check* revealed a world of journalism overrun by publicists and advertisers.[69] He likened the newspapers of his day to prostitutes in a brothel, willing to sell themselves and their integrity to anyone, for any price. The brass check itself was literally a coin commonly used in whorehouses of the era. The customer would pay a couple of dollars to the madam and receive a brass check. The client would then troop upstairs and hand the brass check to the prostitute for services rendered. At the end of the day, the prostitute would turn in her collection of brass checks and receive a portion of the proceeds from the madam. Over the succeeding decades, Sinclair's metaphor has endured in the minds and writing of generations of press critics; one of the more prominent and provocative blogs in recent times devoted to skewering the biases of print and broadcast news media was titled mediawhoresonline.com. But today, instead of evoking the unsavory whorehouse image of Sinclair's day, one might say that modern news organizations resemble high-class, highly compensated call girls who appear upright and respectable on the surface but whose less reputable enterprises are cleverly disguised.

Like video news releases in television broadcasting, press releases from government, business, and special interests have long served an ac-

cepted function in print journalism. No beat reporter in the United States can go a day without receiving reams of press releases via mail, fax, and e-mail. The local congressional representative, the National Organization for Women, People for the Ethical Treatment of Animals, the Future Homemakers of America, the New York Yankees, the local grocery store chain—practically every political, commercial, and special-interest entity employs trained PR workers whose jobs entail writing newslike press releases to gain exposure in the news media.

Modern ethics call for the professional journalist to treat this stream of propaganda and advertising with deep skepticism—not to dismiss it altogether, but to regard it questioningly, searchingly. Perhaps there is a really good feature or news story connected with the press release. Perhaps it contains information that is worth a follow-up, a further inquiry. Perhaps there is another side to the case the press release makes on behalf of the special interest, and maybe out of that will come a well-rounded and more comprehensive story worth exploring for the public. Professional standards call for the reporter to check it out. Standards do *not* allow the press release to be printed verbatim and editorially unfiltered, and certainly not without attributing the source. Professionalism demands such purposeful and vigilant independence.

But in American print journalism today, such independence has widely given way to accommodation, and in a realm far beyond that of mere press releases. Behold the advertorial, the fusing of "news" and advertising. Advertorials in magazines and newspapers have become such significant sources of revenue for the modern print industry that some news organizations have created entire departments especially devoted to writing and publishing eye-catching sections for advertisers that are designed to look like credible news and features. In the industry, this enterprise is called "custom publishing." This form of modern advertising, once again using the illusion of journalism as a messaging vehicle, is often quite effective. One reason is that the legally mandated disclaimer "Paid Advertisement" is printed in tiny, discreet type so that the average reader easily overlooks it. Another fancy trick is the growing use of deceptive disclaimer terminology fabricated by news organizations to conceal their duplicity: "Special Custom Section" or "Custom Special," in order to obscure an advertising section's true nature; or "Photo Illustration" to mask the practices of photographic fabrication on magazine covers.

George Orwell, whose 1946 essay "Politics and the English Language" warned about the dangers to free societies when communicators inflate, abuse, contort, and debase language for their own purposes, gen-

erally had political parties, the military, academics, government bureau-crats, and other such entities in mind. Political language, Orwell wrote, "is designed to make lies sound truthful and murder respectable, and to give an appearance of solidity to pure wind."[70] With manufactured expressions like "Photo Illustration" and "Special Custom Section," however, it is the contemporary press itself—the civic institution presumably most dedicated to linguistic clarity—that displays just as many sickening examples of obfuscation and deceit.

Gannett, Inc., owner of eighty-nine daily newspapers with a combined circulation of more than 7 million and the biggest newspaper chain in the United States, has become an acknowledged leader in "custom publishing." Special departments devoted to producing advertorials and special sections have been set up at the *Des Moines Register,* the *Arizona Republic,* the *Reno Gazette-Journal,* and other newspapers in the chain's empire. Perhaps most revealing and especially troubling is that Gannett's *newsroom journalists* are called on to report and write positive "stories" for these advertorials and special sections, relying solely on the advertisers themselves as "sources."[71]

Evidence of this fusion of journalism with advertising and PR can also be gleaned from a recent job listing posted online at Gannett.com, which described qualifications for the managing editor's position of the custom publishing department of the *Reno Gazette-Journal.* The newspaper announced on its site that "the successful candidate will have a history of outstanding achievement and superior quality in magazine or newspaper publishing, managing expense budgets, supervising senior editors, assigning duties, and possess a keen grasp of marketing and public relations. We also seek a candidate with a minimum of five years' experience as an editor or manager for a newspaper or magazine. In addition, a bachelor's degree in Journalism or Public Relations is preferred."[72]

The ad highlighted two points. First, the newspaper was looking for an editor with experience in journalism to lead its fastest-growing advertising department. Second, it reflected a cultural viewpoint increasingly common in the modern media that sees the fields of journalism and public relations, and the skills inherent in both, as essentially identical. The ad, typical of many in the media field today, was evocative of an employment trend in which the "journalist" with "a history of outstanding achievement" and years of experience as an editor for a "newspaper or magazine" is also viewed as a darn good candidate to oversee the publication of advertisements disguised as news and information.

A recent article in the journal *American Demographics,* reporting on

the explosive growth in custom publishing by newspapers, magazines, and public relations firms in recent years, underscores the reasons why such pitches seem to work:

> Readers [of custom publishing] will often find articles written by professional journalists on topics that may or may not be directly related to the brand the company is marketing. And the best among them try to engage readers without making a hard sell, pushing the essence of the brand instead of trying to seal a deal. "The idea behind custom publishing is to reward the customer," explains Simon Kelly, president of Seattle-based Fluent Communications. "If it does its job properly, the magazine will engage the reader and reinforce the value of the brand of the company."[73]

In the traditional magazine industry, advertorials have become significant revenue sources at a time of falling income from conventional ads. In 2002 alone, advertorial and special-section pages in American magazines increased by 18 percent, while total ad pages dropped by 0.5 percent, according to the Publishers Information Bureau.[74] But the explosion of advertorials in the print media over the past two decades has also created fascinating new problems for advertisers and editorial departments alike. Many advertisers complain that the technique is so overused these days, and many advertorials so badly produced and poorly disguised, that the tool is losing its effectiveness and credibility. In other words, ordinary readers are learning to see through the illusion of advertising as news and information. This makes advertorials as a whole less valuable as vehicles for product messaging, which leads to even further erosion of the credibility of the magazine's or newspaper's actual news and feature articles. Better deception is called for, one presumes.

Indeed, the advertorial's likely success in the future in publishing was explained nicely by Philip Sawyer, a senior vice president and director of Starch Communications, a company that studies reader involvement in magazine advertising:

> Starch's Sawyer points out that it is exactly those publishers that thumb their noses at the hallowed ad/edit line that meet with the most success in their special sections and advertorials. "The ones that do the best are the ones that look most like an article, that are easy to read, have good headlines, great art, and really exploit the line between church and state."[75]

Such candor about the publishing industry's editorial and business realities is remarkable and says a great deal about the economic and moral plight of professional journalism. And in fact the effects of advertorials, product placements in news content, and other deceptive practices in the

newspaper and magazine industry have triggered a range of protests from both journalists and concerned citizens in recent times, much of it failing to produce even the barest hint of ethical reform.[76] In September 2004, for example, a consumer advocacy organization called Commercial Alert teamed up with a group of sixty-one journalism and law professors across the country to release a letter to the American Society of Magazine Editors (ASME) demanding industry reform. The letter, which coincided with the professional trade group's annual convention, called on leading magazine editors and publishers to halt intrusions of commercial messages into editorial content. Part of the letter, in which the signatories demanded full public disclosure of product placements and clearer and more distinctive labeling of advertorials and custom publishing inserts, read as follows:

> Magazine editors in the U.S. are under increasing pressure to weave advertising into their editorial content. In the past, advertisers have sought to influence stories, often with success. Now they are going further, and seeking to turn ads into articles.
>
> These efforts are a fundamental threat to press freedom and to the integrity of American journalism. If magazines become mere tout sheets for products and the interests of those who sell them, then every story will be suspect, and the reading public may have nowhere to turn for information that is truly independent of reigning commercial interests.
>
> If there was ever a need for resolute action by your organization, this is it. You should strengthen the Society's editorial guidelines, to draw a clear line against aggressive advertiser intrusion into story content. This would both provide confidence to readers, and would prevent advertisers from playing one magazine against another. It would also give editors a convincing reason to turn down advertisers' requests.[77]

While lofty and well intentioned, such protests have had as much effect on reforming the magazine industry and reversing the tide of commercialism in news content as the RTNDA's code of ethics has had in preventing the broadcast of advertising and political VNRs on the nation's local news airwaves. An ASME spokesperson, acknowledging receipt of the protest letter, said that the group was "in the process of rethinking its guidelines in the light of new advertising realities," but conceded that no revisions were planned in the immediate future.[78]

Indeed, in a perfect illustration of print news industry priorities and attitudes in early 2006, the two leading trade organizations representing newspapers and magazines announced a major $50 million PR campaign to bolster print advertising in the face of escalating competition from the

Internet, e-mail marketing, and other rivals. The campaign features re-
alistic, cleverly designed advertisements that look as if they have been
torn from the news pages of the magazine and newspapers in which they
appear. The campaign promotes the tangible quality of print media as an
advantage over other forms and features slogans such as "Every day we
try to print something that people on the right and the left can actually
agree on. We call it 'advertising.' "[79] The campaign also proclaims that
advertising in print media is "a destination, not a distraction." One pro-
motional piece for the campaign features period portraits of Benjamin
Franklin and Thomas Jefferson and the following fascinating slogan,
which may or may not be tongue in cheek, given the direction of the in-
dustry: "What made FREEDOM OF THE PRESS so important to the
founders? MAYBE it was THE COUPONS."[80]

What's most compelling about efforts like this by the print media to
save themselves in uncertain economic times is the degree to which *jour-
nalism* is either ignored or deeply subordinated. The stewards of print
media are, after all, making a qualitative choice here about their own
value to society: the industry could just as easily spend tens of millions
of dollars in a national PR campaign to inform the public and potential
advertisers about the value and practical benefits of extraordinary works
of professional journalism on the life of the community and democracy,
to celebrate and honor them.

But instead it chooses to proclaim the virtues of advertising coupons
as a purer expression of the First Amendment. Indeed, some of the na-
tion's leading news media executives no longer bother to hide their dis-
dain for professional journalism as a worthwhile product in its own
right. "Next year," *Philadelphia Inquirer* and Knight Ridder CEO
Tony Ridder once dryly replied to his editors, when told of the awards
his newspaper had won, "I'd like you to win a Pulitzer for cost cut-
ting."[81] William Dean Singleton, meantime, chief of the MediaNews
newspaper chain, which purchased a chunk of Knight Ridder newspa-
pers in 2006, immediately announced the signal journalistic aims of his
burgeoning empire: "We've got to make [newspapers] much more
compelling than they are today," he told listeners at the American So-
ciety of Newspaper Editors. "As an industry, for the last 30 years,
we've edited newspapers for each other and to win awards so we could
pat each other on the back." Now, Singleton said, it was time to give
American consumers what they really wanted: more entertainment
news and "less long series that we love to do but our readers hate to
read."[82]

MIDNIGHT ON THE CITY DESK

Whether compensated by a cheap "brass check" as in the old days or by lucrative automatic deposit in more sophisticated, genteel, and cleverly deceptive modern times, the prostitution of news organizations evidently endures. And it sometimes does so in ways so perverse that one could be excused for believing that fleece artists were in charge of some of America's news and editorial operations, not professional reporters and editors. The drumbeat of transgressions and outright institutional corruption has been persistent.

In 1991, responding to a national survey by communications academics about ethical guidelines and the growing use of newslike infomercials by local television stations, one news director replied, "We're not in a top-50 market. We basically take everything except autographed pictures of Jesus Christ." That same year, a Chattanooga television station, WDSI, sent a pandering, unsigned fax to local companies and entrepreneurs offering positive news stories for $15,000 a trick.[83] Wide condemnation by ethicists and professional journalism associations ensued, but it didn't stop stations in Florida and Mississippi from taking such journalistic fraud to even higher and more creative levels four years later. News officials at WFLA in Tampa, for example, were roundly criticized for charging guests on the station's morning news and entertainment show, *Daytime*, as much as $2,500 per appearance. Similarly, WLBT in Jackson attracted wide scrutiny for airing what its "journalists" euphemistically called "paid-informational segments" produced by advertisers during its *Midday Mississippi* news program. The scandals, which critics likened to the payola scandals in the music and radio industries in the 1950s and 1960s, attracted attention only after an outraged Senator John McCain fired off a public letter of complaint to the Federal Communications Commission.[84]

How far such practices have spread in local television remains difficult to tell, largely because America's local TV stations aren't talking, and because television journalists who care about their jobs customarily don't blow the whistle on the companies that pay them. Still, further episodes of fraud and payola have continued to trickle into the print media. In February 2003, WRVH in Syracuse, New York, was accused of "blurring the traditional line between church and state" by not labeling advertorial segments as paid ads and by turning over time slots traditionally used for news programs to shows produced by advertisers that looked like news programs but featured guests who paid for appearances and former news anchors, who were well known to the local audience, deceptively shilling for products.[85]

Amid all this chicanery, it's little wonder that a national survey conducted in 1999 for the Radio-Television News Directors Association Foundation found that an overwhelming majority of American adults—84 percent—believed that "advertisers often or sometimes" influence news judgments and values.[86] Yet the true effects of breaches in the mythical firewall between news and business extend well past the episodes of obvious fraud and corruption of journalistic values that surface from time to time. Rather, the effects are far more insidious, with business concerns often influencing human judgments about gathering and reporting the news in ways that are often unconscious, unstated, or implicit. Just as business factors—cuts in newsroom staff, for example—played a significant role in ensuring that the fake news Karen Ryan story would be aired, so too do business factors arguably influence how and even whether vital news stories are told.

For many years, local television stations hungry for ratings have turned to media consultants for research expertise, advice, and suggestions on how to improve their productions in order to attract and retain viewers. For its money, the typical station can get focus group research and other data on everything from the Q-rating of its lead anchor to audience reaction to different kinds of news—feature stories about poor people, for example, and breaking news about fire and crime. With local news programs being the chief source of direct income for most stations, the station directors use this valuable research to help develop business strategies to improve their profitability.

One of the leading such media consultants is Iowa-based Frank N. Magid Associates. Although generally unknown to the public, this powerful agency is a legend in the field, whose research on audiences and news has influenced hundreds of local television stations for more than a quarter century. Boasting consultancy contracts with nearly a quarter of the nation's 772 local news stations, including most of the top-100 markets, Magid was a pioneer, as early as the 1970s, in crafting and popularizing the homogenized formula for local news that American viewers are familiar with today: the so-called action news style; the two-anchor set, with plenty of amiable chatter between anchors and sports and weather reporters; the focus on short, quick stories and sound bites; and an emphasis on allowing time for anchors to react to stories—smiles and happy chat to follow funny items, sadness and sympathetic shakes of the head for murders and loss.

For many station owners, Magid's advice has been golden in a business sense, since the consulting group's track record in helping to raise station

profiles, ratings, and profits is unsurpassed. In a journalistic sense, however, the agency's influence is more problematic. Consider, for example, the expensive and time-consuming practice now common at local stations of sending reporters out on locations for live shots, no matter the value of the news story or the time of the shot itself. We've all seen an 11 P.M. news story with a reporter on location for a live shot outside a downtown jewelry store, say, that had been gutted by fire that morning. The "story" itself is more than twelve hours old, and the fire trucks have long since come and gone, but the excited reporter and crew are there on the scene—in fact, they're the only ones on the block at that hour—mainly to provide an illusion of immediacy, sensation, and responsiveness to the community. The shots are expensive because of the satellite uplink required. Yet local television news journalists spend untold work hours each year on this senseless pursuit, time and labor that might better be spent on actual news hunting and reporting.

Although most such live shots have little news value, they are nonetheless ubiquitous because station news directors, heeding the advice of consultants like Magid who have proclaimed live shots to be audience grabbers, consider them good for business. The same explanation applies to the overabundance of news about crime and the live shots of freeway chases during airtime that might otherwise be devoted to important issues affecting far more lives in the community. Such consultancy advice generally follows the precept that it is better and more profitable to give viewers what they want to see and hear instead of what they need to know. Indeed, to more than a few serious and dedicated television news journalists who complain about the compromising influence of outside consultants on their work, Magid is more commonly known by a close homonym, "maggot."[87]

But such influence becomes even more pronounced on the life of democracy when news itself is viewed solely in terms of its profitability, without considering its intrinsic value in informing citizens. In March 2003, on the eve of the U.S. invasion of Iraq, Magid Associates distributed to its client stations the results of a survey it had conducted that questioned more than six thousand Americans about their views of Iraq, the possibility of conflict, and other war-related topics. The most revealing finding was that only 14 percent of respondents approved of news coverage of antiwar protests or felt that opposition to the war should be a news priority. The Magid survey also found that local television viewers would likely be moved to switch channels by reports concerning Iraqi casualties, Iraqi prisoners of war, and local citizens of Iraqi descent. The survey indicated, in short, that any coverage of opposition to the war could be hazardous for stations' bot-

tom lines. While Magid reportedly offered no direct advice about how stations should cover the coming storm in Iraq, and while news directors insisted that they were dedicated to covering all sides, the survey only added fire to complaints by opponents of the war that their views were being ignored or, at best, barely acknowledged by the news media.[88]

The episode underscored perhaps the most salient question about "news" and its tension with the financial bottom line: is it the business of journalists to report the news as they see it, or is it their business to heed business and tell audiences only what they want to hear in order to keep them tuned in? This question is also related to wider issues such as the increasing consolidation of large media conglomerates over the past twenty years and its effect on the practice of modern journalism. In the not so distant past, a news organization like ABC News, CBS News, or NBC News was a jewel in a network's crown and enjoyed its own prestige separate from the network's entertainment and programming divisions. Today, ABC News, for example, is merely one small subdivision of a gargantuan Walt Disney corporate empire spanning movies, theme parks, hotels, entertainment networks, and multitudes of other industries around the globe, many of them often working in synergistic harmony. Along with these entities, ABC News is expected to generate profit.

We are far removed from the days when an expensive broadcast news operation could survive largely on the prestige and public service acclaim it brought to the company, as some did during the 1950s and 1960s. Today's increased emphasis on celebrity, sensationalism, snappy graphics, and other tabloid-style entertainment in broadcast news is not a coincidence. Ratings do matter, and serious journalism does not easily translate into high ratings. Serious journalism is expensive, and its rate of return in terms of immediate profit unpredictable. This business reality perhaps helps to explain the decisions by the nation's major networks over the past twenty years to cut the number of domestic and foreign news bureaus they staff by more than 30 percent.[89]

That mainstream news organizations are ultimately in business to make money is not the issue. A. J. Liebling's famous observation that "freedom of the press is guaranteed only to those who own one" is certainly as valid today as when he wrote it forty-five years ago in the *New Yorker,* just as profit remains the chief reason people own news organizations.[90] But it seems that business concerns trump journalistic values to such an extent today that the raison d'être of many news organizations is seriously eroding. The idea that the age of technology is foster-

ing greater connectivity between journalists, news organizations, and the concerns of ordinary citizens may be the most remarkable myth of all in the media carnival's world of illusions.

Some historical perspective perhaps best illustrates what I mean about this contemporary paradox. Once upon a time, more than thirty years ago, there was no finer place to discover the vibrant role a truly great newspaper plays in the life of an American community than to spend time on the city desk answering phone calls from the public. A young reporter new to the profession could learn not just about journalism and the practice of taking notes, asking questions, and listening well, but also about how much the paper itself meant in the lives of millions of citizens. Reporters assigned to this desk fielded calls from ordinary people who considered the city desk a kind of reference library:

> "My kid's doing a paper about Arizona. Can you tell me the capital and the size of the population?"
>
> "My buddy and I have a bet: do you guys remember who won the Cy Young last year?"
>
> "Hey, I'm new to the area and was kind of wondering about the subway. Do you know when the new Metro station in Springfield is supposed to open?"

The telephones on the city desk rang with calls at all hours, often from annoying questioners, but also from people offering legitimate ideas for stories or tips about news and civic wrongs worth investigating. The phone was a lifeline to readers and the community, a living, breathing connection that let you as a young reporter know that the newsroom was a place where you were in touch with citizens, and where they knew they could be in touch with you. Late at night, long after the midnight deadline had passed, when it was just you and the night city editor on duty in the otherwise empty and darkened newsroom—this was often the time when it was especially compelling, educational, and deeply revealing to answer the phone, for it was then that the deranged, the troubled, and the lonely would telephone the city desk, sometimes to prattle on aimlessly about the CIA or the Trilateral Commission, sometimes simply to find a somewhat sympathetic voice and ear on the other end of the line in the dead of night.

Back in the early 1950s, a popular weekly radio program, *Nightbeat,* was expressly devoted to dramatizing this relationship between often anonymous telephone callers to a big city newsroom and a journalist at work on the overnight shift. The fictional hero's name was Randy Stone, a man whose job on the city desk at the mythical *Chicago Star* was to keep his ears open to the concerns and problems, from the momentous to the trite, of the city's millions. The drama was in many ways a wonderfully affirming reflection of reality about the role of a newspaper in American life. As a young reporter new to a life of daily journalism in Washington in the early 1980s, I found it amazing to work on the city desk and hear the stories people told about their lives and problems, stories that sometimes led to remarkable adventures of learning about the city. It was also wonderful to witness the sheer breadth and cultural significance of a professional daily newspaper in American life.[91]

But with technological advances since the 1970s, American society has changed, our newspapers and other news organizations have changed with it, and that once vital connectivity to citizens has become demonstrably more eerily frayed, fragmented, and indirect. Perhaps the most significant advance has come in communications technology. The advent of the computerized telephone tree, for example, has created significant new barriers to the free flow of information and the direct link to the public so central to the practice of journalism. For most businesses, this telephone system has been a terrific cost-cutter, a labor-saver, and an efficient tool for directing traffic from consumers. Today, in most corporations, it is rare if not impossible for consumers to connect with a human being on the phone. Consumers instead are greeted by a fully automated system in which they are prompted to press numbers in a menu system to direct their calls. In general, the larger and more complex the corporation, the more elaborate and complex—and irritating—the menu system.

Many national and local news organizations have also adopted such a menu system for routing calls from the public, changes that were prompted by business factors, not journalistic ones. As a result, most Americans view the typical news organization in the same light as any other government or corporate bureaucracy.[92] The commonly recorded greeting, "Please hold, your call is important to us," is just as dishonest and evokes the same frustration, if not more, in those who call the news media. News organizations are theoretically in the business of listening

to the public; they are supposed to be open to us. Instead, in order to gain greater efficiency and perhaps even profitability for the company, the organization is no longer open and truly available for public concerns.

For example, when I made a phone call recently at 6 P.M. EST—an hour customarily considered prime time in daily journalism—to the main number for the *Pittsburgh Tribune-Review*, a newspaper picked at random from among America's more than 1,400 dailies, I was greeted by this recorded message:

> Thank you for calling the *Pittsburgh Tribune-Review*.
> If you know the number of the person you would like to reach, please press it now.
> If you'd like to leave a message for advertising, press 1.
> If you'd like to leave a message for editorial, press 2.
> If you'd like to leave a message for circulation, press 3.
> If you don't know who you'd like to leave a message for, press 4.

The response at the main number for the *Lexington Herald-Leader* in Kentucky on a recent Saturday afternoon was in some ways even more daunting:

> Welcome to the *Lexington Herald-Leader*. If you know your party's extension, you may dial it at any time.
> For circulation, newspaper delivery, or subscription information, press 1.
> For the newsroom, press 2.

Pressing 2 for the newsroom immediately put me into another computerized recorded loop:

> You may dial your party's extension at any time. If you do not know your person's extension, please hold.
> For circulation, press 1.
> For advertising, press 2.
> For market research, press 3.
> Otherwise, at the sound of the tone, please say the first and last name of the person or the name of the department you would like to reach.

If at this prompt you say, "Newsroom," the voice recognition technology evidently cannot interpret the request, for after several rings you are transferred yet again, and a recorded voice answers, "Technology," and invites you to leave a recorded message. When you call again and attempt to reenter the computerized system requesting an alternative destination, "City desk," you again somehow end up at "Technology."

Such automated telephone systems are common today, even at the so-called news hotline and consumer action telephone numbers displayed on the screen by local television news stations to trumpet their commitment to the public. Even the most accomplished news organizations with long histories of public service are similarly distanced by technology from the lives of ordinary Americans. This was the voice recording I got at noon on a weekday in early 2006 when I placed a call to CBS's *60 Minutes* using the number displayed under Contact Info on the investigative program's journalistic Web site, (212) 975–3247:

> Thank you for calling CBS program information. Our office hours are Monday through Friday, 10 A.M. to 11:30 A.M., and 2 P.M. to 3:30 P.M., Eastern Standard Time. If you are seeking information on a CBS News or entertainment broadcast, please call back during those hours. If you care to make a comment about a CBS News or information program, please do so during those hours. We regret that we are unable to return phone calls. Thank you.

The telephone number, it turns out, is not for *60 Minutes* as promised but is a generic number for the entire CBS entertainment corporate empire. And the switchboard is staffed by a human being for only three hours a day. How can a news organization feel truly receptive to the public when it erects so many barriers discouraging citizen contact? In order to reach a journalist at CBS, you must already know the protected and privileged numbers for CBS News, which likely means that only the protected and the privileged are empowered and knowledgeable enough to get through. I sent five experimental e-mails to the *60 Minutes* contact address, 60mcbsnews.com, requesting comment; none were answered. The program's Web site, like so many industry sites in the New Media age that promise contact information and "news" that is "on your side" and "reporting for you," is in many ways something of a cipher.

I'm not suggesting that American news organizations should invest in legions of telephone operators to respond to the public. The point is simply that it's not in the best journalistic interests of our news media culture to show such disregard and disdain for the public. For many ordinary Americans, this tiresome, degrading, and dismissive process of trying to find and talk to a human being in the news industry is just like trying to reach someone at Comcast Cable, Amazon.com, Wells Fargo, or any other mammoth corporation interested not so much in your telephone call as in ensuring that you don't waste too much of the corporation's valuable business time.

The telephone tree system seems to be widely used at smaller and mid-sized newspapers, where cost-cutting measures are most pronounced in editorial operations. At many larger newspapers, such as the *Washington Post,* it's still possible and reasonably simple to reach the city desk directly; but at others, callers face a bit of a struggle and some indirect routing. Trying to reach live people at the national network and cable news programs is often an exercise in absolute and utter futility, especially if you don't know exactly which department you want or the number of the person you're trying to reach.

Indeed, this issue of media availability and responsiveness to citizens remains at the heart of an important national debate about the effects of big media consolidation. Since the deregulation of the radio industry in 1996, for example, Clear Channel Communications has grown from forty stations to an empire of more than twelve hundred, owning more than 10 percent of the nation's total of about eleven thousand. To save on costs, the corporation typically cuts local news programming and other staffing at its stations, relying instead on cheaper, centrally produced, automated programming.

One result? In January 2002 in Minot, North Dakota, a train derailed at 1 A.M., sending a cloud of deadly toxic fumes over the town. Local emergency officials who were attempting to communicate news and information about the emergency through the local radio stations said that they were unable to contact a single human being at the city's six commercial stations—all owned by Clear Channel. The police and fire officials reported that the stations instead were piping in satellite programming through Clear Channel's centralized and automated system at the time of the tragedy. Clear Channel later countered that a person was always on duty at the city's designated emergency AM station, KCJB, but that the system had failed that night because of technological problems and overburdened phone lines. Scores were hurt in the accident, and one person died.[93]

Ultimately, the most damaging part of all this technological and business modernization is how it shuts out whole sectors of society: the poor, the disadvantaged, the marginalized, the elderly, the people whose lives journalists should be interested in examining in order to inform the public and improve their plights. The people to whom a newsroom should be accessible are the very people whose voices remain the least likely to be heard through the maze. Most Americans simply don't know any journalists—and certainly don't know their telephone extensions or direct e-mail addresses. Some broadcast and

cable networks even go out of their way to keep reporter contact information secret. Those who are fluent in these computerized communications systems are generally the people who already know the journalist they want to reach, already know the extension to press when prompted by the telephone menu—the publicists, the lobbyists, the politicians, the informed and influential. Those who don't get through are the anonymous ordinary callers seeking advice, offering an important news tip, complaining about an injustice or a crime, or desiring a sympathetic ear.

In the age of New Media, e-mail does provide a new outlet for citizens to connect with the news media. Perhaps late to the game, many news organizations are rapidly opening their Web sites to citizen comment and reaction to news of the day and offering blogs that readers themselves can produce and edit. But as a replacement for direct human communication between consumers of news and professionals charged with reporting, this medium is an arid and poor substitute, deprived of the spontaneity and vitality of direct contact. And in this ghostly realm, the poor, the less educated, and those less technically able and equipped are again largely left out of the discussion altogether.[94]

In *Democracy and the News*, sociologist Herbert Gans points out that the distance between citizens and journalists helps to determine the kind of news that is reported, and he reports polling data that show that this gap is growing significantly in the modern era. "Because journalists cover mainly high-level office holders," Gans writes, "they naturally concentrate on the issues these individuals deem important. Meanwhile, journalists are too far removed from the citizenry to report or even investigate what issues are of highest priority to them." The result, he argues, is that "top-down news turns journalists into messengers of the very political, governmental and other leaders who are . . . felt to be untrustworthy and unresponsive by significant numbers of poll respondents."[95]

In a sense, the pervasiveness of the computerized telephone trees and the chilly, distancing quality intrinsic to Internet communications are just small pieces of a much larger mosaic depicting a news system out of reach and out of touch with the lives of many ordinary Americans, a system steered increasingly by business imperatives that undermine the value, effectiveness, and responsiveness of professional journalism. These imperatives have helped to make newspapers, especially, less relevant and more dispensable than they were a generation or two ago. Indeed, one can argue that the decline and accelerating fall of the newspaper in American life can be understood not only by studying plummeting

circulation figures over the past quarter century. The decline can also be traced to the period when technology changed in so many fundamental ways, eliminating the skilled working-class jobs of engravers, typeset-ters, telephone dictationists, and others deemed obsolete in the transition from "hot" to "cold" type, people who once represented a solid connection between the newspaper and the lives of ordinary citizens. Or perhaps it can be traced to the day the telephones at the city desks stopped ringing quite as freely and constantly as they once did, with calls from common people who considered the newspaper a vital part of their lives.

THE BIG MOUTH VARIETY

Many people today look to the Internet as a bright new alternative for citizen participation in the nation's civic life, and in many ways it is—a virtual world offering new methods, tools, and outlets to help remedy the growing frustration millions feel about the news media. By the thousands, bloggers are bypassing traditional sources of print and broadcast information, publishing their own works and commentary, and in some cases exposing wrongs and providing checks and balances for the mainstream media. The number of blogs and their readership continue to expand: a Pew study found that blog readership had jumped 58 percent in 2004, with 27 percent of all Internet users reporting that they read blogs. But the same study showed that 62 percent of Americans surveyed still didn't know what a blog was as recently as January 2005. The survey also reported that blogging was popular generally among only a very narrow stratum of American society—60 percent male, 48 percent younger than 30, 70 percent possessing broadband technology, 42 percent living in households earning more than $50,000 a year, and nearly half with college degrees.[96]

Another study conducted by researchers at the University of South Carolina, who surveyed the one hundred top current events blogs produced by citizen journalists in 2004, found that more than half of the bloggers who responded said that they got their information chiefly from newspapers, while significant numbers of the remaining respondents acknowledged receiving their information from other bloggers. Nearly 90 percent of the respondents opposed the journalistic tradition of using an editor to check postings for accuracy.[97] There indeed remain many ethical issues that come into play when traditional journalistic professional standards are not widely applied. Online encyclopedia Wikipedia, for ex-

ample, produced by citizen volunteers under limited editorial oversight, has come under particular scrutiny in recent years because of numerous incidents of obfuscation, biographical fiction, and other fabrications engineered by hoaxsters, commercial peddlers, and crafty marketers alike.[98] Thus far, blogging and other Internet-based, citizen-produced news and information sites do not appear to offer a widely trusted *journalistic* landscape for news-gathering and reporting, one offering understandings, insights, original reporting, and truths in which a wide range of Americans take part.

In its annual study of American journalism, the Pew Center's Project for Excellence in Journalism in 2006 reported the fascinating contradiction that while more and more outlets for news and information were emerging in the New Media age, the amount of news reported by these outlets was actually shrinking as a result of steady cuts in journalistic staffing across the country; only a few transitory stories were being incessantly repeated over any given period. The blogosphere, the study observed, focused in general on commentary about broader, longer-term topics with scant coverage of breaking or original news. While concluding that bloggers raised "new issues" and were not "purely parasitic," the study found that bloggers did virtually no original reporting, with fewer than 1 percent of the blogs involving an interview with someone other than the blogger and only 5 percent devoted to even the barest of reporting, such as examining documents or public records.[99]

Although it is certainly true that blogs and other Web-based outlets have sometimes broken news in cases where the mainstream media either failed or were slow to the punch, from exposés about the authenticity of George W. Bush's military service records to the arrest and anti-Semitic ramblings of celebrity Mel Gibson, one might nonetheless conclude that, overall, the blogosphere contains far more rhetoric, carping, provocation, and rumor than meaningful information to benefit wide segments of the American population. Indeed, a *Newsweek* media and technology writer, commenting on a list of the one hundred most popular citizen journalism blogs, described the blogosphere as "dominated by white males of the big mouth variety." Or, as a female blogger cited in the same article put it, "It's white people linking to other white people!"[100]

Yet many participants and observers of the blogosphere view this new and roistering realm of cyberspace as a viable alternative to professional journalism, a point that once again raises the essential question of whether such journalism and its ideals, at least as we have known them for many years, have much meaning or any broadly shared definition in

contemporary society and, if so, what their value is. Consider, for instance, a notion raised by two researchers for the Poynter Institute, who theorized that it will be possible in the not too distant future for search engines like Google to piece together fragments of information from blog entries to create composite "news" stories to compete with traditional media.[101]

Reflecting on this future and the legal implications for copyright violations, Julie Hilden, a writer and lawyer on the legal services and information site findlaw.com, was enthusiastic about the possibilities:

> I believe that the Supreme Court probably would hold such composite stories to be "fair use"—as long as the robots [collecting the information] were careful to take only snippets from each source. . . .
>
> Readers may not judge blogs and other sites to be as reliable as traditional media reportage by the online outposts of long-established journalism institutions. But a more sophisticated system of flagging reliable and unreliable content could fix that. . . .
>
> Remember, a *New York Times* reporter is just a blogger who happened to attend college; impress some bosses with his or her talent; get some training through experience—and possibly (though certainly not always) journalism school; and receive a podium for his or her pains. . . .
>
> Traditional media is not hardly dead yet. But with tools like these, New Media may drive a few stakes in its heart.[102]

According to Hilden's biographical information at findlaw.com, she is a regular columnist and respected practitioner of law with expertise in the First Amendment. If a person of her background and expertise can equate the works of today's average citizen blogger with the professional skills, talent, and mission of a reporter for the *New York Times,* what must that say about the awareness and understanding of other Americans about the profession and its value to democratic society?

Still, it certainly does remain premature to pronounce the traditional news media dead. The top twenty most popular Web sites for news and information continue to be dominated by traditional corporate news media, not alternative forms, including sites for CNN, MSNBC, the *New York Times,* Gannett newspapers, Tribune newspapers, and Knight Ridder. Also among these top news sites are Yahoo! and Google, so-called news aggregators, which are climbing in popularity.[103]

This situation creates an obvious lose-lose predicament for the traditional media, and particularly for newspapers. With declining circulation and ad revenues, and readers turning to the Internet for information that

local newspapers customarily provide,[104] publishers are looking frantically for ways to enhance their profits from the Web, including the use of text, banner, and pop-up advertisements. But these clever efforts to maximize profit frequently have an opposite result, with readers becoming alienated and frustrated by the online news experience. When you visit USAToday.com or NYTimes.com or other news sites these days, you sometimes feel like a gerbil helplessly caught in a treadmill of advertisements. Clicking on a story link might take you not to the story but to an unexpected pop-up ad, an experience not unlike that of a greenhorn tourist being snookered by a three-card-monte dealer working a cardboard box on some street corner in Times Square. Then you have to hunt around the screen for the small "Skip This Ad" link hidden in a corner of the ad to finally move on to the article you wanted.

High-tech gurus at newspapers and other print media news Web sites seem to be continually inventing ever more crafty digital tricks to tease the visitor, anything to induce you either intentionally or accidentally to click on a marketing link or roll your cursor over an ad. USAToday.com has used the trick, now replicated by other newspaper Web sites, of teasing you ever so briefly with the top news of the day on the main Web page, just before the front page quickly dissolves into advertisements which you must acknowledge with your cursor and your attention in order to read the news of the day. What's worse, many newspaper and magazine sites require visitors to register personal information about themselves—name, address, zip code, sex, date of birth, e-mail address, even your mother's maiden name in case you forget the password—just to gain access to the news. In the days before the Internet, at least you received extra value when you paid for a newspaper off the rack or enjoyed a home subscription to keep up with the world. Not only did you possess far more free will to ignore the ads if you wanted; you also didn't have to poke around for an intentionally concealed instruction telling you to "Turn This Page."

You could also carry the printed material around with you, a tangible benefit over its New Media representations.[105] Perhaps just as important, you could do other things with a newspaper or magazine. You could line the parakeet cage with it when you finished reading. You could wash and dry windows with it; use it to make papier-mâché projects with your kid; craft sailboats, kites, and caps with it, as the ever mischievous Curious George once did with the Man in the Yellow Hat; use it to pack away glassware; line garage shelves with it; wrap the garbage in it; use it to

light a fire on a chilly night; line your shoes with it to ward off the winter cold. In more ways than one, for rich and poor, in bad times and prosperity, newspapers, as well as weekly and monthly magazines, were a welcome and ubiquitous presence in American life.

But in its modern incarnation on the Web, the local newspaper or magazine seems to take away from the reader, with no bonus values added. The experience of getting the news takes your time, especially if your computer is slow or your technical skills are less than sharp. Then the publisher demands your personal information, often in order to re-sell it for profit to marketers. The typical newspaper Web site also wants to use your e-mail address to bombard you with advertisements if you do not click the inconspicuous opt-out buttons, thus making the relationship between the reader and the newspaper a wary and somewhat antagonistic one from the beginning. So frustrating is the experience for millions that it has given rise to fight-back sites on the Web: for example, a place fittingly called Bugmenot.com allows Internet users to share generic sign-on names and passwords for Web sites, many of them newspapers and magazines, which helps them avoid the intrusive process of registering.

The thorny problem for newspapers today is that so many are giving away their product for free on the Web, thus worsening their economic situation and accelerating cuts in journalistic staffing. The last resort is to charge customers for online access, which the *Wall Street Journal* has done for several years now. In 2005, the *New York Times* announced that it too would begin charging for premium offerings, including the works of its columnists. But other newspapers have found very little success with this strategy. The *Los Angeles Times* in 2005 dropped a policy of charging readers to access its entertainment section after seeing the number of visitors to its site sharply decline. Meantime, the *Spokane Spokesman-Review* went in the opposite direction in March 2005 and began charging visitors to its Web site, expressly to save the print edition. The publisher, Ken Sands, told the *New York Times,* "We had the sense that a lot of people had canceled their print subscriptions because they could read the paper for free online." After it began charging for its online product, the newspaper immediately found that new traffic to its Web site, which had been growing by 40 percent per year, dropped to virtually zero.[106]

The challenge for the traditional news media to simply survive in the New Media age, much less to maintain profitability, is monumental. And

the challenge for professional, dedicated, and effective journalism to flourish in this same business situation is arguably even more so.

This, then, is the world of illusions in the American media carnival, a show where things are rarely what they appear to be. In this attraction, a journalist is not always a *journalist* exactly, but instead is often a huckster or a charlatan. It features untrustworthy yet incredibly profitable performances in which public relations experts and political and commercial advertisers alike freely disseminate propaganda disguised as news, sometimes with the willing participation of a news industry increasingly strapped for cash. It showcases news organizations that are ostensibly dedicated to seeking and telling the truth but that are disinclined to do so when it comes to questions about their own practices and falling standards.

The illusions are complex, and deeply contradictory at times. Barkers shout out to us that we are increasingly benefiting as a society from the bountiful new outlets of news and information available to us, in all their still-evolving technological forms—and studies do show that we are flocking to these new outlets in growing numbers.[107] Yet as the industry's outlets become more numerous, the actual news, the truly independent and meaningful journalism we receive, appears to be shrinking amid changing news values and ever-tighter cost-cutting. Indeed, the strangest illusion of all may be that just as the age of New Media promises us so many miracles and wonders, the reality is that we are in many ways being shortchanged as citizens and consumers of professional and original news-gathering.

The world of illusions occasionally presents sleights-of-hand so astonishing that even the most accomplished deceivers might be amazed. Several years ago, the *New York Daily News* published a series of investigative articles about local supermarket chains whose stores were too dirty to meet New York state health standards. Titled "Dirty Rotten Shame," the series infuriated grocery store advertisers, most of whom protested by withholding their ads from the newspaper. Losing an estimated $50,000 to $100,000 per week in advertising revenues, the *Daily News* a month later resorted to a tactic that any clever, revenue-conscious modern news medium would readily exercise: it published a lavish, four-page advertorial supplement special, replete with "news," photos, and

feature stories enthusiastically complimenting the local supermarket industry in an effort to curry favor and lure the advertisers back.

Revelations about the production of the unusual advertorial were first reported in a news story in the rival *New York Times,* in which a spokesperson for the *Daily News* candidly expressed the paper's aims: "This advertorial series is part of a package of advertorial, advertising and value-added marketing that we hope will bring supermarkets back to the newspaper." The fawning appeared to work, and the advertisers soon returned.

But perhaps the most fascinating aspect of the episode was that the *Times* reporter who broke the news about this all-too-typical example of deceptive journalistic practice in modern America would himself become a showcase symbol of fraud in the news media just two years later, when he was famously exposed as a pathological liar who had no business covering the news. In this one instance, however, in this one moment, the carnival's world of illusions did not trick the customer or distort reality. The liar was actually telling the truth about the latest example of a highly questionable and increasingly common practice in the endangered news industry, the kind that E. B. White feared would become reality more than thirty years ago. The reporter was none other than Jayson Blair.[108]

5

Defending the News

The panel of young reporters worked for two competing American newspapers, but the stories they told the audience about their experiences covering the Iraq war and the U.S. occupation were similarly intense and riveting. All had gathered on a cool night in April 2005 to hear the young people speak about war correspondence. We met in a library at the University of California at Berkeley, where the reporters had earned their master's degrees in journalism less than a decade earlier. Jackie Spinner, who hails from a white working-class background in southern Illinois and who has covered the American occupation for the *Washington Post,* spoke eloquently and movingly about the extraordinary courage of her Iraqi co-worker in Baghdad, who each day risked his life to help gather news and translate for the *Post* bureau, inspired by the ideals of the free press that the American newspaper symbolized. Edward Wong, an Asian American working for the *New York Times,* participated in the panel by voice, his words reaching the audience live and direct from 7,450 miles away at the *Times* news bureau in Baghdad on a teleconference hookup. Wong also told gripping accounts about the daily struggles of ordinary citizens in Iraq in the war's aftermath and the sheer difficulty of reporting the news amid rampant violence and lawlessness.

But it was the story told by a third journalist, a Haitian American woman named Theola Labbe, that seemed to resonate most deeply with the fifty or so students, teachers, and other spectators. Her words came in response to a short question from a member of the crowd: what made you decide to go over there?

Labbe, thirty-two, a tall and striking woman with short-cropped hair, thought a moment before speaking. Then she recalled for her listeners how it all began for her. She had been working as a metro reporter for the *Post* in Washington, covering a local education beat, at the time the invasion of Iraq started in March 2003. The newspaper's editors had sent word via e-mail to all their reporters that the paper needed volunteers to go overseas to help cover the story. Foreign experience was not absolutely required, nor was prior experience in covering military conflicts. What the editors needed were energetic, eager, and good *reporters,* period.

Like many Americans, Labbe had witnessed on live television the daily news conferences about the war from the White House and the Pentagon, the briefings by officials such as Defense Secretary Donald Rumsfeld and Vice President Dick Cheney, and the coverage by the major television news organizations, which had suddenly begun featuring American flags as part of their on-screen logos as testimony to their patriotism. Labbe saw the television reporters "embedded" with U.S. troops covering the assaults on Baghdad and other cities, but reporting little news coverage from other perspectives, such as that of Iraqi civilians. She heard government officials and the nation's mass media alike frequently invoke Pentagon expressions like "shock and awe" to describe the beginning of the military campaign, and "precision laser-guided bombing" and "collateral damage" to reflect the result of the violence inflicted by U.S. weaponry on the Iraqi army and civilians. She said it seemed that in some ways the news media were acting as an extension of government, at times even endeavoring to rally the American people behind the administration's war, instead of serving as an independent watchdog for the truth. The performance troubled her. What were the real effects and the human toll of that bombing we were witnessing from so far away? she wondered. What stories were the American people *not* hearing, seeing, reading?

Labbe volunteered for the assignment and, to her surprise, was accepted for the mission. She spent three weeks after the war's official end traveling from one end of Iraq to the other, interviewing everyone from U.S. troops and Iraqi civilians to Red Cross workers treating the

wounded and dying for a series of stories about the war's aftermath on the ground, as she saw it with her own eyes. "I think that's why we do what we do, as journalists," Labbe told the audience. "That's why I went. I wanted to see for myself what was really going on."

The young reporter's words seemed a fitting, concise, and compelling summary of the vital role professional journalists must play in a democratic society. She had expressed both the purest motivations and the central purpose of the calling—and had put into stark relief the unstated array of forces that could compromise that mission. Journalism represents the lifeblood of a free society, one of the highest expressions of First Amendment guarantees to freedom of assembly, speech, and religion. For a people who are empowered by a self-governing constitution to render decisions about the best ways to govern and improve society—decisions ideally based on ample and accurate information—it is a priceless and irreplaceable resource. Guided by these civic values, skilled journalists pursue this mission for the people, are expert at gathering the news in a complex world, and possess the professional dedication required to seek truth and report it without fear of countervailing authorities or favor for vested interests. Journalists simply want to see for themselves what is really going on. They serve neither the government nor public relations nor advertisers nor entertainers; rather, they serve the interests of the public in finding the truth, because the public has the right to know.

"Seek Truth and Report It" is the eloquently simple and overarching exhortation written into one of the most important documents expressing the profession's ideals, the Code of Ethics espoused by the Society of Professional Journalists. The SPJ first adopted the code in 1926, borrowing many of its early precepts from a similar code of ethics enacted in the same era by the American Society of Newspaper Editors. In this post–World War I period, industry and professional leaders recognized the urgency of raising the levels of standards and practices in journalism in order to serve the public better and improve the health of democracy. The code has been revised and enhanced numerous times in the years since, but its prime directives remain essentially the same, divided into four simple categories:

Seek Truth and Report It

Minimize Harm

Act Independently

Be Accountable

The powerful document trumpets the highest beliefs of the largest and most influential organization of professional journalists in America today, one whose precepts have been adopted, at least in theory, by most news organizations around the country. It lists scores of directives and prohibitions covering everything from conflicts of interest and plagiarism issues to the importance of avoiding advocacy and inviting public dialogue about journalistic conduct. Examples of its guiding principles include the following:

> Be honest, fair and courageous in gathering, reporting and interpreting information. . . .
>
> Test the accuracy of information from all sources and exercise care to avoid inadvertent error. . . .
>
> Tell the story of the diversity and magnitude of the human experience boldly, even when it is unpopular to do so. . . .
>
> Be vigilant and courageous about holding those with power accountable.
>
> Deny favored treatment to advertisers and special interests and resist their pressure to influence news coverage. . . .
>
> Avoid stereotyping. . . .
>
> Abide by the same high standards to which [journalists] hold others. . . .
>
> Distinguish news from advertising and shun hybrids that blur the lines between the two. . . .
>
> Be free of obligation to any interest other than the public's right to know.[1]

Despite the importance and clarity of these principles and the values they reflect, professional journalism in America today often seems troubled and confused. The picture is daunting. We see increasingly sophisticated billion-dollar public relations firms being given easy access to local television news programs, which broadcast fake news intended to sell products or push political agendas. We see local television news operations, which provide the chief source of news and information for most Americans, so strapped for cash and bereft of skilled and salaried reporters that they are willing to outsource their news "reporting" to advertisers and government. We see those same news stations not only fail to hold themselves publicly accountable in the aftermath of scandal—as ethical codes insist that they must—but actively hide from most outside inquiry, thus holding their own operations to lower standards of openness than they demand of other institutions.

We see news values and editorial decisions influenced by market research firms rather than being shaped by the public's right to know. This is the troubling climate of a system that would judge the newsworthiness of public protests against the Iraq war based directly or even indirectly on market research warning that such coverage could result in lower

viewer ratings and lost revenues. That climate suggests the deeply un-settling notion that in our nation today, freedom of the press is perhaps valuable only when it conforms to popular views, not when it remains open to unpopular ones.

We see the chief licensing body governing the broadcast industry, the Federal Communications Commission, far more concerned about pun-ishing the media for allowing the baring of a woman's breast on the na-tion's airwaves or the uttering of a four-letter word than it is about rep-rimanding and disciplining the same media for peddling commercial and political advertising as news.

We see news media increasingly mistrusted by the people at least par-tially because the people have been so clearly led astray in recent times by a "news ecosystem" rife with falling standards for accuracy, aggres-sive questioning, and fair reporting. Fraud within this system indeed has played a role in shaping important decisions that have affected the func-tioning of democratic society, with the news media on some levels demonstrably complicit. In June 2005, the *Washington Post* and ABC News released findings from a public opinion poll showing that for the first time a majority of Americans—52 percent—believed that they had been duped into supporting the Iraq war by an administration that had "deliberately misled" them by fabricating intelligence information about whether Iraq posed a threat to the United States.[2]

We see newspaper and magazine publishers teaming up with adver-tisers to produce publications and special sections that are intended to resemble professional journalism but serve instead the central goal of snookering readers into buying products. We hear and see hucksters call-ing themselves journalists who push specious products on susceptible consumers through infomercials and documercials that abuse the pre-sumed credibility of real independent journalism and public affairs pro-gramming. We see the *image* of journalism becoming one of the most ef-fective vehicles for marketing in modern America.

We see major television news networks and print media still unwill-ing to answer the decades-old call to diversify their newsrooms in order to improve news coverage across the nation's class, ethnic, intellectual, political, and racial distinctions. We see that stereotyping of ethnic, racial, and religious minorities persists in our media and culture. We see evidence that American newsrooms are increasingly disconnected from the public, at least partially because business factors take precedence over critical journalistic concerns that require being accessible to the public.

We see newsrooms so pressured to fill twenty-four-hour news cycles that traditional journalistic checks and verification procedures are sometimes bypassed or ignored so that the news organization can be first with the most sensational and entertaining news, even at the risk of being wrong or hoaxed. We see journalistic fabricators crafting frauds that take advantage of the same leaky system. We see so-called news organizations ignoring or refusing to cover people and events that are outside the margins of what media owners perceive as the social "accepted norm" of their communities.

We witness growing pressure from the government to influence and shape editorial news judgments on our public television and public radio news programming, working under the assumption that public officials can better assess balance, fairness, and accuracy than the professionals who practice the craft. To a presidential administration in the age of New Media, journalistic "balance" is a simplistic goal reached by counting the talking heads on news and public affairs programs, categorizing each one as "conservative" or "liberal," and making sure that the number of guests perceived as "C" is sufficient to cancel out those perceived as "L."[3] Yet journalists know that the pursuit of truth and the constructive examination of important issues are far more complex processes than that, demanding critical thinking, sensitivity, circumspection, and a willingness to search for meaning in the gray areas beyond the strident extremes. Real journalism stands in opposition to the distortions, abuses, and moral failures that typify the news industry's carnival attractions today. Real journalism means cutting through the deceptions and fraud and being willing to stand up and fight the pressures that would compromise the practice of the craft. It means bearing witness and telling the truth.

Real journalism means remembering and building on the heroic advances made by predecessors long dead and the lessons about democracy they sought to impart: the brave work of the Chicago Commission on Race Relations in the aftermath of the Red Summer of 1919; the ideals of the writers who crafted the first SPJ Code of Ethics in 1926; the elegant and stirring words of E. B. White, ethicist and sublime *New Yorker* magazine essayist, who warned about the dangers to democratic society of erasing the lines between advertising and journalism.

Real journalism is exemplified by the story of a man who overcame the racial animus of his youth to write one of the most stirring narratives of truth and human understanding ever chronicled. John Hersey grew up in China in the 1930s, the child of Christian missionaries. He learned to

despise the Japanese military—and all Japanese—for their brutal treat-
ment of civilians during the occupation of Manchuria. As a journalist
during World War II, Hersey accompanied American troops in numer-
ous engagements in the Pacific, which he documented in magazine and
newspaper narratives. He echoed the GIs' descriptions of the Japanese
enemy as "monkeys" and "animals." Yet this was the same man who
traveled to Japan six months after the first atomic bomb was dropped on
Hiroshima. He was able to transcend racial prejudice to report on the ef-
fects of the blast and its aftermath, as experienced through the vivid and
detailed memories of a small group of Japanese survivors. Hersey's *Hi-
roshima*, first published in the *New Yorker* in 1946 and reprinted in var-
ious editions in book form since, brought home to the world in an un-
precedented way the brutality and horror of war and atomic weapons,
the grace and dignity of those who survived, and the extraordinary hu-
manity that connects us all across our many divides.[4]

It was Hersey, too, who railed against practitioners of the so-called
New Journalism in the 1970s. This newer generation of magazine and
long-form writers—Norman Mailer, Truman Capote, and Tom Wolfe
among them—chose to enhance and dramatize reality by making up di-
alogue and inventing scenes in works ostensibly presented as nonfiction
journalism. In an essay for the *Yale Review* in 1980, Hersey argued that
all genuine journalists possess an intangible but very real "license" that
they must always respect for the honor of the craft and the good of
democratic society, a license whose legend reads "NONE OF THIS WAS
MADE UP."[5]

This essay is still referenced today by journalism ethics instructors at
universities across the country, who make it required reading for their
students. In my view, however, a later, much less quoted essay Hersey
wrote about the singular power of truth and the mission of journalism
drives home the point more strongly, urgently, and vividly. Published in
1989, four years before his death, this essay was written as part of a new
foreword to the reissue of *Into the Valley: Marines at Guadalcanal*,
Hersey's 1943 narrative about jungle warfare and the American marines
who battled for the Pacific island against entrenched Japanese soldiers
during World War II. Throughout this essay, Hersey struggles with the
question of how to update his narrative so many years after the fact.
Should he use the real, raw language the soldiers used then, instead of
the "hell," "damn," and "gosh" that made it past the government cen-
sors in the original? Should he cut the passages in which he, as narrator,
and the soldiers referred to the enemy as "animals" and "savages," in-

cluding the quote from the marine who said he wished "he were fighting against (white, blond?) Germans, who 'react like men' instead of against these Japanese animals, who 'take to the jungle as if they had been bred there'"? Should he modify the words he wrote describing a scene across a river, where he sees "a swarm of intelligent little animals" preparing mortar tubes for fire?[6]

Hersey wrote that he felt ashamed of the dialogue and descriptions in *Into the Valley*, some forty-seven years later, and that his first instinct was to clean up and sanitize the narrative to suit more progressive late twentieth-century racial sensibilities. But as a journalist, he knew that he needed to keep the narrative as it had originally been written. The interest of truth demanded it. And the ultimate truth about war "is that it makes no national or racial or ideological distinctions as it degrades human beings," he wrote. "What argued against cutting shameful words from my book for a new edition was that having them appear there, today, nearly half a century later, might help to show what warfare could do to a young mind that thought it was in pursuit of truth."[7]

The pursuit of truth is the journalist's prime motivation. This pursuit is also, in the end, the journalist's only true value to justice and democratic society. Recalling his coverage of World War II, and how it had so deeply affected his view of humanity's capability for both enormous good and tremendous evil, Hersey in a single anecdote evoked the transcendent power of journalism to make people clear about the difference. "I talked with survivors of Nazi massacres at concentration camps near Tallinn, Estonia, and at Radogocz, Poland. I saw the ruins of the Warsaw ghetto and met survivors, liberated only 10 days earlier, of the Lodz ghetto," Hersey wrote, "some of whom kissed my hand, not because I was an American but because I was a journalist and could tell, tell, tell."[8]

Real journalism is reflected in that story, and in those of countless others, too. It's witnessed in the life of Elijah Lovejoy, the prescient, courageous publisher of the *Alton (Ill.) Telegraph* newspaper, who defied the socially "accepted norm" of his virulently pro-slavery community to editorialize against the owning of human beings. Risking all, Lovejoy was slain by a mob in 1837 for expressing his beliefs and pursuing the truth as he saw it. It's seen in the story of the black American press during World War II and the genius of the "Double V" editorial campaign, in which black newspapers pushed not only for victory over the forces of tyranny overseas but also for victory over the enemies of racial equality and freedom at home. It's apparent in the story of *Chicago Defender* publisher John Sengstacke, who supported the "Double V" campaign

despite threats that his paper would be closed down and that he would be prosecuted for treason by the federal government. Sengstacke insisted that it was the duty of black journalists and publishers to print the truth as they saw it and to press legitimate claims at home to the freedoms that black soldiers were fighting to bring to foreigners in distant lands.[9]

But even more than such examples of bravery in the face of power and vested interests, the value of the calling remains the day-to-day pursuit of multitudes of truths by professionals across America who see their role in society as chiefly to inform people about significant matters affecting their lives—not to remake the world, not to vainly cozy up to the rich and powerful, not to chatter about the news on television talk shows or in public conversation forums, not to pump up support for or opposition to candidates or political agendas, not to opine online in snarky reaction to news of the day, and certainly not to induce the public to buy things. Journalism is the work of contributing fresh information to the body of our common knowledge in a free society. It is what A. J. Liebling once described as a profoundly challenging civic endeavor in which there is no substitute for doing the hard work, for getting the bottom of one's shoes dirty—"you have to climb the stairs," he once wrote, to get out and explore and find the news and ask tough questions about why things are the way they are.[10]

Journalism is giving the score from last night's Yankees game, providing the weather forecast for the Memorial Day weekend, reporting the angry debate or bitter vote on the new city council zoning measure or the high school curriculum change proposed by the county board of education. It's hunting through public records to find the paper trail pointing to graft by an elected official. It's analyzing quarterly data from the U.S. Department of Labor and interviewing experts about why the working poor earn less and less. It's critiquing the latest blockbuster movie that's come to town from Hollywood.

It's reporting the abuse of workers or the pollution of the environment by a major local manufacturer that is also an advertiser and big employer. It's asking tough questions of the governor or the president about taxation or war, questions that are not simple to answer and that might not have been approved by the official's public relations advisers, but that must be asked for the sake of the public and the health of representative government. It's having the chops to dig into society's neglected corners to reveal systemic inequality or into the world's distant reaches to report on injustices and rising resentment toward the West, before a hurricane like Katrina or the 9/11 terror attacks do it for us. It's the sin-

gular pride and confidence of knowing that the news organization you work for will back you up uncompromisingly in your fight to protect the confidentiality of whistle-blowers and other sources who trust you with important news. It's any number of everyday pursuits testifying to the professional journalist's honored—and honorable—obligation to inform the people.

Journalism is, in the end, a deeply human endeavor, one filled with ethical pitfalls and many opportunities for failure. The old cliché remains as apt as ever: it's history's first draft, not the last. It's also a craft whose dedicated practitioners respect the professional and constitutional ideals that guide it, just as the great majority possess a tireless desire to approach perfection in their work even if that standard is impossible.

TRUE CONFESSIONS

Nearly fifty years ago, political scientist Samuel P. Huntington wrote a classic study about military professionalism and its role in democratic societies that in a way helps to shed light on the troubles of contemporary journalism, the shrinkage of professional content and lowering of standards, and the ramifications of those troubles in our world. In *The Soldier and the State,* Huntington stresses three criteria for professionalism in the military. The first is expertise, roughly defined as the officer's trained skill in the methods of applying and managing violence. Second is a keen awareness of responsibility, that the officer plays a role "essential for the functioning of society; the client of every professional is society," and this "social responsibility" is what separates the professional from other experts. Huntington adds that money should play little to no role in defining professional officers or their central purpose; their allegiance is to values far higher than financial gain. Third, Huntington explains, military officers share a common faith that they are professionals bound by high standards that require certain skills and training and that must be upheld at all times. "The members of a profession share a sense of organic unity and consciousness of themselves as a group apart from other laymen."[11]

Huntington's aim is partly to point out the importance of professionalism in the military, as a key underpinning of democracy itself, a form of human organization in which the civilians who govern serve only with the consent of the governed. Professionalism and high ethical standards in the defense of this form of government are vital: in their absence, all manner of chaos is possible, including the fragmentation and disinte-

gration of a society whose citizens may not trust the military to serve in their best interest.

I maintain that many of Huntington's points hold true for professionalism in journalism and its role in democratic society. In a form of human organization so deeply reliant on freedom of expression and an informed citizenry, professional journalism offers the most valuable vehicle for communicating enlightenment, truth, and clarity and for holding our elected leaders accountable. But just as a lack of professionalism in the military can lead to chaos, the decline of professionalism in journalism can also lead to all manner of dysfunction. Our society becomes less democratic and more vulnerable to oligarchic or authoritarian forces whose power depends on keeping citizens ignorant or deceived. Indeed, professionalism in journalism is just as critical to the healthy functioning of democratic society as professionalism in the military.

In this book, I have sought to identify the elements of professional journalism by examining the nature of the many fraudulent works proliferating in popular culture and the news media that are *not* journalism. I began this journey by recounting the troubling news I have been receiving for nearly a decade from former students about the state of ethics in the news media and their growing concerns about the direction of the calling. In this final chapter, I'll briefly return to the topic of young people and their future in journalism. But first, in the interest of full disclosure, I offer a few confessions about my own failures in the profession, one I have practiced and taught for more than a quarter century, to put into a personal context many of the problems addressed in the foregoing pages.

I am neither a media ethicist nor a journalism historian, nor do I presume to have any deep intellectual expertise in these topics. I was hired at my university as a teacher of reporting and writing some years ago on the basis of my experience and skill as a practicing newspaper journalist. In that latter capacity, I made plenty of mistakes in print over a period of seventeen years, most of them when I was young. All journalists do. Most of the mistakes were pretty minor, all things considered. For example, in 1979, I incorrectly reported the home state of a man chosen to head a search for a new school superintendent in a secret vote by the Montgomery County School Board in suburban Washington. Since my beat was the county school system, it was a pretty big story. The guy was from Evanston, Illinois, not Evanston, Ohio—a stupid mistake, published in the paper's first editions, that detracted from what should have been a wonderful scoop for me, a twenty-four-year-old cub reporter.

I also was guilty of several truly idiotic mistakes of storytelling. As a young reporter, I once covered the opening day of hunting season in Maryland by visiting a roadside breakfast joint where dozens of hunters had gathered in the rural predawn. Attempting to wax dramatic later as I crafted the story in the newsroom, I wrote in an explanatory, or "nut," paragraph: "Maryland's week-long deer season (shotguns only) opened yesterday. All over the state, from the hills of Dorchester County to the farmlands of Charles, scenes like the one at the B and J Drive-In were played over and over." The story read fine when it was first published, and it still reads fine in databases and microfilm to this day.[12] Except for one thing: there are no hills in Dorchester County, a fact relayed to me soon after my story appeared by the newspaper's outdoors writer, who informed me that the county, which I had never visited, was "flatter than a pancake."

I fell victim to a kind of hoax, once, too. When I was a young summer news intern, I was handed a telephone number by my news editor one morning and assigned to conduct a telephone interview with a deep-sea diver on the Virginia coast who had reported finding the wreck of a nineteenth-century ship. It was a wonderful story, and the guy filled me in by providing terrific details about the ship's history and condition. Much of the story that appeared the next day about the discovery was in fact based on the diver's description and his narrative.[13] The story was true enough: there had been an old shipwreck, and it had been discovered off the Virginia coast. But the man who deserved credit for the discovery was a different diver—not the man I had interviewed, who appeared so eager to take credit for it. I made the correction in a follow-up story soon after.

I also worked once with one of the great fabricators of modern journalism, Janet Cooke. At the time, I wasn't aware of her talent for fiction. The ethics lesson and anecdote about her that I use in my classroom begins like this: On Monday, March 30, 1981, after giving a speech at the Washington Hilton Hotel, President Ronald Reagan was shot and seriously wounded as he exited the hotel. The assailant was John W. Hinckley. All that week, *Washington Post* reporters scrambled to learn as much as they could about the background of the twenty-two-year-old loner, his family and childhood in Colorado, his aimless college years at Texas Tech University in Lubbock, and the fateful bus ride across America that started in Los Angeles and ended with his attempt on the president's life in Washington.

In the course of this intensive news reporting by *Post* journalists across

the country, details emerged of a deeply troubled young man influenced by a nihilistic Hollywood film of the era, *Taxi Driver,* starring Robert De Niro as a troubled New York cabbie and political assassin. An object of De Niro's obsession in the film was a character played by actress Jodie Foster. Foster herself was Hinckley's love obsession. At the time, there were unconfirmed reports that Hinckley had visited New Haven, Connecticut, at one point in his travels, to attempt to see the actress, who was then an undergraduate student at Yale University. One theory making the rounds at police headquarters, we heard, was that Hinckley shot the president in order to win her attention, as the taxi driver had attempted to do in the Martin Scorsese film.

As part of the *Post*'s mammoth national reporting efforts that frenzied week, Janet Cooke was dispatched to New Haven and Yale to see if she could learn anything from anyone there about Hinckley and his suspected visit. Cooke at the time was riding a crest of extraordinary success and acclaim. Her stunning "Jimmy's World" feature story about the eight-year-old heroin addict had appeared in the *Post* just six months earlier, on September 28, 1980, and by now she was renowned as an up-and-coming *Post* reporter and writer.

My job, and that of another young writer on the Metro staff, Chip Brown, was to try to piece together all the information that we were receiving from Texas, Colorado, California, and other places about the heretofore anonymous drifter in order to write a long narrative article about him for the following Sunday's edition of the newspaper—a profile, in short, of "The Man Who Shot Ronald Reagan." It was Cooke who phoned in a remarkable anecdote about Hinckley, one confirming that the drifter had in fact visited Yale and tried to stalk Jodie Foster barely a month earlier. She dictated the anecdote to a telephone operator in our newsroom, then the most advanced form of communications technology available to us, and the anecdote soon made its way to us in typewritten form along with mountains of other raw reporting information about Hinckley.

Cooke's anecdote was a beauty. She reported that several students in Foster's dormitory recalled the drifter, although none of them wanted to be identified. Cooke quoted one student as follows:

> I live at Welch and I have seen that guy Hinckley over here. He was here in March, hanging around outside the door. At first I thought he was a jock. You know, he was heavy and sort of greasy and he really didn't seem very bright. It was a little weird but there are always people hanging around here so we didn't pay much attention. But then I saw him again and he asked something like "Does Jody live here?" I thought, "How strange." Some of

us made a joke about it and started calling him Mr. Toxic Shock. In a couple of days, he was gone and we sort of forgot about it.

In 1980, the news media had widely reported an outbreak of toxic shock syndrome, a life-threatening bacterial infection often associated with the use of superabsorbent tampons. The outbreak that year had occurred mainly among young women. Cooke's anecdote thus struck me as pretty genuine at the time. "Mr. Toxic Shock" sounded just like a term a group of hip young Yale co-eds would use to describe a fellow who looked a little strange and was acting oddly.

That Sunday, our eight-thousand-word story about John Hinckley's life and the deranged path that led him to shoot the president appeared on the front page of the *Washington Post,* headlined "An Aimless Road to a Place in History." Cooke's anecdote about the unusual impression Hinckley had made on the students in Jodie Foster's dorm at Yale, featuring the vivid anonymous quote, appears about a third of the way into the story.[14]

Little more than a week later, on April 13, Janet Cooke was awarded the Pulitzer Prize for feature writing for her "Jimmy's World" article. The next day, a wire service reporter checking up on her background while reporting a story about that year's Pulitzer winners soon discovered discrepancies in her résumé. Contrary to what appeared in her biographical information, the wire reporter learned that she had never worked as a reporter in Ohio before coming to the *Post.* Nor had she attended the Sorbonne in Paris. The reporter contacted the *Post* about the discrepancies. Editors began grilling Cooke not only about her résumé but also about her "Jimmy's World" article. Many hours later, she finally confessed that she had fabricated most of the story. The eight-year-old heroin addict did not exist. Cooke resigned on April 15, barely ten days after our Hinckley article appeared, and the *Post* announced that it could not accept the Pulitzer.

Anyone who worked at the *Washington Post* back then can't help but vividly remember the scene that morning when our editor, Ben Bradlee, stood atop a desk in the middle of a hushed newsroom to announce how deeply pained he was to officially inform us about the shame and disgrace that had befallen the newspaper. It was by far the lowest moment in the newspaper's history, and it came just seven years after its greatest triumph—the *Post*'s stellar investigative reporting during the Watergate scandal, which culminated in the resignation of President Richard Nixon. I certainly will never forget that scene in the newsroom. But I also

remember just as vividly the anecdote Janet Cooke gave us about John Hinckley's visit to Yale, which we published under our bylines. To this day, I have no way of knowing whether her "Mr. Toxic Shock" anecdote was true. But I'm pretty sure she made that story up, too. The fact is that among scores of reporters who flooded Yale that week, Janet Cooke was the only one to get any information or recollections about Hinckley from any of the students.

The marvels of technology are such that today I can instantly retrieve that story from an Internet database, LexisNexis.com, and use a computer projector to display it on a big screen in my California classroom for my students to read. I tell them everything about the story—Reagan, Hinckley, Janet Cooke's imaginary child heroin addict, the awful morning when Bradlee announced the disgrace to all of us, the systemic flaws that allow journalistic mistakes and crimes to happen. I think the story in one sense reflects how truly hard newspapers work to piece together news events under the pressure of deadlines and the constraints of incomplete information—to craft history's first draft. But the experience also shows how disturbingly easy it is to create a lie that can be sustained forever in the public mind and public record—whether told by individuals or institutions—and the damage that results when loyalty to truth is undermined by other interests and motivations.

My ethical failures, too, provide me with lessons for teaching the craft. My students know the story of how, in 1981, I was dispatched by my editor to rural Mt. Airy, Maryland, to report a day-after feature article on the tragic accidental shooting of a young mother by her three-year-old son. While playing in his parents' bedroom, the boy had discovered his father's .357 Magnum handgun on a bureau. The child picked it up with his hands, slipped his fingers on the trigger, and then, playfully pointing it toward his mother, asked, "Pull this, Mommy?" before pulling the trigger. The boy's mother was critically wounded when the bullet tore through her chest. I learned all this when I interviewed the devastated father and the boy's thirteen-year-old sister the next day at their home. The father told me that when the child had said, "Pull this, mommy," he meant it as a question: "Is this what I pull?"

I jotted down all the information in my notebook, collecting as many details as I could about the gun—when, where, and why the father had purchased it (for home protection, he said)—along with details about the shooting itself, as all of this was described to me by police and other sources. Details were critical to telling the story. When it came time to write the article, I arranged all the details in the proper order, knowing

that the boy's innocent quote would be an important element. But in striving for greater clarity, I elected to quote the toddler using the father's clarification of his words instead of the child's exact words themselves. Instead of the declarative phrase "Pull this, Mommy," I instead quoted the boy asking, "Is this what I pull, Mommy?" The article ran on the front page of the newspaper on August 28, 1981, and was headlined " 'Is This What I Pull?' Boy, 3, Asked, Just before He Shot His Mother."[15]

But in attempting to "clean up" the quote, to make its meaning clearer and easier for the reader to understand, I only ended up corrupting it. One reader telephoned me to ask about the quote, since three-year-olds don't often speak in such perfect syntax. The boy's "Pull this, Mommy" was in fact exactly how a three-year-old speaks. In trying to improve the quote, I put words into the boy's mouth that he hadn't uttered. I admitted to the caller, and to an editor who later asked about the quote, that I had used the father's clarification instead of the actual quote. No correction was ever published about the quote, no written clarification or explanation provided to readers, and no written complaint ever sent in by any reader, as far as I know. Nor did the boy's father, who a few days later expressed appreciation to me for the care with which I tried to write the family's story, make any complaint.

But I knew what I had done, and in the end I felt ashamed of it. I knew I had reported the story well: collected tremendous information and detail from interviews with family members, police, emergency workers, and gun experts and pieced together a complete narrative. But in trying to make the story better and clearer, by improving the grammar of the garbled words from a three-year-old's mouth, I strayed from exactness and cheapened and undermined the story's value as a public service.

As a teacher, I have told my students about my mistakes to drive home the point that journalism demands constant attention to detail, verification, and loyalty to what you know to be true. Don't presume. Check out everything. No one is perfect, I tell them. But always remember that the challenge is constantly to strive for perfection. And when you do fail, it's absolutely essential that you recognize and fix your errors and ethical misjudgments so that they don't occur again. Heed your skepticism, I urge them. Just as you heed your instincts for hunting the truth.

The *truth*. It remains the only reason anyone should practice journalism. And it is especially important for journalists to be keen at recognizing and understanding the forces that would undermine or countervail the truth. Publicists, public relations workers, and advertisers perhaps should not be faulted for trying to spin, deceive, dissemble, sell,

or distort in the process of informing journalists, when they feel they must. That is in the nature of what they are paid to do—to influence public opinion. That has always been in the nature of what they do, and they do it very well. Politicians, armies, and governments, too, are sometimes in the business of deception and distortion. That is in the nature of what they do as well. But journalists are required to heed a higher authority for truth seeking: the public's right to know, and, with it, the health and sustainability of democracy. Their mission is to sift the real from the artificial, to buffer the public from lies. The news organization or system that surrenders its gatekeeping function in deference to other interests does a grave injustice to society and undermines its very purpose.

I teach my students about the critical role government and business publicists can play in informing journalists about important issues and news stories, but I also try to show how such publicists have attempted to spin me with lies and distortion. As a young education reporter, I covered a state board of education meeting at which a local disadvantaged school district was requesting a renewal of funds to support a junior high school pilot reading program. The local school official made a compelling presentation at the meeting, pointing to astonishing increases in functional literacy, replete with statistical data covering a three-year period. The state board was suitably impressed, and so was I. I was eager to report the news about a poor school district succeeding against all odds and so paid a visit to the junior high school to find out how they did it. It seemed a pretty good story. But for nearly a week, the school's administrators did everything they could to avoid me. So did the district's officials. I was never able to get confirmation or proof of any kind about the district's reading numbers, and I suspect that the officials simply cooked the numbers in order to have the grant renewed. (The effort failed.) Again, I tell my students: That's what publicists and governments tend to do. Their allegiance is not necessarily to the truth. Be skeptical. Check it out.

But occasionally the lies are so blatant they can boggle the mind. When I was an Africa correspondent based in Kenya, I once received a press release by fax from UNICEF, the United Nations Children's Fund, announcing a major new initiative focusing on the health and welfare of the world's children. UNICEF hoped to bring attention to widespread problems such as malnutrition, childhood diseases, and poverty by bringing together a host of world leaders at the United Nations to discuss the problems, at a "Year of the Child Summit."

Anyone who has spent time in Africa knows that the continent's myriad problems are often exacerbated both by the demands of foreign

donors and by exceptionally poor leadership in some African countries, prone to systemic corruption and brutal authoritarianism. I had visited numerous war zones as a reporter in Africa by then, including Liberia, Somalia, and Ethiopia, and had seen firsthand the effects of such rule in the form of dismembered bodies, tortured prisoners, and starving children. So when I read the press release and noticed that some of those same rulers were planning to attend the "Year of the Child Summit" in New York, I decided that the most valuable story I could write in service to the public was not the news itself, but a *news analysis* informed by my journalistic experiences in Africa. It would certainly inform readers about the upcoming summit, but it would also point out the hypocrisy of those attending and the human toll of their failures. That, after all, was the real truth, as I had witnessed it as a reporter. The story appeared in the *Post*'s opinion section the week before the conference under a headline reading "Who Is Killing the Children of Africa? Too Often, It's Their Countries' Own Rulers."[16]

The UNICEF publicity official was not pleased with the story. The article did cast an unfavorable light on an occasion that was intended to be partially celebratory. But the meeting represented such an obvious hypocrisy, an obvious lie, that not telling the truth simply wasn't possible. I tell my students that anecdote to point out that the facts may sometimes be different from the truth. From the UNICEF publicist's standpoint, the fact—indeed, the news—was that an important summit of world leaders would take place under the organization's guidance. That was the story the publicist wanted told. The truth, however, was something quite different—and it is the truth, even more than the facts, that reporters must always work hard to tell.

I also confess that I have pursued methods of reporting the news that media critics have characterized as unethical and that few news organizations today would ever allow. In the late 1970s, following the end of the Vietnam War and the enactment of policies that led to the deinstitutionalization of many mentally ill persons, the problem of urban homelessness was becoming a major social issue. At the request of my editor, who was a fan of George Orwell's *Down and Out in Paris and London*, I spent two winter months living as an unemployed, homeless vagrant in Baltimore and Washington. My assignment was to learn and write about what conditions were really like inside flophouses, soup kitchens, and public shelters as the homeless themselves experienced it. It seemed like a pretty exciting journalistic adventure at the time, though I admit I was scared as hell. The remarkable scenes I saw in the flophouses, religious

missions, and blood donor centers, the extraordinary people I met, the hidden worlds I discovered and wrote about remain deeply imprinted in my mind's eye even as I write this sentence decades later. The series of stories appeared in twelve parts over twelve consecutive days and elicited more powerful and approving public feedback than anything I have ever published.[17]

Several years later, in 1983, I masqueraded again as a homeless and jobless man in order to write about life among migrant laborers in the tomato and tobacco fields of North Carolina and the systemic abuses they suffered at the hands of farmers and paymasters. As I waited with the crowd at a soup kitchen in the July heat not far from the nation's capital, a beat-up van bearing Florida license plates arrived. Out jumped the driver, who promised the crowd of idle men great work, high pay, excellent meals, and alcohol if we would get into the van and join him as he made his way south. Six other men and I took him up on his offer. And so began an adventure that saw us work like hell in the 100-degree July heat; sleep in muggy, fly-ridden shacks with worms crawling on the walls and ceiling; and earn so little pay that we ended up owing the crew leader money for our meals and drink. The system was as profoundly harsh as social workers in the District of Columbia and others had warned me it was. It was a story about entrenched poverty both in the nation's capital and in the fields of the South and an abusive labor system that amounted to indentured servitude for many workers. The publication of the six-part series, including a concluding segment in which I returned to the South in my true identity as a reporter to question the crew leader and farmers about their role in perpetuating the system, stirred widespread public anger over the abuses and prompted vows by the state of North Carolina to reform the system.[18] Even today, I believe that such undercover assignments were legitimate and ethically defensible, because I didn't believe that I could really discover the truth by other means.

Still, a few observers were sharply critical of my editors and me at the *Post* for undertaking these projects. The well-meaning critics charged that we had crossed an ethical line in journalism and damaged the profession's integrity.[19] But the *Post* didn't seem overly concerned about the criticism; much of the time, the newspaper's editors were unafraid to take chances when it came to reporting the truth. Undercover reporting had actually become something of a maverick tradition at the newspaper, where reporters Ben Bagdikian and Leon Dash some years earlier had written a serial exposé about appalling conditions in the Maryland

prison system after they spent weeks there undercover as inmates. It was also a proud tradition of American journalism dating at least as far back as Nellie Bly, who pioneered the style in the 1890s with a series of newspaper exposés for Joseph Pulitzer's *New York World* about the horrible conditions and abuses suffered by female mental patients at a New York asylum, where she spent time masquerading as a patient. A decade later, Upton Sinclair went undercover to work as a packer in the dangerous meat industry in Chicago, vividly exposing health violations and the dangers faced by workers for his 1906 classic *The Jungle.*[20]

The undercover projects I reported a quarter century ago still resonate with profound meaning for me and are among the most purposeful and valuable journalism I will ever practice. I tell this to my students. But the sad irony today is that I am preparing them to work in an era that is far chillier than the one in which I came of age, one defined by a much more cautious, uninspired, and timorous press whose institutions are not likely to allow them to pursue similar investigations for fear of lawsuits, conservative backlash, or public criticism.

The investigatory practice isn't dead, just yet. Journalist Barbara Ehrenreich's *Nickle and Dimed: On (Not) Getting By in America,* concerning her experiences as she struggled to support herself while working low-wage jobs, and Ted Conover's *Newjack: Guarding Sing Sing,* about his work as a guard at the tough New York state prison, are two excellent recent examples, pursued notably by individuals for book projects, not as reporters within the news industry. Not long ago, PBS featured a riveting *Frontline* television documentary, *Sex Slaves,* about the brutal, thuggish world of sex slavery in Eastern Europe, in which the filmmakers used hidden cameras to document the trafficking of impoverished women into lives of prostitution.[21]

In general, however, it seems that modern news organizations that take unusually aggressive steps to seek truth and report it often subject themselves to reprimands about their ethics instead of congratulations for their public service. The climate is disheartening, almost as if the news media were operating in a haunted house of sorts, where fear governs their actions more than a dedicated hunt for the news. In 2005, for example, having collected information pointing to sexual misconduct and misuse of his office by the city's mayor, editors at the *Spokane Spokesman-Review* took the unusual step of hiring a computer expert to pose as a teenaged boy seeking a sexual encounter in an Internet chat room. The mayor, Jim West, using his office computer, soon contacted the teenager, suggesting a rendezvous. It was the final bit of evidence the

newspaper felt it needed to support the sexual misconduct charges. But when the *Spokesman-Review* published this story,[22] part of a wider package of articles that eventually led to the mayor's recall from office, a hail of criticism befell the paper's editors from industry leaders around the country. Editors from Philadelphia to Indianapolis to Los Angeles decried the use of deception, charging that the technique could only further alienate the public from the press. As critic Douglas McCollam wrote:

> Joie de vivre . . . seems distant from today's newsrooms. Nowhere is the loss of élan more apparent than in the dearth of undercover work. Once, going clandestine was an accepted tool in a newsroom's reporting kit. It often produced spectacular results. . . .
>
> Today the swashbuckling spirit that once encouraged such subterfuge is flickering. . . . [A] Greek chorus of editors appeared to condemn the [*Spokesman-Review.*] "I don't permit deception; I would not allow it," Amanda Bennett, editor of *The Philadelphia Inquirer,* told *Editor & Publisher.* The editors of several other papers piled on as well. "This is a form of undercover journalism that, thankfully, went out of vogue in the early 1980s," Tim Franklin, editor of the *Baltimore Sun,* told the magazine. Really? Why is that? Dennis Ryerson, editor of *The Indianapolis Star,* made the subtext explicit, noting that there were other ways to get information and "with everyone challenging our credibility, we have to think about how we represent ourselves when we pursue the truth."[23]

Such cautiousness and timidity can be traced to the public apology ABC News had to make to the Food Lion supermarket chain as part of a 1995 court action in which the network's news show *PrimeTime Live* lost a fraud, trespassing, and breach of loyalty suit brought by the chain. Reporters for the show were found guilty of fraud after misrepresenting themselves while applying for jobs to work in a Food Lion store, in order to investigate allegations of unsanitary conditions and the selling of spoiled meat. The reporters had gotten jobs as warehouse workers and clerks inside the chain and used hidden cameras in the course of reporting the story for a 1992 *PrimeTime Live* segment. That the network was eventually compelled to apologize to the supermarket chain is well remembered in the American news industry today. Well remembered, too, are the $5.5 million in punitive damages a North Carolina jury awarded to the southern food chain.[24]

Although the court loss by ABC News has had a chilling effect on such aggressive reporting methods in the years since, what's largely forgotten is that the ABC reporters did uncover very compelling evidence supporting the original allegations, including rat-gnawed cheese and rotten meat. Forgotten, too, is the amount of money a federal appeals court or-

dered ABC to pay Food Lion when it overturned the jury's compensatory and punitive damages decision two years later, in 1997, declaring that the reporters' deception had not damaged the supermarket chain: $2. Each of the network's reporters was ordered to pay Food Lion a total of $1 for trespassing.[25]

Yet timidity continues to characterize much of our established news culture, along with a sense that truth itself perhaps does not signify as much as it once did in our publishing industries. Not long ago, there was a coincidental but telling juxtaposition of two stories in the *New York Times* that illustrated the deeper challenges inherent in the ongoing fight to defend the news today. The stories appeared on facing inside pages of the newspaper on January 11, 2006. One represented a stirring affirmation of the lasting honor, nobility, and value of truth seeking as a profession. The other story illustrated the sickening result when corrupt individuals and institutions are allowed to twist and cheapen the truth in pursuit of political policies or product sales.

The story of honor came from World War II history, told in a fascinating book review by *Times* writer Williams Grimes.[26] The book, *Writer at War: Vasily Grossman with the Red Army, 1941–1945,* was an English-language translation of a collection of war correspondence and other writings by Vasily Grossman, a Russian journalist who covered the Soviet Red Army from the time of the Nazi invasion in 1941 to the Red Army's takeover of Berlin in 1945. Writing for the Soviet army newspaper *Red Star,* Grossman was to the Soviet reading public what Ernie Pyle was to the American public, a journalist who reported brilliantly and movingly about the day-to-day lives and suffering of ordinary soldiers and civilians on the front lines. Grossman was present at the liberation of Treblinka concentration camp and was among the first journalists to enter the Warsaw Ghetto. A Jew, Grossman had escaped from Ukraine at the start of the war and subsequently lost his mother and many family members when the Nazis executed more than thirty thousand Jews in Grossman's hometown of Berdichev. His writing was so gripping, so deeply honest about the horrors he witnessed and about the bungling by officers and other failures by the Red Army that some of his stories never made it into print past Soviet government censors. Yet in his review, Grimes hailed the brave journalist's work and his dedication to bearing witness to the truths of his time as among the finest reportage of World War II, ranking it with the best

of Pyle, John Hersey, and A. J. Liebling. Grimes's review appeared on page B9.

Directly opposite, on page B8 of the *Times,* was a present-day story of a different kind, one typifying patterns of deceit that have become all too familiar. The story, headlined "When Memoir and Facts Collide," featured the latest news about the scandal involving James Frey's best-selling 2003 book, *A Million Little Pieces.* In what was purported to be a memoir of his troubled life, the author recounted a gripping story of fighting with cops, spending time in jails, getting strung out on drugs and alcohol, being mistreated in rehabilitation clinics, and finally redeeming himself through his personal inner strength. Spurred in part by Oprah Winfrey's praise of the book on her popular television talk show, the book became a phenomenal success, resulting in lucrative new book and movie deals for Frey. Eventually, however, an online investigative site, www.thesmokinggun.com, published an account of Frey's experiences that was very different from the book's narrative. Reporters for the site investigated all the incidents Frey described and, after researching court and police records and interviewing officials, concluded that he had made it all up.[27]

But the most revealing part of the *Times* story had to do with the publisher's reaction to the exposé. A spokesperson for Doubleday, which had reaped tremendous profits from the book, released a statement containing this observation: "Recent accusations against [Frey] notwithstanding, the power of the overall reading experience is such that the book remains a deeply inspiring and redemptive story for millions of readers." In short, to a societal gatekeeper entrusted with protecting the truth, the truth didn't matter.[28]

That such wrongdoing within our media and publishing culture disgraces the memory and legacies of truth seekers in our past is almost beside the point. The larger issue is that truth itself is losing primacy in the very institutions that should be most vested and keen to protect it.

A FELLOW AND HIS MATCH...

If professionalism in journalism is critical to the health of democracy, how do we go about inculcating the high standards and ethics that guide it? There is in fact an old debate about the value of journalism education that is possibly more relevant today than it has ever been. The debate centers on a number of questions:

> Given that the field of journalism, unlike architecture or law or medicine, does not require a license in order to practice, what function does a "professional" school of journalism really serve?
>
> Is a degree in journalism necessary or even helpful for a person to become successful, competent, and effective in the field?
>
> How best should academic and professional school programs approach the teaching of journalism?
>
> Should such institutions emphasize the vocational aspects of the "craft" or the broad intellectual development of young minds preparing for entry into a "profession"?

No two journalists seem to think alike on these questions. Many maintain that the practice of journalism should require no formal training at all. In an age of digital technology and instant communications, the argument goes, the best hope for modern journalism and democratic society may rest not with old-fashioned, out-of-touch "mainstream" media traditions but with alternative citizen journalists, bloggers, and others equipped with tools enabling them to publish worldwide and reach millions on the Internet.

Others argue just as strongly to the contrary, asserting that, because of its importance to democratic society and because of the increasing complexity of our world, the practice of journalism today requires more preparation and expertise than ever before. In 2005, academic leaders at Columbia University, which houses the nation's most prestigious school of journalism, acted on this belief, changing the traditional one-year master's degree program for the first time in nearly a century to allow qualified students the option of studying for an extra year. Under this reform, which followed two years of intensive discussions among academic and news industry leaders about the direction of journalism education, the first year of study is devoted to earning the traditional master of science journalism degree. Students may also apply for the second-year program to earn a second master of arts degree, signifying additional learning "about complicated subjects they might encounter in their careers," according to the school's newly revised admissions literature. The change, which "marries deep subject-matter expertise to the advanced practice of journalism," will allow students more time and opportunity to explore the wider university and to gain stronger grounding in law, history, politics, and other subjects in the

sciences and humanities "to better prepare themselves as leaders in the field."[29]

Yet elsewhere within the academy, journalism continues to occupy an uncertain and often precarious place. It is certainly this way at the University of California. Many academics in other specialties of my campus simply don't know what to make of this field of study, its intellectual value to the university, or its connection to modern society. As a long-time Columbia University journalism professor, Melvin Mencher, once put it, journalism "is an old discipline. But it has always been the poor cousin on campus."[30] Indeed, one traditional view still very much alive in the news industry itself holds that journalism school is simply a waste of time, that the best way to learn the craft and its professional values is to get an entry-level newsroom job at a newspaper, an Internet publisher, or a television or radio station. Just get your foot in the door, in other words, and then go about experiencing firsthand how true professionals face the daily challenges of news reporting and writing and work your way up the organizational ladder to one day earn a similar job yourself.

Yet another belief, which is truly old school, argues that the best journalism education any young person can get involves simply experiencing the world itself, exploring society, and learning about people. Waitressing, construction work, Peace Corps volunteering, teaching, bartending—anything that allows compelling insights into the lives of ordinary people is a priceless education and a perfect preparation for practicing the craft. In fact, journalism traditionally has relied a great deal on the hunger of young people to explore the world in just this fashion, an education that arguably offers more practical value than years of cloistered graduate school study could possibly bestow.

All of these views have validity. Most of the finest professional journalists I have ever known never set foot in graduate school or studied journalism at all. They learned the craft by getting jobs at news organizations after undergraduate study, doing the work, and heeding their hunger to understand what makes society tick. From that perspective, journalism education in some ways may be less important, at least in terms of career development, at a time when citizen journalists and so many new forms of media serve as alternatives to the mainstream news industries.

So much is out there these days that is new and different and exciting and can immediately grab and engage the imagination of any aspiring journalist. Howard Dean's 2004 political campaign, which

grew from and relied so extensively on online grassroots support, demonstrated the power of the Internet to arouse citizens and spark widespread debate on important national issues. Web-based self-publishers and journalistically untrained citizen bloggers regularly have proven their power and mettle as watchdogs in society, and over the media itself. Despite their tendency thus far to be more reactive than investigatory, blogs and other Web publications nonetheless demonstrate that any citizen with technological skills and Internet access can play a significant role in informing society without journalistic training.[31]

Immense resources of government, court, and other public records and official documents are available online, offering the raw data of journalism and research that untrained citizens may use to investigate and inform.[32] "Insider" blogs, produced by experts and gossips working within industries and institutions ranging from advertising (Ad Rants.com) to broadcast news (MediaBistro.com/tvnewser) to the nation's system of justice (UnderneathTheirRobes.blogs.com) consistently provide lively, insightful commentary and information, serving as a kind of undercover citizen reporting representative of the New Media era. In addition, video documentaries such as the brilliant *War Tapes* (2006), produced and shot with digital cameras by soldiers in Iraq, reveal the journalistic promise of citizens empowered to tell the narratives of their own lives and the true backstory to world events.

Breaking news stories like the London subway bombings in the summer of 2005, Hurricane Katrina and its aftermath in the fall of that year, and, more recently, the war between Israel and Lebanon's Hezbollah guerrillas in the summer of 2006 and the attendant suffering by civilians on both sides have also shown the extraordinary power of ordinary citizens, using cell phones, high-quality digital photo and video capabilities, e-mail, and blog publishing skills not only to provide fresh content to news organizations but also to put loved ones in more immediate and compelling touch than the traditional media could provide. A recent issue of the *Economist* devoted to New Media concluded that the existing world of mass media is inexorably giving way to an intensely participatory new order in which citizens will enjoy the bounty of "multiple sources of truth," which, one expert predicted, people will sort out for themselves. Young people in particular "will be happy to decide for themselves what is credible and what is not," the magazine reported, adding that already this revolution is seeing millions who are no longer content to "passively consume"

news and information but choose to create it themselves. The study cited 2005 research on Internet use by the Pew Internet and American Life Project showing that 57 percent of American teenagers already create content for the Web—text, pictures, music, video.[33] In a world of astonishing new technologies and dazzling communications possibilities, why spend two years and $90,000 in a professional journalism school?

Yet it's also true that precisely because of this frenetic environment, professional journalism education is more important today than ever. With news organizations downsizing, it becomes less possible to learn on the job. At the same time, economic and political forces so besiege the news industry that there's an urgent need for the journalistic skills required to cut through the lies, deceit, rumors, and propaganda to *find* the news, to tell the people the truth. Communications technologies in some ways bring us closer together, but in other, important ways they hasten our society's fragmentation, segregation, segmentation. Professional journalism and talented, skilled young practitioners are needed as a force for bonding society with shared knowledge and truths.

Just as it is a deeply unsettling age in journalism, it is also an exceptionally exciting one, a time filled with challenges and new possibilities to learn about each other, American society, and the world around us. Like many teachers of news reporting and writing, I have embraced the new technologies as broadly as I can, even as I caution my students about the ways these technologies and information can be used to manipulate and deceive. Students will likely need to perform their craft in multiple forms of media in their jobs after graduation, in newsrooms increasingly defined by a convergence of technologies, so indeed we must teach them how.

I have learned how to build Web sites from scratch; created and published a host of news, information, and community service blogs; and acquired the skills to collect and upload the full range of digital data. Digital advances in cell phone technology are now incorporated into my reporting classes, allowing students to send and immediately upload stories, graphics, photos, and video onto blogs hosted by our school server. They learn how easy and relatively cheap it is to buy your own Web domain and use simple yet powerful blog publishing tools to set up a presence on the Web, for a range of purposes from journalism to personal diaries to political propagandizing to marketing. As part of this lesson, I also point out how businesses and advertising firms are increasingly ex-

ploiting the Web to spark "buzz" and "viral" marketing campaigns to draw attention to their products, at times using the cover of fake "citizen journalism" sites to lend credibility to their pitches.[34] All this is part of a larger classroom lesson about how increasingly skeptical and doggedly committed to truth seeking professional journalists must be in this futuristic age, just as American consumers of information should be wary and watchful.

The sheer bounty and diversity of information at our disposal are reflected in my own research for this book over the past several years. My sources have run the gamut from the seemingly ancient to the most futuristic of communications technologies. I frequently turned to books filling the stacks in the lending library on my campus, including excellent compendiums of American journalism history. I devoured works in their original form, such as 1918's *The Story of the* Sun and 1919's brilliant *The Negro in Chicago,* now so forgotten and neglected that they are filed with thousands of other infrequently circulating tomes in my university system's Northern Regional Library Facility warehouse in Richmond, California, near San Pablo Bay. I spent nights listening to AM radio, too, a still vital, nearly century-old medium, to take in the show as journalistic poseurs peddled their alternative health remedies and anti-aging potions, and spent hours tracking television infomercials in which hucksters hawked products of all kinds in the guise of public affairs news reporting.

I used a push-button landline telephone to track down Calvert McCann, whose beautiful black-and-white photographs of the civil rights struggle in Lexington in the 1960s were published many years too late, in 2004, in the *Lexington Herald-Leader.* In the course of acquiring permission to republish two of those photographs for this book, I struck up an immediate bond with McCann when I learned that he was the brother of Les McCann, the legendary jazz pianist and singer, whose trademark work from thirty years ago, performed with Eddie Harris, "Trying to Make It Real (Compared to What)," served as frequent background LP music to my early years as a reporter. The song's lyrics, which urge the brave-hearted to speak truth to power in times of turmoil and uncertainty, seem as remarkably resonant today as when I first heard McCann sing the song live at New York's Village Vanguard when I was in graduate school in 1978:

> The President, he's got his war
> Folks don't know just what it's for
> Nobody gives us rhyme or reason

Have one doubt, they call it treason
We're chicken-feathers, all without one gut (God damn it!)
Tryin' to make it real—compared to what?[35]

I often used the old standby, the U.S. Postal Service, to communicate. For example, I wrote to a librarian who works in the state historical archives collection at the University of Alabama, who kindly photocopied an article from a rare 1958 work and mailed it to me. I turned time and again to the *Reader's Guide to Periodical Literature,* the old reliable hard copy resource for researching news article topics for many decades before the Internet—a resource widely neglected in an era in which millions presume that the Internet itself holds the key to all answers.

At the same time, I used New Media in myriad ways to investigate, to learn, to communicate. I corresponded by e-mail extensively with everyone from advertising agency executives to representatives of the Radio-Television News Directors Association. I used LexisNexis.com frequently to immediately call up news, journal, and magazine articles dating back to the late 1970s. The brilliant collection of academic journals available online through the University of California allowed me immediate access to important articles in .pdf format touching on everything from the history of advertorials to the ethics of video news releases to the work of media critics in publications ranging from *The Nation* to *National Review.*

I found delightfully informative blogs on the Web offering inside information on the tactics of the advertising and public relations industries. After discovering that the *Lexington Herald-Leader* had sold out of its July 4, 2004, edition, in which its editors confessed to readers that the newspaper had purposefully neglected to cover the civil rights struggle, I found a hard copy of that day's newspaper in its original form fairly quickly through Newstand.com, a remarkable online database in which consumers may download hard copy duplications of many newspapers from around the world.

I even used eBay.com to track down information. Searching for a 1992 issue of *TV Guide* magazine that contained a groundbreaking article on fake news, I was disheartened to discover that my campus library had stopped subscribing to the magazine in the late 1980s because of budget cutbacks. A quick call to *TV Guide* in New York elicited word from a clerk that the company maintained back stocks of only its most popular issues, which did not include the one I wanted. The clerk suggested eBay. Thus I registered on the auction site and within fifteen minutes of searching discovered the issue I needed among several years'

worth offered for sale by an agent in Texas. I offered $7 and was the only bidder. Within a week, the magazine arrived in my mailbox in pristine shape. Similarly, when I was unable to locate an original copy of the 1976 issue of *Esquire* magazine featuring Harrison E. Salisbury's Xerox-funded feature article, which so aroused the moral indignation of E. B. White, I again turned to eBay, where I acquired the issue for $10 and soon received a near-perfect copy in the mail direct from a retired teacher in Kansas whose collections of popular magazines went back more than forty years.

Multimedia tools, so useful for research and for the practice of journalism, are exceptionally valuable. But they can never replace the *soul* of journalism, a point perhaps reflected in an example that sums up the dire struggle of professional journalism to adapt to the modern age. Not long ago, *Sports Illustrated* magazine, which has suffered significant losses in advertising pages and revenues in recent years, announced new plans to take fuller advantage of one of its best-selling issues, the annual February swimsuit issue, by making it available not only in its traditional hard copy form but also online through the publication's Web site. Additionally, readers could purchase videos connected to the issue through Apple's iTunes site and download the images and video content to cell phones and other handheld devices.

The magazine's president and publisher, Mark Ford, expressed enthusiasm for the venture and the new possibilities of reaching potential *S-I* consumers: "It is the mother ship of what we do. We want to leverage the power of that franchise," Ford told the *New York Times*. "*Sports Illustrated* is a multimedia brand. It's a magazine, it's online, it's mobile, it's an event." In the same article, Samir Husni, a magazine consultant, told the *Times* that magazines must offer themselves in multiple media forms in order to stay current with society's technological transformation: "Can you really exist in one medium anymore? We are surrounded by media. The intelligent magazines are the ones that are directing the traffic, sending the public from one medium to another. Otherwise it's a one-way street."[36]

On a certain level, it seems to make compelling business sense for a publication to make itself available in multiple media forms. But as I read the story, I couldn't separate the enthusiastic comments affirming those lofty business aims from the very different reality that *Sports Illustrated* has come to represent journalistically in an age when print media are struggling so desperately to survive. With cuts in journalistic staffing including copy editors, reporters, and writers, the magazine has become a shadow of what it once stood for: the gold standard of sports journal-

ism, a magazine with proud traditions of investigative reporting and feature writing that raised the craft of sports journalism to a level of true literature. But as a twenty-five-year subscriber long inspired by the beauty of the magazine's writing, I ache over what it has become in recent years: much thinner, with its 20 percent loss in advertising in 2005 alone, and the resultant cut of journalistic content;[37] bereft of meaningful or compelling journalism compared to its illustrious past; marred by the egregious typographical errors that are not fixed; filled with cheesy advertorials that eat up more and more pages each week; and written in a scant and superficial style, reminiscent of *People* or *USA Today Weekend,* with its emphasis on news briefs, catchy pop cultural lists, and cheap celebrity gossip, which struggles mightily to replicate the Web experience in order to attract youthful readers and fails pitifully.

I remain a subscriber to *Sports Illustrated* largely out of habit, and perhaps a spirit of nostalgia. But I often feel dejected when the magazine arrives in my mailbox, chiefly because I wonder where the professional journalism of *Sports Illustrated* went, the journalism that inspired so many readers for so many decades. It certainly hasn't migrated to Sports Illustrated.CNN.com or to the Apple iTunes store or to the cell phones or other bundles of new technology that observers maintain the print media must try to accommodate in order to survive. The real journalism is in fact diminishing before our eyes, like a carnival magician's disappearing card trick. It's a fact of economic life that corporate managers are rewarded handsomely for cutting costs. But there is a logical extension of this truism: sooner or later you may cut so many costs that you lose the very product you are in business to sell. Gordon M. Bethune, the imaginative former CEO of Continental Airlines, has a favorite description for the pitfalls of this business strategy. He calls it the "pizza" analogy. "If you are being rewarded for finding ways to make pizza cheaper, eventually you'll take the cheese off," he says. "You'll make it so cheap that people won't eat it."[38] This is what is happening to America's print and broadcast news media today. The cost cutting is hurting their product. Their professional journalism is vanishing.

Growing numbers of media futurists today make a convincing argument that these epic challenges and seismic shifts in journalism are leading us to a world in which the old "objectivity" model of professional journalism is rapidly dying. In its place is arising a new form of practice driven more by opinion, passion, rumor, and edge than by fairness and fact. The accuracy of this view remains to be seen. It is certainly true that objectivity itself was pretty much a myth all along: subjectivity played an

integral role in every newsroom decision ever made, from story selection to sources chosen to tap for information. But what was always more important than the ideal of objectivity was a professional standard that valued independence, accuracy, balance, and public service. In my view, the eroding of these values represents a threat far more significant than the demise of a myth.

As I obsess over the erosion of professionalism in our news and information landscape, I worry too about the implications of the new image of the "Journalist" in the New Media age. The model of the solo blogger and the "backpack" journalist are becoming the vogue, the lone individual equipped with a digital camera, wireless communications, and Internet access who is capable of publishing directly online, from practically anywhere on the planet. It is an attractive and exciting model on many levels, one deeply evocative of the gung-ho spirit of frontier independence and the constitutional ideal of individual free expression in which a person so equipped can reach millions immediately without filters or other editorial assistance. This indeed is the picture of journalism's future, experts in the know tell me.

Yet as this future dawns, I worry about what it may hold. Is the model of professional journalism being left behind in this transformation? That model has posited the journalist not so much as a disconnected individualist but rather as part of a cooperative enterprise with other journalists committed to the larger cause of reporting the news to the people, an enterprise far greater than the sum of its individual parts. The crucible of learning and intellectual discourse that was the American newsroom best symbolized this cause. Although millions of individuals today exercise the right to publish, I fear that the honor of publication is losing significance, meaning, and power, along with our cultural respect for written language. Scenes from the newsroom from many years ago, during my apprenticeship as a young reporter working with skilled and dedicated professional editors, play vividly in my mind still:

> "Don't use the word 'concomitant,' kid. Don't make the reader have to reach for a dictionary. Remember, you're writing for the average Joe, the 'enlightened cab driver,' get it? He's interested in the news, and a pretty smart guy, but don't presume he knows everything. Keep him in mind whenever you write for the people."

> "Good job on the obit, Ace. But look—'heart failure' won't cut it as a cause of death, see? Everybody dies of heart failure. Call the hospital back and get a more specific cause."

"Here's the number of the Anacostia firehouse. Give the guys there a call and tell 'em you want to spend a night at the station next week. I want you to go out on calls with 'em, okay? Might be some good story ideas for you. Most important, try to see the world from inside their shoes."

The American newsroom at its best generated constant debate, aggravation, argument, and cooperative discussion about the news, the best ways to get the news, and the most effective ways to tell it to the people. When I was working as an editor for the foreign desk before heading off to cover Africa, I once got very upset about something my newspaper was reporting from Central America. I was upset not by the story itself but by how our newspaper had chosen to write it. I recall sharing my frustration late that night with Martin Weil, a night police reporter for many years at the *Post,* dating back to the 1960s. Most reporters with any connection to the *Post* likely will tell you that the most valuable journalist in the modern history of the newspaper may well be not Bob Woodward or Benjamin Bradlee, but Marty. This is based on both his extraordinary abilities as a local reporter and the many years of wisdom he has imparted to young reporters, including my former students. I remember what Marty told me that night about my fury over the paper's story. "Just because you feel strongly about something, Neil," he said, "doesn't mean that you are right."

It was that spirit of discourse and constant learning from each other that symbolized the strength and value of the newsroom, when it performed at its finest. It made one regularly able to see through knee-jerk opinion and to understand that it possessed little value in the larger mission of fairly informing the public. The professional newsroom made you think like a journalist—but equally important, it made you think *again*.

This is the world of journalism I come from and the kind of cooperative and intellectually engaged enterprise I have long enjoyed teaching, a professional endeavor closely connected, as Huntington wrote about the military, to clear high standards and an honorable sense of social responsibility shared by specialists joined by a common pursuit. To the extent that democracy depends on clarity and truth, I believe journalism education still must occupy a critical place in the process of informing the people. It could also offer timely and meaningful direction to the industry, beyond the petitions of protest about the proliferation of fake news, advertorials, and other wrong turns in the news media's direction that journalism educators seem to send around to each other every year.

Educators perhaps can do a better job of engaging the industry in important discussions about protecting news values, while continuing to unite to publicly shame the news media when they deserve it.

But a corollary is also true, I think: any journalism education institution that fails to stay current and to systematically educate students about the myriad pressures increasingly threatening to compromise their ideals is in many ways as complicit in maintaining the culture of wrongdoing as the industry itself. Over the past decade, my journalism program has hurriedly struggled to keep up with that battle. Our New Media curriculum rightfully has exploded from virtually a single course called "desktop publishing" in 1995 to today's wealth of offerings testifying to technology's impact on the field. We now train students to research data on the Web, shoot video with digital cameras, collect sound with digital recorders, and upload journalistic content in multimedia forms onto blogs and other Internet-based sites. Numerous classes teach computer-assisted reporting and multimedia skill sets. Our curriculum also features a newly funded lecturer and a program, the Center for Citizen Media, devoted to examining the emergence of citizen journalism, its significance for society, and the ways journalists-in-training can work with the newly evolving order. We are in many ways a market-driven institution, not unlike the news industry itself, in the sense that we strive to give students, our consumers, what they want. And what students want increasingly are the sophisticated digital skills that typify the age.

But like the news industry, we seem to give our clients less and less of what they, and perhaps democratic society, most arguably need. At least I believe this. Over the past ten years of extraordinary technical transformation, our program has offered not a single required or elective course specifically dedicated to exploring journalism history and its bearing on the present, nor has it offered any courses examining public relations, marketing, and advertising as pervasive forces in American media and society. I believe this failure to be a signal disservice to young people aspiring to professionalism. So, in that respect, I believe I have played as much a role in the American media carnival as any participant or sideshow act featured in the previous chapters, in the sense that I too have failed to figure out a way to systematically address these complex issues and their bearing on the current troubles of the profession.

The road I traveled to research and write this book represents an attempt to address my shortcomings as a teacher in response to the dramatic changes of the past decade. For better or worse, I increasingly see myself as something of an iconoclast in my role as a journalism educa-

tor in the New Media age. As our school hurtles along to meet the demands of the era, with eyes constantly riveted on tomorrow, I find myself often inexplicably turning in the opposite direction, an oddball who sees instead the growing urgency and educational purpose of retrieving significant lessons from journalism's past, teaching them to young people, and emphasizing the events that helped to propel the rise of professionalism in the first place—lessons from politics to war to racial hatred that often get lost or ignored amid the present tumult.[39]

Of course, our predicament and challenge in journalism education cannot be separated from the business and ethical problems of the industry itself, and those problems are beginning to have peculiar effects on our mission, too. Not long ago, a professor on my faculty, reflecting on the shrinking job market for our students and the paltry annual salaries of less than $20,000 some of our graduates earn, suggested a reform to our admissions policies that might take into account the chilling economic realities of the besieged industry. The professor suggests that it may be time for our school to begin admitting candidates who desire to pursue careers as communication workers and public relations officers for nongovernmental organizations and other nonprofits. The professor argues that the skills and training of professional journalism could be very useful to such endeavors, even though public relations by definition is counter to the mission of journalism. The professor reasonably believes that such a reform could not only help our school better position itself to accommodate society's technological transformation but also assist nongovernmental organizations and nonprofits in their socially responsible endeavors, while also providing better-paying job prospects for our students.

The suggestion, which our faculty has batted around a bit but not adopted, raises interesting ethical questions: What is a "good" nonprofit? Are UNICEF, Save the Children, and People for the Ethical Treatment of Animals inherently "good"? Are the National Rifle Association, the National Right to Life Committee, and the Moral Majority "bad"? If we venture down this uncharted path, who will make the qualitative decisions about these matters, and on what basis? Isn't this why schools of public relations and advertising are in business and are intended to remain separate from schools of journalism? A decade ago, such a thought about reconsidering our admissions values would have been unthinkable. Journalism education is dedicated to teaching the skills of truth seeking and informing the public fairly and accurately, and with deep moral conviction, not advocacy for special causes. Yet these are the vex-

ing new issues that naturally come before us as the industry itself struggles for footing in the New Media age, and we as educators endeavor to adapt with it. We too are under siege. This is the world we are making.

In *Anthills of the Savannah*, his 1987 suspense thriller about power, politics, loyalty, and repression in a fictional West African country, Nigerian novelist Chinua Achebe offers a compelling view of the ceaseless challenge of making morally correct choices in the face of overwhelming opposing forces. It is a view that may hold some pertinence for the troubles of professional journalism today. It is stated by way of a folktale recited by a widely respected village elder who travels to see the nation's leader to plead for water to assist his drought-stricken people. Instead of listening to his plea, the paranoid ruler regards the elder as a potential insurrectionist and rabble-rouser. Reflecting on the difficulties of dealing with "His Excellency," and cognizant of the immense military power at the ruler's disposal, the elder, in a speech to his people, likens the effort to bring hope to his village to the allegory of the leopard and the tortoise:

> Once upon a time the leopard who had been trying for a long time to catch the tortoise happened upon him on a solitary road. *Aha*, he said; *at long last! Prepare to die.* And the tortoise said: *Can I ask one favour before you kill me?* The leopard saw no harm in that and agreed. *Give me a few moments to prepare my mind*, the tortoise said. Again the leopard saw no harm in that and granted it. But instead of standing still as the leopard had expected the tortoise went into strange action on the road, scratching with hands and feet and throwing sand furiously in all directions. *Why are you doing that?* asked the puzzled leopard. The tortoise replied: *Because even after I am dead I want anyone passing by this spot to say, yes, a fellow and his match struggled here.*[40]

A protagonist in Achebe's novel, the brave and morally conscious editor of a daily newspaper, hears the elder's speech and is deeply inspired, recognizing in its message two significant points: a culture's storytellers in the end are endowed with a great deal of power to affect history and human development, despite how harsh the odds against them may seem; and, more important, the answer and greatest hope of any people or worthy endeavor lies always in the nature of struggle—ceaseless, sustained, and committed struggle. In short, struggle itself is never futile, but is always a source of power and inspiration.

It may be a stretch, but I view the struggles of professional journalism and education today in much the same light as I do the allegory in *Anthills of the Savannah*. Many media critics and researchers in recent

years have offered possible answers and reforms to address the news industry's troubles. In *Breaking the News,* for example, journalist James Fallows issues a call for the news media to recapture the public's support and trust by practicing more works of "public" or "civic" journalism aimed at improving society instead of focusing so ceaselessly on our troubles and ills. In *Democracy and the News,* sociologist Herbert Gans offers numerous suggestions for improving journalism, from paying greater heed to "folk journalism," in which laypeople discuss the news themselves, to doing a better job of "localizing" the significance of national and international news. Gans even proposes providing tax breaks and other incentives to corporate news organizations that agree to put limits on their profits in exchange for investing more heavily in professional journalism. The ideas are fascinating, commendable, and provocative.[41]

But in the end, I think Achebe's folktale remains most pertinent. The answer may not lie so much in large-scale (and highly unlikely) reforms as in the consistent day-to-day struggle itself. The beauty, the truth, the devil is always in the details. And it is in the details of the work of professionals still practicing their craft and believing in its standards that the best hope for the future rests. I remain optimistic about this struggle, despite the power of the leopard. I believe democracy will increasingly demand that journalistic professionalism occupy a central place in our "news ecosystem," our informational lifeblood, just as the defense of democracy demands professionalism in its military. I believe journalists will demand it. And I believe the people will demand it too, just as the public and journalism professionals began to do nearly a century ago in places like 1919 Chicago. As Edward R. Murrow concluded at the end of the 1960s documentary *Harvest of Shame,* which revealed the harsh plight of America's migrant workers, only "an enlightened, aroused and perhaps angered public opinion" can truly address injustices. It may very well be that such demands will help to bring about reforms in our system of news.

Amid all this, I take great inspiration from the young people who continue to come to programs like ours in search of careers in journalism, for it is in their experiences that the struggle is perhaps most keenly admirable. I have a student now, Ryan Lillis, a young New Yorker and an excellent journalist, who came to graduate school after a couple of years working as a police reporter. He made $330 per week at his first newspaper job, which translates to a yearly salary of $17,160. He told me that one of his relatives recently took a six-month contractual job working in

internal public relations for Wal-Mart. After sustaining months of bad publicity about its labor relations, the corporation hired Lillis's relative to help shepherd a PR campaign aimed at convincing Wal-Mart workers that working for the corporation is a fine thing. Her pay for the six-month contract: $125,000. Yet Lillis has faith in journalism and brims with hope about his future. That is a story that reveals the significance of the struggle.

Not long ago, I sent e-mail messages to as many of my former Cal graduate students as I could reach to find out what they were doing with their lives today and what they felt about the performance of the press in recent years. Specifically, I asked them to reply briefly to three questions that I presented as an informal survey:

> Are you as optimistic about the functioning of the press in demo-cratic society as you once were years ago when you went to grad school?
>
> What issues—political, commercial, legal, racial, religious, etc.—concern you most when you reflect about the state of the news media and your career experiences? If you are not currently working in journalism, did issues such as income, job dissatisfaction, or ethics play a role in your decision to seek opportunity elsewhere?
>
> Last, if you could offer a piece of advice to new graduates of the Journalism School to find professional fulfillment, what would it be?

I was happy to hear back from dozens of graduates, many of whom I had lost touch with over the years. Some had gotten married and had kids in the interim. A couple wrote back from as far away as Japan and Bulgaria. Many were working as newspaper and magazine reporters and editors on publications including the *Seattle Times,* the *Los Angeles Times,* the *New York Times,* the *Houston Chronicle,* the *San Francisco Examiner, Forbes* magazine, the *Wall Street Journal,* the *Washington Post, Time,* and the *St. Petersburg Times.* Others were working in local television news in cities as far-flung as Sacramento and New York. A few were working as network and cable television news producers at organizations such as NBC, ABC, and CNN or were involved in documentary filmmaking. Still others had found careers in New Media as writers for online publications and other ventures, including one young man who had gone on to become a leading authority in Silicon Valley on

sports computer games. And some had left journalism behind altogether to pursue different lines of work, becoming public school teachers, private investigators, and lawyers.

Mark Hummels was one who decided to make a change. After his graduation in 1996, he worked for several years as a daily newspaper reporter in New Mexico, starting out covering police news and soon working his way to the political beat, covering the state capital, Albuquerque. Hummels wrote that it was terrific and engaging work, but that over time he became frustrated by both the "game" mentality of daily political reporting and the mediocre standards of the newspapers he worked for. "I came to realize," he explained, "that government officials are so well-trained in obfuscation and spin that it's next to impossible to get a real answer to most questions you ask them. This continues to drive me absolutely nuts with people in general, and with people in positions of public trust especially. I came to think of reporting 'both sides of the story' as either 1) reporting 'both' sides of the octagon, or 2) giving 'equal time' for the Republicans and Democrats to each tell their lies."

He movingly described his learning experiences as a young reporter on the job and the ideals that drove him:

> I might have been too much of a perfectionist to make it as a reporter. I was always haunted by my inadequacies. For the first few months, working the night cops beat (a shift that ended at midnight), I couldn't sleep very well at night because I was always awakened by anxiety dreams telling me that I had mangled some fact in the story I wrote the night before. After I grew more confident in my own ability to avoid errors, I was still plagued by the feeling that I was always missing the important story that should be told. And, as mentioned, I was plagued by the mistakes of those "above" me in the line of editing. I worked in a two-daily-newspapers town that made it both more fun and a lot more stressful to search out scoops and try not to get beat. It's fun when you "win" and not so much when you get beat. But the competition was good for the readers.

Eventually, however, Hummels felt compelled to leave the profession and try something else. The frustration he felt in trying to report the truth had something to do with it. But so did the economic reality he foresaw, one that is typical at most of the nation's newspapers below the level of the few elites such as the *Washington Post,* the *Los Angeles Times,* or the *New York Times.* "The low pay became more of an issue as I began to feel more competent and deserving of a decent salary, and as I began to think about raising a family. It wasn't that I didn't have enough money

to live on, more that I felt the salary was an indication of my worth to the company. This was underscored by the fact that I knew ad-sales reps were making five times more money than me."

In time, one man who did recognize value in hardworking, idealistic, and skilled but poorly paid young political journalists, New Mexico governor Bill Richardson, began offering jobs to the reporters to use their writing and broadcasting skills to work for him instead. His office raided New Mexico's newspapers, radio, and television stations, luring some of the state's best news reporters by offering better-paying work as public relations officers for the Richardson administration. Such is the lure, power, and triumph of public relations in American society today that more than twenty journalists in 2004 alone took Richardson up on the offer.[42]

But Hummels meantime had gone in a different direction. He enrolled in law school and in 2005 passed the bar in Arizona. Today, a married father of two, he practices his new profession assisted by the skills he learned and practiced so well in his first—"interviews, writing, framing an argument, telling a compelling story. I met a lot of lawyers while working on stories, and I came to think of them as the people who really understood what's going on, and the ones who can make real change in the final analysis."

Most of my former students, however, were still very much involved in journalism. Like Hummels, they shared both an eternal optimism and a deeply rooted belief in the mission of the press in modern society, coupled with reservations about its direction. Their replies were as thoughtful as they were deeply impassioned. One, a New York–based staff writer for a national business magazine, was one of a considerable number of graduates who were concerned by the emergence of fake news and other deceptive tools of advertising and their influence on journalism. She asserted that the "blurring line" between news and advertising has become virtually a norm in the news industry today, not an exception:

> The advertorial is taking over, in my view, and we are increasingly less aware of that. In part, this is because our newsrooms are understaffed and our reporters are asked to do increasingly more with increasingly less training—and to do it faster. This is, in part, because the companies that own our news sources are increasingly controlling about the information that they allow to be published. This is not always direct, but often indirect. Culture is everything at a company and at a publication.

Tom Haines, a top staff writer at the *Boston Globe,* was bothered most by the dilution of literary quality in daily journalism, or what he called "the dumbing down of newspapers." He observed:

It is not an exaggeration to say that they are increasingly concerned with trying to compete with television and the internet, to an extent that I think is damaging. I have had editors tell me "We really need to write for a 9th grade education," and "I just thought it was a little long. That's a lot of time for someone to commit to something." This was about a narrative feature story that could be read in 12 minutes. Why do the story, then? The bigger point is that I think newspapers are [devaluing] their currency—the opportunity for depth and substance.

Jeff Gove, who worked in national network news in New York before finding a new job as a film editor in Los Angeles, was most disturbed to find journalistic values increasingly submerged by the hunt for profit. "My biggest concern is the quest for ratings and sales that drive what news organizations choose to cover. I saw this problem first hand at ABC," he wrote. "The producers of the shows were under immense pressure to get high ratings, and the idea of covering important stories, or covering stories in a non-sensational way, usually got lost because of that pressure."

One former television student at Berkeley, now a top network news producer still working in the industry in New York, expressed yet another worry about the escalating pressures he felt from outside political forces to influence news judgments and newsroom values:

> The first main concern is the rise of the conservative media establishment. The huge success of Fox News has forced most other media organizations to stress conservative viewpoints. In other words, journalism these days is geared towards playing to a conservative audience. Instead of straight ahead reporting, a majority of reporting is done in such a way as not to offend conservatives. This is a real pressure that looms larger and larger now. Whereas there was always pressure to get high ratings/viewership/readership in the corporate media, today that pressure is tied up with a conservative slant. Personally, I believe true journalism is not produced with a target audience in mind—but this approach is increasingly rare.

Bill Brazell, a New York–based journalist, expressed frustration that the American public seems to be generally tuning out the news media and its versions of the truth, even as boundless new sources of information emerge in modern society. Referring to a September 2004 poll showing that 42 percent of the American public believed that Saddam Hussein's regime was directly involved in planning, financing, or carrying out the terrorist attacks of September 11, 2001, Brazell noted that he didn't blame the press so much as the people, "too many of whom seem not to care about evidence. . . . The same Americans who do not care about ev-

idence also do not care about protecting the press. So when reporters go to jail for protecting sources, these adults shrug, as if the reporters deserve it, and 'we won't miss any important stories, anyway.' "

Still, most of the graduates strongly affirmed the view about democracy and the news media's role expressed by Alex Cohen, formerly the Los Angeles bureau chief for San Francisco's public radio station, KQED, and currently based in Austin, Texas, where she works as a correspondent for the National Public Radio program *Marketplace*. Was she as optimistic and idealistic today as she was when she took up professional journalism as a calling in graduate school?

"When you are in grad school," she responded, "there is so much excitement around what you are doing and you are champing at the bit to get out there and be a part of the 'real' world of journalism. I've found that once I entered the working world, I began to get a better understanding of how the press works and obviously, it's not a perfect world."

While the profession of truth seeking may seem increasingly under threat, Cohen continued, it's also true that "here in the U.S., we are fortunate to have the system in place we have, and the opportunity to function as a relatively free press. As Anne Frank once wrote, I still believe that people (and the press) are good at heart."

It was my third question, the one soliciting advice for future journalism graduates, that prompted perhaps the most inspired answers. For example, Anita Chabria, a Los Angeles–based reporter for *PR Week* magazine, responded this way:

> I think you have to really want to be a journalist, not because you want to make a name for yourself, or get rich quick, but because you believe it is an honorable and important thing to be. I also think you need to have a very clear sense of your own ethics and standards. There are many self-taught journalists out there, and many of them are very, very good. However, some of them have bad habits from learning on the fly. . . . You will have editors, colleagues and publishers who are willing to print or report in ways that are a bit in the grey area. It's hard to stand by and be the annoying one talking about ethics, but if you lose your reputation, you will have a very hard time getting it back.

Catherine Beck Shoup, who was a graduate student in my first news reporting class in 1993, passionately evoked the enduring challenge and value of journalism in her reply. After working as a stringer in Hong Kong and China for an American newspaper chain, she enrolled in journalism school to study documentary film, hoping, as she put it, to "tell truth through picture and sound and language." Over the years she did

just that. She eventually formed her own Baltimore-based documentary film company and produced award-winning films on health, education, youth, and art. Beck Shoup continues to produce films today. She recently relocated to Michigan with her husband and family, where she got a job teaching journalism at a local college. This was her advice to young professional journalists:

> Be a citizen of the world as well as your town, your state, and your country. Travel widely and read even more widely, and compare our news to that of other countries. Understand why many people in the rest of the world are frightened of us, and why they fear and often hate our government. Learn how other people live. When you understand the larger picture, you will be better able to communicate the details of everyday life in a way that touches something universally human. Be a good person first, and a good reporter second. To thine own self be true, as a great father once said, and it shall follow that your reporting will be more true. And if you ever feel that your report will harm someone needlessly, without helping others in equal measure, think long and hard about what makes it news and why it needs to be reported. If the answer is only about you and your career, think again. Your power comes with responsibility. Take it very seriously.

I now serve on the admissions committee at my school, and as I write this, I have been going over a stack of applications for next year's class. More than three hundred people have applied, but we can accept only about sixty, or 20 percent. It is a highly competitive procedure in which the applicants must make a good case about their academic and work accomplishments and must state why they want to pursue journalism as a professional career. It is painstaking to go through the piles of applications, but the four other faculty members and I take it very seriously, sifting our way through all the college transcripts, the personal essays, the published freelance clips, the photographs, and the television and radio work, struggling hard to separate out the truly promising candidates from the dull, the plain, the uninspired. In a sense, the task gives us the chance each year to take a pulse of young aspirants' attitudes toward journalism, what they think journalism is, and why it still attracts them as a career choice. And in this process, too, we are beginning to recognize the effects of an age of transformation in which the very meaning of journalism and its perceived role in democratic society may be changing in slight but nonetheless compelling ways among the public.

One applicant before us now, with strong test scores and an excellent

undergraduate education, features a lively writing voice in her essays. Her résumé shows a couple of years of experience in journalism at a magazine. Like a growing number of applicants, she has spent time at her publication trying her hand as a writer in New Media, blogging about current events. One of our graduates, who has worked for many years as a distinguished beat reporter at a national newspaper, conducted a half-hour interview with this candidate as part of the application process. The alum's summary notes from the interview with the candidate, whom I will call "X," are revealing about the subtle generational shifts we face as an institution in an era when journalism is being redefined in greater society:

> I pressed her a lot about what she thinks journalism is, because I got a sense that she sees the J School as a writing school. Maybe this is a generational thing. But X has skipped past the open-minded practice of reporting to blogging, where she analyzes and criticizes existing news through the lens of opinion/political position. There is nothing wrong with that. But I was hoping to get more of a sense that X understood the concept of multiple perspectives on an issue, and understood journalism as a tool to get closer to the truth on very complex issues. X does not see it that way. X said several times that she wants to come to the school to perfect her talents. She did not say that she wants to come to the school to learn how to be a reporter, which she is not right now. I found that odd. . . . I think she would benefit greatly [from the J School] and, once humbled, might come to a deeper understanding of journalism. But she lacks it now, and feels most comfortable serving more of an advocacy/activist role by opining on the news. X does not really seem to understand the practice of journalism and would prefer to skip straight to writing analysis. Again, maybe this is what more and more candidates look like in the age of blogging, but those are my thoughts.

Recently, in connection with this admissions work, I received an e-mail message from a woman whose work I respect very much. She works in the education program at the California State Prison at San Quentin, located across the Bay from our school, where she oversees a range of humanities courses offered to inmates as part of a larger effort to reduce recidivism rates. I have gotten to know her in recent years as a result of my introductory news reporting class, in which I lead the students on a number of field trips each year. I've taken classes to the Alameda County Superior Courts in Oakland to sit in on criminal trials and meet the public records clerks, to the Alameda County Coroner's office to talk to pathologists and sheriff's deputies, even to weekly press conferences by the head coaches of the Oakland Raiders professional football team in

Alameda—anything to get the students outside and far away from the Web, their computers, iPods, BlackBerries, cell phones, and other tools of communication. My aim is to get them in touch as much as possible with the *soul* of journalism. This spirit of exploration was perhaps best evoked by a crotchety editor working in the Washington bureau of the *Los Angeles Times* during the Watergate era. Tired of getting beaten by the *Washington Post,* and watching as reporters sat at their desks making telephone calls, he yelled out to them, "Get off your asses and knock on doors!" Each year I similarly try to get the students outside the school and into the real world at every opportunity. In recent years, I have taken them to San Quentin Prison so that they can see the execution chamber with their own eyes, talk to correctional officers about their difficult work, and witness, smell, and hear exactly what life is like inside a tough state prison, as I did many years ago as a cub reporter on assignment for my newspaper in 1979.

In her e-mail, my contact from San Quentin informs me that someone she knows is applying to our program. She tells me the candidate's name. She says that the applicant has taught English as a volunteer in the prison project on occasion and has experience in radio journalism. She asks me to keep an eye out for the application, adding that she recommends her highly as a young journalist and person. Coincidentally, I discover the candidate's application in the pile before me, where by chance our admission's director has included it. I open it up and spend the next thirty or so minutes examining the contents and taking notes.

Inside, I find solid academic achievement from the applicant's college transcript, fine Graduate Record Examination scores, and a sampling of published print and broadcast radio work testifying to her seriousness of purpose. She is twenty-five years old, a good age for our program. After earning her college degree, she spent some time earning a living in various capacities, immersed in the real world, and she got a taste of what society is really like. Included in the application are strong letters of recommendation from two professional journalists I respect highly, who express enthusiasm about her character and intellect. I take note.

Then I open her personal essay statement. In it, she explains her interest in journalism. I am impressed by the clarity of the composition. She writes about the critical role professional journalism must play in American society and the dangers to democracy when the people are misled by poor, incomplete, and unfair journalism or prevented from learning significant truths because of pressures from the powerful. The essay is convincing, moving. It contains a short sentence near the end that res-

onates with conviction. "Marketers are eating us alive," she writes, "and consumerism is replacing citizenship and democracy." She tells us she wants more than anything to learn to dig, to explore—to *report*. Here's a kid with spark, I tell myself. Here's a critical and lively mind. I'll speak up for her, I decide, as I anticipate the admissions committee meeting with my fellow faculty members the next day. I'll be sure to present a good case. I pick up my pencil to write a single word on the evaluation form and underline it with two bold strokes to be sure: *Admit.*

Notes

Certain citations in these notes derive from the LexisNexis.com online database, as indicated; in some cases, page numbers from the original printed versions are unavailable. LexisNexis.com, which contains more than five billion searchable news, legal, corporate, and academic documents, is also a valuable resource for locating television and radio transcripts. Occasionally a URL may no longer be active, and the content may be consigned to publication archives or may be unavailable. Where possible, URLs for such sources are supplied from the Internet Archive, a nonprofit digital library that records, tracks, and maintains links to copies of millions of Web pages that are no longer active.

INTRODUCTION

1. The series of stories about the Tigray assignment, "Tigray Province: Land of the Night," was published in the *Washington Post*, May 16–18, 1990, p. A1.

2. Edmund Morris's biography of Ronald Reagan, *Dutch: A Memoir of Ronald Reagan* (New York: Random House, 1999), is a notable recent example of a nonfiction work in which the author intentionally fabricated scenes and characters in order to lend greater entertainment value and narrative thrust (as well as sales potential) to the subject's life story. Works billed to the public as nonfiction memoirs have come under greater scrutiny, and numerous examples of fakery and fabrication have been uncovered. Most recently, James Frey's 2003 best seller, *A Million Little Pieces*, marketed as a memoir of his harrowing life

251

and struggle with alcohol and drugs, was exposed as a pack of lies. Despite the revelation of the fraud, Frey's publisher, Doubleday, strongly supported the author and the book, concluding that the power and wide cultural impact of the story were more important than whether or not it was actually true (Sheila Kohatkar, "In Frey Fabrication, Publishers Only Care If Mt. Oprah Blows," *New York Observer,* Jan. 16, 2006, p. 1). Chapter 5 discusses the Frey incident in more detail.

3. The fabrications alluded to in this paragraph are examined further in chapter 1 and its notes.

4. Digital tools arguably have far more profound implications and meaningful effect in politically repressive societies, where dissidents increasingly are turning to Web logs and other New Media tools for outlawed political discussions. See, for example, Andrew Heavens, "African Bloggers Find Their Voice," *BBC News Focus on Africa,* Dec. 20, 2005, available online at http://news.bbc.co.uk/2/hi/africa/4512290.stm; and Neil MacFarquhar, "In Tiny Arab State, Web Takes On Ruling Elite," *New York Times,* Jan. 15, 2006, p. A1. Interestingly, the nexus of China's white-hot free market economy and the era's new communication capabilities has put the world's major technology companies in a quandary: should they side with citizens who desire unrestricted access to the technologies or with government authorities seeking tight control? Recent events indicate that corporate choices by Microsoft, Yahoo!, and Google increasingly tilt toward the latter. See David Barboza and Tom Zeller Jr., "Microsoft Shuts Blog's Site after Complaints by Beijing," *New York Times,* Jan. 5, 2003, p. C3; Joe MacDonald, "Microsoft Shuts Down Chinese Blog That Carried Politically Sensitive Content," Associated Press, Jan. 6, 2006; "Technology Firms Bowing to China," *China Post,* Jan. 11, 2006, www.lexisnexis.com; Mure Dickie, "Google's Acceptance of Restrictions, Censorship in China Draw Charges of Hypocrisy," *Financial Times,* Jan. 26, 2006, p. 7; and Stephanie Kirchgaessner, "Yahoo Wants Help to Fight Chinese Censors," *Financial Times,* Feb. 13, 2006, p. 1.

5. Ben H. Bagdikian, *The Media Monopoly* (Boston: Beacon Press, 1983), reissued and updated as *The New Media Monopoly* (Boston: Beacon Press, 2004); Edward S. Herman and Noam Chomsky, *Manufacturing Consent: The Political Economy of the Mass Media* (New York: Pantheon Books, 1988).

6. Since 1983, the number of media corporations who own and directly control most of the nation's newspapers, magazines, book publishers, movie studios, and television, cable, and radio stations has diminished from more than fifty to just five gigantic entities: Time Warner, the Walt Disney Corporation (owners of ABC, ESPN, and others), Rupert Murdoch's News Corporation (owners of Fox News and others), Bertelsmann of Germany, and Viacom (owner of CBS and others). A close sixth in 2005 was General Electric, owner of NBC. *The Nation* magazine reported on the extent of media conglomeration in 1996, offering a widely discussed four-page chart titled "The National Entertainment State," which graphically highlighted the lengthy ownership tentacles of major media corporations (Mark Crispin Miller, "Free the Media," *The Nation,* June 3, 1996, pp. 9–10, 12, 14–16, 18–26, 28–32). The chart was updated to reflect even greater media consolidation in 2002 (Mark Crispin Miller, "What's Wrong with This Picture?" *The Nation,* Jan. 7, 2002, pp. 18–25, available online at

www.thenation.com/doc/20020107/miller) and more recently in 2006 (The Editors, "10th Anniversary, National Entertainment State," *The Nation,* July 3, 2006, pp. 21–26).

7. John Stauber and Sheldon Rampton, *Toxic Sludge Is Good for You: Lies, Damn Lies, and the Public Relations Industry* (Monroe, Maine: Common Courage Press, 1995).

8. Edward Bernays, *Propaganda* (1928; New York: Ig Publishing, 2004), p. 37. Although *Propaganda* was out of print for many years, it was reissued as a paperback in 2004, perhaps a sign of increasing public interest about the origin and practices of the public relations industry.

9. Bernard Goldberg, *Bias: A CBS Insider Exposes How the Media Distort the News* (Washington, D.C.: Regnery, 2001). The political terms *liberal* and *conservative* highlight what is something of a conundrum in the chaotic field of popular media criticism. The terms have become heavily weighted, highly charged code words meant to convey many different things to different people, rendering their wider informative value very problematic. The conundrum may be best reflected by a slogan (and bumper sticker) popular among some leftists: "The Media Are Only as Liberal as the Conservative Businesses That Own Them."

10. William McGowan, *Coloring the News: How Crusading for Diversity Has Corrupted American Journalism* (New York: Encounter Books, 2001), reissued as *Coloring the News: How Political Correctness Has Corrupted American Journalism* (New York: Encounter Books, 2003).

11. Eric Alterman, *What Liberal Media? The Truth about Bias and the News* (New York: Basic Books, 2003).

12. William McGowan, *Gray Lady Down: Jayson Blair and How the* New York Times *Lost Touch with America* (New York: Encounter Books, 2006).

13. Seth Mnookin, *Hard News: The Scandals at the* New York Times *and Their Meaning for American Media* (New York: Random House, 2004).

14. James Fallows, *Breaking the News: How the Media Undermine American Democracy* (New York: Pantheon Books, 1996).

15. Bill Kovach and Tom Rosenstiel, *The Elements of Journalism: What Newspeople Should Know and the Public Should Expect* (New York: Crown, 2001).

16. Dan Gillmor, *We the Media: Grassroots Journalism by the People, for the People* (Sebastopol, Calif.: O'Reilly Media, 2004).

17. With private venture capital backing and tremendous fanfare, Gillmor, a former reporter for the *San Jose Mercury News,* launched one of the most ambitious citizen journalism Web sites to date in 2005. Based in the San Francisco Bay Area and called the Bayosphere, the site aimed to showcase the news reporting and commentary work of citizen journalists, working in complement with professionals. Seeking to take advantage of ad revenues flowing to the Web, the site was viewed as a bold and imaginative effort to reinvent the model of a news publication in a time when ad revenues were drying up for the traditional media. The site failed to gain significant readership or to produce widely meaningful journalism, however, and was shut down in 2006. See Heather Green, "Great Online Expectations: Bayosphere Wanted to Reinvent Journalism; Here's How the Dream Died," *Business Week,* Feb. 20, 2006, p. 68.

18. Rebecca MacKinnon, "Blogging, Journalism, and Credibility: Battleground and Common Ground," Executive Summary, Final Conference Report, sponsored by the Berkman Center for Internet and Society, the Shorenstein Center on the Press, Politics, and Public Policy, and the Office of Information Technology Policy of the American Library Association, Jan. 21–22, 2005, Cambridge, Mass., p. 3; available online at http://cyber.law.harvard.edu:8080/webcred/wp-content/CONFREPORT2.htm.

19. The project's 2006 annual report and earlier reports can be found online at www.stateofthenewsmedia.org/2006; see "2006 Annual Report on the State of the News Media, Executive Summary."

1. AMERICAN CARNIVAL

1. My former student told me this story confidentially. Like the anecdotes from several other former students in succeeding paragraphs, it was provided during the course of informal career counseling over a period of years in my work as a teacher, and I have therefore chosen to protect the identities of the students. By contrast, statements from other students, which I actively solicited with their knowledge and consent, both for this chapter and for the concluding chapter are on the record and the sources identified.

2. "The State of the News Media 2004: An Annual Report on American Journalism," available online at www.stateofthenewsmedia.org/2004. This report is prepared by the Project for Excellence in Journalism, an institute affiliated with Columbia University's Graduate School of Journalism and supported by the Pew Charitable Trusts. In addition to examining the industry's economic climate, this report contains a survey of attitudes toward the news industry among American citizens and journalists. The survey is conducted by the Project for Excellence in Journalism and the Pew Research Center for the People and the Press. Over the past twenty years since the survey began, the percentage of Americans who believe that news organizations are moral has declined from 72 percent to 49 percent; 39 percent now consider the media immoral, as opposed to 13 percent who felt this way twenty years ago. Fewer Americans today believe that news organizations care about the people they report on (30 percent, in contrast to 41 percent in earlier years); while the number of those who see the media as politically biased rose from 45 percent to 59 percent. These annual surveys are reported widely in the press and are available on the Web at www.stateofthenewsmedia.org.

3. Margaret Steen, "*Mercury News* to Cut News Staff 15 Percent," *San Jose Mercury News*, Sept. 24, 2005, p. C3; Seth Sutel, "*New York Times* Cuts 500 Jobs; Philly Papers Cut 100," Associated Press, *Business Wire*, Sept. 20, 2005; Katherine Seelye, "Group Says Tribune's Cuts Hurt the Public," *New York Times*, Dec. 26, 2005, p. C5.

4. "The State of the News Media 2006: An Annual Report on American Journalism," prepared by the Project for Excellence in Journalism, available online at www.stateofthenewsmedia.org/2006.

5. Claude Moisy, "Myths of the Global Information Village," *Foreign Policy*, no. 107 (Summer 1997): 77–78. See also Claude Moisy, "The Foreign News

Flow in the Information Age," Discussion Paper D-23, Joan Shorenstein Center on the Press, Politics, and Public Policy, John F. Kennedy School of Government, Harvard University, November 1996, available online at www.ksg.harvard.edu/ presspol/Research_Publications/papers.shtml#DISCUSSION.

While newspaper circulation has declined generally since 1984, the fall in numbers has accelerated with the rise of the Internet and cable television. From December to March 2005, newspaper circulation fell 1.9 percent, one of the sharpest drops in recent years, according to the Audit Bureau of Circulations. At the *Washington Post,* the decline was particularly sharp: 2.9 percent. See the Associated Press article "Newspaper Circulation Sinks by 1.9 Percent over Six Months," reported in the *Wall Street Journal,* May 2, 2005, p. A1. See also Paul Maidment, "Stopping the Presses," On the Media, *Forbes,* Feb. 2, 2005, available online at www.forbes.com/home/business/2005/02/22/cx_pm_0222news.html.

6. The survey, commissioned by the Carnegie Corporation and conducted in May 2004 by the influential media consultants Frank N. Magid Associates, found that young Americans are abandoning traditional print and broadcast news media in droves in favor of the Web and other nontraditional sources, seriously threatening the future of the American news industry. The full report, titled "Abandoning the News," is available online at www.carnegie.org/ reporter/10/news/. Various news media reported on the survey; see, for example, "Carnegie Corporation Report Tracks Changes in Media Consumption by 18–34-Year-Olds; Report Survey Data Reveal That Young Adults Surf the Internet for News, Abandoning Newspapers and Traditional Media," *Business Wire Inc.,* May 4, 2005, www.lexisnexis.com.

7. See Tom Fenton, *Bad News: The Decline of Reporting, the Business of News, and the Danger to Us All* (New York: Regan Books, 2005).

8. Lucinda Fleeson, "Bureau of Missing Bureaus," *American Journalism Review,* Oct./Nov. 2003, pp. 32–33. Interestingly, the *Times* of London in May 2006 announced plans to launch an American edition specializing in world coverage, to take advantage of the growing dearth of foreign coverage in the U.S. news media. "I think there's genuine demand for international news in America," said Robert Thompson, the paper's editor. "Yet fewer American journalists [are] in the field than perhaps at any time in history" (Eric Pfanner, "*Times* of London to Print Daily U.S. Edition," *International Herald Tribune,* May 27, 2006, p. 3).

9. Monica Davey, "Chicago Journal: Tears Well Up as Reporters' Boot Camp Nears End," *New York Times,* Dec. 13, 2005, p. A27.

10. Bernard Goldberg's *Bias: A CBS Insider Exposes How the Media Distort the News* (Washington, D.C.: Regnery, 2001) indicates in some ways how complex the idea of newsroom diversity, and its lack, can be. Goldberg recounts numerous incidents supporting his allegations that, in the absence of true political diversity, white liberal attitudes and "political correctness" helped to create a newsroom environment that skewed coverage, softening or ignoring stories that were critical of minorities and feminists. But he also points out how the lack of diversity, coupled with commercial pressures, helped to exacerbate these problems. He charges that news producers habitually decline to feature blacks in even the most benign and random of feature stories, if given a choice, largely because

of a network perception that stories about black people result in low ratings. Similarly, a lack of true diversity—of backgrounds (racial, ethnic, religious, and class) and of political beliefs—both inside the newsroom culture of the *New York Times* and in its news coverage, was cited as an important factor in recent ethical failures, including the paper's flawed reporting on the run-up to the Iraq war; see Daniel Okrent, "Briefers and Leakers and the Newspapers Who Enable Them," *New York Times,* May 8, 2005, sec. 4, p. 12; and "Preserving Our Readers' Trust," the *Times*-commissioned study of the newsroom's failures by a panel of outside experts, available online at www.nytco.com/pdf/siegal-report050205 .pdf.

11. The explosion hoax occurred on the NBC television program *Dateline NBC* on Nov. 17, 1992. Protests by General Motors eventually led to exposure of the scandal and the resignation of NBC News president Michael Gartner.

12. The effort by Bush administration officials to disseminate positive news about White House policies by using taxpayer money to fund public relations contracts with newspaper columnists and broadcast commentators was covered extensively in the press after the story broke in January 2005. Conservative media personalities who accepted such contracts included syndicated columnists Maggie Gallagher and Michael McManus and radio figure Armstrong Williams, who received $250,000 to sell black audiences on the administration's No Child Left Behind education plan. See Dave Astor, "Syndicates: Has 'Pundit Payola' Hurt Columnists?" *Editor and Publisher,* May 1, 2005, p. 12.

13. The issue of the *Los Angeles Times Sunday Magazine* dedicated to the opening of the Staples Arena was published on Sunday, Oct. 10, 1999. The *Times* later issued a front-page apology for the deception and published a special section with several long stories that examined every aspect of the scandal (Dec. 20, 1999). Numerous reports in ensuing years have examined the growing cooperation between editorial and business functions at American news organizations, largely brought on by difficult economic circumstances; see, for example, Sharyn Vane, "Taking Care of Business," *American Journalism Review,* March 2002, p. 60.

14. The Glass, Blair, and Kelley scandals were the most extensively publicized in recent times; see Seth Mnookin, *Hard News: The Scandals at the* New York Times *and Their Meaning for American Media* (New York: Random House, 2004). Blair himself wrote about his downfall in *Burning Down My Masters' House: My Life at the* New York Times (Beverly Hills: New Millennium, 2004). Ann Reilly Dowd examines Glass's frauds in "The Great Pretender: How a Writer Fooled His Readers," *Columbia Journalism Review,* July/Aug. 1998, p. 14. Jill Rosen covers Kelley's life as a plagiarist and fabricator in "Who Knows Jack?" *American Journalism Review,* April/May 2004, p. 29.

15. During the 2004 presidential campaign, Dan Rather reported on CBS that the network had obtained thirty-year-old memos purportedly showing that George W. Bush had received preferential treatment by commanders during his National Guard duty in the Vietnam era and had lied about undergoing a physical exam. Subsequent reactive reports by conservative bloggers and others pointed to discrepancies in the story and to evidence that the memos were fabricated. The controversy led Rather and the network to admit that they had been

duped and sparked an investigation by CBS that resulted in the dismissal of the producers and Rather's retirement from the anchor job. See, for example, David Folkenflik, "CBS Forces Out Four Senior Journalists Because of the National Guard False Information Report concerning President Bush," *Morning Edition*, National Public Radio, transcript, Jan. 11, 2005, www.lexisnexis.com; audio available online at www.npr.org/templates/story/story.php?storyId=4277948.

16. Much has been written and broadcast in the news media about the publication of fraudulent information by the *New York Times* regarding Iraq and Saddam Hussein's supposed possession of weapons of mass destruction, an issue key to the U.S. decision to go to war. The information was based on anonymous sources in the intelligence community, including Iraqi exile Ahmed Chalabi, whose credibility had been called into question before the war began. In a report to readers in 2004, the editor of the *Times* admitted that the paper had misled the public about the Iraqi weapons issue in the run-up to the war and that its reporters had relied too heavily on insufficient or fabricated information and on sources whose credibility was suspect ("From the Editor: The *Times* and Iraq," *New York Times*, May 26, 2004, p. A10). Numerous critics pointed out that the *Times* had reported the Jayson Blair fabrication scandal in a ten-thousand-word front-page investigation, while the newspaper devoted barely a thousand words on an inside page to explaining the weapons fraud (Peter Johnson, "*New York Times* Is Criticized for Quiet Mea Culpa," *USA Today*, May 27, 2004, p. D3).

In a similar self-study and report to its readers, the *Washington Post* admitted that it also had been too trusting of sources on Iraq's weapons capability and had downplayed stories presenting information that undermined the weapons claims; see Howard Kurtz, "The *Post* on WMDs: An Inside Story; Prewar Articles Questioning Threat Often Didn't Make Front Page," *Washington Post*, Aug. 12, 2004, p. A1. In this article, the *Post*'s executive editor, Leonard Downie, is quoted: "We were so focused on trying to figure out what the administration was doing that we were not giving the same play to people who said it wouldn't be a good idea to go to war and were questioning the administration's rationale. Not enough of those stories were put on the front page. That was a mistake on my part." Across the country, "the voices raising questions about the war were lonely ones," Downie said. "We didn't pay enough attention to the minority."

Reporting by both newspapers in advance of the war contributed to their editorial support of the American invasion.

17. The popularity of Jon Stewart's *Daily Show* on the Comedy Central cable network among young Americans is particularly interesting. Polls suggest that the Stewart program, with its biting satire of the news of the day and theatrical representations of real news, constitutes a chief source of actual news and information for Americans twenty-one years of age and younger (Peter Neil Nason, "Popular Comedy Show Delivers Serious Political Messages," *Tampa Tribune*, Oct. 10, 2004, p. 4). More fascinating still, young people consider the *Daily Show*'s entertaining fare of fake news a more accurate reflection of real news and information than the reporting provided by either the political establishment or the mainstream media. As Tim Goodman writes in the *San Francisco Chronicle*: "Where once it was just fake news and a source of consternation about how it's the only place young people were getting their news, the *Daily*

Show has become arguably the most valuable news filter on television" (Oct. 28, 2005, p. E1).

18. Claude Moisy, former chairman of Agence France-Presse, describes the fragmenting, shut-off character of citizen involvement in New Media as "a haven for a myriad of one-issue chapels estranged from the rest of the world" ("Myths of the Global Information Village," pp. 77–78).

19. Nick Gillespie, *Reason* magazine editor, described this sentiment about the promise of citizen journalism during an interview and call-in session with Brian Lamb of C-Span's *Washington Journal* cable television program on Jan. 1, 2006. Jimmy Wales, founder of Wikipedia and Wiki News, similarly extolled these futuristic mass-based news and informational initiatives in an interview on National Public Radio: "We have technology now that enables ordinary people to communicate in a way that really wasn't possible before. And it's not just communication like e-mail. It's actually communication that builds something, building up a knowledge base over time" (Neal Conan, "Wikipedia, Open Source, and the Future of the Web," *Talk of the Nation*, National Public Radio, transcript, Nov. 2, 2005, www.lexisnexis.com; audio available online at www.npr.org/templates/story/story.php?storyId=4986453). On the creation and launch of Wiki News, see Robert D. Hof, "All the News You See Fit to Write," *Business Week*, Dec. 27, 2004, p. 13; and Aaron Weiss, "Don't Like This Story? Write Your Own Then," *Toronto Star*, Feb. 13, 2005, p. D10.

20. Rebecca MacKinnon, "Blogging, Journalism, and Credibility: Battleground and Common Ground," Executive Summary, Final Conference Report, sponsored by the Berkman Center for Internet and Society, the Shorenstein Center on the Press, Politics, and Public Policy, and the Office of Information Technology Policy of the American Library Association, Jan. 21–22, 2005, Cambridge, Mass., p. 3; available online at http://cyber.law.harvard.edu:8080/webcred/wp-content/CONFREPORT2.htm.

21. See, for example, Jane Kirtley, "Web of Lies: A Vicious Wikipedia Entry Underscores the Difficulty of Holding Anyone Responsible for Misinformation on the Internet," *American Journalism Review*, Feb./March 2006, p. 66. The article centers on the experience of retired newspaper editor John Siegenthaler, who discovered to his fury that his biography on the citizen-produced and edited Web site reported that "he was thought to have been directly involved in the Kennedy assassinations of both John and his brother Bobby."

22. Franklin Foer of the *New Republic* argues that the conservative movement has attacked the idea of "objective" reality, a central tenet of modern professional journalism, and has attributed innate bias to "experts," including professional journalists. Postmodern American conservatism, Foer writes,

has harbored a suspicion of experts, who, through adherence to inductive reasoning and academic methodologies, claim to provide objective research and analysis. To be sure, this social-scientific approach has its limits. Conservatives have raised genuinely troubling questions about its predilection for downplaying the role of "culture" and "values" in shaping human behavior. But the Bush administration has adopted a far more extreme version of this critique: It takes the radically postmodern view that "science," "objectivity," and "truth" are guises for an ulterior, leftist agenda; that experts are so incapable of dispassionate and disinterested analysis that their work

doesn't even merit a hearing. And the results have been disastrous ("Closing of the Presidential Mind," *New Republic,* July 5, 2004, p. 17).

23. "News Media's Improved Image Proves Short-Lived," Pew Research Center for the People and the Press, Aug. 4, 2002, available online at http://people-press.org/reports/display.php3?ReportID=159. The Pew surveys of American attitudes about the news media are frequently cited and examined in the American press, including the following: Peter Johnson, "Public Unsettled by Media Consolidation, Poll Shows," *USA Today,* July 16, 2003, p. D3; Reed Johnson, "Trashing the Media: Veteran Journalists Are Coming to Some Grim Conclusions about Their Industry," *Los Angeles Times,* Jan. 11, 2004, p. E4; Eric Boehlert, "Setback for Big Media," Salon.com, June 25, 2004, available online at http://dir.salon.com/story/news/feature/2004/06/25/fcc/index.html; David Shaw, "Half in Poll Say Media Biased and Inaccurate," *Los Angeles Times,* Nov. 29, 2001, p. A36.

24. "Strong Opposition to Media Cross-Ownership Emerges," Pew Research Center for the People and the Press, July 13, 2003, available online at http://people-press.org/dataarchive/signup.php3?DocID=151.

25. "Bottom Line Pressures Now Hurting Coverage, Say Journalists," Pew Research Center for the People and the Press, May 23, 2004, available online at http://people-press.org/reports/display.php3?ReportID=214.

26. Circulation scandals in 2004 affected numerous newspapers, including the *Chicago Sun-Times* and the *Dallas Morning News.* The biggest scandal centered on the Tribune Co. and *Newsday* of New York, where an independent investigation revealed that *Newsday* officials had overstated the paper's paid circulation to ABC by more than one hundred thousand; similar fraudulent reports went as far back as 2001. *Newsday* executives eventually admitted the wrongdoing, offered rebates to advertisers, and set aside a reported $90 million to fund potential lawsuit settlements. Tribune Co. shareholders did file suit against the company, alleging that executives had inflated circulation figures "to fraudulently extract higher incentive payments from the newspaper's advertisers" and that the inflated numbers "were reported to investors and the market on a regular basis and artificially inflated the Tribune's financial results" (James Berstein, "Shareholders File Suit; Allege Tribune Company Was Aware It Overstated Circulation Numbers at *Newsday* and *Hoy,*" *Newsday,* May 3, 2005, p. A46). See also Holly M. Sanders, "Free for All: *Newsday* Admits to Paper Giveaway Scheme," *New York Post,* Jan. 28, 2005, p. 33.

27. Alan Price, "Cases of Plagiarism Handled by the United States Office of Research Integrity, 1992–2005," *Plagiary: Cross-Disciplinary Studies in Plagiarism, Fabrication, and Falsification,* Jan. 20, 2006, pp. 1–11; see www.plagiary .org/papers_and_perspectives.htm. (The journal is published by the University of Michigan in Ann Arbor. Articles are initially published online and are later bound and published in hard copy at the end of each year.) See also Sara Ivry, "Plagiarists Exposed, Then Explored," *New York Times,* Feb. 6, 2006, p. C6.

28. Jordan Muhlstein, "New Technology Harbors New Era of Cheating," *Brigham Young Daily Universe,* May 11, 2004, p. A1, University Wire news service.

29. The figure comes from the 2005 Identity Fraud Survey Report, compiled by the Javelin Strategy and Research Agency and co-released by the Better Business Bureau of America and the Privacy Rights Clearinghouse, a nonprofit organization. The survey was based on interviews with four thousand consumers, including more than five hundred victims of identity theft. It indicated that such fraud occurs more often offline (via stolen checkbooks, credit cards, and so forth) than through online commerce. The report was an update of a similar study conducted in 2003 by the Federal Trade Commission. The annual dollar cost of identity fraud stood at $52.6 billion in 2005. A summary of the survey is available online at www.bbb.org/alerts/article.asp?ID=565. See also Tiffany Ray, "Most Identity Theft Takes Place Offline," *Montgomery Advertiser,* Jan. 28, 2005, p. C1.

30. Robert Siegel, "*Newsweek* 'Photo Illustration' of Martha Stewart Stirs Debate," *All Things Considered,* National Public Radio, transcript, March 2, 2005, www.lexisnexis.com; audio available online at www.npr.org/templates/story/story.php?storyId=4520166. *USA Today* first reported on the *Newsweek* photo doctoring in its March 2, 2005, issue (Mark Memmott, "Is It Real? Or Is It Martha?" p. D1).

31. Mark Whitaker, "The Editor's Desk," *Newsweek,* March 14, 2005, p. 4.

32. Cited in Murray B. Light, "*Time* Sacrifices Ethics in Altering Simpson Photo," *Buffalo News,* June 29, 1994, local ed., p. A1.

33. The Cox Center at the University of Georgia compiles annual salary data for undergraduate journalism and mass media graduates across America; these statistics are often cited as a barometer of industry wages. The 2004 Cox report, "2004 Annual Survey of Journalism and Mass Communication Graduates," is available online at www.grady.uga.edu/ANNUALSURVEYS/grd04/grd04sum.htm. Figures for fees paid to photo retouchers are cited in Kate Betts, "The Man Who Makes the Pictures Perfect," *New York Times,* Feb. 2, 2003, sec. 9, p. 1.

34. A doctored photo purportedly showing John Kerry and Jane Fonda together at a demonstration opposing the Vietnam war in the 1960s was disseminated on the Internet and published in several newspapers, including the *Times* of London. The photograph enraged many Vietnam war veterans and helped to galvanize early opposition to Kerry's presidential candidacy. See Stephen Dinan, "Photo of Kerry with Fonda Enrages Vietnam Veterans," *Washington Times,* Feb. 11, 2004, p. A1; and Ken Light, "Is That Digital Photo the Real Thing?" *Newsday,* April 28, 2004, p. A40.

The *Daily Mirror* published the doctored and staged British photos on May 1, 2004. Two weeks later, the newspaper was forced to admit that it had been duped, and its editor resigned in disgrace ("Editor Sacked over Hoax Photos," *BBC News Online,* May 14, 2004, http://news.bbc.co.uk/2/hi/uk_news/politics/3716151.stm). See chapter 3 for a more detailed account of this incident.

35. Robert Silverman, "Wired: Is It 'World News' or Is It Memorex?" *Variety,* Feb. 14-20, 1994, p. 68.

36. Perry Smith, "The Lessons of Tailwind," *American Journalism Review,* Dec. 1998, p. 45.

37. The headline on the *Evening Graphic's* depiction of Caruso and Valentino in heaven read, "Rudy Meets Caruso in Heaven! Singer's Spirit Breaks!" (Bob Stepno, "The *Evening Graphic's* Tabloid Reality," paper prepared for the School of Journalism and Mass Communication, University of North Carolina, Chapel Hill, available online at www.stepno.com/unc/graphic).

38. The doctored photo was published in the *Los Angeles Times,* March 31, 2003, p. A1; the *Chicago Tribune,* March 31, 2003, p. B1; and the *Hartford Courant,* March 31, 2003, p. A1. The admission that the photo had been doctored appeared in the *Los Angeles Times* on April 2, 2003.

Another war photo scandal erupted in August 2006 during Israel's invasion of Lebanon, when a Reuters photographer was fired after revelations that photos he had taken had been digitally manipulated to dramatize the violence. The blogger who exposed the deception, Charles Johnson, had also helped to uncover the faked memos used in the 2004 CBS report about George W. Bush's National Guard record (see note 15, above). See Patrick Barkham, "Media: Spot the Difference," *Guardian* (London), Aug. 14, 2006, p. A3; and Editorial, "Photos Real and Faux," *Baltimore Sun,* Aug. 22, 2006, p. A10.

39. The first quotation from Jefferson is from the text of a letter to Col. Edward Carrington, dated Jan. 16, 1787; the second, on advertising, is from an undated letter to Nathaniel Macon. Both are cited in Bergen Evans, *Dictionary of Quotations* (New York: Delacorte Press, 1968), pp. 484, 8. Art Young's cartoon, titled "Freedom of the Press," appeared in the December 1912 issue of *The Masses,* which was published monthly in the United States from 1910 until 1917, when government suppression shut it down.

40. Liebling's observation is cited in Catherine Seipp, "May No More," *National Review Online,* March 10, 2005, www.nationalreview.com/seipp/seipp 200503100740.asp. The comment from Richards is often quoted among public relations and advertising professionals and trade groups; Richards himself includes the quote among many he has compiled on his Web site at http://advertising.utexas.edu/research/quotes/Q100.html#Advis. Cockburn's observation is found in his essay "How to Be a Foreign Correspondent," *More* magazine, May 1976, pp. 22–26. The essay was reprinted in Alexander Cockburn, *Corruptions of Empire* (London: Verso Press, 1988).

41. Upton Sinclair, *Brass Check: A Study of American Journalism,* introduction by Robert W. McChesney and Ben Scott (Urbana: University of Illinois Press, 2003); originally published in 1920.

42. Terence Smith, "Two Parallel Lives: Red and Shirley," *New York Times,* April 17, 2005, p. B11.

43. The power of news and information—and fabrications—to instantly influence world events was evidenced in May 2005, when *Newsweek,* relying on anonymous sources, reported a brief 320-word item in its Periscope column noting that a forthcoming Pentagon internal report would reveal that American interrogators had flushed a Koran down a toilet to intimidate and coerce Islamic detainees at the prison at Guantanamo Bay Naval Base in Cuba (Michael Isikoff and John Barry, "Periscope: Gitmo—SouthCom Showdown," *Newsweek,* May 9, 2005, p. 10). The item helped to trigger waves of protests and rioting that left seventeen persons dead and scores injured in Afghanistan

and other Muslim countries. *Newsweek*'s editors retracted the report a week later, admitting that its anonymous source was in fact a single official in military intelligence who could not later explicitly confirm the accuracy of the prison account (Mark Whitaker, "The Editor's Desk," *Newsweek,* May 16, 2005, p. 4). Nevertheless, two months later, in July 2005, radical Islamic groups who claimed responsibility for the terror attacks in London's transit system, which killed more than fifty persons, vowed more such attacks to avenge the alleged desecration of the Koran at Guantanamo (Alan Cowell and Don Van Natta Jr., "Four from Britain Carried Out Terror Blasts, Police Say," *New York Times,* July 13, 2005, p. A1). This round of violence came more than a year after the first press reports and photographs, later confirmed as accurate by military investigators, of American abuse and torture of Iraqi detainees at Abu Ghraib prison in Baghdad, which similarly produced protests throughout the Muslim world.

44. "The Separate Realities of Bush and Kerry Supporters," Program on International Policy Attitudes (PIPA)/KnowledgeNetworks Poll, The American Public on International Issues, Oct. 21, 2004, Steven Kull, principal investigator; available online at www.pipa.org/OnlineReports/Iraq/IraqRealities_Oct04/Iraq Realities%20Oct04%20pr.pdf. The poll was referenced extensively in the news media after the election: see, for example, Alan Wirzbicki, "Divide Seen in Voter Knowledge," *Boston Globe,* Oct. 22, 2004, p. A23; and Michael Tracey, "Truth Matters Not to Bush Voters," *Rocky Mountain News,* Oct. 30, 2004, p. C14. See also David Folkenflik, "Study Hits War Views Held by Fox Fans," *Baltimore Sun,* Oct. 4, 2003, p. D1.

45. See "Big Year for the Big Ten," *Multichannel News,* Jan. 2, 2006, p. 12.

46. Robert McChesney argues these points more extensively in "The Rise of Professional Journalism," *In These Times,* Dec. 8, 2005, available online at www.inthesetimes.com/site/main/article/2427. McChesney believes that the greatest impact Fox News has had on society is the devaluing of professional and independent journalism as a featured product of broadcast and cable news.

47. The early years of network news, and the forces that shaped the institution, figure prominently in the autobiography of Reuven Frank, the pioneering television journalist who began his career in 1950 and eventually rose to become president of NBC News; see Reuven Frank, *Out of Thin Air: The Brief Wonderful Life of Network News* (New York: Simon and Schuster, 1991). See also Terry Teachout, "If the Nightly News Goes Out, It's with a Whimper," *New York Times,* March 24, 2002, sec. 2, p. 27.

48. In *Democracy and the News* (New York: Oxford University Press, 2003), Herbert Gans discusses the impact of the "golden age" on contemporary journalism and today's comparative sense of disempowerment. He writes, "Golden ages are images of the past that emerge from dismay with the present and are constructed to fit the shortcomings of that present" (p. 42).

49. A fine treatment of Richardson's story can be found in Earl Caldwell's excellent compilation of narratives about the history and experiences of African American journalists in the mainstream press, available on the Web site of the Robert C. Maynard Institute for Journalism Education; see www.maynard ije.org/news/features/caldwell/Chapter15/. Richardson's experiences during the

Watts riots were also the subject of *Heat Wave,* a 1990 film produced by Turner Network Television.

50. See Robert Siegel, "Reuven Frank, Broadcast News Pioneer, Dies at 85," *All Things Considered,* National Public Radio, transcript, Feb. 6, 2006, www.lexisnexis.com; audio available online at www.npr.org/templates/story/ story.php?storyId=5192604. The original interview was conducted in 1991 and rebroadcast in 2006 to commemorate Frank's death a day earlier.

51. The generally accepted view of the role of the press during the Vietnam war perpetuates the idea of the golden age of journalism, holding that the American press fulfilled its watchdog role and gave citizens an unvarnished, critical picture of a conflict that eventually proved enormously unpopular. Numerous experts, however, point out that this view is more myth than reality and charge that the mainstream press in general presented a sanitized version of the conflict, largely supported it, relied far too extensively on the administration and military leaders for information, and usually heeded official requests to withhold images of American and Vietnamese casualties. See, in particular, *The "Uncensored War": The Media and Vietnam* (New York: Oxford University Press, 1986), by Daniel Hallin, a professor at the University of California at San Diego who has written extensively on press coverage of the war.

52. Bergman's experience with CBS was the basis for a popular film, *The Insider* (2000), starring Al Pacino and Russell Crowe. Lieberman's fall at Sinclair Broadcasting for protesting the airing of the Kerry story so close to the election was widely reported in the news media in October 2004. He specifically protested the fact that the documentary, titled *Stolen Honor,* was to be presented as a news segment. After he was fired for publicly opposing his supervisors, Lieberman wrote about his experience in "Why I Stood Up to Sinclair," an essay published in *Broadcasting and Cable* on Oct. 25, 2004 (Airtime, p. 48). He noted: "At Sinclair headquarters, nobody was happy with the project, as far as I could tell. But there was no room for dissension. Everyone was afraid for their jobs. My former colleagues are excellent journalists, but need to feed their families, and can't afford to take the hit of being fired. And at Sinclair, everyone is expendable."

53. Fassihi's experience with her e-mail and the reaction of the *Wall Street Journal* were covered extensively in the press in October 2004; see, for example, Tim Rutten, "Of Biases and Boundaries in the Newsroom," *Bergen Record,* Oct. 5, 2004, p. L15. The e-mail itself can be found on the Web at numerous sites, including www.poynter.org and www.warandpeace.com. Fassihi described the difficulty of life as a reporter in Iraq, fleshing out details she had originally included in her e-mail, in a personal essay titled "Baghdad Diary" (*Columbia Journalism Review,* Dec. 2004, p. 36).

54. The Harris resignation received considerable publicity and discussion in professional journalism publications and the mainstream press; see, for example, Chris O'Brien, "Resignation Touches a Nerve in the Newspaper Industry," *San Jose Mercury News,* March 21, 2001, p. A15.

55. Bob Susnjara, "Restaurant Reviews Tricky for Businesses, Newspapers," *Chicago Daily Herald,* Sept. 17, 2003, p. A11.

56. One of Miller's key sources, Iraqi exile Ahmed Chalabi, had long been

supported politically and financially by American intelligence agencies, although he later fell out of favor with the United States after the 2003 invasion. In *A Pretext for War: 9/11, Iraq, and the Abuse of America's Intelligence Agencies* (New York: Doubleday, 2004), James Bamford examines the fraudulent information Chalabi disseminated about Iraqi weapons before the invasion as well as the extent to which Miller and other journalists relied on him as a source. After the *Times* admitted its failures in reporting prior to the invasion, Miller's role was referenced in numerous press articles: see, for example, Tim Rutten, "*N.Y. Times*' Latest Misstep Is Also Its Greatest," *Los Angeles Times,* May 29, 2004, p. E1. For the *Times*' explanation of the Miller case, see Don Van Natta Jr. et al., "The Miller Case: A Notebook, a Cause, a Jail Cell, and a Deal," *New York Times,* Oct. 16, 2005, p. A1.

57. Murray Waas, "Cheney 'Authorized' Libby to Leak Classified Information," *National Journal Online,* Feb. 9, 2006, http://nationaljournal.com/about/njweekly/stories/2006/0209nj1.htm. The Bush administration's use of fabricated, distorted, and selective intelligence data to make the public case for war in Iraq has been covered extensively, after the fact, by the press and in books by former government officials. Most recently, Paul R. Pillar, who oversaw intelligence assessments about the Middle East for the CIA from 2000 to 2005, claimed that the administration ignored or distorted prewar evidence on a wide range of subjects related to Iraq in order to justify a decision to invade that had already been made by the administration not long after the 9/11 attacks (Paul Pillar, "Intelligence, Policy, and the War in Iraq," *Foreign Affairs* 85, no. 2 (March/April 2006): 15, available online at www.foreignaffairs.org/2006030 1faessay85202/paul-r-pillar/intelligence-policy-and-the-war-in-iraq.html. In an interview with the *New York Times,* Pillar said that he hoped the article would begin to repair the "broken" relationship between the intelligence that is produced and the ways political leaders use such information to advance policies (Scott Shane, "Ex-CIA Official Says Iraq Data Was Distorted," *New York Times,* Feb. 11, 2006, p. A6).

58. Joseph C. Wilson, "What I Didn't Find in Africa," *New York Times,* July 6, 2003, sec. 4, p. 9.

59. The journalistic lessons of the Miller saga were no less troubling than the story of syndicated newspaper columnist and seasoned television commentator Robert Novak. After more than two years of silence about his role in the Plame controversy, Novak admitted in July 2006 that presidential adviser Karl Rove had been a key anonymous source behind a 2003 Novak column in which the writer first identified Plame as a CIA agent (Robert Novak, "My Role in the Plame Leak Case," *Chicago Sun-Times,* July 14, 2006, p. A14). Novak also revealed that he had secretly cooperated with federal prosecutors seeking information on leaks to the press, in exchange for legal waivers (Howard Kurtz, "Novak Says He Named 3 Sources in Leak Case," *Washington Post,* July 12, 2006, p. A4).

The same week the Novak news broke, Plame and her husband filed a federal lawsuit against Vice President Dick Cheney, Karl Rove, and Libby, alleging that the White House had violated her civil rights and put her family in danger by using the press to reveal her identity as part of a campaign to undermine oppo-

nents of the war (Jerry Seper, "Plame, Husband Sue Cheney, Libby, Rove; Say CIA Leak Violated Their Rights," *Washington Times,* July 14, 2006, p. A6).

60. See, for example, "GM to Halt Ads in the *Los Angeles Times*," *New York Times,* April 8, 2005, p. C2. The daily circulation of the *Los Angeles Times* in 2005 was reportedly nine hundred thousand. Four months later, after the paper refused to recant its criticism, GM quietly announced that it would renew advertising in the *Times.* A GM spokesperson said that the two companies had "respectfully agreed to disagree on some of the issues" ("GM Ends Tiff with *LA Times*," *Automotive News,* Aug. 8, 2005, p. 54). The struggle to maintain professional standards at the *Los Angeles Times* led to more turmoil in late 2006, when conflict between the paper's cost-cutting owner, the Tribune Co., and its editor and publisher resulted in the dismissal of both men amid widespread staff protests. See Mary Wisniewski, "Trib Forces Out L.A. Editor," *Chicago Sun-Times,* Nov. 8, 2006, p. A69.

61. On stations that solicited payment for favorable coverage, see Lou Prato, "Punishing the Ethically Challenged," *American Journalism Review,* Sept. 1999, p. 86, which discusses the case of Fox affiliate WDSI in Chattanooga, the nation's eighty-seventh-largest market. Also see Joe Strupp, "With Revenue Still Flowing Slowly, Some Fear Temptation to Bend Pay-for-Play Rules May Rise," *Editor and Publisher,* Nov. 17, 2003, p. 6; in this case, the stations in question were WFLA in Tampa, Florida, and WLBT in Jackson, Mississippi.

On the fake "news conferences," see Ray Frager, "Fake News Event a Bit Bogus," *Baltimore Sun,* Nov. 11, 2005, p. F9; and David Bauder, "Blurring the Lines between Entertainment and News on *SportsCenter*," Associated Press, Nov. 7, 2005.

62. In the early 1990s, the *Miami Herald* began publishing press releases for corporate advertisers in order to boost ad revenues. The *Los Angeles Times* also began to consider the practice. See Doreen Carvajal, "Is It News, Ad, or Infomercial? The Line between News and Advertising Is Going, Going . . . ," *Fine-Line: The Newsletter for Journalism Ethics* 3, no. 4 (April 1991): 1–8; Jerry Walker, "*Miami Herald* Sells Space for PR Releases," *O'Dwyer's Newsletter,* Feb. 7, 1990, p. 3.

63. Steven Levingston, "Putting Their Names over the News: Banks' Sponsorships of Radio Newsrooms Raises Questions," *Washington Post,* Dec. 15, 2005, p. D5. Two radio stations in Madison, Wisconsin, owned by Clear Channel Communications, sold the naming rights to their newsrooms to a local bank, Pyramax, in 2005. This followed similar naming-rights sales at radio stations in Milwaukee and other cities in recent years.

64. James Bandler, "How Companies Pay TV Experts for On-Air Product Mentions; Plugs Come amid News Shows and Appear Impartial; Pacts Are Rarely Disclosed," *Wall Street Journal,* April 19, 2005, p. A1. Bandler's exposé focuses on three television journalists and product experts, including Corey Greenberg, the "Tech Editor" of NBC's *Today Show.* The article reports that Greenberg charges companies $15,000 per tour to get their products mentioned on local television news programs, according to his signed contracts, and that these clients include Sony, Hewlett-Packard, and Energizer Holdings.

65. Reed appeared nude with other participants in a public art installation.

She was asked by her producer to take part in the event and readily agreed. It took place in June 2004, but the station withheld airing the tape until November sweeps, when it promoted the segment frequently as a ratings grabber. The incident attracted national attention when the *New York Times* published an account by David Carr ("When a TV Talking Head Becomes a Talking Body," Nov. 25, 2004, p. E1). As Carr noted: "In local television news, the business end of the business begins and ends with four annual sweeps months, a time when the number of viewers will determine the price that can be charged for ads for the following quarter. The November sweeps month is one of the most important, and television stations spend much of the year looking for material they can promote." The station reportedly earned record high ratings that month. As for Reed, she was quoted as defending her decision to take off her clothes for ratings: "I'm in it to win," she said. "When did that become a crime?" ("Anchors Reed and Smith Stand behind Decisions," *Cleveland Plain Dealer*, Nov. 19, 2004, p. E3).

66. On the controversy over Priest's report, see Tim Rutten, "Reporting So Good . . . It's Criminal?" *Los Angeles Times*, April 22, 2006, p. E1.

Kevin Sites documented the story of the killing of the Iraqi prisoner and the reaction to it in a blog he compiled at www.kevinsites.com. He was eventually pulled from Iraq by NBC in the wake of the death threats, which came generally from right-wing groups in the blogosphere who considered his actions treasonous. For an especially good interview and an overview of the incident, see Alex Chadwick, "Kevin Sites Discusses the Marine Shooting Footage," *Day to Day*, National Public Radio, transcript, May 10, 2005, www.lexisnexis.com; audio available online at www.npr.org/templates/story/story.php?storyId=4646406.

67. See Fairness and Accuracy in Reporting, "Lifestyles of the Rich and Fatuous," April 1994, available online at www.fair.org/index.php?page=1227, which mentions Diane Sawyer, among others; and Michael Starr, "*Today* Payday Will Exceed $65M for NBC Katie," *New York Post*, Dec. 12, 2001, p. 9.

68. ESPN's Suzy Kolber, Kenny Mayne, and Chris Berman are only three examples of broadcasters who playacted in soft drink, insurance, airline, and car commercials in 2005 and 2006. In 1999, Dan Patrick appeared as a central performer in a multimillion-dollar television ad campaign by Coors beer, which also sponsors sporting events on ESPN and other networks. He came under fire for the ethical conflict from critics in the news media: see, for example, Phil Mushnick, "Beer and Loathing: ESPN Anchor Turns Suds Salesman," *New York Post*, July 18, 1999, p. 108. Patrick continues to participate in ads endorsing sports-related products, including national radio commercials for a sports ticketing brokerage house, Stubhub.com. Patrick's blurring of the line between journalism and product endorsements is an increasingly common practice at ESPN, a relentlessly self-promoting network where news, entertainment, and marketing are merged so tightly that the network's anchors and reporters frequently appear in ESPN commercials with the athletes they are supposed to be covering.

69. Joe Buck of Fox Sports, who broadcasts major league baseball, reportedly told advertisers at a trade association convention in Los Angeles in 2005 that he would happily hawk their products live during his telecasts (Chris Baker, "Fox Aids Airing of Stealth Auto Ad," *Washington Times*, July 20, 2005, p. C8).

Numerous television news anchors, reporters, and commentators have traded

on their fame to appear in acting roles as television journalists in Hollywood and television films, from Claire Shipman to Bryant Gumbel to Chris Matthews.

70. The number of players who have worked both sides of the street has increased markedly, including NBC correspondent Pete Williams (formerly a spokesperson for the Department of Defense), ABC correspondent George Stephanopoulos (formerly a White House aide and senior adviser to President Clinton), and magazine writer Sidney Blumenthal (formerly a *Washington Post* reporter before taking a job as a Clinton adviser). In 2006, longtime Fox News commentator and journalist Tony Snow became White House press secretary.

71. *Time* reporter Viveca Novak admitted in 2005 that she had secretly shared information with a lawyer for White House adviser Karl Rove concerning Rove's possible involvement in disclosing classified material before she conveyed this information to either her editors or readers. She took an extended leave of absence from the magazine after her contact with the lawyer was disclosed (David Johnston, "Reporter Recounts Talk about CIA Leak," *New York Times,* Dec. 12, 2005, p. A23). Similarly, in 2005, *Sports Illustrated* reporter Michael Bamberger, after observing a possible minor rules violation by teenage golf sensation Michele Wie during her first professional tournament, chose to inform on Wie to officials of the Ladies Professional Golf Association a day after the fact instead of reporting his observations and news to the general public (Dwayne Wickham, "Writer Should Have Reported Error to Readers, Not Golf Officials," Gannett News Service, Oct. 22, 2005).

72. The survey of fifteen hundred adults took place in the spring of 2005; detailed results are available online at www.annenbergpublicpolicycenter.org/ 6.13.05.pdf. Of those polled, 27 percent considered Rush Limbaugh a journalist, and 44 percent gave the title to Bill O'Reilly (cited in Howard Kurtz, "Who's a Journalist? It Depends," *Washington Post,* June 14, 2005, p. C4). In the *Post* article, Kathleen Hall Jamieson noted that the results offer "disturbing evidence that the public defines the word very differently from the way most journalists do." Limbaugh reacted by saying he was "not surprised" by the findings and claimed that it reflected public disenchantment with the performance of traditional media. He told the *Post,* "I am America's anchorman, doing news play-by-play 15 hours a week for nearly 17 years now, and this is just more evidence that the old media's monopoly-like dominance is finished. I think the 'mainstream' media should heed Ms. Jamieson's warning and seriously examine how they appear to their readers."

73. The revelations about James Guckert, also known as Jeff Gannon, were first disclosed by bloggers in January 2005 and eventually resulted in his resignation. See, for example, Johanna Neuman, "An Identity Crisis Unfolds in a Not-So-Elite Press Corps," *Los Angeles Times,* Feb. 25, 2005, p. A18; and Scott Shepard, "Jeff Gannon Back—at National Press Club?—Reporters Ponder: Who Is a Journalist?" Cox News Service, April 8, 2005.

74. James Fallows effectively addresses the ethical problems of elitism in contemporary journalism in *Breaking the News: How the Media Undermine American Democracy* (New York: Pantheon Books, 1996). More recently, in *Feet to the Fire: The Media after 9/11—Top Journalists Speak Out* (Amherst, N.Y.: Prometheus Books, 2005), a series of interviews with twenty-one reporters

about the failures of American journalism in the run-up to the Iraq war, volume editor Kristina Borjesson reveals that the few mainstream journalists who aggressively examined and questioned official evidence supporting the administration's decision to go to war were those who felt closer ties to the readers for whom they were writing than to the political establishment in Washington. The Washington bureau of the Knight Ridder news service, for example, which supplied news to numerous daily papers in its chain around the country, including those in military towns in Georgia, Texas, Kentucky, and South Carolina, was distinguished from other news organizations by its aggressive, probing style. "Unlike a lot of our competitors who write for the people who send other people to war," John Walcott, the Knight Ridder bureau chief told Borjesson, "we write for the people who get sent to war." The ethical problems involved in journalists' participation in off-the-record sessions with elites at retreats such as Davos have also been discussed in the media; see "Eason Jordan Resigns," *CNN Reliable Sources,* transcript, Feb. 13, 2005, available online at http://transcripts .cnn.com/TRANSCRIPTS/0502/13/rs.01.html.

75. In 2006, NBC's Katie Couric was hired to become the new CBS anchor, replacing Dan Rather. Her hiring was questioned by longtime CBS commentator Andy Rooney (Dusty Saunders, "Andy's Math Adds Up," *Rocky Mountain News,* Jan. 23, 2006, p. D2).

76. Novelist Michael Crichton won this award for his 2004 novel *State of Fear* (Cornelia Dean, "Truth? Fiction? Journalism? Award Goes to . . . ," *New York Times,* Feb. 9, 2006, p. A17).

77. See Renee Montagne, "Conspiracy Theories Find a Home on the Internet," *Morning Edition,* National Public Radio, August 9, 2006; audio available online at www.npr.org/templates/story/story.php?storyId=5629332. *Loose Change* may be viewed online; see http://video.google.com/videoplay?docid= 7866929448192753501&hl=en. DVDs are sold at http://loosechange911.com, the Web site of the video's maker, Dylan Avery. According to the site, the DVD will be sent free to "anybody who lost friends or family on September 11th, 2001."

78. The film *Mighty Times: The Children's March* was produced by two documentarians, Bobby Huston and Robert Hudson, whose staged scenes, fabricated newsreel style, and other questionable practices were harshly criticized by journalists and nonfiction filmmakers around the country after they received the Academy Award. See Irene Lacher, "Documentary Criticized for Re-Enacted Scenes," *New York Times,* March 29, 2005, p. E1; and Dick Hubert, "Shameful Oscar Honor for 'Fake' Documentary," *Television Week,* May 2, 2005, p. 12.

79. The columnist, Mike Barnicle, continues to write for the *Herald.* The scandal and his continued employment in the profession have been cited frequently in discussions about journalistic ethics; see, for example, Stan Simpson, "An Examination of Ethics," *Hartford Courant,* March 13, 2004, p. B1.

80. See chapter 2 for more about journalist Stephen Glass and the film *Shattered Glass.*

81. Benny Evangelista, "Free Speech Case Opens: Apple Tries to Track Source of Leak of New Design on Web," *San Francisco Chronicle,* March 5, 2005, p. C1. The bloggers lost the case in a lower trial court, but in May 2006

an appeals panel ruled that they were indeed protected by California's shield law, like other journalists from traditional media, and were not compelled to reveal their confidential sources. The panel concluded that the First Amendment equally protects Web sites and traditional media. Apple was expected to appeal.

82. Princeton political philosopher Robert George interestingly observes that Plato's *Gorgias* may hold especially relevant lessons about the inflated value of rhetoric, lessons that would seem to hold true for political punditry as well as journalism: "The explicit point of the dialogue is to demonstrate the superiority of philosophy (the quest for wisdom and truth) to rhetoric (the art of persuasion in the cause of victory). At a deeper level, it teaches that worldly honors that one may win by being a good speaker . . . can all too easily erode one's devotion to truth—a devotion that is critical to our integrity as persons. So rhetorical skills are dangerous, potentially soul-imperiling gifts" (quoted in David Brooks, "Harvard Bound? Chin Up," *New York Times,* March 26, 2006, p. A27).

83. A new academic project at the Annenberg School of Communications at the University of Southern California focuses on examining, analyzing, and compiling data on the conflicting images of journalism in American popular culture. The project covers topics ranging from mainstream Hollywood films and television commercials to the evolution of such imagery in popular magazine and newspaper cartoons. Information on the project is available online at www .ijpc.org.

84. In addition to Judith Miller of the *New York Times* and Matthew Cooper of *Time,* who were threatened with jail time on contempt charges for refusing to divulge the names of sources in the Valerie Plame case, numerous other journalists in recent years have faced similar charges. Several reporters were held for contempt in connection with a case brought against the press by scientist Wen Ho Lee, who had been wrongfully accused of espionage at the Los Alamos nuclear laboratory. Another reporter for a television station in Rhode Island served four months after refusing to name sources he used for a story about political corruption in Providence. In addition, encouraged by the growing judicial skepticism over special protections claimed by reporters, police and prosecutors feel increasingly emboldened to pressure journalists by subpoenaing their phone records, notebooks, and tape recordings, long considered off limits to official prying. In June 2005, when the U.S. Supreme Court declined to hear appeals by Miller and Cooper in their contempt cases, making jail time more likely, Jane Kirtley, a professor specializing in media ethics at the University of Minnesota, observed: "We're seeing outright contempt for an independent press in a free society. The fact that courts have no appreciation for this is new, is troubling, and you cannot overestimate the impact it will have over time" (Adam Liptak, "Court Declines to Rule on Case of Reporters' Refusal to Testify," *New York Times,* June 28, 2005, p. A1).

85. Adam Liptak, "*Time* Inc. to Yield Files on Sources, Relenting to U.S.," *New York Times,* July 1, 2005, p. A1. Among the many critics of *Time*'s decision quoted in the article was David Halberstam, author of *The Powers That Be* (New York: Knopf, 1979), which examines the history and evolution of major American media organizations, including *Time* Inc. Halberstam reportedly said: "It is very disturbing. It is a strange company and it is a different company now,

and it is really part of an entertainment complex. The journalism part is smaller and smaller. There is a great question out there: Is this a journalistic company, or an entertainment company?"

Another signpost of the moral ambiguity in contemporary journalism was symbolized by one of the anonymous sources involved in the Plame case, a source whose identity at least one reporter had sworn to protect. Far from being a whistle-blower or a courageous government insider protesting official wrong-doing, the figure protected by the journalist was presidential adviser Karl Rove, who acknowledged to federal prosecutors that he communicated with *Time's* Matthew Cooper by phone and e-mail on a background basis about the story. Whereas Mark Felt, the Deep Throat source, strove to reveal scandal in the Nixon White House in the 1970s and received sworn pledges from journalists to protect his identity, Rove attempted to claim the same honorable arrangement to do everything he could to advance the political agenda of the Bush White House.

86. The *Plain Dealer's* decision to withhold the two investigative articles was first revealed in a column written by the paper's editor, Doug Clifton, objecting to court pressures in the Miller and Cooper cases. In a later interview with the *New York Times,* Clifton called the articles "profoundly important" and noted that they "would have been of significant interest to the public." He said that the reporters were willing to risk jail if the stories were published, but that the paper's lawyers had told him, "This is a super, super high-risk endeavor and you would, you know, you'd lose. The reporters say 'well, we're willing to go to jail,' and I'm willing to go to jail if it gets laid on me, but the newspaper isn't willing to go to jail." See also Mark Fitzgerald, *"Plain Dealer:* 'We're Hiding Big Stories Because of Fear of Jail,' " *Editor and Publisher,* July 8, 2005, available in the *Editor and Publisher* fee-based online archives at www.editorandpublisher .com/eandp/search/article_display.jsp?vnu_content_id=1000976374.

While editors at many newspapers questioned and disapproved of the *Plain Dealer's* decision not to publish, a few expressed concern that the new cautious-ness of some news media could be related to the circumstances of their owner-ship. With the news media so increasingly consolidated and encompassing a broad range of print and electronic holdings, many companies possess broadcast and cable systems that are licensed by the government. As a result, they may be less inclined to stand up to government pressure on news gathering since they are dependent on government's good graces for the right to operate. See David Cay Johnston, "Most Editors Say They'd Publish Articles Based on Leaks," *New York Times,* July 11, 2005, p. C3.

87. Aristotle's view about education of the young, that "there is nothing that is more needful to learn and become habituated to than to judge correctly and delight in virtuous characters and noble action," certainly holds true as much for journalism as for any field of study (*The Politics* [Chicago: University of Chicago Press, 1984], p. 236). The exemplary works of journalism cited here include Lincoln Steffens, *The Shame of the Cities* (New York: McClure, Philips, 1904); and John Hersey, *Hiroshima* (New York: Knopf, 1985), which was originally published in 1946. Ernie Pyle's classic 1943 newspaper article "The Death of Captain Wachow," reported from the front lines in Italy and published by the Scripps

Howard chain, was reprinted in James Tobin, *Ernie Pyle's War: America's Witness to World War II* (Lawrence: University of Kansas Press, 1997), pp. 134–37.

2. FREAK SHOW

1. Don Barry, David Barstow, Jonathan D. Glater, Adam Liptak, and Jacques Steinberg, "Correcting the Record: *Times* Reporter Who Resigned Leaves Long Trail of Deception," *New York Times,* May 11, 2003, p. A1

2. Ibid.

3. Roger Clegg, "Blairingly Obvious," *National Review Online,* May 19, 2003, www.nationalreview.com/clegg/cleggo51903.asp; Tim Chavez, "Diversity Push Must Be Revamped for Good of All," *Nashville Tennessean,* May 18, 2003, p. A20.

4. *Buchanan and Press,* MSNBC, transcript, May 15, 2003, www.lexis nexis.com.

5. Williams was one of a number of commentators who were paid considerable fees under government- and Republican Party–financed contracts to disseminate positive information about the White House's No Child Left Behind education policies. See William Powers, "Make 'Em Pay," *National Journal,* Jan. 15, 2005, p. 15; and Jonathan Adler, "D.C. Payola," *National Review Online,* Jan. 28, 2005, www.nationalreview.com/adler/adler200501280805.asp.

6. William Kristol, "America's Next Great Newspaper," Editorial, *Weekly Standard* 8, no. 36 (May 26, 2003), available online at www.weeklystandard .com/Content/Public/Articles/000/000/002/685ikxze.asp.

7. "The *New York Times*, PETA, and Yale," Scrapbook, *Weekly Standard* 8, no. 34 (May 12, 2003), available online at www.weeklystandard.com/ content/protected/articles/000/000/002/625cnjok.asp.

8. Stephen Haycox, "Striking Blows against Truth," *Anchorage Daily News,* May 23, 2003, p. B6.

9. William McGowan, *Coloring the News: How Crusading for Diversity Has Corrupted American Journalism* (San Francisco: Encounter Books, 2001), reissued as *Coloring the News: How Political Correctness Has Corrupted American Journalism* (San Francisco: Encounter Books, 2003); William McGowan, *Gray Lady Down: Jayson Blair and How the* New York Times *Lost Touch with America* (New York: Encounter Books, 2006); Seth Mnookin, *Hard News: The Scandals at the* New York Times *and Their Meaning for American Media* (New York: Random House, 2004); Jayson Blair, *Burning Down My Masters' House: My Life at the* New York Times (Beverly Hills: New Millennium, 2004).

10. For a fine examination of post–Jayson Blair ethical scandals involving fabrication and plagiarism at newspapers in Texas and elsewhere, see S. C. Gwynne, "Behind the Lines: Mea Culpa," *Texas Monthly,* June 2004, p. 10.

11. Blake Morrison, "Ex–*USA Today* Reporter Faked Major Stories," *USA Today,* March 19, 2004, p. A1.

12. David Brock's writings include "The Real Anita Hill," *American Spectator,* March 1992, pp. 18–21; *The Real Anita Hill: The Untold Story* (New York: Free Press, 1993); and *Blinded by the Right: The Conscience of an Ex-Conservative* (New York: Crown, 2002).

13. "To Our Readers," *New Republic,* June 1, 1998, p. 9; Ann Reilly Dowd, "The Great Pretender: How a Writer Fooled His Readers," *Columbia Journalism Review,* July/Aug. 1998, p. 14.

14. The May 26, 2003, *Newsweek* cover photograph showed Blair staring into the camera, dragging on a cigarette, under a headline reading "The Secret Life of Jayson Blair." The photograph was taken during an interview with Blair in a Manhattan apartment. Interestingly, the photo was shot by another recently fallen *New York Times* journalist, photographer Edward Keating. Several months earlier, in October 2002, Keating had been forced to resign from the *Times* amid charges that he had staged a provocative news photograph that had been published in the *Times* and other newspapers in the *Times* wire service in September 2002. The photo showed a six-year-old boy aiming a toy pistol as he stood next to a sign reading "Arabian Foods" outside a store in a suburb of Buffalo, N.Y. It accompanied an article about alleged Arab American terrorists operating in a Buffalo cell in support of al-Qaeda. Other news photographers contacted the *Times* to protest the staging, as did Arab American readers, who felt that the episode reinforced the stereotype that Arabs teach violence to their children. See James T. Madore, "*NY Times* Photographer Staged News Picture," *Newsday,* Oct. 22, 2002, p. A49.

15. Barry et al., "Correcting the Record."

16. Cited in Jonathan Peter Spiro, "Patrician Racist: The Evolution of Madison Grant" (PhD diss., University of California at Berkeley, Department of History, 2000).

17. Edwin Black, *War against the Weak: Eugenics and America's Campaign to Create a Master Race* (New York: Four Walls Eight Windows, 2003); extracted in "Hitler's Debt to America," *Guardian,* Feb. 6, 2004, p. 8, available online at www.guardian.co.uk/g2/story/0,3604,1142027,00.html.

18. Wilson's words are quoted on the screen at the beginning of most prints of the silent film. No one, however, seems to know the exact source for the quote, which is mentioned in nearly every discussion of the film and its impact on the history of American cinema. See, for example, Roger Ebert, "Birth of a Controversy," *Chicago Sun-Times,* March 30, 2003, p. 4.

19. Richard Wright, *Black Boy (American Hunger): A Record of Childhood and Youth* (1944; New York: Perennial Classics, 1998), p. 131.

20. Chicago Commission on Race Relations, *The Negro in Chicago: A Study of Race Relations and a Race Riot* (Chicago: University of Chicago Press, 1922). The study is divided into eleven chapters focusing on topics such as the origins of the riot, the problems of housing for the city's black population, competition between blacks and whites for jobs, and the increasing contacts between the races in public spaces. Chapters 9 and 10, devoted to the topic of public opinion in race relations, discuss the performance and prejudices of the city's newspapers.

21. Ibid., pp. 27, 28, 30.

22. Ibid., p. 31.

23. Ibid., pp. 436, 520.

24. William M. Tuttle Jr., *Race Riot: Chicago in the Red Summer of 1919* (New York: Atheneum, 1970), p. 104. Tuttle's book, considered the definitive ac-

count of the Chicago race riot, features excellent background on the role newspapers played in forming and perpetuating racial stereotypes that helped to exacerbate tensions before and during the days of violence.

25. Mark Bauerlein, *Negrophobia: A Race Riot in Atlanta, 1906* (New York: Encounter Books, 2001). Bauerlein's book offers numerous examples of the Atlanta press hysteria directed against blacks, including reprints of front pages and articles from the period.

26. In 1999, the *Washington Post* featured a front-page story about the deadly 1919 riot that examined the role of the newspapers (Peter Perl, "In the Riot of 1919, a Glimpse of Struggles to Come," *Washington Post,* March 1, 1999, p. A1). See also Chalmers Roberts, *The* Washington Post: *The First 100 Years* (Boston: Houghton Mifflin, 1977), which describes the *Post's* coverage of the 1919 race riot as "shamefully irresponsible."

27. James S. Hirsch, *Riot and Remembrance: The Tulsa Race War and Its Legacy* (Boston: Houghton Mifflin, 2001), p. 92. Among the most fascinating and disturbing aspects of the riot is how the city of Tulsa took steps to erase the horror from its history and collective memory. Hirsch's remarkable narrative describes the omission of the riot from Tulsa and Oklahoma state history schoolbooks, official histories, public records, and newspaper archives. He points out that although recollections of the riot specifically mentioned the *Tribune* editorial as the key spark, no copy of it could be found in any archive, and the page on which it was published has been removed from all surviving copies of the newspaper. Many white Tulsans apparently felt that it was in the city's interest to erase the riot from history, pointing to it as a dreadful time when many "new Negroes" under the spell of activists like W. E. B. Du Bois tried to take over their city. (Du Bois at the time was the leader of the National Association for the Advancement of Colored People, the NAACP.) Blacks recalled it as the time when whites destroyed their community. Whites feared another uprising; blacks feared another attack. Thus both the city and the state simply attempted to forget the past, according to Hirsch, at least until the 1990s, when national debates arose over reparations for blacks for centuries of slavery, racial segregation, and other wrongs. In 2005, a civil suit against Tulsa and the state of Oklahoma by black survivors seeking damages from the catastrophe was dismissed by the U.S. Supreme Court. The decision left intact a lower U.S. Circuit Court of Appeals ruling that blocked a suit because the statute of limitations had run out (Jim Myers, "Tulsa Race Riot: High Court Rejects Riot Case," *Tulsa World,* May 17, 2005, p. A1).

28. Cited in Richard Wormser, *The Rise and Fall of Jim Crow* (New York: St. Martin's Press, 2004). The riots across America during the Red Summer of 1919 typically involved mobs of whites attacking blacks, but they also featured a consistent pattern of blacks fighting back to protect their lives and homes against the terror. In Chicago, Washington, and Tulsa, in particular, black residents armed themselves and fired back in the face of the onslaught. In a 1963 PhD dissertation on the Washington riot, in which he interviewed survivors, sociologist Arthur Waskow wrote that the experience gave black citizens in Washington, D.C., and elsewhere a new self-respect and "a readiness to face white society as equals. . . . The Washington riot demonstrated that neither the silent

mass of 'alley Negroes' nor the articulate leaders of the Negro community could be counted on to knuckle under" (cited in Peter Perl, "Nation's Capital Held at Mercy of the Mob," *Washington Post Sunday Magazine*, July 16, 1989, p. W19).

In addition, black publications of the era reported on the newfound pride African Americans felt over the black community's response to the riots. A letter to the editor published in *The Crisis*, the journal of the NAACP, from a writer describing herself as a "Southern black woman" read: "The Washington riot gave me a thrill that comes once in a life time . . . at last our men had stood up like men. . . . I stood up alone in my room . . . and exclaimed aloud, 'Oh I thank God, thank God.' The pent up horror, grief and humiliation of a life time—half a century—was being stripped from me" (cited in Wormser, *Rise and Fall of Jim Crow*, pp. 127–128). While the white press reflected fear and loathing for the image of the "new" Negro in American society, the black press welcomed it widely as a replacement for old and degrading stereotypes.

29. Cited in John D. Stevens, "The Black Press Looks at 1920s Journalism," *Journalism History*, Autumn-Winter 1980, pp. 111, 110.

30. Maurine Beasley, "The Muckrakers and Lynching: A Case Study in Racism," *Journalism History*, Autumn-Winter 1982, pp. 87, 89. Beasley notes that one exception was the muckraker Ray Stannard Baker, a leading journalist who had exposed corruption among railroad executives and labor leaders for *McClure's* before turning his attention to reporting and writing two articles on lynching in 1905. He was, Beasley writes, the only muckraker to write a comprehensive account of the crime: "While he didn't defend lynching, neither did he picture it for what it was—a racist way of keeping blacks 'in their place.' Instead he depicted it as the reflection of an evil political system arisen in response to failure of 'good citizens' to ensure that courts moved swiftly against criminal offenders. . . . It would be unfair to judge Baker a bigot for failing to transcend the assumptions of his era. Even in his endorsement of segregation, as a temporary measure to quiet racial strife, Baker continued to advocate first-class citizenship for blacks as a long-range goal" (pp. 89–90).

No muckraker investigated and decried lynching as consistently and fearlessly as Ida B. Wells, the Memphis-based African American editor and writer who crusaded against the crime in the 1890s. See Jacqueline Jones Royster and Ida B. Wells, *Southern Horrors and Other Writings: The Anti-Lynching Campaign of Ida B. Wells, 1892–1900* (New York: Bedford/St. Martin's, 1996).

31. Many texts cover the general history of the press; see, for example, W. David Sloan and Lisa Mullikin Parcell, eds., *American Journalism: History, Principles, and Practices* (Jefferson, N.C.: MacFarland, 2002), pp. 44–51.

The finest, most insightful, and most comprehensive treatment of the evolution of modern press standards and practices, including balance, fairness, objectivity, and other values—and the factors motivating many of the advances—remains Michael Schudson's *Discovering the News: A Social History of American Newspapers* (New York: Basic Books, 1978).

32. As Carolyn Martindale and Lillian Rae Dunlap write:

Studies of white newspaper coverage of African Americans before 1934 showed that the press provided almost no coverage of blacks, except for black crime news. One study of news about blacks in the Philadelphia press between 1908 and 1932 found

that coverage of African Americans constituted only 2 percent of the papers' news space, and between 50 and 75 percent of that coverage was devoted to black crime. Another study of coverage of blacks in seventeen major papers around the nation in 1928 and 1929 found that 47 percent of the news concerned antisocial behavior; the coverage emphasized the bizarre and pathological in black life. . . . A 1931 study of news about blacks in the Southern press found that the newspapers examined expressed no objections to the lynchings of blacks ("The African Americans," in *U.S. News Coverage of Racial Minorities: A Sourcebook, 1934–1996*, ed. Beverly Ann Deepe Keever, Carolyn Martindale, and Mary Ann Weston [Westport, Conn.: Greenwood, 1997], p. 71).

33. National Advisory Commission on Civil Disorders (Kerner Commission), *Report of the National Advisory Commission on Civil Disorders, New York Times* ed. (New York: Dutton, 1968), p. 483.

34. Ibid., p. 389.

35. Martindale and Dunlap, "African Americans," pp. 81–82.

36. Daniels is described in positive terms in Frank Luther Mott, *American Journalism: A History, 1690–1960* (New York: Macmillan, 1962), p. 576; cited in W. Joseph Campbell, " 'One of the Fine Figures of American Journalism': A Closer Look at Josephus Daniels of the *Raleigh News and Observer*," *American Journalism* 16, no. 4 (Fall 1999): 37–55.

37. Campbell, " 'One of the Fine Figures,' " pp. 43, 42.

38. Helen G. Edmonds, *The Negro and Fusion Politics in North Carolina, 1894–1901* (Chapel Hill: University of North Carolina Press, 2003), p. 141; cited in Campbell, " 'One of the Fine Figures,' " p. 42.

39. Campbell, " 'One of the Fine Figures,' " p. 45.

40. Ibid., p. 44.

41. As citizens of both Rosewood, Florida, and Tulsa did in the 1990s, the people of Wilmington in 2005 finally confronted the devastation wrought by press-fueled aggression against black people by examining the destruction of the city's black community and leadership that had occurred in 1898. The state-commissioned, five-hundred-page study officially determined that the rioting that year had amounted to a coup by powerful whites, leading to generations of racial injustice that the state has yet to overcome (John DeSantis, "North Carolina City Confronts Its Past in Report on White Vigilantes," *New York Times,* Dec. 19, 2005, p. A19). The *Times* story and a subsequent opinion article by columnist Brent Staples resulted in a fascinating letter to the editor from Daniel L. Evans of Cambridge, Mass., which was published in the *Times* on Jan. 8, 2006. Evans wrote:

> Coming so close to Martin Luther King's Birthday and Black History Month in February, Mr. Staples's article, I'm sure, will provoke responses like one I heard from a well-meaning associate some years ago: "African-Americans should look less in the rear-view mirror and more through the windshield. Dwelling on that ugly stuff in your past isn't good for you and your children and is especially unpleasant for those of us whose ancestors weren't here when it happened."
>
> My response to him was that immigrants (like all of us) covet the great promise of this country, but we cannot have the bounty of the present and the future without the "baggage" of the past. Imagine suggesting to some citizens that the Bill of Rights didn't apply to them because their ancestors weren't in the United States when the Constitution was adopted.

42. See Joseph L. Morrison, *Josephus Daniels: The Small-d Democrat* (Chapel Hill: University of North Carolina Press, 1966).

43. Campbell, " 'One of the Fine Figures,' " p. 48.

44. Keever, Martindale, and Weston, *U.S. News Coverage of Racial Minorities,* p. 345.

45. Janet Cooke, "Jimmy's World: 8-Year-Old Heroin Addict Lives for a Fix," *Washington Post,* Sept. 28, 1980, p. A1. On the *Washington Post's* internal investigation of the Cooke scandal, see Bill Green, "The Players: It Wasn't a Game," *Washington Post,* April 19, 1981, p. A12.

46. Stephen Glass, "Monica Sells," *New Republic,* April 13, 1998, p. 11. Also see Dowd, "The Great Pretender," p. 14.

47. Karen MacPherson, "Shattered Illusions: Glass Ex-Colleagues Thought His Deceptions Were Obvious," *Pittsburgh Post-Gazette,* Nov. 22, 2003, pp. C8, C12.

48. Morrison, "Ex–*USA Today* Reporter," p. A1.

49. John Gorenfeld, "Blood-Thirsty Arabs, Vigilante Jews," Salon.com, March 30, 2004, available online at http://dir.salon.com/story/news/feature /2004/03/23/jack_kelley/index.html. This fine piece was reprinted in several newspapers; see, for example, "Journalistic Sins of Commission," *Pittsburgh Post-Gazette,* April 4, 2004, p. E1.

50. Ibid.

51. Ibid.

52. In the *Post* investigation of the Janet Cooke scandal, reporters cited the "holy shit" factor as part of the pressure on *Post* journalists to produce extraordinary work. The idea was to report and write stories so fabulous and newsworthy that they would prompt readers of the morning paper to look up from their coffee and exclaim, "Holy shit!" (Green, "The Players," p. A12).

53. David Wiegand, "After Getting Fired by the *New York Times* for Lying in Print, a Reporter Stumbled on the Story of His Life," *San Francisco Chronicle,* June 11, 2005, p. E1. The interview with Finkel coincided with a book tour by the fallen journalist. His book, *True Story: Murder, Memoir, Mea Culpa* (New York: HarperCollins, 2005), is a rumination on his fall, coupled with an investigation of a bizarre incident that happened in the wake of the scandal. An Oregon man who had killed his wife and three young children assumed Finkel's name and pretended to be a reporter for the *New York Times* in Mexico. After the man's arrest and conviction, Finkel got in touch with him. His account of the man's life, and his own, and their relationship, forms the basis of the book. Finkel's story and apparent resurrection attracted coverage by CBS's *48 Hours* and by National Public Radio, and he sold the rights to the book for $500,000 to a production company owned by actor Brad Pitt. "America might be the land of second chances, but it ain't the land of third chances," Finkel told the *Chronicle.* "I am guaranteeing you that if you see my byline on a story, it's going to be the cleanest story you've ever read."

With varying degrees of success, other fabricators have also cashed in on their ignominy. Glass penned a novel based on his experiences, *The Fabulist,* and saw his story made into the film *Shattered Glass.* Janet Cooke, too, eventually profited, though it took many years. After her scandal in 1981, she sold the rights to

her story in 1996 for $1.6 million, which she shared with writer and former lover Mike Sager, whose cover story about her rise and fall appeared that year in *Gentlemen's Quarterly* magazine The story revealed that Cooke had fled to France after her journalistic ruin, where she lived for several years. By 1996, when Sager rediscovered her, she was working for subsistence wages as a department store sales clerk in Kalamazoo, Michigan.

54. Jack Shafer, "Press Box: The Fabulous Fabulists," *Slate,* June 12, 2003, available online at www.slate.com/id/2084316.

55. Cited in "Shame on Us," Editorial, *Los Angeles Times,* Jan. 14, 2005, p. B10.

56. Ibid.

57. In June 2003, the U.S. Supreme Court, supported by briefs from numerous companies in private industry, including the news media, issued a ruling upholding the right of universities to factor race into admissions decisions with the aim of improving diversity and career chances for minorities. But the Court also cautioned that such affirmative action programs would likely not be needed after twenty-five years or so. The justices believe that by then the nation effectively will have become "color blind" as a result of better race relations and equal access to schooling and jobs.

58. Some interesting mottoes are listed in "Motto a Go-Go," *American Journalism Review,* April 2000.

59. Media scholars and political activists have long scrutinized press self-censorship and its effects on democracy. One of the most sustained examinations has been conducted by Project Censored, which publishes an annual compilation of issues and news stories that the mainstream press has avoided. The project's authors are a collection of political activists, educators, journalists, students, and other citizens working for a nonprofit organization associated with the Department of Sociology at Sonoma State University in California. The project focuses especially on what it considers sins of omission by the corporate media. As Peter Phillips and Project Censored declared in the preface of the 2003 compilation:

> Freedom of information is in crisis in the United States. Big media no longer values news as vital to the democratic process. Instead, the media giants release news as guileful information designed to build governmental-protective dependency and consumptive behaviors. Corporate media in the U.S.—interlocked with capitalism's core—spews top-down propaganda interwoven with titillation, gossip and emotion. . . . Real news stories that challenge the powerful are repressed or spun to fit the dominant ideological frame. News stories that speak to collective social concerns . . . find little space in the bylines of the dailies or the timelines of the broadcast domains (*Censored 2003: The Top 25 Censored Stories* [New York: Seven Stories Press, 2002], p. 11).

Some of the top twenty-five self-censored stories in 2003—omissions motivated by profit or political interests, the authors charge—included a range of reports concerning the environment, the poor, and labor, some of which appeared in the alternative press, but all of which were ignored by big media: "Large U.S. Temp Company Undermines Union Jobs and Mistreats Workers," "NAFTA Destroys Farming Communities in U.S. and Abroad," "Corporations Promote HMO Model for School Districts," and "U.S. Policies in Colombia Support Mass Murder," among others.

Journalists working for the mainstream media report that self-censorship and intentional ignoring of news stories is a growing concern in the workplace, according to a 2000 survey of three hundred journalists conducted jointly by the Pew Research Center and the *Columbia Journalism Review:*

> Self-censorship is commonplace in the news media today. About one-quarter of the local and national journalists say they have purposely avoided newsworthy stories, while nearly as many acknowledge they have softened the tone of stories to benefit the interests of their news organizations. Fully four-in-ten (41%) admit they have engaged in either or both of these practices. . . . The poll of 206 reporters and 81 news executives—150 from local news outlets and 137 from national news organizations—found widespread concern over commercial and competitive pressures. As a result of these pressures, say journalists, good stories all too frequently are not pursued. . . . The survey provides considerable evidence that at least for some journalists, there has been an unmistakable intrusion of commercial interests into newsroom decisions. For instance, about one-in-five local (20%) and national (17%) reporters say they have faced criticism or pressure from their bosses after producing or writing a piece that was seen as damaging to their company's financial interests ("Self Censorship: How Often and Why—Journalists Avoiding the News," Pew Research Center in association with *Columbia Journalism Review,* April 30, 2000, available online at http://people-press.org/reports/display.php3?ReportID=39).

In addition, a well-maintained and comprehensive library of articles and surveys about press censorship and other timely issues concerning the media and democratic society can be found at the Web site of Free Press (www.freepress .net), a nonpartisan organization working to increase "informed public participation in media policy debates."

60. Linda Blackford and Linda Minch, "Front-Page News, Back-Page Coverage," *Lexington Herald-Leader,* July 4, 2004, p. A1.

61. See John Carroll, "Pseudo-Journalists Betray the Public Trust," *Los Angeles Times,* May 16, 2004, p. M1. This article was adapted from Carroll's speech at the University of Oregon earlier that month.

62. Barbara Bedway, "Late, But Not Lost," *Editor and Publisher Online,* Aug. 1, 2004, www.editorandpublisher.com/eandp/article_brief/eandp/1/1000586489.

63. Blackford and Minch, "Front-Page News," p. A8.

64. Ibid.

65. Ibid., p. A9.

66. Ibid. Phelps was originally quoted in George Wright, *A History of Blacks in Kentucky* (Lexington: University of Kentucky Press, 1992).

67. Blackford and Minch, "Front-Page News," p. A9.

68. Ibid.

69. Ibid., p. A9.

70. James Dao, "40 Years Later, Civil Rights Makes Page One," *New York Times,* July 9, 2004, p. A1; Michele Norris, "Marilyn Thompson Discusses Her Decision to Apologize for the *Lexington Herald-Leader*'s Failure to Cover the Civil Rights Movement in the 1960s," *All Things Considered,* National Public Radio, transcript, July 5, 2004; audio available online at www.npr.org/templates/story/story.php?storyId=3147027.

71. "Error of Our Old Ways," Editorial, *Lexington Herald-Leader,* July 11, 2004, p. F1.

72. Bedway, "Late, But Not Lost."

73. "Alabama Paper Publishes Civil Rights Photos," Associated Press, Feb. 27, 2006; "Editorial: Of Regrets," *Waco Tribune-Herald,* May 14, 2006, p. A1; Patrick Dorsey and Bob Gabordi, "50 Years Coming: Our Apology," *Tallahassee Democrat,* May 21, 2006, p. A1.

74. David Halberstam, *The Powers That Be* (New York: Knopf, 1979), pp. 447–449.

75. James Risen and Eric Lichtblau, "Bush Lets U.S. Spy on Callers without Courts," *New York Times,* Dec. 16, 2005, p. A1; James Risen, *State of War: The Secret History of the CIA and the Bush Administration* (New York: Free Press, 2006).

76. Byron Calame, "Beyond the Eavesdropping Story, a Loud Silence," *New York Times,* Jan. 1, 2006, sec. 4, p. 8.

77. Byron Calame, "Eavesdropping and the Election: An Answer on the Question of Timing," *New York Times,* Aug. 13, 2006, sec. 4, p. A10.

78. "Scott McClellan Holds White House Regular News Briefing," *Congressional Quarterly,* transcript, Feb. 14, 2006, www.lexisnexis.com.

79. CBS admitted in its initial report that it had withheld the Abu Ghraib story at the request of administration officials. The report included the following tagline, read by Dan Rather, who reported the story:

> A postscript. Two weeks ago, we received an appeal from the Defense Department, and eventually from the chairman of the military Joint Chiefs of Staff, General Richard Myers, to delay this broadcast given the danger and tension on the ground in Iraq. We decided to honor that request while pressing for the Defense Department to add its perspective to the incidents at Abu Ghraib Prison. This week, with the photos beginning to circulate elsewhere and with other journalists about to publish their versions of the story, the Defense Department agreed to cooperate in our report ("Court Martial in Iraq; US Army Soldiers Face Court Martials for Actions at Baghdad's Abu Ghraib Prison," *60 Minutes II,* transcript, CBS TV, April 28, 2004).

The self-censoring by CBS was covered in various press outlets. See, for example, Eric Boehlert, "Reality Check: The Media Are Finally Showing the War in Its Full Horror; What Took Them So Long?" Salon.com, May 6, 2004, available online at http://dir.salon.com/story/news/feature/2004/05/06/images/index .html; and David Peterson, "Self Censorship and Torture: Abu Ghraib, CBS, and American Power," *Counterpunch,* May 4, 2004, available online at www.counterpunch.org/peterson05042004.html. Interestingly, the Abu Ghraib story also points up the hesitancy of many American news organizations to shine the light of reality on the full nature and toll of human conflict. In the first days after the CBS report, most newspapers declined to publish many of the most offensive photos of torture and abuse, citing reader sensibilities. Indeed, such patterns of self-censorship in wartime reflect long traditions in the American press but represent something of an anachronism in a modern age in which the full reality of war's horror can be found on the Web in the form of videos of executions of prisoners, for example, by Islamic terrorists. This topic is examined by Neil Henry in "Picture Power: The Image of Wartime in the Digital Age," *Notre Dame Journal of Law, Ethics, and Public Policy* 19, no. 2 (2005): 475–486.

80. See Eric Lichtblau and James Risen, "Bank Data Sifted in Secret by U.S.

to Block Terror," *New York Times,* June 23, 2006, p. A1; Peter Baker, "Surveillance Disclosure Denounced," *Washington Post,* June 27, 2006, p. A1; Editorial, "What a Free Press Does," *Baltimore Sun,* June 28, 2006, p. B6.

81. *New York Times,* Oct. 20, 1862; cited in William A. Frassanito, *Antietam: The Photographic Legacy of America's Most Bloody Day* (New York: Scribner, 1978), pp. 14–19. (For an extensive collection of Brady's war photographs, see George E. Sullivan, *In the Wake of Battle: The Civil War Images of Mathew Brady* [New York: Prestel Books, 2004].)

82. The U.S. government's ability to completely control imagery has been highly elusive in the Iraq war and the war against terror, as Islamic terrorists in Afghanistan, Iraq, Pakistan, and elsewhere have proven repeatedly. Time and again, these extremists have turned to imagery and the Internet to document their violence, including the beheading of hostages, in order to instill fear and revulsion in Americans and other Westerners who might otherwise be shielded from the barbarism of war by the mainstream press.

83. "Worldwide Interest in Coffin Photo Was Surprising, Gratifying," *Seattle Times,* May 2, 2004, p. A2.

84. Stephen Lemons, "No Gays or Abortions Allowed in My Newspapers!" Salon.com, March 20, 2000, available online at http://archive.salon.com/people/feature/2000/03/20/weyrich/index.html.

85. Sally Ann Connell, "Resignations Rock Newspapers: Editors and Writers Quit after Owners Refuse to Run Positive News on Gays or Abortion," *Los Angeles Times,* Feb. 25, 2000, p. A3.

86. Lemons, "No Gays or Abortions."

87. Connell, "Resignations Rock Newspapers."

88. Herman B. Chiu, "Power of the Press: How Newspapers in Four Communities Erased Thousands of Chinese from Oregon History," *American Journalism* 16, no. 1 (Winter 1999): 59–77.

89. Marilyn Chase, *The Barbary Plague: The Black Death in Victorian San Francisco* (New York: Random House, 2004). The coverage of the epidemic by the *Chronicle,* the *San Francisco Examiner,* the *San Francisco Call,* the *Sacramento Bee,* and other newspapers forms a significant part of Chase's narrative.

90. Monica B. Morris, "Newspapers and the New Feminists: Black Out as Social Control?" *Journalism Quarterly* 50 (Spring 1973): 42.

91. Gwen Knapp, "A Big Confession: I Lied about Bonds," *San Francisco Chronicle,* Feb. 24, 2005, p. D1. Knapp's comments were echoed by several other sportswriters, who also criticized the nation's press for sins of omission in covering baseball in the 1990s; see, for example, Brian Burwell, "McGwire's Shrinking Credibility Takes a Beating," *St. Louis Post-Dispatch,* March 18, 2005, p. C1. Burwell calls the 1998 home run chase between Sosa and McGwire baseball's "fraudulent summer of love," and the press "its embarrassingly romantic protectors."

92. Jacques Steinberg, "*Times* Should Lose Pulitzer from 30s, Consultant Says," *New York Times,* Oct. 23, 2003, p. A29. The *Times* had hired a Columbia University Russian history professor, Mark von Hagen, in 2003 to examine Duranty's work from the 1930s. He concluded that Duranty's coverage was a "dull and largely uncritical recitation of Soviet sources" and that the "lack of bal-

ance and uncritical acceptance of the Soviet self-justification for its cruel and wasteful regime was a disservice to . . . American readers" (cited in Steinberg, "*Times* Should Lose Pulitzer"). Duranty's omissions as a foreign correspondent were first widely reported in Sally Taylor's book *Stalin's Apologist: Walter Duranty, the* New York Times *Man in Moscow* (New York: Oxford University Press, 1990). Taylor writes that Duranty "believed himself the leading expert on the Soviet Union, and his faith in his own insight drew him into a downward spiral of distortions and untruths, typified by his memorable excuse for Stalin's crimes 'You can't make an omelet without breaking eggs' " (pp. 184–185). On at least two separate occasions, Taylor notes, Duranty used the expression in his *Times* articles as a rationalization for Stalin's forced collectivization campaign (pp. 207, 222). After its own review of Duranty's work and the prize he had been awarded, the Pulitzer board decided in November 2003 not to revoke his prize, much to the fury of thousands of Ukrainians in North America who had lobbied hard for the revocation. According to the board's written statement, "the board determined that there was not clear and convincing evidence of deliberate deception, the relevant standard in this case" ("Reporter's Pulitzer Prize Will Not Be Revoked," *Los Angeles Times,* Nov. 23, 2003, p. A26). The decision underscored a fascinating dilemma about how the profession views its ethics and standards. Janet Cooke's prize for feature writing was rightfully revoked because she committed an intentional act of deception when she admitted fabricating the story of the eight-year-old heroin addict. In contrast, Duranty's prize for foreign reporting was not revoked because, though he largely ignored one of history's biggest and most tragic news stories happening right before his eyes, he didn't intentionally lie in the work he did publish. Sins of commission, in other words, appear to rank higher on the scale of journalistic justice than sins of omission, no matter the wider effects of the crime.

93. Amy Goodman and David Goodman, *The Exception to the Rulers: Exposing Oily Politicians, War Profiteers, and the Media That Love Them* (New York: Hyperion, 2004), p. 297.

94. Cited in ibid., p. 296.

95. Ibid.

96. Robert J. Lifton and Greg Mitchell, *Hiroshima in America: Fifty Years of Denial* (New York: Putnam, 1995), p. 52.

97. By contrast, the U.S. military censored remarkable and valiant firsthand reporting in September 1945 on the effects of the atomic bombing of Nagasaki, including radiation sickness, by a *Chicago Daily News* reporter named George Weller. Weller's first-person accounts were not revealed to the public until sixty years later, in June 2005, when Weller's son discovered the stories and more than two dozen photographs in his father's Rome apartment three years after his death.

Using a motorboat and posing as a U.S. Army colonel, Weller defied occupation authorities and sneaked into Nagasaki less than one month after the August 9 bombing, which had effectively ended World War II. He was the first foreign journalist to witness the devastation. His account included visits to hospitals, where he talked to doctors and described the burns, lesions, fevers, and mysterious diseases victims were contracting, some of them with few other symptoms of injuries from the bomb. Doctors, he said, called it "Disease X" and told him

that it derived from poisoning by the bomb's radiation and that thousands of residents would continue to die from it in the weeks and months to follow.

Weller, a veteran war correspondent who had won a Pulitzer Prize in 1943 for a story about a U.S. submarine crew's efforts to save a sailor's life during an emergency appendectomy, submitted his series of stories for review by the U.S. military. He later told his editors that General Douglas MacArthur had personally rejected them. Weller's stories finally appeared in print when they were serialized in the *Mainichi Daily News,* a Japanese daily, in both Japanese and English, on June 17, 2005 ("American's Censored Nagasaki A-Bomb Report Unearthed after Sixty Years," *Mainichi Daily News,* June 17, 2005, p. 8). Also in 2005, Anthony Weller was interviewed on National Public Radio about his father's life and the Nagasaki stories; see "Anthony Weller Discusses Finding His Father's Long Lost Articles from the End of World War II in Japan," *Talk of the Nation,* National Public Radio, transcript, June 20, 2005; audio available online at www.npr.org/templates/story/story.php?storyId=4711211.

98. Eason Jordan, "The News We Kept to Ourselves," *New York Times,* April 11, 2003, p. A25.

99. Ibid.

100. Emphasis added; see Mark Steyn, "Burying Augusta," *New York Sun,* April 21, 2003, p. 6.

101. "Vietnam: One Week's Dead," *Life,* June 27, 1969, p. 20.

102. Cited in "Perspectives," *Newsweek,* May 10, 2004, p. 25.

3. FUN HOUSE

1. The BBC interview can be viewed online at www.theyesmen.org/hijinks/dow/video.html. A complete transcript of the interview is available at www.countercurrents.org/en-goodman071204.htm, as part of a larger report, "Jude Finisterra Interviewed by Democracy Now!" Dec. 7, 2004.

2. "Dow Chemical Admits Bhopal Responsibility, Sets Up $12 Billion Fund," AFX News Ltd., AFXPress.com, Dec. 3, 2004, www.lexisnexis.com; *Daybreak,* CNN transcript #120304CN.V73, 5:00 A.M., Dec. 3, 2004, www.lexisnexis.com; "Corrections," *Atlanta Journal-Constitution,* Dec. 7, 2004, p. A2; "Bhopal Hoax Sends Dow Stock Down," CNN.com, Dec. 3, 2004, www.cnn.com/2004/WORLD/europe/12/03/bhopal.hoax.

3. Kate Nicholas, "Bhopal Hoax Inflicts Widespread Damage," *PR Week,* Dec. 10, 2004, p. 20.

4. The BBC retraction was widely covered in the world's media the next day; see, for example, James Burleigh, "BBC Apologizes for Bhopal Interview with Bogus Official," *The Independent* (London), Dec. 4, 2004, p. A6.

5. Bichlbaum and Bonanno were profiled in several articles published after the BBC hoax, in which they explained the motives behind it and how it all began. See, for example, Vincent Graff, "Media: Meet the Yes Men Who Hoax the World; the Two Men behind the Bhopal Interview Stunt Reveal How They Did It—and Why They Now Feel Sorry for the BBC," *Guardian* (London), Dec. 13, 2004, p. A6. The hoaxers' account of the Bhopal BBC deception is available online at www.theyesmen.org/hijinks/dow and www.theyesmen.org/hijinks/

dow/bhopal2004.shtml. See also "Jude Finisterra Interviewed by Democracy Now!" Dec. 7, 2004, available online at www.countercurrents.org/en-goodman 071204.htm.

6. Graff, "Media: Meet the Yes Men."

7. Cited in Dennis Roddy, "Liar's Poker," *Pittsburgh Post-Gazette,* Dec. 12, 2004, p. JI.

8. For a definition of news in a typical journalism textbook, see Melvin Mencher, *News Reporting and Writing,* 10th ed. (New York: Columbia University Press, 2006), pp. 54–73.

9. Today, much of the settlement money remains tied up in red tape and courtroom haggling in India, which exacerbates the frustration and suffering of the victims; see "Bhopal: The World's Worst Industrial Disaster; Victims Still Wait for Compensation," Associated Press, Dec. 3, 2004.

10. Peter Foster, "Bhopal Is Still Suffering after 20 Years: Bitterness and the Smell of Poison Remain in the Air in the City Blighted by One of the World's Worst Industrial Disasters," *Daily Telegraph* (London), Dec. 2, 2004, p. 18.

11. Graff, "Media: Meet the Yes Men," p. A6.

12. *Daybreak,* CNN transcript #120304CN.V73, 5:00 A.M., Dec. 3, 2004, www.lexisnexis.com.

13. For Dow's statement, see George Hohmann, "Dow Denies It Plans to Sell Carbide," *Charleston (W. Va.) Daily Mail,* Dec. 3, 2004, p. A8.

14. Roddy, "Liar's Poker," p. J1.

15. Fred Fedler, *Media Hoaxes* (Ames: Iowa State University Press, 1989), pp. 84–96.

16. Ibid., p. 96.

17. Ibid., pp. 130, 132.

18. Ibid., pp. 133, 141.

19. Ibid., p. 7.

20. Max Hall, *Benjamin Franklin and Polly Baker: The History of a Literary Deception* (Chapel Hill: University of North Carolina Press, 1960), p. 5.

21. Ibid., p. 7.

22. Ibid., p. 154.

23. Fedler, *Media Hoaxes,* p. 35.

24. Mark Twain, *The Autobiography of Mark Twain* (New York: Harper and Row, 1959), p. 102; cited in Fedler, *Media Hoaxes,* p. 43.

25. Fedler, *Media Hoaxes,* pp. 18–23.

26. John Locke's thinking and influence on the American founders is discussed particularly well in J. Robert Altschull, *From Milton to McLuhan: The Ideas behind American Journalism* (Baltimore: Johns Hopkins University Press, 1990):

> Locke's name is forever associated with two elements of what we can safely identify as the American belief system and indeed the professional ideology of American journalists: the contract theory, which holds that our government thrives under the consent of the governed, and the doctrine of the right of revolution, which holds that we have the absolute right, indeed the duty, to rise up against tyrannical leaders and throw the rascals out, by force and violence if that is necessary. These two doctrines undergird our most basic and fundamental civil liberties, the freedom to say what we want and the freedom to print and publish our opinions and beliefs. (p. 51)

27. A number of works examine Locke's Moon Hoax, including Fedler's *Media Hoaxes* and Alex Boese's *The Museum of Hoaxes* (New York: Dutton, 2002). Frank M. O'Brien's *The Story of the* Sun (New York: George H. Doran, 1918), remains one of the finest discussions of the hoax. Locke's stories can be read in their entirety and in their original form on microfilm, but the series was also reprinted in book form in several popular editions in the 1850s, including William N. Griggs, *The Celebrated Moon Story: Its Origin and Incidents* (New York: Bunnell and Price, 1852); and Richard Adams Locke, *The Moon Hoax; Or, A Discovery That the Moon Has a Vast Population of Human Beings* (New York: Gowans, 1859). The most recent edition is in the Gregg Press science fiction series, published in 1975. This edition features an introduction by Ormond Seavey, who elaborates on the hoax's significance in American cultural and literary history, notes its influence on showmen like P. T. Barnum, and compares it to Poe's hoax.

28. O'Brien, *Story of the* Sun, p. 78.

29. Ibid., pp. 79, 80, 81.

30. Emphasis in original; Locke, *The Moon Hoax,* p. 45.

31. O'Brien, *Story of the* Sun, pp. 81–82.

32. Lynda Walsh, "What Is a Hoax? Redefining Poe's *Jeux d'Esprit* and His Relationship to His Readership," *Text, Practice, Performance* 4 (2002): 103–120.

33. Cited in O'Brien, *History of the* Sun, p. 93.

34. This anecdote is cited in "All That Jazz," *Time,* July 21, 1958, p. 56.

35. George Plimpton, "The Curious Case of Sidd Finch," *Sports Illustrated,* April 1, 1985, p. 59.

36. The actor John Houseman, who cofounded the Mercury Theater of the Air in 1936 with Welles, noted that Morris's news narration of the *Hindenburg* disaster had inspired the voice inflections of the actor playing the reporter Carl Phillips in *War of the Worlds*. Houseman's remembrance of the production is recounted in his memoir *Run-Through* (New York: Simon and Schuster, 1980), in which he also discusses the numerous lawsuits brought against the Mercury Theater seeking damages for everything from injuries and emotional distress to miscarriages. None of the cases was validated by the courts. While CBS and Welles did apologize later for the nation's reaction to the hoax, they and Houseman noted that at least five disclaimers were aired during the broadcast reminding listeners that it was a dramatization.

37. The original script of the Mercury Theater's *War of the Worlds* broadcast is reprinted in Howard Koch's *The Panic Broadcast: Portrait of an Event* (Boston: Little, Brown, 1950). Koch, the author of the script, updates the story by visiting Grovers Mill and interviewing residents who heard the original broadcast. He also discusses the steps taken by the broadcast industry, the government, and the press to prevent similar future media-inspired panics.

38. Ibid.

39. Welles became such a national celebrity as a direct result of the *War of the Worlds* broadcast that he landed on the cover of *Time* magazine in 1939 and soon found opportunities in Hollywood. In 1941, he directed and starred in another work that featured journalism as a significant dramatic theme—the film

Citizen Kane, loosely based on the life and times of megalomaniacal newspaper publisher William Randolph Hearst and considered by many critics the finest American film of all time.

40. The most widely known resource for validating or debunking rumors, myths, hoaxes, and urban legends in popular American culture is the Web site run by Barbara and David P. Mikkelson at www.snopes.com, also called the "Urban Legend Reference Pages." The researchers track down truths and lies in nearly fifty categories ranging from sports, movies, radio and TV, crime, and religion to racial rumors, legends about the *Titanic,* Walt Disney, and media matters (which includes subcategories for celebrities, media goofs, and "Not Necessarily the News"). Numerous other sites are also devoted to investigating truth and falsehood in contemporary society, including www.factcheck.org, which is run by the Annenberg Public Policy Center; and www.straightdope.com, written and edited by journalists at the *Chicago Reader.*

41. LuAnne Sorrell, "Bizarre Game Targets Women: Hunting for Bambi," KLAS-TV Channel 8 *Eyewitness News* transcript, July 10, 2003, available online at www.klas-tv.com/Global/story.asp?S=1356380&nav=168XGqko. Subsequent quotations from Sorrell's report are taken from this same source.

42. Reuters, "Nude Women Hunts Ignite Fear," *Ottawa Sun,* July 18, 2003, p. A16. Mayor Goodman was quoted in "Word of Mouth," *Gold Coast Bulletin,* July 24, 2003, p. A2. For reactions of women's rights groups, see Susan Paynter, "Readers Spare No Ammo on Bambi Hunt," *Seattle Post-Intelligencer,* July 23, 2003, p. D1. Rita Haley was quoted in Bill Hoffmann's article "Loaded for Bare," *New York Post,* July 16, 2003, p. 23.

43. Paynter, "Readers Spare No Ammo."

44. Reuters, "Nude Women Hunts Ignite Fear."

45. Paynter, "Readers Spare No Ammo."

46. The headlines are taken from, respectively, the *Green Bay (Wis.) Press Gazette,* July 24, 2003; the *St. Louis Post-Dispatch,* July 24, 2003; the *Seattle Post-Intelligencer,* July 18, 2003; and the *New York Post,* July 16, 2003.

47. Cited in Paynter, "Readers Spare No Ammo."

48. Bill O'Reilly, *The O'Reilly Factor,* Fox News, transcript # 071706cb. 256, July 17, 2003.

49. Ibid.

50. Russell Watson, "Hitler's Secret Diaries," *Newsweek,* May 2, 1983, p. 50.

51. Skaggs is profiled in numerous newspaper and magazine articles; see, for example, Patty Hartigan, "Cyberlinks: Look Who's behind the Final Curtain," *Boston Globe,* June 2, 2000, p. C10. Skaggs keeps a list of his media scams, and corresponding press cites, at www.joeyskaggs.com.

52. Mark Dery, "The Merry Pranksters and the Art of the Hoax," *New York Times,* Dec. 23, 1990, sec. 2, p. 1.

53. John Tierney, "The Big City: Falling for It," *New York Times,* July 17, 1994, sec. 6, p. 16.

54. Hartigan, "Cyberlinks."

55. Thomas Haden, "Gotcha! Strange but True, This Is the Golden Age of Hoaxes," *U.S. News and World Report,* August 26, 2002, p. 30.

56. Thomas Frank and Matt Weiland, eds., *Commodify Your Dissent: Salvos from the* Baffler—*the Business of Culture in the New Gilded Age* (New York: W. W. Norton, 1997), pp. 203–206, provides a useful recounting of the Megan Jasper grunge hoax.

57. Rick Marin, "Grunge: A Success Story," *New York Times,* Nov. 15, 1992, sec. 9, p. 1.

58. Ibid.

59. Ibid. The hoax was first widely referenced in Editor's Notebook, "Rocky Mountain Low," *New Republic,* Jan. 25, 1993, p. 8. Jasper's first admission of the hoax appeared in Thomas Frank, "Harsh Realm, Mr. Sulzberger!" *Baffler,* Winter/Spring 1993, pp. 12–13 (reprinted in Thomas and Weiland, *Commodify Your Dissent,* pp. 203–206). See also Jean Godden, "Great Day for Grunge: *New York Times* Done Dirty," *Seattle Times,* Feb. 26, 1993, p. F1.

60. J. Barton Bowyer, *Cheating: Deception in War & Magic, Games & Sports, Sex & Religion, Business & Con Games, Politics & Espionage, Art & Science* (New York: St. Martin's Press, 1982).

61. The show aired in March 2005, and the hoax was covered in the media; see, for example, Pierre Amanda, "Iowa Town Readies for Iowa Invasion; Residents Are Willing to Laugh but Are Saving Final Judgment on the William Shatner–Led Hoax on Spike TV," *Des Moines Register,* Feb. 9, 2005, p. E1.

62. For an extensive profile of Phil Hendrie, see Paul Cullum, "Radio Provocateur," *LA Weekly,* June 11, 2004, p. 32.

63. In 2006, Hendrie announced that he would retire from his nationally syndicated radio program by 2007 in order to focus on a new acting career in television, hoping to find a home for his carnival of voices on network sit-coms. An audio archive of Hendrie's shows from the past decade can be found online at his fee-based Web site, www.philhendrieshow.com.

64. See "Editor Sacked over Hoax Photos," BBC News Online, May 14, 2004, http://news.bbc.co.uk/2/hi/uk_news/politics/3716151.stm.

65. "Drive Kills 216 Reds in Saigon," *Albuquerque Journal,* March 17, 1968, p. A3.

66. See, for example, Associated Press, "Allies Kill 128 VC in Drive in Saigon Region," *San Francisco Sunday Examiner and Chronicle,* March 17, 1968, p. A4; and Associated Press, "Allies Win Big Victory around Saigon; Kill 128 Guerrillas," *Chicago Tribune,* March 17, 1968, p. A22.

67. The My Lai atrocity, the subsequent cover-up, and the official myth-making in its aftermath have been eerily echoed by a similar incident in the Iraq war. In November 2005, news reports based on official U.S. military accounts described a conflict between U.S. Marines and insurgents in the town of Haditha. U.S. Marine officials reported that a marine and fifteen Iraqi civilians had been killed in a roadside bombing and that eight insurgents had also been killed after the marine convoy came under small-arms fire. In January 2006, after *Time* magazine presented evidence that fifteen unarmed civilians had been killed by gunfire, not by the bombing, the military launched its own investigation and acknowledged that the civilians, including women and children, had been slain by the marines. *Time* published a full account of the atrocity in March 2006, nearly four months after the fictional press reports based on the official military ac-

count: see Tim McGirk, "One Morning in Haditha: U.S. Marines Killed 15 Iraqi Civilians in Their Homes Last November—Was It Self-Defense, an Accident, or Cold-Blooded Revenge?" *Time,* March 27, 2006, pp. 34–36.

68. Cited in Steve Coll, "Managing the Facts: Army Spun Tale around Ill-Fated Mission," *Washington Post,* Dec. 6, 2004, p. A1.

69. "Tillman Died by Friendly Fire," *Memphis Commercial Appeal,* May 30, 2004, p. A5.

70. Steve Coll, "The Unnecessary Death of Pat Tillman: Barrage of Bullets Drowned Out Cries of Comrades," *Washington Post,* Dec. 5, 2004, p. A1. In response to requests for the full truth about Pat Tillman's death from the Tillman family and Arizona senator John McCain, the army ordered an investigation, led by Brigadier General Gary M. Jones. Jones issued a report on his findings on May 3, 2005, one year after Tillman's memorial service. It found "gross negligence" by Tillman's fellow Rangers. Jones added that "nothing has contributed more to an atmosphere of suspicion by the family than the failure to tell the family that Cpl. Pat Tillman's death was the result of suspected friendly fire, as soon as that information became known within military channels" (Josh White, "Army Withheld Details about Tillman's Death," *Washington Post,* May 4, 2005, p. A3).

Pat Tillman's family was not satisfied by the army's report. Family members charged that the army had disrespected his memory by lying in its initial report on his death. His mother, Mary Tillman, told the *Washington Post* in an interview, "Pat had high ideals about the country. That's why he did what he did. The military let him down. The administration let him down. It was a sign of disrespect. The fact that he was the ultimate team player and he watched his own men kill him is absolutely heartbreaking and tragic. The fact that they lied about it afterwards is disgusting" (Josh White, "Tillman's Parents Are Critical of Army: Family Questions Reversal on Cause of Ranger's Death," *Washington Post,* May 23, 2005, p. A1). In March 2006, the story took an entirely new direction when the army announced the launch of a criminal probe into Tillman's death and whether it was the result of negligent homicide ("Army Probes Whether Tillman's Death Was Homicide," Reuters, March 4, 2006).

The army's newest probe was ongoing at the time of this writing, but the longer it continues, the more outraged critics become. Writing in the *Portland Oregonian,* columnist Steve Duin observed:

> The Pentagon couldn't handle the truth . . . with recruitment lagging, the Army couldn't admit, in the indelicate phrasing of Tillman's father, that they'd just blown up "their poster boy." Instead, the Army trotted out a fairytale about a deadly Taliban ambush and awarded Tillman the Silver Star. The Army maintained the charade until a stirring, nationally televised memorial service could milk his death for all its pathos and recruitment value. Only when Tillman's unit, the 75th Rangers, prepared to return home, and the Army realized it could no longer manage or manipulate the message, did the Pentagon consider coming clean about the affair ("The Ongoing Desecration of Pat Tillman," *Portland Oregonian,* April 16, 2006, p. B1).

The Tillman tragedy and the attendant themes of truth and myth were similar to those of an earlier controversy, which concerned the rescue of army private Jessica Lynch from captivity in Iraq. In March 2003, Lynch was part of a

supply convoy of American vehicles that came under attack. Eleven soldiers were killed, and five were captured and later freed. Lynch was taken separately and held prisoner for nine days. According to official army reports, she was rescued during a daring nighttime mission by a Special Forces team from a hospital where she had been held. A videotape of the rescue taken by the military and released to the media portrayed the mission as far more dangerous than it actually was. The *Washington Post,* citing anonymous official U.S. sources, originally reported that Lynch had fought desperately at the time of her capture, emptying her weapon at the enemy, killing several, and suffering critical wounds herself. One U.S. official said, "She was fighting to the death. She didn't want to be taken alive" (Susan Schmidt and Vernon Loeb, "She Was Fighting to the Death," *Washington Post,* April 3, 2003, p. A1). There were also unsubstantiated reports based on official sources that she had been tortured while in captivity.

The Jessica Lynch story and her heroic rescue were seminal events in the early history of the war and occupation. And, like the Tillman story, the Lynch narrative was fraught with deception and untruth fed to the public by government officials and largely sustained by the press. In truth, Lynch didn't fire her weapon. Her serious injuries were incurred when the humvee in which she was traveling crashed. She was generally well cared for by Iraqi medical staff, who risked their lives to take care of her in a hospital. Her rescue by U.S. forces came without a fight; the hospital was unguarded, with only medical staff in attendance (Dana Priest, William Booth, and Susan Schmidt, "A Broken Body, a Broken Story, Pieced Together," *Washington Post,* June 17, 2003, p. A1). Lynch at first said that she resented the videotape of her rescue, but later commented that if it helped military morale, it was worth it. She also insisted that, despite the Pentagon's reports, she had done nothing heroic. "I'm not a hero. If it makes people feel good to say it, then I'm glad. But I'm not. I'm just a survivor" (Rick Bragg, *I Am a Soldier, Too: The Jessica Lynch Story* [New York: Knopf, 2003], p. 5).

4. WORLD OF ILLUSIONS

1. The news segment, along with additional B-roll material and the script, is available online at http://journalism.berkeley.edu/faculty/henry/hhs_video.php. Until January 2006, the script for the segment appeared on a Web site run by WBRZ-TV in Baton Rouge, Louisiana, one of the local stations that aired the story in its entirety. But that month, the station, without explanation, stopped posting its news scripts. The script can still be found, however, by checking the address http://www.2theadvocate.com/scripts/012304/noon.htm at the Wayback Machine of the Internet Archive, at www.archive.org, and clicking on the link for April 5, 2004.

2. Robert Pear, "U.S. Videos for TV News Come under Scrutiny," *New York Times,* March 15, 2004, p. A1.

3. Kennedy made this comment on a New York Public Radio program; see "On the Media," Feb. 6, 2004, transcript and audio available online at www.onthemedia.org/transcripts/transcripts_020604_aid.html.

4. Linda Winer, "Selling News to the Public," *Newsday,* March 21, 2004, p. C4.

5. Frank Rich, "White House New Ally: Faux Journalism," *International Herald Tribune,* March 27, 2004, p. 9.

6. Doug Halonen, "News Videos Spark Inquiry: Democrats Say Medicare Press Releases Covert Advertising," *Television Week,* March 22, 2004, p. 3.

7. Jerry Walker, "ASNE Protests HHS Video News Release," *O'Dwyer's Newsletter,* March 31, 2004, p. 3.

8. Chris Matthews, *Hardball,* MSNBC, transcript, March 16, 2004, available online at www.msnbc.msn.com/id/4547303.

9. U.S. Government Accounting Office, "Department of Health and Human Services, Centers for Medicare and Medicaid Services—Video News Releases," May 19, 2004, file B-302710, available online at www.gao.gov/decisions/appro/302710.htm#_ftn7.

10. Ibid.

11. Unsigned editorial, *O'Dwyer's PR Services Report* 18, no. 4 (April 2004): 6.

12. Greg Hazley, "Ethics Questioned, Video News Release Pros Sound Off," *O'Dwyer's PR Services Report* 18, no. 4 (April 2004): 1.

13. Anita Chabria, "Video News Releases: Using Video News Releases without Sparking Controversy," *PR Week,* May 17, 2004, p. 26.

14. Ibid., p. 27.

15. Paul Griffo, "Spotlight on Video News Releases: Karen Ryan, PR Professional," *Public Relations Tactics,* available online at www.prsa.org/_Publications/magazines/0604spot1.asp.

16. Ibid.

17. Karen Ryan, "Checking Facts Basic to Good Journalism," *Television Week,* March 29, 2004, p. 5. Subsequent quotations from Ryan in this section are also drawn from this article. See also Zachary Roth, "Karen Ryan: 'I Feel Like Political Roadkill,'" *Columbia Journalism Review Daily,* March 18, 2004, available online at www.cjrdaily.org/archives/000305.asp.

18. The RTNDA Code of Ethics and Professional Conduct is available online at www.rtnda.org/ethics/coe.shtml.

19. Gary Hill, "SPJ Objects to Bogus News Reports and Their Use by TV Newsrooms," press release, Society of Professional Journalists, March 19, 2004.

20. CNN's changes were reported in a variety of news sources, including Hazley, "Ethics Questioned."

21. Rob Johnson, "*Daily Show* Satirizes Channel 5 for Running Fake Government News," *Nashville Tennessean,* March 19, 2004, p. B1.

22. Deborah Potter, "Virtual News Reports," *American Journalism Review,* June/July 2004, p. 68.

23. Ibid.

24. See "The State of the News Media 2004: An Annual Report on American Journalism," available online at www.stateofthenewsmedia.org/2004. This report is prepared by the Project for Excellence in Journalism, an institute affiliated with Columbia University's Graduate School of Journalism and supported by the Pew Charitable Trusts. For the statistics cited in the chapter text, as well as general observations about the decline in network ratings, see www.stateofthenewsmedia.org/2004/narrative_networktv_newsinvestment.asp?cat=6&

media=4. The report reveals that newspaper circulation dropped 11 percent in thirteen years and that ratings for network news programs have dropped 34 percent since 1993. In this economic climate, and with fewer staff employees, news operations were increasingly driven to focus more on celebrity and sensationalism at the expense of time-consuming, capital-draining, and more public interest–driven journalistic projects.

25. Emphasis added; see David Lieberman, "Fake News: A Special Report: What We See Isn't Always News—It's Public Relations," *TV Guide*, Feb. 22–28, 1992, pp. 13–14. This article was the first major journalistic work examining the growing use of VNRs in American newsrooms. It prompted strong reactions in trade journals of the public relations industry, where professionals defended their ethics and lauded VNRs as new tools for advertising.

26. The PEJ studies are supported by the Pew Charitable Trusts and the Columbia University Graduate School of Journalism. The 2001 studies of local news are divided into chapters with titles including "Gambling with the Future," "News for Sale," and "Thinner, Cheaper, Longer." They are available online at www.journalism.org/resources/research/reports/localTV/2001/public.asp.

27. Ibid.

28. Marion Just and Tom Rosenstiel, "All the News That's Fed," *New York Times,* March 26, 2005, p. 13.

29. David Barstow and Robin Stein, "News or Public Relations: For Bush It's a Blur," *New York Times,* March 13, 2005, p. A1. In addition to the HHS piece, the *Times* story described numerous other fake "news" segments produced over the past six years for the White House, including segments produced by the Defense Department that emphasized humanitarian efforts run by the military and another showing Iraqi Americans celebrating the fall of Baghdad.

30. Barstow and Stein, "News or Public Relations."

31. Ken Herman, "White House Backs Video News Releases," *Atlanta Journal-Constitution,* March 15, 2005, p. A6.

32. Pierce was quoted in Barstow and Stein, "News or Public Relations." This article also first revealed the memo from the Justice Department and the Office of Management and Budget.

Late in 2005, federal auditors ruled that the Ryan videos and secret payments to Armstrong Williams and other commentators to promote White House policies violated federal laws prohibiting the use of taxpayer money for "covert propaganda." The decision carried no penalties, however, and it was uncertain how the auditors' decision would immediately affect such practices (Robert Pear, "Buying of News by Bush Aides Is Ruled Illegal," *New York Times,* Oct. 1, 2005, p. A1).

This ruling was followed by a court decision in California, where a judge found that VNRs similarly produced in the guise of professional news to push political policies of the Schwarzenegger administration were illegal. The state senate passed a law prohibiting the practice in early 2006 (Don Thompson, "Senate Passes Bill to Ban State from Making News-Like Promotions," Associated Press, Jan. 31, 2006).

33. Federal Communications Commission, Public Notice FCC 05–84, issued

April 13, 2005, available online at http://hraunfoss.fcc.gov/edocs_public/attach match/FCC-05-84A1.pdf. The advisory read in part:

> With this Public Notice, the Commission reminds broadcast licensees and cable operators that air video news releases, as well as all entities and individuals involved in the production and provision of the material at issue here, of their respective disclosure responsibilities under the Commission's sponsorship identification rules. These rules are grounded in the principle that listeners and viewers are entitled to know who seeks to persuade them with the programming offered over broadcast stations and cable systems. For the reasons noted in this Public Notice, and as provided for in the statutory provisions and in the Commission's rules, whenever broadcast stations and cable operators air video news releases, licensees and operators generally must clearly disclose to members of their audiences the nature, source and sponsorship of the material that they are viewing. We will take appropriate enforcement action against entities that do not comply with these rules.

34. Ira Teinowitz and Matthew Creamer, "Fake News Videos Unmasked in FCC Crackdown," *Advertising Age,* April 18, 2005, p. 3.

35. The RTNDA's new guidelines were developed specifically to answer public and industry concerns about video news releases. The guidelines, which are designed to govern industry practices, although they have not been specifically incorporated into the group's standing Code of Ethics, are listed on the RTNDA Web site under Ethics, in a subcategory titled Coverage Guidelines; see www .rtnda.org/ethics/ethicsguidelines.shtml and www.rtnda.org/foi/finalvnr.shtml. Also see Daisy Whitney, "VNR Guidelines Issued in Time for Conference: Heightened Scrutiny after Controversies Doesn't Slow Use," *Television Week,* April 18, 2005, p. 56.

36. Teinowitz and Creamer, "Fake News Videos Unmasked."

37. In April 2005, the U.S. Senate voted 98–0 to approve an amendment to a spending bill that required video news releases produced that fiscal year by the federal government at taxpayer expense to carry explicit warnings and disclosure of their origin. In October 2005, the Senate Commerce Committee voted 19–3 to make the amendment permanent. However, the disclosure requirement applies only to VNRs that are aired in their entirety, a provision accepted after robust lobbying by broadcasters and public relations industry leaders. The measure still requires both the full House and Senate to vote on its passage. See Anne Kornblutt and David Barstow, "Debate Rekindles over Government-Produced 'News,'" *New York Times,* April 14, 2005, p. 17; Christopher Lee, "Update: Prepackaged News," *Washington Post,* Oct. 26, 2005, p. A17; and "Commerce OKs Weaker VNR Measure," *O'Dwyer's Newsletter,* Oct. 26, 2005, p. 6.

38. Larry Thomas is quoted in Erica Lacono, "FCC 'Clarification' Further Confuses Debate on Video News Releases," *PR Week,* April 25, 2005, p. 3. The report by the Center for Media and Democracy, compiled by Diane Farsetta and Daniel Price and titled "Fake TV News Widespread and Undisclosed," is available online at www.prwatch.org/fakenews/execsummary. For information on the KRON broadcasts, see Evelyn Nussenbaum, "Cash-Strapped KRON Lets Advertisers Buy into News Broadcasts: The Boss Says It's Just a Sign of the Times," *San Francisco Chronicle,* April 5, 2006, p. E1; Ron Russell, "KRON's Last Gasp: How a Once-Proud San Francisco Television Station Became Ground

Zero in the Nation's Most Controversial Experiment in Local TV News," *SF Weekly,* April 12, 2006, p. 1.

39. Joseph Carroll, "Local TV and Newspapers Remain Most Popular News Sources," Gallup News Service, Dec. 20, 2004, www.lexisnexis.com. The first question in the poll was "How often do you get your news from the following sources?" The two major sources were local television and local newspapers; 39 percent of the respondents cited cable television news, and 36 percent cited network television news. Other sources included morning television interview programs (27 percent), public television news (27 percent), radio talk shows (21 percent), news on the Internet (20 percent), National Public Radio (17 percent), and national newspapers such as the *New York Times* (7 percent).

Interestingly, the only news source that gained as a chief source of daily news was the Internet, which rose from 15 percent in 2002, two years earlier, to 20 percent. In 1995, only 3 percent had specified the Internet as a source for their daily news. The audience for local television has declined: in 2002, 57 percent of respondents viewed local television for news every day, but this number had declined by 6 percent by 2004.

As the Internet has gained in audience, it is also becoming more central to debates about ethics and the nexus of journalism and advertising, including the issue of "embedded" advertising in news Web sites. The *New York Post* Web site has begun using such tools, which allow the newspaper to increase ad revenues by steering readers to selected words in news stories; when readers click on the words, they are sent to ads. This practice, which *Forbes* magazine adopted but then abandoned after its reporters complained about their work being fused with advertising, points up both the ethics of "keyword" advertising and the pressure on both traditional media and New Media to increase revenues in the face of stiff competition for audience share. See, for example, Nat Ives, "Ads Embedded in Online News Raise Questions," *New York Times,* Feb. 24, 2005, p. C1.

40. Controversy over the administration's economic projections and the Medicare reform legislation was reported by many news sources in March and April 2004; see, for example, Eric Boehlert, "Lies, Bribes, and Hidden Costs: Bush's Medicare Quagmire and the Striking Parallels to Iraq," Salon.com, April 6, 2004, available online at http://dir.salon.com/story/news/feature/2004/04/05/medicare/index.html. During early 2004, when the pro–White House Karen Ryan stories were being aired, news reports revealed that the administration had pressured a top analyst for Medicare to withhold information from Congress that might have influenced the congressional vote—specifically, the analyst had information indicating that the prescription drug program would cost over $100 billion more than the White House was telling the public. The true costs were admitted only after the legislation had already passed by a very narrow margin, setting the stage for a federal investigation of whether any laws were broken in the apparent White House effort to mislead Congress.

The Medicare story took a different direction in 2006, when the prescription drug reforms went into effect. Millions of elderly Americans expressed confusion and anger over the changes, and many elderly poor suddenly found themselves unable to procure the medicines they needed, either because the medications were not covered under the new law or because seniors found the medicines pro-

hibitively expensive. See, for example, Neal Conan, "Seniors Struggle to Sort Through Drug Plan," *Talk of the Nation,* National Public Radio, transcript, Jan. 30, 2006, both text and audio available online at www.npr.org/templates/story/story.php?storyId=5179062.

41. The longstanding promotion of authenticity in product advertising holds especially true today for the embattled American tobacco industry, which frequently bills its cigarettes and other products as "Authentic U.S.A." on billboards in countries across sub-Saharan Africa, where it is desperately seeking to expand its market among the region's 800 million inhabitants in order to pick up the slack for its fallen fortunes in the West. See Akinbode Oluwafemi, "Regional Summary for the African Region," American Cancer Society report, available online at www.cancer.org/downloads/TOB/AFRO_Summary.pdf. See also Okey Ndiribe, "Tobacco Advertising Raises Concerns," *The Vanguard* (Nigeria), Oct. 19, 2005, www.lexisnexis.com.

42. Lydia Pinkham's promotion is considered one of the earliest and most successful newspaper campaigns in American advertising history; see, for example, James Twitchell, *Twenty Ads That Shook the World: The Century's Most Groundbreaking Advertising and How It Changed Us All* (New York: Crown, 2000). For a general history, see Juliann Sivulka, *Soap, Sex, and Cigarettes: A Cultural History of American Advertising* (Belmont, Calif.: Wadsworth, 1988).

43. See Thomas Leonard, "The Wall: A Long History," *Columbia Journalism Review,* Jan. 2000, p. 28. See also Gerald Baldasty, *The Commercialization of News in the Nineteenth Century* (Madison: University of Wisconsin Press, 1992).

44. See Ives, "Ads Embedded in Online News."

45. Dan Mitchell, "What's Online: Eyeballs Are Back, but Maybe Not: 'Informercialtainment,'" *New York Times,* Dec. 3, 2005, p. C5.

46. Lucinda Franks, "E. B. White Takes on Xerox and Wins," *New York Times,* June 15, 1976, p. C1.

47. *Letters of E. B. White,* ed. Dorothy Lobrano Guth (New York: Harper and Row, 1976), p. 660.

48. Ibid., p. 668.

49. White's crusade was covered in the press and mentioned prominently in published remembrances after his death in 1985. See, for example, Franks, "E. B. White Takes on Xerox and Wins"; "Advertising: The Master's Voice," *Newsweek,* June 28, 1976, p. 56; Herbert Mitgang, "E. B. White Is Recalled in Readings," *New York Times,* Feb. 11, 1986, p. C13; Keith Love, "*New Yorker*'s E. B. White Dies; Essayist, 86, Also Known for Children's Books," *Los Angeles Times,* Oct. 2, 1985, p. A1.

50. The annual revenue figure comes from the Electronic Retailers Association, the national trade organization of the infomercial industry, which also reported in 2004 that American consumers had spent $91 billion that year on products that had been advertised in thirty-minute infomercials (Frank Ahrens, "Miracle Infomercials: TV's Hard Sells Are a $256 Billion Industry," *Washington Post,* Sept. 26, 2004, p. F1). The industry's phenomenal growth began with a deregulatory action in 1984, when the Federal Communications Commission struck down rules prohibiting the airing of more than sixteen minutes of com-

mercials in any one-hour period. The move opened the way for the thirty-minute advertisement, which has provided a new and growing source of income for broadcast and cable stations. Local broadcast stations can charge about $15,000 per half-hour infomercial, while national cable channels can charge upward of $40,000. Revenue from infomercials amounts to about 5 percent of local and cable station income, but in recent years, with the expanding use of such advertising, stations have been able to raise rates and income. See Stuart Miller, "Beyond the Ginsu Knife; Shoppers and Advertisers Change Their Attitude about Infomercials," *Multichannnel News,* April 25, 2005, p. 38. Miller relies on figures provided by a company called IMSTV.com, which monitors and tracks infomercial data for use in research by advertisers and corporate clients.

51. In *The Sponsored Life: Ads, TV, and American Culture* (Philadelphia: Temple University Press, 1994), former *Village Voice* columnist and advertising critic Leslie Savan estimates that the typical individual encounters more than sixteen thousand print and broadcast ads in the ordinary course of daily life in America. Since 1994, this frequency has undoubtedly risen, with the growth of the Internet and the expansion of advertising in public spaces, television, and radio. A new and highly controversial incursion of commercials in public spaces is occurring in the nation's movie theaters, which until recently had been largely immune from nonmovie advertising. In some theaters, films are preceded by as much as twenty minutes of commercials. Public protests over the practice grew so heated in New York and Connecticut that the two state legislatures authored bills to ban it. Still, spending on such ads continues to grow, up 37 percent between 2002 and 2003 alone. More important, research suggests that the effectiveness of these ads is far greater than that of television ads, with moviegoers three times more likely than television viewers to remember the ads (Alex Mindlin, "For Advertisers, the Silver Screen Is Golden," *New York Times,* May 23, 2005, p. C5).

52. Amy Goldwert Eskridge, "The View from the Newsroom," *Public Relations Tactics* 11, no. 6 (June 2004): 27. *Public Relations Tactics,* written from the vantage point of public relations professionals, is an excellent source that documents the practices of video news producers and the placement and use of VNRs by news organizations.

53. Ibid.

54. Paul Griffo, "The Top Five VNR Myths," *Public Relations Tactics* 8, no. 6 (June 2001): 1, 18.

55. Ibid.

56. Emphasis in original. See the "Frequently Asked Questions" page of the TVA Web site at www.tvaproductions.com/html/body_about_tva.html#7. The TVA client list can be found at www.tvaproductions.com/html/body_clients.html.

57. See "TVA News Team," at www.tvaproductions.com/html/News_Team .html.

58. Emphasis in original. See www.tvaproductions.com/html/body_about_ tva.html#18.

59. Lorne Manley, "Satellite Alters the Sound of Radio; 5 Million Turn to New Stations, and away from Broadcasters," *International Herald Tribune,* April 6, 2005, p. 16.

60. See Charles Gibson, "Residents of Yuzuri Hara, Japan, Believe Their Diet, High in Hyaluronic Acid, Is Secret Fountain of Youth," *Primetime Thursday,* ABC News, transcript, Nov. 2, 2000:

> While hyaluronic acid has proven useful in orthopedics and ophthalmology, many Western experts are skeptical that swallowing it in a pill could actually help prolong one's life. "I cannot today imagine any possible benefit," says Dr. Endre Balazs, a leading expert on HA.
>
> "The only way it acts, as far as I can see, as an anti-aging remedy," adds Dr. Irving Raphael, "is because if you're not limping, and your joints feel better, you feel younger."

61. In 2006, Sardi renamed his Web site, changing it from askbillsardi.com to Bill Sardi's Knowledge of Health, located at www.knowledgeofhealth.com. His publishing business also changed its name, from Here and Now Books to Natural Health Librarian. Older versions of Sardi's Web site, including his claims about his schooling and expertise, remain available through the Wayback Machine of the Internet Archive. Insert the term askbillsardi.com in the search window, and click on any date in 2004 or 2005 to find his bio under "Meet Bill Sardi."

62. Sardi identifies himself as the president of Longevinex in an article available online at www.longevinex.com/article.asp?story=alternatives%20to%20 alcohol. See also Jay Dixit, "Seeking Immortality," *New York Sun,* July 12, 2004, p. 18.

63. Various periodicals reported the story of Trudeau's infomercials and the FTC crackdown and ban on his activities; see, for example, Jim Edwards, "News Analysis: Ad Industry Takes Action to Police Infomercials," *Brandweek,* Sept. 20, 2004, www.lexisnexis.com; Claudia Deutsch, "FTC Bars Producer of Cure Infomercials," *New York Times,* Sept. 13, 2004, p. C12; and Frank Ahrens, "FTC Pulls Plug on Infomercial Giant," *Washington Post,* Sept. 13, 2004, p. B1. See also the FTC press releases available online at www.ftc.gov/opa/2003/06/trudeau.htm and www.ftc.gov/opa/2004/09/trudeaucoral.htm.

64. Both organizations maintain Web sites: see www.quackwatch.org and www.prwatch.org.

65. The Pentagon's fake news PR campaign in the Iraq press was first reported in the *Los Angeles Times* (Mark Mazzetti and Borzou Daragahi, "U.S. Military Covertly Pays to Run Stories in Iraqi Press; Troops Write Articles Presented as News Reports. Some Officers Object to the Practice," *Los Angeles Times,* Nov. 30, 2005, p. A1). *USA Today* later reported that the Iraq fake news initiative was part of a $300 million campaign to generate and plant pro-American news articles in the press of strategically important nations around the world (Matt Kelley, "Pentagon Rolls Out Stealth PR," *USA Today,* Dec. 15, 2005, p. A1).

66. Jim Sanders, "Governor's Use of Video Format Prompts Debate: Is It Just a High-Tech Press Release? Latest Media Approach Draws Fire," *Sacramento Bee,* April 3, 2005, p. A3. See also Patt Morrison, "Commentary: Maria, Define 'News' for Him," *Los Angeles Times,* March 9, 2005, p. B11.

67. Eric Fisher, "Forbes Rates Redskins Value at $1.1 Billion," *Washington Times,* Sept. 4, 2004, p. C2.

68. Lorne Manly, "Redskins Try to Become the Messenger," *New York*

Times, Jan. 7, 2006, p. D1. Interestingly, the same strategy of bypassing traditional media is being adopted by the entertainment industry. Hollywood producers increasingly are turning to the Internet not only to spend advertising dollars formerly allocated for print media but also to control or shut out advance criticism of films by professional journalists. Traditionally, the advertising and marketing campaigns that accompany film openings have included advance screenings of the films for newspaper and magazine critics. Now, however, to forestall bad reviews that could hurt earnings, studios increasingly do not allow advance screenings for print or broadcast journalists and instead turn to the Internet to create "buzz" and "viral" marketing campaigns that can spur box office interest and gain tighter control over marketing messages and the review process. New technologies such as peer-to-peer text messaging directly from theaters by customers are also changing the role and influence of the traditional craft of professional film criticism. See David Carr, "Studios Turn Thumbs Down on Film Critics," *New York Times,* May 29, 2006, p. C1.

69. Upton Sinclair, *Brass Check: A Study of American Journalism,* introduction by Robert W. McChesney and Ben Scott (Urbana: University of Illinois Press, 2003); originally published in 1920.

70. George Orwell, "Politics and the English Language," in *A Collection of Essays* (Orlando, Fla.: Harcourt, 1970), pp. 156–170; originally published in *Horizon* magazine (London), April 1946.

71. See Joe Strupp, "With Revenue Still Flowing Slowly, Some Fear Temptation to Bend Pay-for-Play Rules May Rise," *Editor and Publisher,* Nov. 17, 2003, p. 6. Strupp writes:

> According to [*Des Moines Register*] publisher Mary Stier, the sections sell advertising to local businesses and create stories by their own staff writers, often primarily using advertisers as prime sources, with some stories running next to the source's ad. A number of the *Register*'s special sections, however, have had nothing that explicitly identified them as an advertising product. A line at the top of the front page simply reads: "A *Des Moines Register* Custom Publication." Although the sections' typeface is different from the main newspaper, the layouts are eye-catching and featurey enough to possibly mislead some readers, minus the "paid advertising" tag. "Newspapers are moving from a mass medium to offer targeted content to a targeted audience," Stier said. "It is like a traditional special section. . . . It is not our attempt to confuse the consumer."

72. The job ad was listed in June 2005 on the corporation's advertising jobs page at www.gannett.com/job/jobs/ad.htm.

73. Hassan Fattah, "Custom Publishing Grows Up," *American Demographics,* July 1, 2002, pp. 7–10.

74. Sarah Gonser, "The Downside of the Advertorial Boom," *Folio,* Nov. 2003, p. 46.

75. Cited in ibid., p. 46.

76. In recent years, many professional journals and magazines have written extensively about the merging of business and news interests in American newsrooms. Editors at many publications have accepted the trend as a fait accompli. See, for example, Sharon Vane, "Taking Care of Business," *American Journalism Review,* March 2002, p. 60. Vane, who interviewed numerous top newspa-

per editors around the country about the influence of business and advertising on their news content, writes in her lead:

> The apocryphal "wall" between newsrooms and advertising departments is often referred to without a hint of self-consciousness as the separation between church and state. Indeed, despite ample evidence to the contrary, it's an undeniable part of the journalism culture to view the newsroom as an oasis separate from the messy details of money and business.
>
> Yet the truth is very different especially in these tough financial times. While interaction between the two sides of the industry isn't brand-new, it is becoming more widespread and more nuanced.
>
> As an economy in the doldrums results in tightened newsholes and smaller staffs, what was once verboten now looks to some like good business practice.

77. The full text of the letter of protest is available online by checking the address www.commercialalert.org/index.php/category_id/1/subcategory_id/89/article_id/272 in the Wayback Machine of the Internet Archive at http://archive.org. See also Claire Atkinson, "Mags Urged to Half Placement in Edit Content," *Advertising Age,* Sept. 27, 2004, p. 10.

78. Atkinson, "Mags Urged to Half Placement."

79. Stuart Elliott, "Working to Sell Advertisers on Newspapers and Magazines," *New York Times,* Feb. 15, 2006, p. C4.

80. Ibid.

81. Michael Shapiro, "Looking for Light: The *Philadelphia Inquirer* and the Fate of American Newspapers," *Columbia Journalism Review,* March 2006, p. 24.

82. Katherine Q. Seelye, "Four Knight Ridder Papers to Be Sold for $1 Billion," *New York Times,* April 26, 2006, p. C1.

83. Doreen Carvajal, "Is It News, Ad, or Infomercial? The Line between News and Advertising Is Going, Going . . . ," *Fine Line,* April 1991, p. 13, available online at www.journalism.indiana.edu/gallery/Ethics/isnews.html.

84. John Eggerton, "WFLA-TV Will ID Paid Segments; Station Reacts to FCC, McCain Pressure," *Broadcasting and Cable,* Nov. 10, 2003, p. 11. Reacting to the scandal, FCC member Jonathan Adelstein said in a speech to the Federal Communications Bar Association, "It's time for the FCC to probe whether our rules adequately deter potentially new forms of payola. We need to determine whether the public is being deceived, thinking a story or product review was broadcast on its own merit when in fact it was a paid commercial advertisement or a cross-promotional plug for the media company's other products" (Eggerton, "WFLA-TV," p. 11). Eggerton also reported that FCC commissioner Michael Copps expressed fears that such ethical violations could become even more pervasive with increased media consolidation: "Linking the WFLA-TV issue to consolidated newsrooms that would come from mergers," he said, 'That's one hell of a synergy and not one that's in the public interest' " (ibid.).

85. Dan Trigoboff, "Church, State Mix in Syracuse, NY," *Broadcasting and Cable,* Feb. 17, 2003, p. 8.

86. Lou Prato, "Punishing the Ethically Challenged," *American Journalism Review,* Sept. 1999, p. 86. See also David Hatch, "News, Sponsorship an Odd Couple," *Electronic Media,* Dec. 11, 2000, p. 1.

87. A good study of the effect of business and marketing in local television news remains John H. McManus's *Market-Driven Journalism: Let the Citizen Beware?* (Thousand Oaks, Calif.: Sage, 1994). A short history by Eric Rothenbuhler of Frank N. Magid Associates and its influence on the modern development of local television news is available at the fine Web site of the Museum of Broadcasting; see www.museum.tv/archives/etv/M/htmlM/magidfrank/magidfrank.htm.

For a revealing profile and interview of a longtime Los Angeles–based television journalist, Pete Noyes, who resigned from the industry in protest of the growing influence of media consultants and commercial interests in news content, see Howard Rosenberg, "Local News' Best Friend Says He's Had Enough," *Los Angeles Times,* Dec. 22, 1997, www.lexisnexis.com.

88. The Magid survey was reported in numerous newspapers and trade journals in March and April 2003. See, for example, Paul Farhi, "For Broadcast Media, Patriotism Pays; Consultants Tell Radio, TV Clients That Protest Coverage Drives Off Viewers," *Washington Post,* March 28, 2003, p. C1; Dusty Saunders, "Protests Don't Play on TV," *Rocky Mountain News,* April 2, 2003, p. D2; Kim Campbell, "Antiwar Protestors in a PR Fix," *Christian Science Monitor,* April 2, 2003, p. 1; Eric Deggans, "Pride and Prejudice," *St. Petersburg Times,* April 25, 2003, p. D1. See also Frank Rich, "Happy Talk News Covers a War," *New York Times,* July 18, 2004, p. B1.

89. "State of the News Media 2004," www.stateofthenewsmedia.org/2004.

90. A. J. Liebling, "The Wayward Press: Do You Belong in Journalism?" *New Yorker,* May 14, 1960, pp. 105, 109.

91. Many other playwrights, screenwriters, and novelists have similarly explored the rich dramatic link between newspapers and readers and callers. Nathaniel West's novel *Miss Lonelyhearts* is a darkly cynical portrait of a young newspaper columnist's descent into madness and despair after being assigned by his editor to respond to letters and calls the paper received from the lovelorn seeking advice about their troubled lives. The novel was a harsh indictment of American cultural and spiritual decay, seen through the eyes and experiences of a young journalist connected to society's most miserable. The 1933 novel was made into two vastly different films: a 1933 screwball comedy about life in a Los Angeles newspaper city room titled *Advice to the Lovelorn;* and the 1959 dark drama *Miss Lonelyhearts,* starring Montgomery Clift.

92. Lauren Weinstein, interview with the author, Dec. 30, 2004. Weinstein, a telecommunications specialist in Los Angeles who has studied the evolution of telephone systems and customer services over the past two decades, traces the explosive growth of telephone trees and call service centers to the expansion of the airline industry more than twenty years ago and the advent of twenty-four-hour ticketing services. Today, customers frequently encounter voice recognition technology of varying degrees of effectiveness, in which a computer theoretically is able to understand what you want when you request it by speaking. According to Weinstein, the technology is aimed at making customers feel better and more comfortable about the often frustrating experience of dealing with computers instead of humans. The bottom line remains the same, however: the system is intended to cut costs, and the result is to create more barriers between the com-

pany and the public. For an amusing story about the public fighting back, see Katie Hafner, "Hunting a Rare Breed: Human Online Support; Buyers Battle to Beat Automated Systems," *International Herald Tribune*, Jan. 4, 2005, p. 15.

The vast changes in telephone communications over the past quarter century are reflected in advances in automated telephone answering devices. The first commercially viable answering machine was marketed by PhoneMate in 1971. Today, the answering machine is ubiquitous in American homes and businesses, along with other aids that help to collect and screen calls, such as caller-ID services. Interestingly, according to the history of the patent and intellectual rights company PhoneTel Communications, a Swiss inventor named Willy Müller created the first telephone answering device, a contraption nearly three feet tall, in 1935. It was popular especially among Orthodox Jews, whose religious laws forbade them to answer the phone on the Sabbath. See Mary Bellis, "The History of Answering Machines," available online at http://inventors.about.com/od/astartinventions/a/Answering.htm. See also www.fcc.gov/kidszone/history_ans_machine.html, a Web site operated by the Federal Communications Commission; and www.phonetel.com/html/hashimoto.html, which provides a short history of the PhoneTel corporation.

93. The Minot incident figured in many FCC debates about the impact of media consolidation on local news and public service. See David B. Wilkerson and Russ Britt, "It's Showtime for Media Deals: Radio Lessons Fuel Debate over Control of TV, Radio," *CBS-Marketwatch*, May 30, 2003, available online at www.poynter.org/content/resource_popup_view.asp?id=16853; Jennifer Lee, "On Minot, ND Radio, a Single Corporate Voice," *New York Times*, March 29, 2003, p. C1.

94. Recent evidence appears to indicate that the digital divide separating Americans who own personal computers and have Internet skills from those who lack both computers and technical skills is closing markedly in at least one way: a 2005 Pew national survey of Americans age eighteen and older reported that 74 percent of whites, 61 percent of blacks, and 80 percent of English-speaking Latinos go online regularly; a similar survey seven years earlier found the respective figures to be 42 percent, 23 percent, and 40 percent. The survey did find differences in how the Internet is used, however, suggesting that the digital divide may be evolving from a question of access to a question of quality and kind of use: downloading music and instant messaging on dial-up connections, for example, as opposed to building virtual communities or promoting businesses with broadband access. See Michel Marriot, "Digital Divide Closing as Blacks Turn to Internet," *New York Times*, March 31, 2006, p. A1. The Pew research cited in this article showed that 68 percent of all Americans in 2005 used the Internet in some fashion, an increase of 5 percent from 2004. Yet 32 percent of Americans still did not go online at all as of 2005; for most, including the poorest Americans, this was not by choice but was dictated by economic circumstance. Pew also reported that one in five Americans said that they had never used the Internet at all. Pew's report on digital divisions is available online at www.pewinternet.org/PPF/r/165/report_display.asp.

95. Herbert Gans, *Democracy and the News* (New York: Oxford University Press, 2003), pp. 48–49.

96. Lee Rainie, "The State of Blogging," Jan. 2, 2005, available online at www.pewinternet.org/pdfs/PIP_blogging_data.pdf. The survey was part of an ongoing series of polls on technology and society by the Pew Internet and American Life Project.

97. Bryan Murley and Kim Smith, "Bloggers Strike a Nerve: Examining the Intersection of Blogging and Journalism," a paper presented at the annual meeting of the Association for Education in Journalism and Mass Communication, Aug. 10–13, 2005, San Antonio, Tex., available online at www.bryan murley.com/mambo/images//bloggersstrikeanervefinalbmks.pdf.

98. Benjamin Sutherland, "The People's Encyclopedia: As Wikipedia Grows into a Mainstream Internet Brand, Will It Be Able to Keep Its Volunteers in Line?" *Newsweek*, Jan. 9, 2006. See also Julie Bosman, "Fakin' It: A Marketer Intends to Tease Consumers," *New York Times*, Feb. 16, 2006, p. C4; this news article exposed a clever, Internet-based advertising campaign for a cell phone company that relied on "buzz" generated by a fake Wikipedia entry about the product.

99. The full report, "The State of the News Media 2006: An Annual Report on American Journalism," prepared by the Project for Excellence in Journalism, is available online at www.stateofthenewsmedia.org/2006. The general findings about blogging appear in the study's introduction and overview; see www.state ofthenewsmedia.org/2006/narrative_daymedia_intro.asp.

100. Steven Levy, "Blogging beyond the Men's Club," *Newsweek,* March 21, 2005, p. 16.

101. Robin Sloan and Matt Thompson proposed this vision in a film they produced for Poynter and Britain's Museum of Media History, *Epic2014.* The film is available online at http://epic.makingithappen.co.uk.

102. Cited in Dan Mitchell, "What's Online: Blogs and News," *New York Times,* June 11, 2005, p. C5. Hilden's column, titled "Do Search Engines Compete with—or Merely Publicize—Online News Outlets? Calculating Damages if Copyright Infringement Occurs," is available online at http://writ.news.find law.com/hilden/20050530.html.

103. Nielson/Net ratings, a division of the A. C. Nielson Company, provides monthly survey results of the top news sites on the Internet in terms of numbers of visitors and time spent at each site. These findings are published regularly in the *New York Times* and on Web sites including the Media Center of the American Press Institute. See, for example, www.cyberjournalist.net/news/ 002314.php. The Nielson/Net ratings site is located at www.nielsen-netratings .com.

104. The spectacular success of Craigslist.com and similar online ventures connecting consumers and sellers has contributed mightily to the decline of classified advertising in American newspapers. See, for example, Ryan Blitstein, "Craigslist.com: The Much-Loved Web Site Is Taking Millions from Bay Area Newspapers and Causing Layoffs That Adversely Affect Coverage. And Its Founder's Well-Intentioned Support of Citizen Journalism Has a Slim Chance of Fixing the Problem," *SF Weekly,* Nov. 30, 2005, p. 1.

105. These qualities of print media interestingly figured in major corporate discussions surrounding the potential breakup of the media conglomerate Time-

Warner/America Online. In 2005, after a severe 20 percent drop in advertising pages over the previous year for magazines, including *Fortune* and *Sports Illustrated*, and layoffs of 105 editorial employees in the company's 154 publications, corporate executives pushed for a separation of Time Inc. from Warner, calling the former's failing journalism and publishing enterprises a drain on the stock price of Warner entertainment and its New Media divisions. Time Inc., the largest magazine publisher in America and the heart of the corporation's journalistic enterprises, is also the least profitable entity within the conglomerate and, most telling, the least integrated with Time-Warner's online enterprises, AOL in particular. The man at the center of this struggle, Time-Warner's chief executive, Richard Parsons, reportedly commented that magazines should still thrive as long as New Media are unable to present a viable alternative to what he called "the three B's: The Beach, the Bedroom, and the Bathroom." See Julie Bosman and Richard Siklos, "Time Inc., Facing Declining Ad Pages, Lays Off 105, Including Top Executives," *New York Times*, Dec. 14, 2005, p. C3.

106. See Katherine Q. Seelye, "Publishers Face the Risky Economics of Charging Online," *New York Times*, March 14, 2005, p. C1.

It's also worth noting that many news organizations appear increasingly concerned about what they sense as a disconnect with average Americans in the technological age and are trying to improve lines of communication with readers, viewers, and listeners. These efforts range from the small to the truly inventive. For the first time in its 153-year history, for example, the *New York Times* in 2003 announced the appointment of a public editor, or readers' representative, to critique the newspaper and respond to reader complaints and inquiries about how it covers the news. For similar reasons, *Newsday* appointed its first readers' representative in 2005.

Newspapers across the country who are attempting to engage citizens with their Web sites are publishing blogs where readers are encouraged to offer comments and reaction to news and events in their communities. The *Houston Chronicle*, for one, began using Moveable Type software in 2005 to publish three blogs inviting reader participation in discussions about sports and local arts. In addition, increasing numbers of reporters are producing their own blogs and podcasts to augment their connection to the public.

A recognized leader in this new frontier of news and technology "convergence" is the *Lawrence Journal-World* in Kansas, which publishes numerous subject-related blogs in addition to providing outlets for citizens to publish their own blogs through the newspaper's Web site. Related sites on the newspaper's server also allow a range of other high-tech activities including downloading musical files from the city's annual music festival and transcripts of locally significant court cases and live online chats with experts about the judicial system. See the transcript of a fine, two-part National Public Radio examination of the *Journal-Herald*'s projects: Rene Montagne and David Folkenflik, "Newspaper Creating Model of How Media May Operate in the Future," *Morning Edition*, National Public Radio, transcript, April 13–14, 2005, www.lexisnexis.com; audio available online at www.npr.org/templates/story/story.php?storyId=4597203.

107. As daily newspaper and magazine circulations continue to fall—by 2.5 percent in the first six months of 2006—Web visitors to the sites of news orga-

nizations have increased by 8 percent (Seth Sutel, "Newspaper Circulations Down, Web Readers Up," Associated Press, May 8, 2006). Oddly, recent studies seem to suggest that Web "surfing" as a pastime may be declining even as the Internet continues to grow in popularity. A 2006 report by Britain's Cabinet Office found that although 76 million Web sites were available to curious British Web surfers, Internet users were hooked on an average of just six "supersites" to fill their daily diet for shopping, banking, travel, and news. As the Web expands, then, general exploration of it appears to be restrained ("Average Web Users Visit Just Six Sites a Day," *The Times* [London], March 6, 2006, p. 13). Studies of U.S. Web surfers report similar constraints, chiefly because of consumer irritation over marketing and unrestrained advertising, including pop-up ads, and fears of spyware and other incursions on privacy (Dave Gussow, "Ad-Riddled Web Changing Habits," *St. Petersburg Times*, July 7, 2005, p. D1). Gossow's article cites a report on changing Web habits of Americans conducted by the Pew Internet and American Life Project, a series of studies available online at www.pewinternet.org.

108. Jayson Blair, "Daily News Lures Back Ads from at Least Two Supermarkets," *New York Times*, June 28, 2001, p. B7.

5. DEFENDING THE NEWS

1. The Code of Ethics of the Society of Professional Journalists is available online at www.spj.org/ethics_code.asp.

2. Richard Morin and Dan Balz, "Survey Finds Most Support Staying in Iraq; Public Skeptical about Gains against Insurgents," *Washington Post*, June 28, 2005, p. A1.

3. In 2005, a provocative debate about journalistic ethics concerned efforts by Bush administration officials to influence news coverage at National Public Radio and the Public Broadcasting System, both funded in large part by the Corporation for Public Broadcasting. The CPB was then headed by Kenneth Y. Tomlinson, a Republican Party supporter who had embarked on a campaign to monitor NPR and the system's 350 public television stations for liberal bias and to institute what he called "ideological balance" in public affairs programming and journalistic practice. As part of this campaign, Tomlinson authorized $14,000 in taxpayer funding to hire a conservative activist to monitor certain PBS programs and take note of the political leanings of guests and interview subjects, separating them into categories such as "C" for conservative, "L" for liberal, "anti-Bush," and "anti-business," among others. The aim appeared to be a crackdown on any programs perceived as liberal—in particular, *NOW with Bill Moyers*, a public affairs program. When the existence of this "study" was revealed, it produced widespread debate about growing government pressure on the practice of professional journalism. Tomlinson's charges about bias in NPR and PBS news ran counter to two polls conducted by the CPB in 2002 and 2003 showing little to no concern among Americans that public broadcasting was politically biased in any way. See, for example, Eric Boehlert, "Pushing PBS to the Right," Salon.com, May 10, 2005, available online at http://dir.salon.com/story/news/feature/2005/05/10/cpb_bias_campaign/index.html.

4. John Hersey, *Hiroshima* (New York: Knopf, 1985); originally published in 1946.

5. John Hersey, "The Legend on the License," *Yale Review* 70, no. 3 (Autumn 1980): 1–25.

6. John Hersey, *Into the Valley: Marines at Guadalcanal* (Lincoln: University of Nebraska Press, 2002), p. xvii.

7. Ibid., p. xix.

8. Ibid., p. xviii.

9. For a fine biography of Elijah Lovejoy, see *Tide without Turning: Elijah P. Lovejoy and Freedom of the Press* (Boston: Star King Press, 1958). A most revealing account of the Double V campaign and the story of black publisher John Sengstacke appear in Stanley Nelson's 1999 documentary film *The Black Press: Soldiers without Swords,* Half Nelson Productions, San Francisco, Calif., distributed by Newsreel. For background on this film, see www.pbs.org/blackpress.

10. Cited in Melvin Mencher, *News Reporting and Writing,* 8th ed. (New York: Columbia University Press, 2000), p. 104.

11. Samuel P. Huntington, *The Soldier and the State: The Theory and Politics of Civil-Military Relations* (Cambridge, Mass.: Harvard University Press, 1957), pp. 7–19.

12. Neil Henry, "Ritual Breakfast, and Then the Woods," *Washington Post,* Nov. 28, 1982, p. B1.

13. Neil Henry, "Divers Find the Nina at 15 Fathoms," *Washington Post,* Oct. 8, 1978, p. B1.

14. Neil Henry and Chip Brown, "An Aimless Road to a Place in History; Aimless Wanderings of a 'Sick Boy' out of the Bubble in Dallas, Turned into a Long Troubled Journey and a Cross Country Search," *Washington Post,* April 5, 1981, p. A1.

15. Neil Henry, " 'Is This What I Pull?' Boy, 3, Asked before He Shot His Mother," *Washington Post,* Aug. 28, 1981, p. A1.

16. Neil Henry, "Who Is Killing the Children of Africa? Too Often, It's Their Countries' Own Rulers," *Washington Post,* Sept. 23, 1990, p. B5.

17. The twelve-day series began with Neil Henry, "Exploring the World of the Urban Derelict: Inside the Crumbling Walls of Baltimore's Helping-Up Mission, Where Men Recount the Legend of Old Louie, Eat Macaroni, and Mumble in Their Sleep," *Washington Post,* April 27, 1980, p. A1.

18. The series appeared on six consecutive days, beginning with Neil Henry, "The Long, Hot Wait for Pickin' Work," *Washington Post,* Oct. 9, 1983, p. A1.

19. See Tom Goldstein, *The News at Any Cost: How Journalists Compromise Their Ethics to Shape the News* (New York: Simon and Schuster, 1985), pp. 143–144.

20. The Bagdikian and Dash series can be found in Ben Bagdikian and Leon Dash, *The Shame of the Prisons* (New York: Pocket Books, 1972). For a fine treatment of the reporting work of Nellie Bly, see Brooke Kroeger, *Nellie Bly: Daredevil, Reporter, Feminist* (New York: Times Books, 1994). See also Upton Sinclair, *Upton Sinclair's The Jungle,* ed. Harold Bloom (Philadelphia: Chelsea House, 2002).

21. Barbara Ehrenreich, *Nickle and Dimed: On (Not) Getting By in Amer-*

ica (New York: Henry Holt, 2001); Ted Conover, *Newjack: Guarding Sing Sing* (New York: Random House, 2000). For more about the *Frontline* documentary, see www.pbs.org/wgbh/pages/frontline/slaves.

22. Bill Morlin, "West Tied to Sex Abuse in 70s; Using Office to Lure Men; Allegations Shadow Politician throughout His Career," *Spokane Spokesman-Review,* May 5, 2005, p. A1.

23. Douglas McCollam, "The Crowded Theater," *Columbia Journalism Review,* July/Aug. 2005, p. 24.

24. Amy Singer, "Food, Lies, and Videotape," *American Lawyer,* April 1997, p. 56.

25. McCollam, "Crowded Theater," p. 24. See also Jean McNair, "ABC Food Lion Verdict Reversed," Associated Press, Oct. 21, 1999.

26. Williams Grimes, "Dispatches from the Hottest of Hot Zones," *New York Times,* Jan. 11, 2006, p. B9. The book being reviewed was Vasily Grossman, *A Writer at War: Vasily Grossman with the Red Army, 1941–1945,* ed. and trans. Antony Beevor and Luda Vinogradova (New York: Pantheon, 2006).

27. Edward Wyatt, "When Memoir and Facts Collide," *New York Times,* Jan. 11, 2006, p. B8; "The Man Who Conned Oprah," www.thesmokinggun.com/archive/0104061jamesfrey1.html, Jan. 8, 2006.

28. Wyatt, "When Memoir and Facts Collide"; Sheila Kohatkar, "In Frey Fabrication, Publishers Only Care if Mt. Oprah Blows," *New York Observer,* Jan. 16, 2006, p. 1.

29. Columbia's new two-year journalism degree program is described on the school's Web site; see www.jrn.columbia.edu/admissions/apply/ma-program/index.asp.

30. Cited in Teresa Mendez, "Journalism Students Ask: Why Am I Here?" *Christian Science Monitor,* Oct. 26, 2004, p. 12.

31. Dan Gillmor's *We the Media: Grassroots Journalism by the People, for the People* (Sebastopol, Calif.: O'Reilly Media, 2004) explores some of the ways citizens using New Media are challenging the traditional media's control of news and offers guidance for citizen journalists seeking reporting skills.

32. Late in 2005, for example, when lobbyist Jack Abramoff was indicted on numerous felony counts in connection with his business dealings with elected officials on Capitol Hill, many journalists relied on invaluable data on this topic maintained online in 2.2 million official public records and analysis of the work of registered lobbyists by the nonprofit, nonpartisan Center for Public Integrity. Subtitled "Investigative Journalism in the Public Interest," the center's Lobby-Watch project, which uses public records and documents to track the ways private interests affect public policy, can be found at www.publicintegrity.org/lobby/.

33. Andreas Kluth, "Survey: New Media—among the Audience," *Economist,* April 20, 2006. The expert quoted is Joe Kraus, founder of JotSpot, a maker of Wikis.

34. See "Coke Lies, Misleads with Fake 'Zero' Blog," www.adrants.com/2006/01/coke-lies-misleads-with-fake-zero.php. The AdRants.com site is an industry insider blog devoted to exposing advertising tactics of American corporations, particularly those deploying new strategies on the Web. This article

concerns an attempt by Coca Cola to trigger a viral marketing campaign on the Web to sell Coke Zero, a new diet product, to young consumers using a fake citizen blog produced by a fictional youth. Coke withdrew the site after the Ad-Rants exposé. See also Aaron Patrick, "Foster's to Launch Web-Only U.S. Ad Strategy," *Wall Street Journal,* Aug. 3, 2006, p. B2. This article revealed that advertisers for Foster's beer intended to use open-source Web sites to disseminate ads in the form of faux "citizen" amateur videos touting the product. The beer maker said that it would no longer advertise on American television, instead shifting most of its advertising to the Web.

35. The song was written by Eugene McDaniels in 1969, recorded by Mc-Cann and Harris live at the Montreaux Jazz Festival in 1970, and released as a track on their album released that same year, *Swiss Movement,* by Atlantic Records.

36. Lia Miller, "So Many Models in Bikinis, So Many Ways to See Them," *New York Times,* Feb. 13, 2006, p. C4.

37. Julie Bosman and Richard Siklos, "Time Inc., Facing Declining Ad Pages, Lays Off 105, Including Top Executives," *New York Times,* Dec. 14, 2005, p. C3.

38. Cited in Joseph Nocera, "His Airline Didn't Skimp on the Cheese," *New York Times,* Jan. 7, 2006, p. C1.

39. While I do not consider myself a Luddite—and indeed cannot afford to be one as a teacher of modern journalism—I do share a view about technology and journalism that is expressed well by sociologist Herbert Gans: "The history of technological innovation does suggest that the cultural, social, and economic innovations expected from new technologies do not often materialize. Consequently, technology alone will do little to create a bright future for journalism" (*Democracy and the News* [New York: Oxford University Press, 2003], pp. 42–43).

40. Chinua Achebe, *Anthills of the Savannah* (Nairobi: Heinemann Kenya, 1987), p. 128.

41. James Fallows, *Breaking the News: How the Media Undermine American Democracy* (New York: Pantheon Books, 1996), pp. 247–277; Gans, *Democracy and the News,* pp. 113–125.

42. Leanne Potts, "Stockpiling Journalists: New Mexico Governor Bill Richardson Lures Lots of Experienced, Underpaid Reporters to His Staff," *American Journalism Review,* Feb.-March 2005, p. 16.

Index